TREASURES FROM
THE BRONZE AGE OF CHINA

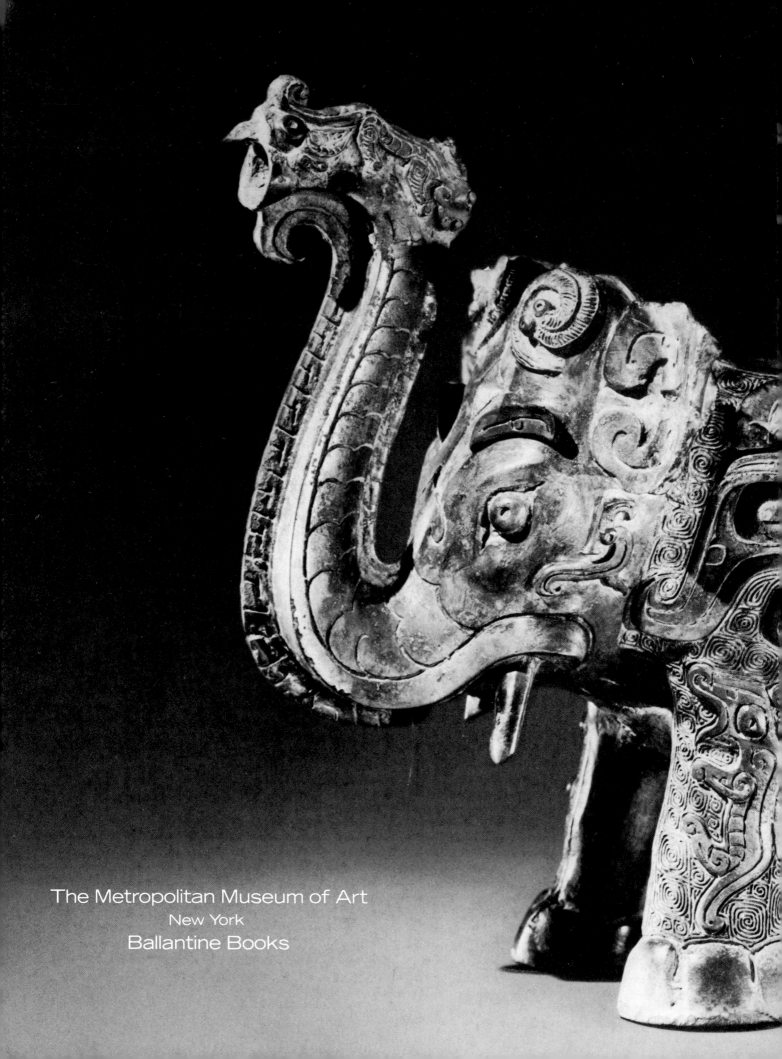

The Metropolitan Museum of Art
New York
Ballantine Books

TREASURES FROM THE BRONZE AGE OF CHINA

An Exhibition from the People's Republic of China

The Metropolitan Museum of Art, New York
Field Museum of Natural History, Chicago
Kimbell Art Museum, Fort Worth
Los Angeles County Museum of Art
Museum of Fine Arts, Boston

Published in conjunction with the exhibition *The Great Bronze Age of China* held at:
The Metropolitan Museum of Art, New York, April 12—July 9, 1980
Field Museum of Natural History, Chicago, August 20—October 29, 1980
Kimbell Art Museum, Fort Worth, December 10, 1980—February 18, 1981
Los Angeles County Museum of Art, April 1—June 10, 1981
Museum of Fine Arts, Boston, July 22—September 30, 1981

The exhibition was made possible by grants from The Coca-Cola Company and the National Endowment for the Humanities, Washington, D.C., a federal agency.

Under the Arts and Artifacts Indemnity Act, indemnity was granted by the Federal Council on the Arts and Humanities.

The color photographs, made especially for this exhibition, were taken in China by Seth Joel. The color photographs of the gilt-bronze lamp no. 94 and of the excavation site of the terracotta warriors were taken by Wang Yugui, Cultural Relics Bureau, Beijing.

Chapters 1 through 10 and the catalogue entries have been adapted from text in the exhibition's scholarly catalogue, *The Great Bronze Age of China: An Exhibition from the People's Republic of China,* by the following authors: Chapters 1—6 and Entries 1—63 by Robert W. Bagley, Research Assistant, Department of Fine Arts, Harvard University; Chapters 7—9 and Entries 64—97 by Jenny F. So, Research Assistant, Department of Fine Arts, Harvard University; Chapter 10 and Entries 98—105 by Maxwell K. Hearn, Assistant Curator, Department of Far Eastern Art, The Metropolitan Museum of Art. We have followed the *pinyin* system of transliterating Chinese characters into the Latin alphabet; Peking, for example, becomes Beijing in *pinyin*.

Manufactured in the United States of America
First Edition: April 1980

Library of Congress Catalogue Number 80-11099
ISBN 0-87099-230-9 (MMA)
ISBN 0-345-29051-8-1295 (Ballantine)

Cover: Detail of no. 94
Frontispiece: Elephant-shaped wine vessel (no. 24)

Contents

Preface

Chinese civilization is among the oldest of the world. The bronze objects of the Shang and Zhou periods represent the level of cultural development achieved during the early times of Chinese slave society. They possess a unique national style, distinctive characteristics of their time, and an outstanding degree of artistic achievement. By the Qin and Han periods, bronze vessels with inlays of gold and silver had reached a new brilliance, which today makes them artistic treasures.

Since the founding of the People's Republic of China, the many important bronze vessels discovered throughout the country have contributed invaluable scientific material for the study of political, economic, and cultural aspects of the long period of Chinese slave society. The eighty-five bronze objects displayed here are gathered from fifteen provincial and municipal museums and archaeological organizations, including those of Beijing, Shanghai, Shaanxi, Henan, and others. Through these bronze artifacts—the finest selected from the large quantity of objects archaeologically excavated in China during the last thirty years—a comprehensive picture of the bronze art of ancient China emerges.

The eight terracotta figures and terracotta horses were selected from among the thousands of burial figures recently excavated on the eastern side of the tumulus of First Emperor Qin Shihuangdi (third century B.C.). The animation of their forms, the maturity of technique, and their heroic demeanor make them unique among the painted terracotta sculpture of ancient China. They reflect the high level of sculptural art in the Qin period.

In 1974 and 1975, cultural relics unearthed in China and, in 1976 and 1977, copies of wall paintings of the Han and Tang were exhibited in the United States and received the warm welcome and appreciation of the American people. As a result of the establishment of Sino-American diplomatic relations, new prospects for relations between our two countries have been opened. This group of historic treasures has been gathered especially for presentation to the American people. We hope that this exhibition will make a contribution toward increased cultural exchange and friendly relations between China and the United States, and will advance the mutual friendship and understanding between the peoples of the two countries.

The Committee for the Preparation of Exhibitions of Archaeological Relics, People's Republic of China

Foreword

Archaeology in China today promises to disclose the secrets of ancient China in much the same way that nineteenth-century archaeology revealed the ancient Greek world, both by refuting cherished notions of the later historians and by restoring myths and vanished kingdoms to history. The 105 exhibits in the present exhibition sent by the People's Republic of China, carefully selected for their aesthetic and historical importance, summarize the most brilliant achievements in recent Chinese Bronze Age archaeology.

The advent of bronze metallurgy in any ancient civilization assured the creation of better tools for increased productivity, and more effective weapons for making war. In ancient China, however, bronze technology was put to a third important use, the one with which this exhibition is primarily concerned, namely, the casting of imposing drinking vessels and food containers. These objects were created for rituals in ancestral temples by kings and nobles whose rank and order were measured by the size and the number of their bronzes. Such bronzes display the incredible range of inventive genius of the ancient Chinese, who successfully combined art and industry to form some of the most accomplished and enduring works of art the world knows. Splendid works in bronze and jade, these objects stand as eloquent and tangible testimony to the great early civilizations of China. The ultimate importance of such works of art lies not only in their revealing the extraordinary skill and genius of the earliest Chinese artisans, but also in their role as keystones in the reconstruction of ancient Chinese history.

Legend has it that after King Yu of the Xia dynasty controlled the flood, about 2200 B.C., he divided his land into nine provinces, and had nine *ding* (cauldrons) cast to represent them. Thus, the "nine *ding*," also called the "Heavy Vessels of the State" or the "Auspicious Bronzes of the State," became symbols of power and prestige. When the Xia dynasty fell, it is recorded, the "nine *ding*" passed to the Shang dynasty, and, in turn, to the Zhou when they conquered the Shang.

Whether weapons or ritual vessels, bronze objects meant power for those who possessed them. In times of war, the bronze from ritual vessels could be used to make weapons; in times of peace weapons might be transformed into ceremonial objects. After the First Emperor of Qin unified China in 221 B.C., he ordered that all the bronze vessels and weapons captured from his vanquished enemies be melted down and made into twelve colossal bronze statues to adorn his pal-

aces. The real purpose of this grandiose act was to keep weapons out of the hands of his subjects, but, eventually, the giant bronze statues were melted down and recast into weapons by enemy invaders.

The Great Bronze Age of China, the exhibition that the People's Republic of China has lent to five United States museums, makes a unique contribution to Western understanding of the greatness of ancient Chinese civilizations. It opens with the earliest known Chinese bronze vessel and concludes with the extraordinary terracotta soldiers and horses that were recently excavated from the burial complex of the First Emperor of Qin. Unlike the first Chinese exhibition of archaeological finds that toured the United States in 1974 and 1975, which consisted of a general sampling of objects dating from the Neolithic through the Yuan periods, the present show has a unified theme: it presents us with a thorough review of the most brilliant latest achievements in Chinese Bronze Age archaeology with discoveries that have fundamentally changed our knowledge of ancient Chinese history and art.

The recent reopening of diplomatic relations between the People's Republic of China and the United States insured that the planning and organization of the exhibition would become a reality. Many of the spectacular objects included are of such outstanding importance that there was some doubt at first that the Chinese government would permit them to leave the country. Equally unprecedented is the unstinting cooperation of the Chinese in the preparation of the major scholarly catalogue that accompanies the show. With contributions by Ma Chengyuan of the Shanghai Museum, and by a team of American scholars led by Professor Wen Fong of Princeton University and The Metropolitan Museum of Art, the catalogue is a full summary by scholars both in China and in the West of current interpretations of the latest Chinese Bronze Age finds; the catalogue you are reading is a shortened adaptation of material in that book.

I had the personal pleasure of joining the exhibition's work team in China in February 1979. The sheer magnificence and beauty of these ancient art objects, especially when seen in their original setting, left me with a profound and lasting impression. Their transcendent beauty cannot fail to move and quicken the senses of the American public. Moreover, the warm reception and unfailing support that we received from His Excellency Wang Yeqiu, Director of the State Administrative Bureau of Museums and Archaeological Data, and the staff of the Committee for the Preparation of Exhibitions of Archaeological Relics will be

remembered long after the exhibition closes and the artifacts return to China.

It was, we remember, the remarkable Burlington House exhibition of Chinese art in London, in 1935 and 1936, that stimulated an entire generation of art historians and enthusiasts in Europe and the Americas. I am certain that the current exhibition of Chinese Bronze Age art will open a new era in the appreciation and understanding of ancient Chinese art and archaeology in the West.

Philippe de Montebello
Director,
The Metropolitan Museum of Art

Acknowledgments

The Metropolitan Museum of Art is delighted to have the opportunity of presenting a loan exhibition of major scholarly importance from the People's Republic of China. His Excellency Chai Zhemin, Ambassador to the United States, took a personal interest in the exhibition and lent powerful support to the negotiations. The Honorable Xie Qimei, Counselor of the Chinese Embassy in Washington, D.C., not only was instrumental in getting the initial negotiations for the exhibition under way, but also guided the project through its various stages. The Chinese embassy's First Secretary for Cultural Affairs, Zhang Wenying, always efficient and affable, made all our dealings with that embassy pleasurable and rewarding.

But it is to the active interest and support of His Excellency Wang Yeqiu, a scholar and Director of China's State Administrative Bureau of Museums and Archaeological Data, and to the unfailing cooperation of the members of the Bureau's Committee for the Preparation of Exhibitions of Archaeological Relics that we owe the successful accomplishment of this undertaking of unusual complexity and magnitude. Mr. Wang personally guided the selection of the objects. The Bureau's Foreign Affairs Section Chief, Guo Laowei, an extraordinary diplomat, solved many difficult problems with skill and graciousness. We must express our deep gratitude to the Bureau's Office for the Preparation of Exhibition Materials, especially its chief Yu Jian and its deputy chief Qiu Zhenbang, for the kind and patient assistance given to our photographer and researchers during their long stays in Beijing, as well as for supplying the large number of excellent photographic and illustrative materials used in the exhibition and catalogues. We also thank the heads and the curators of the many distinguished institutions that we visited, especially: Xia Nai, Director of the Institute of Archaeology, Beijing; Yang Zhenya, Director of the Historical Museum, Beijing; Peng Yan, Deputy Director of the Palace Museum, Beijing; Shen Zhiyu, Director of the Shanghai Museum; Liu Wenlin, Deputy Director of the Xi'an Provincial Museum; Chen Mengdong of the Shaanxi Cultural Relics Bureau; and Xiong Chuangxin of the Hunan Provincial Museum. Their warm help and advice greatly enriched our knowledge of the field.

We are most grateful to the Honorable Leonard Woodcock, the United States Ambassador in Beijing; the Honorable Stapleton Roy, the Deputy Chief of Mission; and John Thomson, First Secretary at the Embassy, for granting us every courtesy and help in matters relating to the project.

At the Metropolitan Museum, the entire administrative staff has for the past two years given its best effort to the planning and mounting of the exhibition. We wish to thank in particular the Director, Philippe de Montebello, who led the research and photographic expedition in China in February 1979 and successfully negotiated the inclusion of some of the most important objects in the exhibition. William Macomber, President; James Pilgrim, Deputy Director; John Buchanan, Registrar; and other members of the administration played essential roles in many matters relating to the budget, application for indemnification, and logistical planning. We also want to thank the editors of the scholarly catalogue, Lauren Shakely and Rosanne Wasserman, and the editor of this condensed version, Katharine Stoddert Gilbert, all of whom did a remarkably skillful and sensitive job. Within the Metropolitan Museum's Far Eastern Art Department, everyone connected with the project has worked countless hours, but special mention should be made of Maxwell K. Hearn and Alfreda Murck, who reviewed the text for this book, and managed and supervised the physical production of the exhibition at the Museum. Julia K. Murray, now at the Freer Gallery of Art, Washington, D.C., did preliminary research and coordinated the project while she was on the staff of The Metropolitan Museum of Art. For the installation design we are grateful to Lucian Leone, Assistant Manager for Design. While at the Metropolitan the exhibition is presented in The Sackler Exhibition Hall.

We are deeply indebted to those who have made this exhibition possible: the National Endowment for the Humanities and The Coca-Cola Company. In turn, we thank both the National Endowment for the Humanities and the American Council of Learned Societies for the funding of the symposium to be held in conjunction with the exhibition at the Metropolitan Museum.

Wen Fong
Edwards Sanford Professor of Art and Archaeology, Princeton University, and
Special Consultant for Far Eastern Affairs, The Metropolitan Museum of Art

INTRODUCTION

At about the same time that Stonehenge was rising and Abraham was framing the principles of Judaism, a Bronze Age culture was developing in China that in many respects was seldom equaled and never surpassed.

This development seems to have occurred early in the first half of the second millennium B.C. in the fertile Central Plains of the Yellow River valley, in what are now northwest Henan and southern Shanxi Provinces (see map on p. 16). For thousands of years this area had sustained Neolithic cultures of increasing complexity, leading to the emergence of the first Chinese civilization, characterized by a strong centralized government with stratified social classes, urban communities, palatial architecture, a distinctive system of writing, elaborate religious rituals, sophisticated art forms, and bronze metallurgy.

Bronze is an alloy of copper and tin (although in ancient China, lead was also frequently used). The earliest manufactured metal objects seem to have been made exclusively of copper, but it was soon discovered that the addition of tin not only increased the metal's hardness but made it quicker to melt and easier to control.

The use of bronze is a major watershed in the development of any civilization, requiring a settled, specialized, and tightly organized community. Most of the crafts of earlier periods were based on portable, easily obtainable materials such as clay, stone, shell, and bone. But the production of bronze is a major undertaking. Sources of copper and tin must be located and, having been located, protected. The ore must be mined and the metal removed. In the case of copper, this is a mammoth enterprise, since copper accounts for only a very small fraction of the volume of the ore in which it is found. In ancient China, the metal seems to have been smelted at the mines and then shipped to the communities in which it was to be used. Melting large batches of metal required elaborate kilns and huge fires of high intensity; controlling the cooling to avoid holes and cracks in the finished object was equally demanding.

Considering the craft's exacting technical demands, the speed with which bronze casting was perfected in ancient China is remarkable. The earliest bronze vessels so far uncovered—such as no. 1 in this exhibition—are thin and rather crudely made, though stylish and full of character; yet within a few generations bronzes display a staggering technical virtuosity and a compelling aesthetic power and sophistication (nos. 9, 11, 14).

Several influences may have encouraged this rapid development. In the first place, by the end of the Neolithic period Chinese artisans were already in command of exceptional technical skills, such as the production of exquisite, hard, thin-walled ceramics whose creation and firing involved many of the same techniques that bronze casting was to require. Secondly, in the early centuries of its use in China, bronze was a surpassingly precious commodity. Indeed, throughout the Bronze Age its use and distribution seems to have been almost a monopoly of the ruling class; a Chinese king presented a loyal subject with bronze in the way a Western ruler might hand out gold. During the Chinese Bronze Age, the metal was used for the weapons the aristocracy needed for its occupations of hunting and war, but despite its superior efficiency,

bronze was less often devoted to common tools such as agricultural implements, which were usually made of the traditional Neolithic materials of stone, bone, and wood until the introduction of iron.

A final, compelling influence in the refinement of the bronze caster's art was one characteristic of ancient China. From the outset, bronze was used to create the majestic vessels that played central roles in state rituals and ancestor worship. This exhibition features sixty-two of these precious vessels, spanning over a thousand years of continuous production. The principal art form of the Chinese Bronze Age, they epitomize the technical and artistic accomplishments of early Chinese civilization in their often monumental size and in their surpassing beauty.

According to tradition, the first emperor of China's Golden Age cast nine monumental bronze cauldrons symbolizing the nine provinces of his realm. When his dynasty fell, these "Auspicious Bronzes" were claimed by the new rulers, the Shang. And, in turn, with the defeat of the Shang these symbols of the state were taken over by their conquerors, the Zhou. This legend has recently received extraordinary confirmation with the discovery in 1976 of a bronze vessel commissioned only eight days after the Zhou conquest in the eleventh century B.C. (no. 41); its inscription not only mentions the defeat of the Shang but the capture of their cauldrons.

Bronze cauldrons were the symbols of the state, and bronze ritual vessels were used by the rulers to hold offerings of food and wine that were presented to the royal ancestors and deities; thus they became expressions of power and legitimacy. Central to the Shang state cult of ancestor worship were two ideas: that the king derived his power from his divine forebears, and that a "Supreme Ancestor" controlled the course of events. The spirits of the royal ancestors participated in this power structure, linking gods and men, and thus might favorably influence events if propitiated by sacrifices and offerings.

These rituals, around which the destinies of men and the state revolved, were performed at the altar of the ancestral shrine. Wine seems to have played a major role in Shang ceremonies, and containers for wine outnumber other types. The most popular shapes of wine vessels in Shang times were spouted cups such as no. 1; containers for holding and heating wine such as no. 16; and vessels in which wine and water might be mixed, such as no. 30. Other important shapes include cauldrons for cooking food offerings (no. 4) and food containers such as no. 8. The Shang were criticized for their overindulgence in wine by their conquerors, the Zhou, and accordingly, after the Zhou conquest, fewer wine vessels were produced, favorite Shang shapes fell out of fashion, and other types of vessels replaced them in popularity (nos. 41, 63, 67, 70).

During the Shang period, the performance of rituals seems to have been restricted to the king, royal family, and members of the aristocracy who could claim descent from royalty. The respect with which the maintenance of the rituals was regarded is underscored by the fact that when the Zhou defeated the Shang, they made a point of installing a member of the former royal family to continue the Shang rituals. And so fraught with political significance were bronze vessels and rituals that in later centuries the heads of vassal states might signal their challenge to the ruling house by casting ceremonial bronzes and performing rituals themselves. After the Shang period, ritual vessels increasingly became expressions of personal prestige. Inscriptions, rare in Shang, become common on Zhou bronzes, relating the achieve-

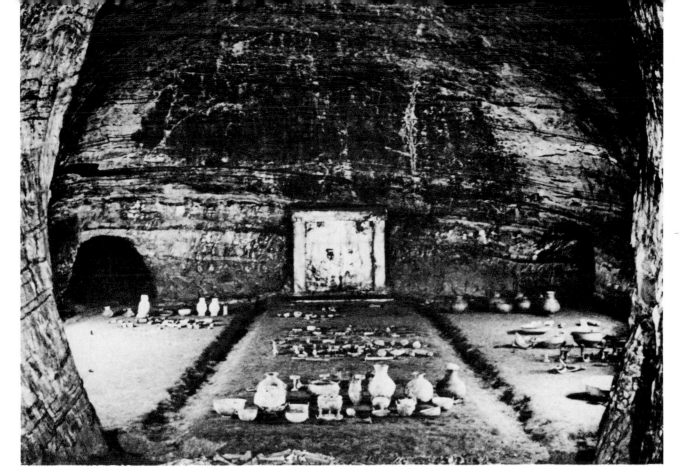

The impressive tomb of Prince Liu Sheng, dating from the second century B.C., in which the magnificent bronzes nos. 95 and 96 were found

ments of the owner and expressing the poignant wish that the piece might not only honor his forebears but also recall his own merits to his descendants "for generations without end." By the end of the Bronze Age, the dazzling elegance of bronze vessels indicates that they served as worldly status symbols more important in celebrations of the living than in rituals for the dead.

We owe the preservation of these ancient bronzes to the fact that they were buried, for the vessels not only dignified ceremonial altars but took pride of place among the grave goods that were buried with royalty and members of the upper class. In the Shang period a royal funeral was a momentous—and, to modern eyes, a terrible—event. Accompanying the ruler to the afterlife might be not only ceremonial bronzes and ceramics for religious observances, weapons and amulets for protection, and ornaments for delight, but also the human and animal entourage that had surrounded him in life: concubines, bodyguard, and even his horses, chariot, and charioteer. Ritual bronzes and sacrificial offerings of people and animals (such as dogs and cattle) were also buried with the nobility, as well as on the occasion of the consecration of altars, building foundations, and city walls (which had been laboriously built up in the distinctive Shang construction technique of numerous layers of tightly packed earth). By the late Zhou period, about the fourth century B.C., sumptuous burials continued but sacrifices were rarely practiced, although the custom was preserved by the substitution of figurines of wood or clay made to resemble the retinue of the deceased. Usually these figurines were quite small, but perhaps the most startling section of this exhibition is devoted to an imperial version

What sets Chinese ritual bronzes apart from most Western art—and even from Chinese art of the fifth century B.C. onward—is their lack of interest in representational realism. Instead, emphasis is put on the formal qualities of their design: symmetry, an often insistent frontality, and vigorous elaboration of ornament, usually arranged in horizontal bands that complement a vessel's contours. The rare animal-shaped bronzes are remarkable for the lengths to which the artist goes in his transformation of reality (no. 45), and actual depictions of people or animals in other media (nos. 38, 39) are oddly clumsy compared to the controlled power of the ritual utensils.

Although the decoration of Shang ceremonial bronzes may ultimately have been based on forms of animals—whether evoking those used in sacrifices or serving as clan totems or symbolizing the spirits of nature—the motifs are maddeningly incorporeal and resist attempts to identify their inspiration. However insubstantial in shape, they are given dramatic presence by the emphasis on the eye, which often seems to animate a vessel and is itself one of the most potent Shang motifs. The most ubiquitous decoration in the Shang period is a frontal animal mask created by two creatures in

An exquisitely drawn eye, a motif that often invests ancient Chinese bronzes with a strange intensity (no. 14)

13

profile, with their heads meeting in the center of the motif, to which they each contribute an eye, a C-shaped ear or horn, and a jaw; another common decorative device is an open-jawed "dragon" that often flanks the mask motif (both are seen on no. 32). During the Western Zhou period zoomorphic forms become more and more abstract, as the Shang motifs are increasingly subjected to linear elaboration, until forms dissolve into ornamental arabesques. A new vocabulary of interlace based on serpentine shapes develops during the Eastern Zhou era, and these, along with purely geometric designs, are used in an overall patterning of the vessels' surface. At the same time handles become sculptural, depicting felines, dragons, and other beasts in poses that emphasize the swells and curves of the body's musculature.

The best of the ritual bronzes have a quality beyond their aesthetic impact. Even removed by half a world and 3,000 years from the ceremonies they honored, these works can have an intensity of presence characteristic of great religious art.

Ritual bronzes can also be extremely important historical documents, by virtue of the inscriptions that many of them bear. Cast into the surface of a vessel, these inscriptions begin during the late Shang dynasty as identification of the vessel's owner, or the ancestor to whom it was dedicated. During the Western Zhou period inscriptions appear in increasingly greater numbers and longer lengths, extolling the achievements of the owner for the benefit of his posterity. Offering contemporary sources of information uncluttered with later moralizing, bronze inscriptions are first-hand sources that often serve as a check against the accounts of early events preserved in later histories.

Another primary source of historical data for ancient Chinese history are the "oracle bones" found at the Shang capital of Anyang and at a predynastic Zhou palace site at Qishan in Shaanxi Province. An oracle bone is an animal's shoulder blade or a turtle's shell that has been used in divination at the court: the king would ask a question (as mundane as the success of the day's hunt, as momentous as the success of his army's attack), a heated rod would be applied to the bone, and the diviner would interpret the answer from the pattern of cracks that appeared on the surface. Sometimes both question and answer would be inscribed on the oracle bones before they were stored in the court archives. From these questions and answers we can learn an enormous amount about ancient Chinese rulers and their activities; admittedly much of the oracle information is trivial or unintelligible, but at times it is extraordinarily useful in amplifying facts derived from other sources. The oracle bones' inscriptions were excitingly corroborated by the discovery in 1976 of an intact and undisturbed royal tomb at Anyang. The excavation yielded over 440 bronze objects, 590 jades, 560 bone objects, plus stone, ivory, and shell carvings, pottery vessels, and nearly 7,000 cowrie shells (used as money). More than seventy of the bronze vessels are inscribed, and on the basis of these inscriptions, most scholars identify the owner of the tomb as Fu Hao, who was the consort of Wu Ding, the fourth Shang king to rule at Anyang. From oracle-bone records we know that Fu Hao was a woman of character and consequence, leading military expeditions on behalf of the king and on occasion presiding in his name at state sacrifices. The various inscriptions on her tomb's bronzes also add to our understanding of how Shang ritual vessels were used. Some were inscribed "Fu Hao," and were evidently cast during her lifetime for use on the altar of her family ancestral temple. Others were inscribed with her posthumous

temple name, the name by which she was addressed by her descendants; these must have been cast at the time of her death for use in the funeral rites and to carry food and wine offerings into her grave.

Seven of the jades from Fu Hao's tomb are shown in this exhibition (nos. 34-40), along with four other examples of this ancient art. The craft of the jade carver was hundreds of years old by the time bronze was introduced; the shapes and techniques were typical of the stoneworking expertise that gave the Stone Age its name. Jade, however, is so hard that it cannot be cut even by steel, and could only be shaped by painstaking grinding with abrasives. Thought to have potent protective properties, jade was especially treasured in ancient China. It was probably not indigenous; if there were mines within Chinese borders, they had been exhausted by historical times, for we know that by the Han period it was imported from Khotan, thousands of miles distant in Central Asia, and possibly from Siberia. Its value and rarity explain the care with which it was used and even reused; one object in the exhibition seems to have been recut from a broken weapon (no. 36), so that not even a fragment would go to waste.

The products of the Bronze Age have long been admired in China. As early as the eleventh century A.D., a scholar-politician studied early bronzes and collected fine examples. But controlled archaeology is comparatively recent in China. Excavations supervised by scholars did not become widespread until the 1920s, and many of their earliest professional excavations were at sites that had already been looted by grave robbers. Recently, however, it seems that every Chinese is an archaeologist. This is particularly fortunate, for China includes some of the oldest inhabited sites anywhere, as well as some of the richest for the study of early man. Year after year some spectacular find is made, year after year some new information broadens our knowledge of ancient history, confirms age-old records, or upsets commonly held ideas. As each new piece of evidence appears, theories can change overnight, and there are still many disagreements about dating, techniques, and interpretation among scholars. Chinese archaeological information is one of the fastest growing areas of art history today, and one of the most exciting and interesting.

It would be hard to choose the most impressive objects in this exhibition. For the student of prehistory, it might be the elegant vessels from the earliest sites that already embody a surprising sophistication in appearance and technique. For the specialist in Chinese art, it might be the idiosyncratic pieces from the south, far more accomplished than their provincial origins would have led us to expect. It might be the remarkable treasures from the tomb of Fu Hao, who bore the Shang king's children and led his armies. For the military historian, for sculptors, for children, and, indeed, for most of us, it might be the life-size clay warriors that guarded the emperor who unified China more than 2,000 years ago. Staggering in size and quantity, unparalleled in technique, and uncannily realistic in appearance, they bring to life the Chinese people who created the marvels included in this exhibition, and suggest the untold riches that still await the archaeologist in the Chinese soil.

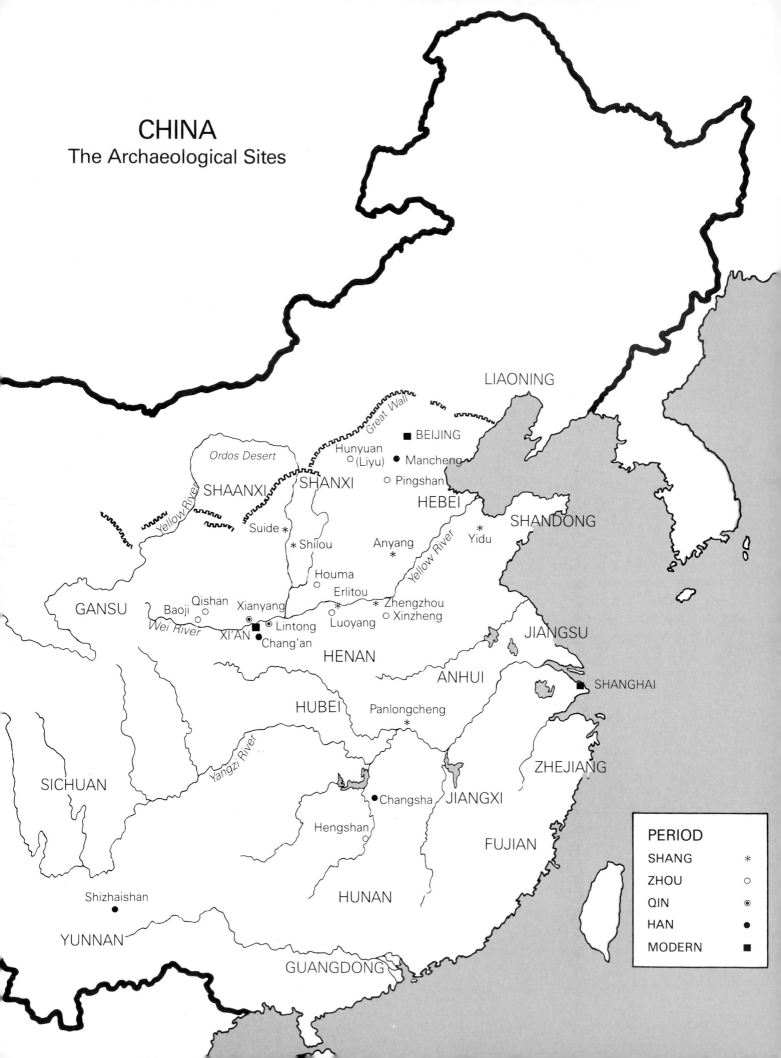

CHINA
The Archaeological Sites

LIAONING

Ordos Desert

Great Wall

■ BEIJING

Hunyuan
(Liyu) ○ ● Mancheng

SHAANXI SHANXI

○ Pingshan

HEBEI

SHANDONG

Yellow River

Suide *

* Shilou

Anyang
*

* Yidu

Yellow River

Houma ○

GANSU

Baoji Qishan
○

Xianyang
◉ ■
XI'AN ● Lintong

Erlitou
○ * * Zhengzhou
○ Xinzheng

Luoyang

Wei River

● Chang'an

HENAN

ANHUI

JIANGSU

■ SHANGHAI

HUBEI

Panlongcheng
*

ZHEJIANG

Yangzi River

SICHUAN

● Changsha

JIANGXI

Hengshan

FUJIAN

HUNAN

Shizhaishan
●

YUNNAN

GUANGDONG

PERIOD	
SHANG	*
ZHOU	○
QIN	◉
HAN	●
MODERN	■

1 The Beginnings of the Bronze Age

The Erlitou Culture Period
First Half of the Second Millennium B.C.

The origins of the Bronze Age in China are still obscure. There are indications that metal was in use before 2000 B.C., but the first substantial metal artifacts so far unearthed have come from the earliest sites of the Shang dynasty, several centuries later. At this time Chinese civilization emerges, and with it the full range of cultural achievements that the word "civilization" calls to mind—among them writing, cities, the use of metals, and a highly stratified society ruled by an all-powerful king. But while these basic features are shared with Bronze Age societies elsewhere in the ancient world, Chinese civilization was distinctly individual from the first. Excavation of Shang sites has revealed a cultural tradition already recognizably Chinese and directly linked with the civilization of later historic times. The individuality of one facet of the Chinese Bronze Age—its artistic side—is to be seen everywhere in the present exhibition.

According to later Chinese historical writing, the first dynasty was not the Shang but the Xia. Nevertheless, archaeologists have yet to find conclusive evidence for a dynasty of that name. With Shang we are on firmer ground, for the last capital of the dynasty has been found at Anyang in Henan Province. Inscribed animal bones that record divinations made on behalf of the Shang kings were found in great numbers at Anyang; the discovery of these divination inscriptions, the only written records surviving from Shang times, removed the Shang dynasty from the realm of historical legend.

Only the final and most opulent stage of Shang civilization is represented at Anyang (Chapter 4). Sites belonging to the earlier part of the Bronze Age remained unknown until the 1950s and 1960s when two major pre-Anyang sites, both south of the Yellow River in Henan Province, were discovered. The walled city found at Zhengzhou (Chapter 2) was an important settlement before the founding of the capital at Anyang (ca. 1300 B.C.?). The site discovered at Erlitou is earlier still: successive strata there show a primitive Shang culture following closely on levels still apparently Neolithic.

Erlitou was no minor settlement, but a city that could well have been a capital. The bronzes and jades so far recovered from Erlitou, including the three shown in this exhibition (nos. 1-3), have all come from the remains of a very large palatial enclosure. The only bronze vessels recovered are four small spouted three-legged drinking vessels (cf. no. 1). These modest objects are the earliest bronze vessels yet known from China and thus represent the ancestors of all the examples in this exhibition.

In the wine cup no. 1 we glimpse for the first time the origins of a bronze-casting industry that is already vigorous and mature in the next period, the Zhengzhou phase. Awkward as it may appear, the wine cup displays certain basic features that set the metalworking of the Chinese Bronze Age sharply apart from Near Eastern traditions. The odd shape, which becomes a standard vessel form in later centuries (nos. 15, 47), speaks of an artistic tradition of decided character. The metal composition, reported to be 92 percent copper and 7 percent tin, is not an accidental alloy but a deliberate bronze and implies all the complex metallurgical knowledge required to mine both metals and win them from their ores. Most important, the vessel has seams, which show it to have been cast from a mold made in sections—at least four separate parts designed to fit together—which distinguishes the technology of the Chinese Bronze Age artist from the lost-wax process used by his counterparts in the West.

The second great art form of Bronze Age China is that of carved jade. "Carved" is not precisely the right word, since this most admirable of minerals is too hard to be cut even by steel tools, and must instead be shaped entirely by means of abrasives. The two jades from Erlitou (nos. 2, 3) are replicas of a weapon and a tool; although they may have served some ritual purpose aboveground, they were no doubt intended primarily as funerary offerings or sacrificial gifts to spirits. Such replicas, painstakingly ground from jade or other fine stone, took pride of place among the offerings in the richest

Neolithic graves. When we find the same shape copied, with still greater finesse, in the Shang period, we are reminded that the working of jade is not in essence a Bronze Age craft at all, but a technology characteristic of Neolithic times; the term "Neolithic" was coined in the nineteenth century precisely in order to contrast the polished stone tools of the "New Stone Age" with the chipped tools of the "Old Stone Age" that they replaced. At Erlitou, the products of the nascent bronze industry are of the most obvious simplicity, scarcely hinting at the splendors to come; but the jades are not primitive at all. Their sophistication is nothing less than astonishing.

2 Vigorous Development

The Zhengzhou Phase (The Erligang Period)
Mid-Second Millennium B.C.

The civilization whose beginnings are seen at Erlitou came to maturity around the middle of the second millennium B.C. This period is referred to by archaeologists as the Zhengzhou phase, named after a city sixty-two miles east of Erlitou. Excavations in the vicinity of Zhengzhou have uncovered a few scattered remains that resemble artifacts from Erlitou, but it is clear that the main occupation of the site came later, following closely on the uppermost level at Erlitou. Without written evidence, only the relative dates of the two sites can be securely established, and the clumsy terms "Erlitou culture period" and "Zhengzhou phase" have at least the virtue of being noncommittal.

Since recent exhibitions have featured bronzes found at Zhengzhou itself, the present show includes only one object from this site, a newly discovered square cauldron (no. 11) that in its monumental size surpasses anything else known from its period; it also is evidence of the importance of the city at Zhengzhou—the cost and difficulty of casting bronzes on such a scale very likely imply a royal patron.

The Zhengzhou phase is represented here by objects unearthed at the recently excavated site of Panlongcheng (nos. 4-10), which is open to more systematic digging than is present-day Zhengzhou. Although Panlongcheng was clearly not so important a city in Shang times, stylistically there is nothing to distinguish the bronzes from the two sites, which do not differ culturally in any other respect.

This cultural uniformity is not to be taken for granted: Panlongcheng is situated 279 miles south of Zhengzhou, in a region that might once have been judged well outside the range of Shang civilization. Furthermore, Panlongcheng appears to be far from unique in this respect: within the last few years there have come reports of early sites even more distant from the middle reaches of the Yellow River valley, where the early Shang culture presumably had its center. In fact, these new discoveries require a revision of earlier notions of Shang history, which identified the next period, the Anyang era, as the height of Shang power. This conclusion now seems suspect, since bronze finds belonging to the Zhengzhou phase are generally uniform in style, regardless of provenance, while this is no longer true in Anyang times, in which outlying regions began to diverge from the artistic tradition of central North China. The geographic spread of sites culturally indistinguishable from Zhengzhou, apparently far greater than the range of the Anyang civilization, suggests that during the Zhengzhou period the power of the early Shang state must have made itself felt much more effectively in peripheral areas.

The bronze industry at Erlitou was already technically sophisticated enough to serve as foundation for a vigorous artistic development in the Zhengzhou phase. The course subsequently taken by the bronze art was set at this early stage, as the founders began to experiment with cast decoration and to work out the possibilities offered by their distinctive piece-mold technology.

The technical repertory of the Chinese metal-

worker in fact underwent little expansion for the next millennium. Throughout that time the basis of metalworking technology remained section-mold casting, with decoration made by casting—that is, decoration added by working the mold surfaces, not applied to an object already cast. The first significant exceptions to this rule, inlaid bronzes, do not become popular until about the sixth century B.C. (Chapter 8).

During the Shang period, workshop practice insistently favored casting in one pour. The caster took pains to prepare a mold assembly, complete with decoration, that would yield a finished object, with no remaining parts to be joined on or decoration to be added. Only in the case of intricate shapes, or for monumental vessels, might the Shang master be persuaded to make a vessel in several steps. This strict preference for unitary casting has the important result that Shang bronzes seldom have the look of composites. They were not assembled from independent parts: both shape and decoration emerge together from the mold.

Having learned to decorate his bronzes by decorating the mold, the Shang caster seems to have devoted his full attention to the possibilities of cast ornament. Decoration added to the bronze itself after casting, which plays so large a part in Western metalworking traditions, held no attraction for him. Apart from cleaning and polishing after removal from the mold, and the effects of corrosion following burial, Shang bronzes are seen today essentially as they left the mold. As a result, the designs have a sharp-edged crispness of execution typical of a technique that cuts the design with ease and fluency in clay.

The varieties of ornament that succeeded the simple thread relief of no. 4 were all produced by casting and reflect continual improvements and elaborations of the moldmaking process. The first step beyond thread relief is seen on many bronzes of the Zhengzhou phase (nos. 5-7). Here the raised parts of the decoration are no longer simple lines, but carefully shaped bands of varying width. The greater expressive possibilities of these modulated lines were immediately exploited to give richer, more forceful designs, which by the end of the Zhengzhou phase approached a labyrinthine complexity (nos. 8, 9, 12). The decorative friezes grew wider, the lines of the pattern narrower and more densely packed.

Although the ornament of each bronze acquires an individual character from the hand responsible for its execution, the patterns nevertheless fall into a very limited number of classes. Leaving aside a few purely abstract design elements of lesser importance, there were during the Zhengzhou phase only two distinct sorts of pattern, either of which could be used to fill a frieze section. One is a creature seen in profile, showing only a single eye; it sometimes suggests a bird (no. 5?) but otherwise can be loosely termed a dragon. The other is a vaguely discernible face seen from the front (thus, with two eyes visible); the earlier of the two designs (no. 4), it remains the principal motif of the bronze art for as long as the Shang artistic tradition survived. Successive generations of bronze casters steadily elaborated the face, adding

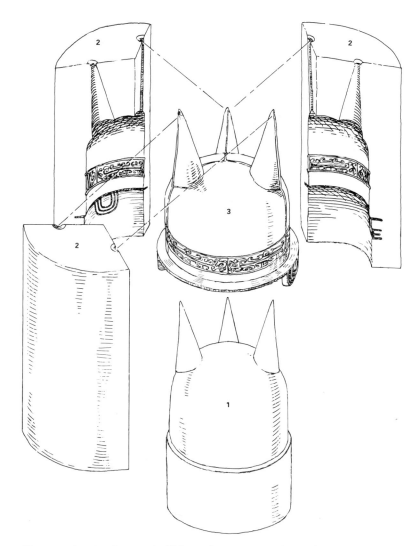

Diagram showing how early Chinese bronzes were formed: the model or core (1), the sections of the mold (2), and the completed vessel (3—the cauldron no. 4)

suggestive organic details, so that while it never turns into a recognizable, real animal, it does constantly grow more persuasively animallike. In an example like that on no. 6, a sympathetic observer will not only find a pair of eyes, but also a nose and, to each side of it, a comma-shaped lower jaw in profile. We have no knowledge of what this motif was called or what it may have signified in Shang times; here it is referred to as the animal-mask motif. Like all Shang patterns, zoomorphic or not, it belongs to an art of pure ornament, of matchless intelligence and sophistication.

3 The Spread of Shang Culture
The Appearance and Growth of Regional Bronze-Using Cultures, 15th—11th Centuries B.C.

The early expansion of Shang culture disseminated bronze-casting technology over a large area, laying the foundations for regional bronze-using cultures that became recognizably distinct from the civilization centered on the Shang court. Systematic excavation of Shang sites in outlying regions is only just beginning. At the moment the most revealing archaeological evidence consists of scattered finds of bronzes and jades. Some are imports from metropolitan workshops or faithful copies of imports; others adapt metropolitan forms and technology to the expression of radically different tastes. The wide spectrum of styles must in part reflect the varying strength of the political bond between the Shang court and each local center of power: areas that had strong ties with the Shang would have kept in better touch with the course of metropolitan fashions.

This chapter brings together a selection of "nonmetropolitan" bronzes—those from outside the middle reaches of the Yellow River valley (northern Henan Province). They span about three centuries, from the end of the Zhengzhou phase until the end of the Shang dynasty. (Two other objects of nonmetropolitan provenance, nos. 24 and 25, are not discussed in this chapter because they in no way depart from styles associated with the Anyang capital. On the assumption that they may have been imports, made at Anyang and carried elsewhere, they are treated in the next chapter, under the heading of Anyang bronzes.)

A few years ago, when the only known Shang sites of any importance all lay within Henan Province, archaeological accounts of the Shang dynasty were written in terms of three cities: Erlitou, Zhengzhou, and Anyang. Erlitou and Zhengzhou were both large cities in Shang times and are likely to have been capitals, while oracle inscriptions found at Anyang identified it as the last capital of the dynasty. Since the Zhengzhou remains clearly predated the Anyang occupation, and Erlitou was earlier still, it was tempting to conclude that the entire history of the dynasty lay open to view in a sequence of these three sites.

The gradual accumulation of new discoveries has made this simple scheme appear less and less satisfactory. Finds made in the outlying regions have shown beyond any doubt that the three sites certainly do not suffice to treat the full range of Shang civilization, and improved understanding of the Zhengzhou and Anyang sites has now begun to suggest that the scheme is inadequate even to represent the mainstream of the Shang tradition.

As far as bronzes are concerned, there is a noticeable gap between Zhengzhou and Anyang in the archaeological record—and bronze vessels are virtually the defining artifact of the Shang culture. This hiatus is one that historical accounts might have led us to expect. Tradition has it that the capital of the Shang dynasty was moved five times, the last move to Anyang. The first two capitals were Bo (Erlitou?) and Ao (Zhengzhou?); the next three have so far not been identified even tentatively with excavated sites. But bronze vessels that make the transition from the latest style at Zhengzhou to the first typical Anyang products are precisely

those found in recent excavations in Hebei Province, in the far northeast of the Shang realm (nos. 12-14). The cauldron no. 12 is little if at all advanced beyond styles associated with Zhengzhou; the same tomb contained vessels perceptibly more advanced, and, like no. 13 and perhaps no. 14, they are well removed from Zhengzhou precedents. The remoteness of the sites in which these pieces were discovered does not guarantee that these novel bronze designs can be taken as "provincialisms." Traditions about the locations of the Shang capitals are fairly well agreed that the center of Shang activity between the departure from Ao (Zhengzhou?) and the move to Anyang lay in the region where Henan, Shandong, and Hebei Provinces meet: northeast of Erlitou, Zhengzhou, and Anyang, this is the area in which the novel bronzes nos. 13 and 14 were found. Given that the Shang capital may actually have been in Hebei Province, there is every reason to believe that bronzes of this period found in Hebei may well represent the metropolitan tradition of a stage intermediate between Zhengzhou and Anyang.

Elsewhere, however, there are unambiguous departures from metropolitan styles in about the same period. The rise of a partly independent artistic tradition is best documented in the south, along the course of the Yangzi River through the provinces of Hunan, Hubei, Jiangxi, Anhui, Zhejiang, and Jiangsu. The cauldron no. 17 from Jiangxi is one of the very earliest assertions of a taste at odds with that of northern foundries. The shape and ornament are owed to a northern prototype, but the openwork treatment of the legs is unexpectedly flamboyant and clumsy, while the small tigers cast onto the handles are quite exceptional, stylistically as well as technologically. Tigers, especially three-dimensional ones, are a motif connected particularly with the south.

Another peculiarity of the southern region is the prominence there of bronze bells and drums. The rather insignificant bells known from Anyang are invariably quite small—easily held in one hand —and usually undecorated. In Hunan, by contrast, monumental clapperless bells, supported stem downward and struck on the outside, are probably the most common of bronze artifact types. The one shown in the exhibition (no. 19), weighing over 338 pounds, is the largest Shang bell yet discovered. The bronze drum (no. 18) comes from the southern part of Hubei Province; it is one of only two bronze drums known from the Shang period. The prominent role played by large bronze musical instruments in the southern tradition seems to have had no parallel in the north.

In decoration, too, the drum and bell depart considerably from northern precedents. In both, the loose interpretation of the animal-mask motif and the generous use of spirals as space fillers dilute the motif almost beyond recognition—it is more texture than pattern. Already there is a hint here of something that seems undeniable a little later: that the animal mask did not have the same absorbing interest for the southern artist that it did for the Anyang master. Too often it is strangely distorted or carelessly allowed to fall apart and dissolve away in meaningless scrollwork.

Though offering more immediately striking proof of southern independence in artistic matters, the astonishing four-ram vessel (no. 20)—from the same area as the bell just discussed—is in many respects closer to metropolitan sources. In shape it represents an inspired transformation of a standard vessel type. At Anyang, small animal figures set on the shoulder of this sort of vessel are employed as minor accents within an abstract, almost architectural scheme. On this southern version, these unessential details have been replaced by a quartet of large rams, whose lifelike three-dimensionality nearly overwhelms the underlying vessel form—a mutation too extreme to be contemplated by the Anyang artist. Other features peculiar to the southern tradition include the snakelike dragons coiled on the shoulder of the vessel, and the fresh and lively motif of tall, crested birds seen on the haunches of each ram. Yet the influence of Anyang bronze casting remains pervasive: a smooth low-relief technique typical of Anyang bronzes is used to draw the crested birds and an animal-mask design that could not be told from Anyang manufactures. Despite their admirable independence of taste, the southern foundries must at least at times have been in close contact with Anyang, attentively following developments at the capital.

The southern provinces were not unique in harboring cultural or political rivals to Anyang. For the most part, however, the bronze finds made elsewhere in China have been too meager and too scattered to give a coherent picture of other provincial traditions. The idiosyncrasies of individual pieces may be extreme, but for the moment they remain in stylistic isolation. This is true in particu-

lar of the last two vessels treated in this chapter, nos. 21 and 22, which come from two different sites in the northwest. No. 21 is from Shilou in Shanxi Province, a district that has yielded a variety of unusual bronzes. In shape it reproduces a familiar Anyang type, though it is unusual in having a handle. Far more eccentric is its decoration, which does not fall into the usual array of horizontal friezes but instead fills the entire vessel with a single motif: a large animal mask faces upward as if to suggest that its mouth is the mouth of the vessel itself. The second vessel (no. 22) is conventional in decoration but unfamiliar in shape: instead of being a flattened oval in cross section with an S-shaped silhouette, the body is perfectly round, steadily narrowing to the mouth.

The stylistic distinction between metropolitan and nonmetropolitan is not always so clearcut as in these last two examples. The bronze ax from Yidu (no. 23) displays a certain (provincial?) crudity in style, yet it is difficult to argue that Yidu lay far outside the mainstream of Shang culture. The area seems to have been held by an ally or vassal of the Shang king, and excavations there have uncovered large tombs scarcely distinguishable from the royal tombs at Anyang.

The oracle inscriptions give the impression that the overlordship of the Anyang court was maintained against the incursion of its neighbors only by incessant military activity. All the bronzes described in this chapter, with the possible exception of the earliest (pre-Anyang) vessels, are relics of powers that were vassals or rivals of the Shang. The stylistic eccentricities discussed here reflect differences of culture and probably at times political differences as well. On the other hand, these variations should not be overstressed. The very occurrence of bronze ritual vessels in outlying regions would seem to signify religious ideas and ceremonial practices held in common; and, like the distinctive Shang metal technology and its potent ornamental style, these were probably acquired in the wake of an expansion of the Shang state that had taken place earlier, in pre-Anyang times.

4 A Classic Period in the Bronze Art

The High Yinxu Phase (Anyang Period)
About 1300—About 1030 B.C.

Tradition has it that Anyang—the last capital of the Shang dynasty—was the seat of twelve kings, who ruled for 273 years. The oracle inscriptions found at Anyang, however, confirm the presence there of only the last nine kings; no inscribed bones or other remains of any consequence at Anyang can be assigned to the reigns of the first three kings. As suggested in Chapter 3, it is possible that the Shang capitals were located further north in the years between the decline of Zhengzhou and the establishment of Anyang as a capital site.

In any case, a distinct upsurge of activity at the Anyang site is apparent during the long reign of Wu Ding, fourth of the traditional Anyang kings. A tremendous wealth of oracle inscriptions from Wu Ding's court document an obsessive round of sacrificial observances, in which the bronze vessels surely played a central role. The oracle records also allude to wide-ranging military expeditions, which may well have been aimed at recovering territories lost earlier, at the end of the Zhengzhou phase.

One name that occurs especially often in the oracle inscriptions from Wu Ding's court is that of the lady Fu Hao. A royal consort and lady-general, Fu Hao was evidently a person of some character and consequence, mentioned as at times leading military expeditions on behalf of the king and on other occasions presiding in his name at state sacrifices. Wu Ding repeatedly inquired of the spirits about Fu Hao's childbearing; his special concern in her case may hint that her sons were heirs to the throne.

The most remarkable single find ever made at Anyang was the discovery in 1976 of Fu Hao's tomb, intact and undisturbed. Many of the bronzes it contained were inscribed, more than sixty of

them with Fu Hao's name (nos. 29, 31-33), others with a posthumous title under which she would have received sacrifice from sons or nephews (nos. 28, 30). Such inscriptions seem never to occur on pre-Anyang bronzes. The brief dedications on the Fu Hao bronzes represent the beginnings of a practice that culminated centuries later in the lengthy and increasingly secular inscriptions of Western Zhou times (Chapter 5).

The discovery of Fu Hao's tomb was altogether unprecedented; none of the other major Anyang burials was either intact or assignable to a particular person or reign. Her tomb consisted of a modest rectangular pit, twenty-six feet deep and eighteen by thirteen feet on the sides. Her lacquered wooden coffin was enclosed by a larger wooden housing, and outside the housing were found sixteen sacrificial victims and six dogs. Unpretentious in scale compared to other royal tombs at Anyang, this grave nevertheless contained nearly 200 bronze vessels—almost twice the number recovered by archaeologists from all the looted tombs together. In addition, there were well over 200 bronze weapons and tools (tokens, perhaps, of Fu Hao's military career); 600 sculptures and ritual objects of jade and stone; drinking cups of elephant ivory inlaid with turquoise; 500 objects of carved bone; 7,000 cowrie shells (used as money); and the first securely identified bronze mirrors known from the Shang period.

There is disagreement about the dating of Fu Hao's tomb, and some scholars have suggested that the tomb's occupant was another person of the same name who would have lived a few generations later; nevertheless, recent finds at other sites have helped to establish a context in which an early date for the Fu Hao bronzes seems quite plausible.

Most of the bronzes from Fu Hao's tomb are decorated in styles that mark a sharp break with the previous gradual evolution of ornament. The earlier diffuse, intricate patterns, which threaten constantly to dissolve into abstract surface texturing, must have seemed to the Anyang artist too ambiguous and too understated. This ambiguity was wholly eliminated: at first, motifs come into sharp focus against an abstract background of dense spirals, and then still greater emphasis is placed on the motif by setting it in high relief against the spiral background.

The Fu Hao bronzes seem in many cases to represent experiments with the possibilities of the newly invented high relief, and they explore a wide variety of surface treatments. The decoration of the bird-shaped vessel no. 29 is an extravagant compound of textures and motifs, ranging from the smooth face of the bird to the heavy plasticity of the snake coiled on its wing. The vessel's shape, with its broken silhouette and clumsily aggressive proportions, offers an appropriate setting for the lavish display of surface ornament, and the combination achieves an effect of baroque violence.

The artistic progression that led to the emphatic varieties of surface ornament did not leave the vessel shapes untouched. By comparison with the owl-shaped vessel, the decoration of no. 33 is almost subdued: it is confined within strictly compartmented areas of the surface. The ferocious energy of the vessel is owed more to its heavy flanges, which insistently draw attention to every vertical contour, and to the commanding monumentality of the shape itself. The two earlier vessels of this type, nos. 6 and 16, are landmarks of a steady progress toward dramatically heavier, more angular, and more architectural vessel shapes.

As Anyang artists learned to judge their effects more precisely, the overstatement that characterizes many of the Fu Hao bronzes was refined away. This is not to say that the bronze vessels became less imposing. On the contrary, the more restrained ornament of no. 27 speaks with immeasurably greater force than the somewhat bewildering exuberance of Fu Hao's bird-shaped vessel: clarity of effect demanded designs less varied and distracting. The separate contributions of shape, ornament, and flanges attain a perfect balance. With no. 25, this piece belongs to a classic moment in the history of the bronze art: the two vessels represent a level of artistic achievement never surpassed.

The jades found in Fu Hao's tomb include an extraordinary array of familiar Shang forms, such as axes and halberd blades. Much more unexpected are the numerous small human and animal sculptures, several of which are shown in the exhibition. By comparison with the extreme refinement characteristic of nonsculptural jades—even those from much earlier times (nos. 2, 3, 10)—the small figures from Fu Hao's tomb appear curiously awkward and primitive (nos. 39, 40). This is due partly to the difficulty of working so refractory a material as jade; even the simplest of shapes required a formidable amount of sawing and grinding.

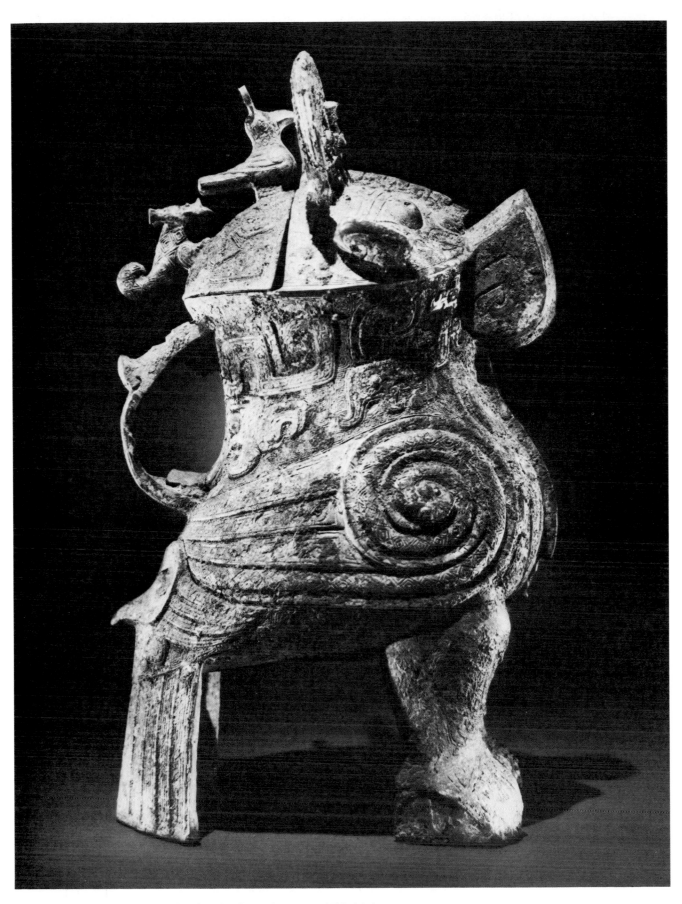

Its lavish decoration does not disguise the dramatic power of this bird-
 shaped wine container (no. 29)

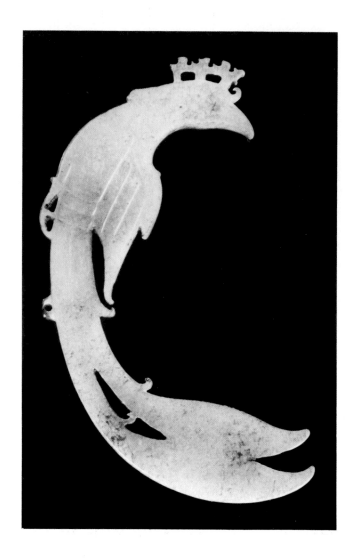

But other factors beyond mere technique may enter into this rigid symmetry, as the elephant-shaped bronze vessel no. 24 serves to suggest; though made in an entirely different material and technique, its simple pose is the same as that of the jade elephant from Fu Hao's tomb (no. 40). Admittedly the bronze caster's technique, like that of the jade worker, favors a symmetrical shape, but it is likely, too, that the Shang artist's taste preferred symmetry above the accidental character of any more transient pose.

The remaining jades from the tomb, nos. 34-37, are for all practical purposes two-dimensional. Like most archaic jades, they are worked from slabs rather than blocks of material, and they escape the awkwardness that usually attends the Shang lapidary's essays in three dimensions. The small hawk with outspread wings (no. 34), covered with patterns little different from those seen on the jade figures, is typical of the Shang artist's overriding concern with flat shapes and decoration. For the Shang artist, patterns are adapted to the form they decorate with considerable subtlety, but on the whole their function is not representational: it is surface embellishment for its own sake.

This breathtakingly elegant bird (no. 35) was among hundreds of jade objects buried with the lady-commander Fu Hao

5 Unrestrained Invention
The Rise of the Western Zhou Dynasty
Late 11th—Early 10th Century B.C.

We know almost nothing of the peripheral statelets that neighbored on the Shang empire, vassals and enemies alike. While the archaeological evidence surveyed in Chapter 3 may hint at their cultural attainments and idiosyncrasies, there is scant basis for associating archaeological finds with recorded names. Of their histories we have only a dim reflection in the oracle texts, and even that only on the occasions when their activities impinged on the Shang court.

The one exception in this otherwise indistinct historical picture is the Zhou people, who lived toward the end of the Shang dynasty in the Wei River valley of central Shaanxi Province. Sometime in the latter half of the eleventh century B.C., the Zhou overthrew the Shang royal house, and in its place founded a dynasty that lasted, in name at least, for eight centuries. Zhou rule is divided into two dynasties. The Western Zhou encompasses the period from their conquest of the Shang in about

1030 B.C. until 771 B.C., when the western part of their empire was overrun by barbarians, the Zhou king killed, and their traditional capital abandoned. Thereafter, the Zhou kings ruled from their eastern capital, on the site of present-day Luoyang, and the second half of the dynasty is accordingly known as Eastern Zhou.

To historians of the Zhou period and of later times, the rise of the Zhou to power and their conquest of Shang were subjects of the most absorbing interest. As a result, while we lack texts contemporary with the period of the conquest, later writings preserve a wealth of traditions relating to the history of the dynasty. Fortunately, the variant traditions of Zhou history can be supplemented by an extremely important historical source: the corpus of Western Zhou bronze inscriptions. Each of these inscriptions is a contemporary document of the most unimpeachable authority, since we possess the actual bronze vessel on which a Zhou dignitary recorded some event of importance to himself and his family. Though the surviving inscriptions reflect isolated events, not necessarily those of greatest interest to the historian, and seldom supply any extended narrative, they can illuminate details here and there in the texts, as well as provide occasional facts of real significance that are missing entirely from later writings.

Bronzes with lengthy commemorative inscriptions are all but unknown in the Shang period, and their sudden prominence in early Zhou suggests that the bronze art was being diverted to new and more secular purposes after the conquest. Shang bronze vessels were cast, as far as we have any evidence, for use in rituals of sacrifice to the spirits. Many, if not most, are uninscribed; those that are inscribed usually carry nothing more than the name of the owner, or that of his family or clan, and sometimes the posthumous designation of the owner's relative who is receiving sacrifices.

From the first years of the Zhou dynasty, on the other hand, inscriptions are more common and often conspicuously longer. The purpose for which the bronze vessels were cast is ostensibly the same as before; no. 50 is explicitly dedicated to an ancestor. In the longer inscriptions, however, it is clear that other motivations enter, and they are by no means purely religious. Most often, bronze vessels were cast to commemorate important events in the life of the owner. The founder of a family's fortunes recounts the decisive events of his career, lists in full the gifts of the king that were his reward, and concludes by naming the ancestor for whose sacrifices he has commissioned the casting of the vessel. Presumably the ancestor is thereby notified of his descendant's merit; no doubt the owner's posterity will also be effectively reminded, for as long as the vessel remains on the altar of the family temple. In the course of the Western Zhou period, the longest inscriptions grow ever more prolix and circumstantial. Enormous effort is sometimes lavished on casting long and elegant inscriptions in vessels that have no pretension to artistic quality. In these cases, at least, the bronze vessel serves as nothing more than the vehicle for an inscription; at times we receive the impression that, for the Zhou nobleman, bronze casting was merely the most prestigious form of publication.

The inscriptions of two bronze vessels included in the present exhibition bring us close to the time of the Zhou conquest, and probably rank as the most remarkable inscriptions of their time yet known. The text cast on no. 41 opens with the statement: "Wu Wang vanquished Shang; it was in the morning, on the day *jia zi.* . . ." As usual, the occasion for casting the vessel was not what to us is the central event, the conquest of Shang, but rather a benefaction conferred by the king in connection with the conquest. From the concluding phrases of the inscription, we learn that the owner is named Li, and that he has dedicated the vessel for sacrifices to an ancestor named Tan Gong. The middle part of the inscription, which probably describes the service performed for Wu Wang by Li, is obscurely worded and difficult to interpret; according to one view, it was a divination, carried out by Li and pronounced auspicious, that persuaded Wu Wang to launch his attack. The inscription goes on to say that the king rewarded Li and that Li commissioned the bronze vessel on the eighth day following the conquest. It is perhaps needless to add that this is the earliest dated bronze known from the Zhou dynasty. It was probably a treasured possession of Li's family for generations. It was found buried with a hoard of bronzes, some of which date to the very end of the Western Zhou period, so that it must have been kept aboveground for more than two centuries.

The remarkable inscription of no. 42 is even longer, and it gives an exact date for the event that it describes, the founding of the secondary capital

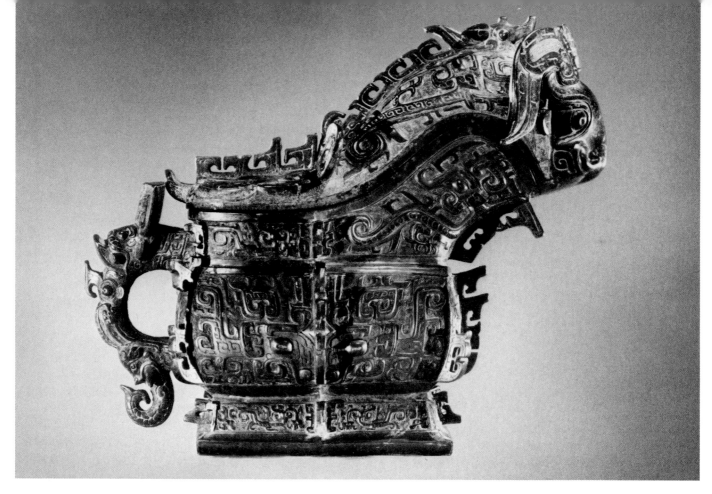

The entire vessel is animated by the intense gaze and formidable arched
 neck of this hybrid beast (no. 45)

at Luoyang. Even more interesting than any indi-
vidual fact gleaned from the text is the tone of the
inscription, which invokes the will of Heaven re-
peatedly; implicit in these references is the
assertion that the Zhou rulers were commanded by
Heaven to overthrow the Shang. Transmitted texts
and bronze inscriptions alike give the impression
that the early Zhou rulers were deeply conscious
that they had usurped the throne and were much
exercised to justify themselves. By contrast, the
oracle bone inscriptions from Anyang give no sign
that the Shang rulers were ever concerned to assert
their legitimacy; since the principal deities were
the spirits of the deceased Shang kings, the living
king had a unique and unassailable position. The
care with which the Zhou kings appointed Shang
descendants to maintain the Shang sacrifices sug-
gests that they themselves were unable to dismiss
or ignore the foundations of Shang legitimacy. The
Zhou rulers, however, asserted that because the
Shang kings had declined in virtue, Heaven chose
to withdraw its protection from them and confer it
on the Zhou house instead. Heaven deliberately
shifted its allegiance to a more virtuous line. The

Zhou rationale for imperial legitimacy, which was
central to Chinese thought in later times, clearly
implies that the right to rule is dependent on the
moral quality of the ruling house.

As might be expected, Western Zhou bronzes
are found in the greatest abundance in the old
Zhou territory, in or near the Wei River valley in
Shaanxi Province (nos. 41-52). But they are also
found throughout the Shang domain, at the sec-
ondary capital at Luoyang, in the territories of the
various fiefs such as the state of Yan in the north-
east near the Great Wall (nos. 53-57), and often far
beyond. Nearly every province of China has yielded
at least isolated examples, though in the south
Zhou finds are significantly less common than
bronzes of Shang style. In some of the more remote
areas, purely local variants of conventional Zhou
shapes and ornament are encountered. These few
provincialisms aside, however, the immense stylis-
tic variety of early Western Zhou bronzes cannot be
explained in terms of neatly circumscribed regional
styles.

It was the military men above all who were
likely to cast bronzes in the early years of the dy-

nasty, and they were certainly the most geographically mobile of patrons, whether campaigning or journeying to and from their fiefs. Vessels might travel far from their points of manufacture—which in consequence are almost impossible to determine—and in so doing transmit the latest ideas and fashions to foundries throughout the empire. The unusual vessel no. 55, from Yan territory in Liaoning, is a case in point. A similar example has been found at the old Zhou capital at Qishan in Shaanxi Province, and two more were unearthed in Sichuan, some 1,200 miles distant from Liaoning.

Zhou artists drew on other sources besides the Anyang inheritance. For instance, it is likely that in the years preceding the conquest, Shaanxi bronze casting had given rise to local fashions that survived into the dynastic Zhou period. It might be suspected that the peculiar motif decorating the shoulder of the vessel from Liaoning, no. 55, as well as nos. 49-51, had its origins in Zhou territory before the conquest: this strange animal, whose gaping mouth is attached to a body that consists of nothing more than a large, plastically rendered spiral, appears on Zhou bronzes from the first years of the dynasty, while no Shang example is known.

The absorption of Shang neighbor states into the Zhou empire must also have brought Zhou artists into contact with a wide variety of regional traditions unknown or unheeded at Anyang, and the sudden mixing of these formerly isolated traditions may partly explain the stylistic complexity of early Western Zhou. Large bells of southern type, for example, are the only possible prototype for numerous bells of Western Zhou times, and for their bird- or tiger-shaped flanges (see no. 58).

Yet despite all departures from metropolitan Shang bronze casting, the novelty of the earliest Zhou styles is not unlimited. Much that at first glance seems most characteristically Zhou can in fact be traced to ideas already explored at the Anyang capital. Many Zhou vessels are distinguishable from Shang counterparts only by their inscriptions or provenance; many more represent Zhou variations on Shang themes. In the period following the conquest, what is remarkable is not so much the stylistic independence that is displayed at the outset but the speed with which the Zhou bronze industry diverged from its Shang sources. Within a few generations the art was transformed.

To some extent this transformation was a re-sult simply of the Zhou caster's selective use of the Shang legacy. His choice of which possibilities to explore and which to neglect was in itself enough to alter the character of the bronze industry. In particular, the repertory of vessel types was drastically affected; a few shapes, like the food container no. 41, enjoyed special favor, while some of the most standard Shang types all but disappeared (such as nos. 1, 25, and 33).

More positive contributions are to be found in the realm of surface decoration and motifs. Animal-mask designs continued in popularity, but the relief treatments and details are often far from any Shang precedent (nos. 41, 42, 45, 52, 54-56). At the same time, a great many new motifs arose to challenge the supremacy of the animal mask. The coiled animal (nos. 49-51) is one, and its influence can be detected in another typical early Zhou motif that appeared somewhat later: no. 57 is decorated with elephants instead of imaginary animals, but the bodies of the elephants are embellished with a spiraling design borrowed from the animal that had no body except the spiral.

Neither of these motifs survived for more than a few generations. Elaborately crested birds were more long-lived and provide many of the most impressive designs from the Western Zhou period. Something of their character can be illustrated by the motif seen on no. 53, where a dragon's head is joined to the body of a bird. This casual attitude toward his motifs is typical of the Zhou artist at this stage: neither the dragon nor the bird is of much importance for its own sake—each motif is valued only insofar as it lends itself to an overriding ornamental purpose and provides a graceful flow of elaborate curvilinear shapes.

The animal-mask motif was subject to the same distortions. In the decoration of no. 45, something of the clarity and individuality of the motif has been exchanged for a florid, richly patterned effect. This decorative uniformity is enhanced by the resemblance in shape between the hooked flanges of the vessel and hooked borders of the relief areas. In such details we can discern the beginnings of a patternizing tendency that increasingly dominates the bronze art of Western Zhou times and lays the foundation for many of the most influential systems of ornament in the succeeding Eastern Zhou period.

6 Patterns and Interlace

Transformation of the Bronze Art in Later Western Zhou
Late 10th Century—771 B.C.

The countless grants of land with which the first Zhou kings rewarded their allies and retainers put the administration of the conquered Shang territories into the hands of hereditary lords. At first the central government seems to have been strong enough to compel the allegiance of the provincial lords; with the passage of time, however, the vassals grew less dependent on the support of the Zhou king. Eventually the pressure of a century of barbarian attacks from the north brought about the collapse of the central government. When the Zhou king was killed and his capital sacked in 771 B.C., the invaders were barbarian tribes allied with two of the king's own vassals. Although a son of the king was able to reestablish the Zhou court at the secondary capital, Cheng Zhou, at Luoyang, the power once exercised by the Western Zhou kings was never recovered, and the history of the Eastern Zhou period is accordingly not the history of a dynasty, but of a large number of independent states.

The forced abandonment of the ancestral Zhou homeland in Shaanxi Province may help to explain why so many of the bronzes found in that region come not from graves, but from large hoards or storage pits. Fleeing before the invading nomads, noble families must have collected and buried their most valuable—and heaviest—possessions in the vain hope of returning someday to recover them.

The earliest phase of the history of Western Zhou bronze vessels has been outlined in the preceding chapter. By the end of the dynasty, the patternizing tendency whose beginnings were remarked in early vessels, such as nos. 45 and 53, had led to the nearly complete elimination of Shang motifs and decorative principles from the bronze art. On the vessel no. 53, the subordination of individual motifs to a large-scale effect of flowing movement and patterned uniformity is already evident.

The final stage of this process of dissolution can be represented by the simple pattern of repeated recumbent C-shapes encircling the neck of no. 61. These purely abstract design elements are all that is left of the birds, dragons, and animal masks that once filled the narrower friezes of early Zhou bronzes; through intermediaries like those on nos. 59 and 60, all three motifs dissolve into the same indistinguishable ribbons. Western Zhou bronze art, which began with a bewildering stylistic diversity, ends in something approaching unison.

But this elimination of Shang motifs and styles should not be viewed only in negative terms. The effect of restless movement that arises from the barbed and spiraling shapes on no. 53 represents a deliberate departure from the stability and static monumentality of Shang designs, and one that in time led to an art based on altered decorative principles. By the end of Western Zhou, the symmetrical, rigidly compartmented designs of the Shang had been discarded. Even so simple a design as that on no. 61 represents something fundamentally new, not so far seen on any vessel here: it is a design that does not respect the divisions of the mold assembly. The narrow bands of overlapping scales, lying in one direction on the foot and lid and in the other direction on the widest part of the body, renounce the bilateral symmetry of earlier designs for the sake of a faint but undeniable hint of movement.

The possibility of movement was fully exploited by a bold new pattern: the wave pattern that sweeps unbroken around an entire vessel, without any allowance made for the mold divisions. The wave pattern is one of the most inspired inventions of the ninth century B.C. and decorates many large and stately vessels from the end of Western Zhou and the beginning of Eastern Zhou (no. 62).

Another invention of the ninth century is a pattern concocted of interwoven dragons. In this design the most important feature is the overlapping of crests and bodies; the surface patterns are, by implication at least, three-dimensional, since the body of one dragon can pass above or below another. Bearing in mind that the artist of

late Western Zhou was restricting himself more and more to abstract or near-abstract patterns, in which the surface treatment is uniform and the intrinsic interest of the motif is negligible, the invention of interlaced designs represented a sorely needed enrichment of the grammar of decoration. The possibilities of two-dimensional surface patterns must have seemed disappointingly limited, and the wave pattern is in fact the only one that achieves any real distinction in late Western Zhou. The possibilities of interlace, on the other hand, are boundless—an assertion justified equally by the Alhambra, the Book of Kells, or the bronzes of Eastern Zhou.

7 Variety and Freshness

New Departures in Eastern Zhou Bronze Designs
The Spring and Autumn Period (770-476 B.C.)

In 771 B.C. the Zhou capital fell to marauding nomads descending from the steppes of the Ordos region of northwest China. The Zhou king was killed, and his son fled east to the secondary capital at what is today the city of Luoyang. This marked the end of the period known to historians as Western Zhou. With the removal of the court to Luoyang, the eastern city became the principal capital of the dynasty, and the dynasty became known as Eastern Zhou. Luoyang remained the seat of the Eastern Zhou kings until 256 B.C., when their greatly diminished domain was annexed by the expanding power of the Qin state, under the leadership of Qin Shihuangdi, the First Emperor of Qin (for whose burial complex the terracotta army was made; see Chapter 10). Of greater historical importance, however, is the date 221 B.C., since in that year the Qin armies brought about the final unification of China and founded the Qin dynasty. The 550 years of the Eastern Zhou period are subdivided into two successive periods. The earlier, traditionally known as the Spring and Autumn period (770-476 B.C.), was named after the *Spring and Autumn Annals of the State of Lu*, the official chronicle of Confucius' home state. The subsequent Warring States period (475-221 B.C.) drew its name from the *Discourses of the Warring States*, a series of philosophical and theoretical tracts on the ideal system of alliances needed to maintain a stable balance of power among the numerous contending states of the time.

In the Eastern Zhou period, the royal domain around the eastern capital at Luoyang continued to dwindle as the territories of neighboring states expanded. The Eastern Zhou kings possessed little actual power, becoming ceremonial figureheads to whom the increasingly powerful and ambitious feudal lords paid merely nominal allegiance.

The weakening of central authority during Eastern Zhou and the rise of powerful local governments greatly affected the realm of the ritual bronze vessel and the bronze-casting industry. Sets of bronze vessels were commissioned by local princes in increasing numbers, tokens of their desire to usurp the royal rights by practicing similar religious and courtly rituals. Bronze vessels were put to more secular uses, for banquets and festivities at home and at war, as diplomatic tokens of good faith, and as dowries in important marriage contracts. The richly inlaid bronzes from the latter half of the period (see Chapter 8) were coveted not only by the feudal princes, but also by the newly prosperous merchant class, who valued them mainly as beautiful objects that would grace their households and enhance their social position.

Regional bronze-producing centers, only intermittently active in earlier periods (Chapter 3), now expanded to meet the growing demands of local lords and began to flourish on a much larger scale, often producing bronzes with a distinctly local character. Regional artistic traditions began to play an ever greater part in the formulation of the Eastern Zhou bronze style and must be regarded as one of the major contributing forces

behind the endless variety and freshness of all the arts of the period. One tradition that had a pervasive influence on the art of Eastern Zhou is native to the Chu state in the south. This is the art of painted lacquers (not represented here), an art based on color contrasts and the dynamic, sweeping movements of the brush. Artistic impulses of a different nature entered China through continual contact with the nomadic cultures, distributed across the vast Central Asian steppes north and west of the Great Wall. These include a growing interest in the representation of real animals and a delight in richly inlaid articles of war and personal adornment, such as the belt hook (no. 76). Jade-working techniques reached breathtaking heights, and beautifully carved jades were a major artistic accomplishment of the time (no. 72).

One might suppose that the cultural differences that distinguished the various states—especially prominent in the arts of Chu—would receive further emphasis from the political disunity of the times, ultimately dividing China into separate artistic and cultural spheres. But this did not happen. Instead, improved communications encouraged an unparalleled flowering of the arts. As trade prospered, articles of bronze, jade, lacquer, and embroidered silk traveled up and down the country along crowded waterways and a growing network of roads. Some of these goods penetrated as far as Central Asia, where a Chinese mirror and a piece of embroidered silk used to decorate a saddlecloth were found among the furnishings of a tomb dating to the fourth century B.C. of a nomad chieftain, frozen high in the Altai Mountains.

Although nominally the Bronze Age ended in the sixth century B.C. with the appearance of the first iron implements, iron came only gradually into common use, and it never challenged bronze in the realm of art. Iron was first used primarily for agricultural tools, for which bronze was too precious. As experience with the metal grew, it was adapted for the production of superior weapons, notably the long sword. In contrast to the development of Western metallurgy, iron technology in China seems to have relied principally on cast rather than forged iron. In the West, where forging was known far earlier (fifteenth century B.C.), casting remained unknown until the Middle Ages. China's early use of cast iron no doubt reflects a longstanding mastery of large-scale bronze-casting techniques.

China during the Eastern Zhou period presented a picture of bustling artistic, technological, and economic activity. The brilliant, kaleidoscopic nature of the arts is its most eloquent and colorful reflection. The forces that favored political unification contributed at the same time to the spread of regional artistic traditions. These, in turn, were slowly incorporated into the greatly expanded territory that was to become the basis of a large unified country during the Qin and Han dynasties.

The increased demand for ritual bronzes by the numerous feudal dignitaries led to a decline in quality (a tendency already apparent by the end of the Western Zhou period). Yet the finest works of the period, represented by nos. 62 and 63, are far from mediocre, rivaling even the greatest masterpieces of the preceding century. Bronzes from the earliest years of Eastern Zhou are often hardly distinguishable from their late Western Zhou counterparts, and precise dates of manufacture are therefore often almost impossible to determine. While the events of 771 B.C. no doubt marked a significant break in China's political history, they seem to have less immediate impact in art.

The continuous wave pattern decorating no. 62 was a late Western Zhou invention, a bold departure from the static symmetry in surface decoration established since the Shang period. The graceful rhythm of this pattern apparently had considerable appeal; not only was it widely adopted in the early decades of Eastern Zhou, but a simplified and schematized version of it, seen on no. 64, is found on bronzes as late as the sixth century B.C. Bronzes decorated in this manner are often correspondingly outdated in shape and are usually associated with nobles of the state of Qi, as is the basin no. 65. In their staunch support for the sacred authority of the Zhou kings, the dukes of Qi were also the most traditional. By deliberately choosing established Western Zhou shapes and ornaments for their ritual bronzes, the dukes of Qi gave concrete expression to their political conservatism.

While the wave pattern is essentially a late Western Zhou design, the interlaced pattern on no. 63 is more characteristic of early Eastern Zhou and, unlike the wave pattern, it plays a more

vigorous role in the subsequent development of Eastern Zhou bronze decoration. The design typically involves large dragon motifs, symmetrically arranged. The dragons' bodies are in broad, flat bands with narrow grooves running their entire lengths. The rhythm they set up is slow and deliberate, at times graceful and almost dancelike. These smooth, flowing patterns are closely linked with bronze designs from late Western Zhou, where a similarly even surface effect is generated by continuous, ribbonlike bands (see nos. 58, 59, 60).

The decoration of no. 63 represents the beginning of an important development. The large, meandering dragon units were progressively reduced in size, while interlacing and overlapping became more common (no. 67). This development culminated in a new design, based on a repeated application of greatly reduced and simplified units, its zoomorphic ancestry apparent only in the circular "eyes" of each unit, and this uniform surface treatment is shown in no. 68. This stage was reached in the seventh century B.C. and reigned for a time as the overridingly popular style in bronze decoration.

The examples described so far belong essentially to the mainstream of late Western Zhou designs. But local traditions and cultures were active outside the Central Plains, the heartland of Chinese civilization, and it is to their fresh and unconventional approach to bronze forms and decoration, often deeply rooted in the particular character of the local culture, that we owe some of the most exciting ritual artifacts from this period (nos. 65, 66).

At the present time, knowledge of these provincial centers is still fragmentary. As in the Shang period, quality alone is no guide for identifying provincial bronzes, since local castings, though at times rough and awkward (nos. 17, 65), can also be of superb quality (nos. 20, 66). Provenance is not dependable either, for vessels might frequently be exported to the provinces from metropolitan centers (nos. 24, 25; 68, 69). Stylistic criteria—including decorative features, form, and idiosyncrasies of technique—remain the most effective.

The shallow basin on three wheels from the eastern province of Jiangsu (no. 65) is outspokenly provincial in every respect. Of particular interest is the decoration around the exterior,

which has no prototype in bronze but is a pattern commonly found impressed on contemporary pottery vessels from the area.

A small wine container from Hunan Province (no. 66) presents an even more striking picture of the regional bronze-casting industries that blossomed during the early half of the Eastern Zhou period: it is of remarkable quality, scarcely to be anticipated from the southwest at this early date. The vessel shape is traditionally and characteristically Western Zhou and is rarely found in Eastern Zhou sites in the Central Plains. In the outlying regions, however, vessels of this shape decorated with clearly local motifs are known from late Western Zhou and from Eastern Zhou sites. Thus the shape of the vessel alone indicates that the regional workshops were at least a century or two behind the fashion set in contemporary metropolitan foundries. It is the surface decoration of no. 66, however, that speaks most convincingly of its local manufacture. The dense arrangement of irregularly placed wormlike creatures as the primary design has no counterpart in either contemporary or earlier traditions of central China. The wormlike creatures appear again inside the flaring mouth, but in ordered pairs, facing each other with heads raised as if in polite tête-à-tête.

The magnificent vessel no. 67 falls somewhere between the original inventions of regional workshops and the steadfast followers of tradition in the metropolitan centers. Part of an accidental find made in the summer of 1923 in Xinzheng, Henan Province, by a landowner sinking a well in his fields, this monumental piece and its companion vessels remain among the most spectacular and important of Eastern Zhou bronzes.

The styles of the over one hundred bronzes from the hoard span late Western Zhou to early Eastern Zhou (eighth to seventh centuries B.C.). While the site name has come to be associated with a style of decoration particularly prominent on bronzes from the find, characterized by repeated units of tightly interlocked zoomorphic motifs that produce a smooth, even surface texture (no. 68), the finds at Xinzheng actually included a much wider range of decorative styles. A small group of monumental vessels, including no. 67, defy classification, and should perhaps be interpreted as local manipulations of a traditional form.

The vessel no. 67 is probably the most outstanding object from the find. Its shape is clearly derived from a traditional type in use during the early years of the Eastern Zhou period, and even the elaborately petaled crown on the lid is not unprecedented (cf. no. 62). Most striking, however, is the unapologetic manner in which its traditional silhouette is almost completely overwhelmed by a profusion of curvilinear animal forms. The vessel appears disturbingly alive: the creatures at the bottom seem ready to walk away with their burden, and the birds and dragons interlace across the surface with slow deliberation. Even the surface decoration contributes to the general feeling of bustle.

Vessels like nos. 65, 66, and 67 compel us to recognize two categories of regionalism in Eastern Zhou bronzes. The first is represented by nos. 65 and 66, whose outlandish provincialism leaves them in geographical isolation as fascinating but strictly local eccentricities. The second is represented by no. 67, which transfigures traditional bronze forms and designs with an unpredictable combination of unusual features with conventional ones. To regional bronzes of both categories we owe the immense variety and freshness that typify the art of the Eastern Zhou period and that chiefly distinguish it from the more homogeneous Shang and Western Zhou industries.

The summer of 1923 brought to light another major find of Eastern Zhou bronzes, this time from the small village of Liyu in northern Shanxi Province, about forty-seven miles south of the Great Wall. The hoard was discovered and excavated by a local peasant. When the authorities were informed of the find, they took charge of most of the bronzes. Many of these are now kept in the Shanghai Museum.

The exhibition includes three superb examples from the Liyu find (nos. 68-70). They offer some indication of the stylistic variety of the hoard, which ranges from the ubiquitous seventh-century design of no. 68 to the more advanced late sixth- to early fifth-century ones of nos. 69 and 70. Like Xinzheng, the site name "Liyu" has been used to designate a particular decorative style common to most, but by no means all, of the bronzes from the find. This so-called Liyu style, of which no. 69 is a mature example, is characterized by horizontal friezes of interlaced dragons in varying degrees of relief against a plain ground. The interlacing is accompanied by great textural variety, achieved through a profusion of motifs in which geometric filler ornaments (such as spirals and meanders) occur side by side with more descriptive motifs, such as scales, feathers, granulation, rope, and cowries. Some Liyu bronzes even carry thoroughly realistic animals rendered plastically, such as ducks, fish, reclining water buffalo, and various feline animals.

In general, such vessels with highly sculptural decoration, created by abundant layering and overlapping in the tracery, are the latest within the style (no. 69). The earlier forms of interlace were less elaborate and flush with the bronze surface. In the course of this evolution, the comma-shaped relief elements came to dominate the designs, obscuring the zoomorphic character of the dragons and masks, which eventually were submerged in a sea of feathered, striated, and meander-filled curls. The dense surface of raised curls of the large fifth-century basin (no. 71) illustrates the final transformation of the Liyu motifs, and the beginning of an entirely new type of design commonly associated with bronzes from the Warring States period. Both inscribed and archaeologically datable examples of this style suggest that the change must have already begun by the end of the sixth century B.C.

At the height of their development, the Liyu designs enjoy a distinction to which few Chinese bronze decorative styles can lay claim—a consistently high level of workmanship, especially in the precise execution and perfect casting of the fine filler motifs. This points clearly to improved decorative skills and advanced casting techniques in this period. It is the brilliant high point in the history of Eastern Zhou bronze decoration, and, as it happens, it is also the final expression of the characteristically Chinese practice of executing all designs in the mold. The prevailing decorative style of the subsequent Warring States period relies heavily on the cold-working technique of inlaying precious metals and semiprecious stones into the cast bronze, a method that is, by contrast, unmistakably foreign in character.

The metropolitan character of the Liyu style was confirmed by a series of excavations carried out between 1956 and 1961 in southwest Shanxi: just outside the remains of an Eastern Zhou city at Houma, the excavators discovered a major Eastern

Zhou bronze foundry of exceptional artistic standards, with a large-scale operation and a relatively long period of activity. Over 1,000 decorated mold and model fragments were found, many duplicating designs known from the Liyu bronzes. Three large bone workshops and several pottery kilns and workshops were also found nearby, and the entire area was strewn with the remains of what must have been flourishing industries. The height of productivity for the workshops is likely to have extended from the sixth to early fifth centuries B.C., although workshops may have been active in the area before this time.

It is clear from this discovery that the foundry at Houma was a major manufacturing center for bronzes in the so-called Liyu style, and that what was formerly thought to be a regional style was actually the product of a large metropolitan workshop. Excavations elsewhere also suggest that the particular decorative styles of Liyu bronzes were popular in many parts of China during the sixth and early fifth centuries B.C.

The Houma excavations are an important key to our understanding of the bronze-casting industry in the Spring and Autumn period. Not only were the different industries—bone carving, ceramics, and bronze casting—carried on in separate workshops, but even the bronze-casting industry itself was specialized, with some workshops limited to the production of only a single type of object. Bronzes were manufactured at Houma in an enormous variety of types, ranging from ritual vessels of all shapes and sizes, to bells, horse and chariot fittings, mirrors, belt hooks, and even bronze coins.

The countless mold fragments found at the site show that the section-mold method was still the dominant technique, while fragments of intricately decorated models show that the section molds were generally made and decorated by forming them around a model, which was itself reusable. There are many well-preserved rectangular pieces, each corresponding to one design unit that is repeated many times on the finished bronze article. These are evidently master stamps used to prepare molds for casting. Instead of following the time-consuming method of decorating each mold section individually, as Shang and Western Zhou bronze masters did, the Houma craftsmen seem to have used extensively the much more efficient technique of stamp impressing the decorations in the mold sections. This technique must have arisen in response to the rapid commercialization of the bronze industry during the Spring and Autumn period, when both specialization and mass production were needed to meet the states' increasing demands for bronze articles of war, of ritual panoply, and of personal adornment. The invention of the decorative stamp at this point might also have been directly linked to the development of designs like the Xinzheng pattern (seen on no. 68), for standardized units readily lend themselves to stamped repetition. The decorative stamp continued to be widely popular in the Warring States period.

The Houma bronze masters must also have been familiar with the technique of inlaying metals and semiprecious stones on bronze, for model fragments showing the stiff geometric designs commonly associated with early Warring States inlaid bronzes were also found at the site; still others include a host of more realistic human and animal figures. The extraordinary variety shows that the bronze industry at Houma was not only highly organized and commercially successful, but also that it encompassed a wide range of decorative techniques—traditional (section-mold casting), newly invented (stamping), and foreign (inlaying). Its major stock in trade was bronzes with the Liyu dragon interlace, but it apparently also produced bronzes with pictorial and inlaid decorations, both representing radical departures from the long-established tradition of bronze designs.

An important factor in the originality of the Houma foundry is to be found in its borrowings from the Animal Style of the steppe nomadic cultures in the northwest. Here, Liyu may have played an intermediary role: the covered vessel no. 70 from the hoard is most suggestive in this connection. Its shape is typically Chinese and is frequently encountered at sites throughout China. The casting of no. 70 is equal to the best metropolitan workmanship, and certainly well within the capabilities of the Houma foundry. Yet neither the freely drawn hunting scene nor the technique of inlaying with copper is particularly Chinese. Inlays of turquoise are known in the Shang period, but metal inlays of copper, gold, or silver are a strictly Eastern Zhou phenomenon. On the other hand, such lively animal designs and hunting scenes, as well as colorful inlays, are common in

the art of the nomadic tribes that roamed the Central Asian steppes during the first millennium B.C., the best known being the Scythians of the eighth to fourth centuries. Similar hunting-style, copper-inlaid bronzes have been excavated at other border sites in northern Hebei, all close to the Great Wall and all reasonably open to nomadic infiltrations.

The essence of the Eastern Zhou creative genius, however, lies in the Liyu interlaced dragons themselves, which represent the primary and most vigorously inventive style in China from the sixth to early fifth century. Even so, many of its motifs were influenced by, or borrowed from, the more representational art of the steppes. This foreign element is visible in whole motifs, such as the realistically conceived three-dimensional animals, or the rope and cowrie bands, but equally in the suggestive naturalism of the furry, feathery, and scaly textures. Nevertheless, these motifs are transformed and Sinicized in the Liyu decorative scheme as they are set in subtle juxtaposition to create not straightforward depictions but a purely ornamental arrangement of elegant forms, graceful rhythms, and exciting textures. The boldness

with which these novel features are exploited in a strictly decorative context reflects the self-confidence that only a long-established ornamental tradition can boast. Next to the superb integration of form and decoration in the Liyu designs, more outspoken inventions like the Xinzheng wine vessel (no. 67), dazzling though they may be, appear awkward and somewhat bizarre.

The jade pendant no. 72 expresses the advances in jade-carving technique made since the Neolithic period. Earlier designs were created chiefly by incision (nos. 2, 3, 34-40) and were characteristically two-dimensional and linear. The relief surfaces, seen most clearly on the middle three sections of the pendant, are an Eastern Zhou innovation and a major technical feat. To produce a smoothly modeled, evenly rounded shape in the surface of a piece of jade, the carver had to grind away the surrounding material slowly and carefully. It is the outstanding technical achievement of the Eastern Zhou lapidary that he could have produced these gently undulating surfaces with such astonishing control and precision, and with no trace of the painfully laborious process that was involved.

8 Splendor and Sophistication
The Inlaid Bronzes of the Warring States Period (475-221 B.C.)

The regional stylistic differences that were so pronounced during the Spring and Autumn period began to dissolve in the course of the Warring States. This change was largely the result of improved trade and communication that disseminated new artistic ideas over vast areas. But perhaps the style that appeared early in the Warring States period also played a part in bringing the regions together: its sumptuously inlaid designs, offering an unprecedented and dazzling display of gold, silver, and semiprecious stones, had such universal appeal that the various regions yielded readily to their colorful charm. This style of decoration has come to be known as the Inlay Style. Excavations have uncovered inlaid bronzes from all parts of China (see nos. 73-93)

—from Hebei in the north to Guangdong in the south and from Sichuan in the west to Jiangsu in the east—a territorial distribution far wider than that of the Houma/Liyu bronzes. It is clear that the Inlay Style was the primary decorative style of the fifth to third centuries B.C., and its universal acceptance is an early indication of the cultural unity that foreshadowed the political unification of 221 B.C.

The widespread popularity of the Inlay Style was not achieved overnight. From its beginnings in the sixth century, over a hundred years elapsed before it was finally established as the most highly prized style of decorating bronzes throughout China. The history of the Inlay Style and of its conquest of China may be seen in three broad

stages. The first spans the period from the sixth century to about 450 B.C.; the second, from 450 to about 350 B.C.; and the last, from 350 to the beginning of the Western Han period.

The first of these stages is represented here by nos. 70 and 91. They illustrate two crucial points: first, that copper was the first metal to be used as an inlay (the use of gold sheets applied over bronze, known in the seventh century, is not technically inlay); and, second, that the idea of inlaying bronze vessels with metal did not become popular in China until the sixth century B.C., through the influence of the colorful inlaid metalwork of the steppe cultures—the immediate source for the Animal Style motifs of no. 70.

Although the Chinese adopted ideas of inlay from the West, they did not borrow the technique without modification. In Near Eastern workshops, casting ordinarily played no essential role in the inlay process; the designs were applied into the cold surface of an undecorated bronze. The Chinese craftsman, however, with his traditional reliance on the casting process, obtained the same result by casting depressions in the bronze to receive the inlay. The distinction apparent a millennium earlier between the Chinese preference for casting and the usual Western method of cold-working thus holds up even in the era of inlaid bronzes, and in a context of artistic borrowing. Clearly, what the Chinese bronze master valued was not a set of new techniques, but the exciting possibilities afforded by the introduction of color to the hitherto monochromatic bronze surface.

The Animal Style motifs that were borrowed along with the idea of inlay quickly proved to have little appeal for native Chinese taste, and they were soon replaced by more familiar subjects, such as the pictorial scenes on no. 91. Neither variety of decoration enjoyed any lasting popularity, and the geographical distribution of copper-inlaid bronzes is limited. The muted contrasts of copper against bronze soon gave way to richer inlays of gold, turquoise, and malachite, arranged in abstract ornamental patterns derived from more familiar bronze motifs. Examples from this early stage of inlaid designs are relatively rare, and so far attested for only in metropolitan China.

The brilliant ornamental inventions that were to come from this modest beginning were to have far greater consequence in the history of the Inlay

Style. They belong to the second stage of inlaid designs, beautifully illustrated by the complex, purely abstract patterns of nos. 73 and 74. The superb square wine vessel no. 73, inlaid with copper and malachite, comes from western Henan and dates between 400 and 350 B.C. Its decorative patterns are cast in the bronze and set off by an inlaid background of copper, originally red but now corroded to a bright blue-green, and dark green bits of malachite. Whether the design is in the cast bronze (no. 73) or in the inlays themselves (no. 76), color remains the primary decorative feature. The complete loss of the inlay materials from no. 74 has left its design, essentially similar to that of no. 73, nearly illegible despite the unintended compensating effect of relief.

As the Inlay Style matured, the appeal of its rich, brocadelike surface increased, and inlaid bronzes of the second stage are accordingly found over an area that extends beyond metropolitan China to Hebei in the north, Shandong in the east, and Hunan in the south. The third stage, beginning about 350 B.C., is best understood in terms of two parallel developments, one dominant in metropolitan China (that is, Henan and southern Shanxi), the other, in the south.

The first of these developments, a direct outgrowth of the preceding stages, is represented at the highest level of quality by no. 75, which, like no. 73, comes from western Henan. Here the design remains abstract and geometric, but it is executed with a combination of airy lightness and mathematical control that makes the richness of no. 73 seem heavy and effusive. The rarefied design of no. 75 is complemented by the precision and refinement of the inlays themselves: the gold lines have a wiry thinness, the turquoise accents (some now lost) are minute and calculatedly placed. Even the bodies of the felines climbing up the sides of the vessel are exquisitely inlaid, their sinuously curving silhouettes relieving the austere angular shape and rigid paneled design of the vessel. The precious inlay materials, its modest size, and the surpassingly elegant design give this piece an almost jewellike delicacy.

From this time on, the inlaid bronzes of the metropolitan tradition show a tendency toward ever greater refinement, a draftsmanlike precision, and an exacting restraint.

The third inlay stage saw a second line of

development, associated particularly with inlaid bronzes of southern provenance. In contrast to the stiff geometric designs typified by no. 75, it is a style of free-flowing curvilinear patterns, occasionally combined with motifs of dragons and birds, represented by the large gold- and silver-inlaid belt hook no. 76 from a fourth-century Chu tomb in Hubei Province. Despite the shared emphasis on color, a design like that on the belt hook has more in common with the painted designs on lacquered wooden objects from Chu tombs of the fourth and third centuries than with those of nos. 73 and 75. Both the inlaid and the painted designs have a graceful fluidity generated by sweeping curves and many spiraling tendrillike terminations. These new qualities must have been inspired by the growing popularity of the painted lacquers and, as might be expected, the earliest such designs in bronze are encountered primarily at southern sites.

The introduction of a new, dynamic curvilinear style demonstrates that regional artistic traditions still played key roles in the art of the Warring States period, although regional distinctions were already beginning to blur. Since the southern arts of painted lacquers and luxurious silks were coveted by metropolitan patrons, the new bronze designs were also welcomed there with enthusiasm. As a result, bronzes of both metropolitan angularity and lacquer-inspired fluidity are found throughout China, so that neither style can justifiably be characterized as regional.

The splendor and sensuous appeal of inlaid decoration reflect the dynamic vigor and sophistication of the Warring States period, and mark the final separation of the bronze vessel from the solemn realm of ritual. In this period the bronze vessels occupied as important a place in the wealthy man's home as they did in the ancestral temple. The religious spirit that pervades Shang vessels and that can still be felt in the solemnity of the eighth-century wine vessel no. 62 has evaporated from these luxury objects. No other decorative style could better suit the new social and secular role of Warring States bronzes than the sumptuous elegance of the Inlay Style.

In keeping with their new role in society, most bronze vessels of the Warring States period lack significant inscriptions. When inscriptions do occur, they normally record only prosaic matters, such as the year of manufacture, name of the workshop or craftsman, and, more frequently, the weight of bronze used and the capacity of the vessel.

The Western Han bronzes from the second-century B.C. tombs of Prince Liu Sheng and his wife, Dou Wan, stand at the climax of this secularizing trend, when even religion seems to serve only the most mundane aspirations of its devotees. A representative selection of the objects from their tombs, including Dou Wan's jade burial suit, has been shown in the 1974-75 exhibition of archaeological finds from the People's Republic. Not included in that exhibition were the beautiful gilt-bronze lamp no. 94, the wine vessel no. 96, whose inscription wishes on the prince endless banquets, good health, long life, and immortality, and the gold-inlaid incense burner no. 95, a glittering image of the utopia of Taoist myth.

The colorful inlaid bronzes of the fifth to second centuries B.C. constitute the last brilliant episode in the history of Bronze Age ornament in China. The Warring States period witnessed intensified activity in an art form that was to replace the bronze vessel as the major artistic achievement of the first millennium A.D.: the art of representation, in both sculpture and painting.

Since the Shang period, human and animal images appeared alongside purely abstract ones (see nos. 24, 34-40), but their rarity shows that such depictions represented a minor artistic concern of the time. Expressive forms and beautiful patterns took precedence over representational meaning, and it is to the realm of ornamental art that the greatest achievements of the Bronze Age artist belong. In sharp contrast, ancient civilizations in the West concentrated on representation, both in sculpture and in two-dimensional pictorial scenes from an early stage. Perhaps it is significant that the deities of civilized Mesopotamia were personified in myth and portrayed in art, while those of the Shang dynasty in China remained shadowy and were never depicted.

Viewed in this light, the stiff, naive pictorial scenes on the early fifth-century wine vessel from Sichuan (no. 91) take on a special historical significance. They represent one of the earliest known Chinese attempts at pictorial art, when the artist first began to grapple with the problem of portraying a three-dimensional space on a two-dimensional surface. The solution offered here is simple and primitive: various scenes of archery,

The Chinese love of surface ornamentation is amusingly illustrated by the
delicate cloud scrolls that drift over the body of this imperturbable
rhinoceros (no. 93)

duck hunting, music making, banqueting, and
land and sea battles are set next to each other
with no regard for spatial relationships. The
scenes resemble line diagrams, and each individ-
ual scene functions more like an elaborate
pictograph to be *read* for its contents than as a
convincing pictorial evocation of the event.

This sudden appearance of pictorial scenes
in bronze decoration might have been indirectly
inspired by contacts with the Animal Style art of
the steppes. The lid and the bottom register of no.
91 carry animal designs identical to those found
on copper-inlaid bronzes from Liyu (cf. no. 70)
and other regions close to the Great Wall. Perhaps
uncomfortable with the strange vocabulary of
animal forms, the Chinese soon found a more
interesting substitute in these scenes of rituals,
festivities, and battles, which were closer to their
own everyday experiences.

Steppe Animal Style art had an even more
immediate impact on the development of sculp-
ture in China. While nos. 70 and 91 remain as
scattered hints of steppe infiltrations, concrete
evidence came only recently with excavations
at Pingshan Xian in Hebei Province. The exca-
vations, begun in 1974 and completed in June
1978, uncovered numerous burials, the two
largest of which belonged to the rulers of the
small state of Zhongshan. During the Warring
States period, Zhongshan was ruled by the Di
tribe, which had been harassing China's northern
and western borders since the seventh century.
Although the Di were not true mounted nomads
of the Central Asian steppes, they nevertheless
shared cultural traits with nomadic groups to their
north and west with whom they must have been in
constant contact. Thus, for a period of almost
300 years, from the sixth to early third centuries

B.C., a seminomadic tribe with a steppe cultural background lived in the midst of Chinese territory. The Di must have been heavily Sinicized by interactions with their more sophisticated Chinese neighbors but no doubt they contributed something in return. The contents of the Zhongshan kings' burials, which included dramatic examples of animal sculpture, document both their steppe origins and their adopted culture. The brutally simple form of the large standard top (no. 92), one of a set of six found in a Di tomb at Pingshan Xian, is hitherto unknown in China. Its origin was probably nomadic, where similarly crudely fashioned standard tops must have formed part of the chieftain's regalia—silent but evocative emblems of his overpowering authority.

Remarkable works of Warring States sculpture, such as the rhinoceros (no. 93), must have been inspired by the forceful animal representations typical of steppe cultures. But compared with the nomadic Animal Style art, the rhinoceros appears unmistakably Chinese. The heavy folds of skin at its neck, the lumbering weight of its body, and the bony structure of its head and legs are all convincingly rendered with great plastic substance, but distinctively Chinese is the attention to a richly ornamented surface. Its entire body is draped with a dense pattern of cloud scrolls once inlaid with gold. These cloud scrolls are exclusively ornamental, flowing with utter disregard for organic structure over the folds of the neck and head, body, and legs. This rhinoceros becomes an apt illustration of a unique characteristic of the early development of sculpture in China—the paradox created by the new desire for realistic depiction and the entrenched habit of ornamentation.

The tension between these two contradictory forces reached a masterful resolution in the incense burner of the second century B.C. (no. 95). The censer represents the Isle of the Immortals described in Taoist myth: the island is the conical top, depicted with numerous fingerlike peaks; the bowl is the Eastern Sea, its swirling currents expressed by the sweeping scroll pattern inlaid with gold. Although these cloud scrolls belong to the same category of abstract ornamental forms as those on the rhinoceros' body, they are here more than mere surface decoration. By virtue of context and layout, the cloud scrolls—mere ornaments on the body of the rhinoceros—acquire a representational meaning on this censer. Without losing their beauty as ornaments, the gold-inlaid motifs have become the essential elements of an evocative realistic image. This elegant blending of form, meaning, and decoration is a grand invention that belongs both to the era of ornament, now drawing to a close, and to the emerging age of representational art in China.

9 The Waning of the Bronze Age
The Western Han Period (206 B.C.—A.D. 8)

The collapse of the Qin dynasty was signaled by the death of the First Emperor of Qin in 210 B.C. and the murder of the legitimate heir by his younger brother; peasant uprisings erupted throughout the country, even while the dead emperor was entombed in his magnificent mausoleum (see Chapter 10). After four years of bloodshed, the new Han dynasty was established with its capital at Chang'an (near modern Xi'an), so founding one of the longest and most colorful dynasties in Chinese history. The Han dynasty continued for over 400 years, ending in A.D. 220.

The first half of the period (206 B.C.—A.D. 8), when the capital was at Chang'an, is known historically as Western Han. After a brief interregnum, the Han dynasty reestablished itself at Luoyang in A.D. 25, and the subsequent period from A.D. 25 to 220 is known as Eastern Han.

In archaeology, the period is documented by a wealth of material from innumerable sites scattered throughout the country, providing a virtually inexhaustible source for the study of Han history, society, and art. Among the many Han sites discovered in the past twenty years, three stand

out in historical, cultural, and artistic importance. These are the tombs of the early second century B.C. at Mawangdui, Changsha, Hunan Province (not represented); the tombs dating from the late second century B.C. of the Han prince Liu Sheng and his consort Dou Wan at Mancheng, Hebei Province (nos. 94-96); and the remains of a cultural center of the Dian tribe at Shizhaishan in Yunnan Province (represented by no. 97, which comes from a Dian site twenty-five miles south of Shizhaishan). Together, these excavations present a cross section of Western Han culture and art that ranges from metropolitan sophistication to the rough candor of local expressions.

The second-century tombs at Mawangdui and Mancheng both magnificently demonstrate the prosperity and high artistic achievement reached during the Western Han period. Only local lords were buried at Mawangdui, but their burial furniture was extravagant: the three tombs together yielded over 2,500 objects, most of them handsomely decorated lacquers and exquisitely embroidered silks and damasks, as well as many texts written on silk, bamboo, or wooden slips, all preserved in nearly pristine condition. The tombs at Mancheng were for the ruling elite: they yielded the two jade suits worn by Prince Liu Sheng and his consort, Dou Wan, each made of over 2,000 pieces of jade sewn together with gold thread, and a total of almost 3,000 objects of bronze, iron, gold, silver, jade, pottery, lacquer, and silk. Liu Sheng was the stepbrother of Wu Di, one of the greatest Han emperors, whose fifty-four-year reign saw the territorial expansion of the empire, the opening of the Silk Route across Central Asia, and a period of peace and prosperity.

In technology, the furnishings from Mancheng and Mawangdui tell us that, by the Western Han period, the Bronze Age in China was nearing its end. While the Mancheng burials contained large numbers of both bronze and lacquered objects, the richest of the tombs at Mawangdui yielded only a single bronze item—a mirror— from among its over 1,000 objects of lacquer, silk, wood, and bamboo. Bronze was still a luxury metal (the cost of an undecorated bronze basin from Dou Wan's tomb, recorded in its inscription, is estimated to be roughly the same as a working man's wages for one to one and one-half years), but lacquers were even more expensive. A Han dynasty source notes that the price of one lacquered cup is equivalent to that of ten bronze ones. Clearly, the monopoly of bronze as a material for luxury goods was challenged by the beginning of the Western Han period.

In the manufacture of daily tools and agricultural implements, bronze had always been sparingly used, except in weapons where it was used extensively. But even here, this metal was losing ground to another competitor, iron. Among the weapons from Liu Sheng's tomb, the number of iron ones exceeded that of bronze. Furthermore, laboratory tests on a long iron sword buried by his side reveal that the metal is extremely low in carbon content and other impurities, and closely approximates steel in its metallurgical structure and strength. Greatly improved since its first appearance as crude cast iron in the Eastern Zhou period, iron was to replace bronze in the production of superior weapons during the Han period. At the same time, its low cost continued to make iron the most desirable metal for tools and agricultural implements. From this time on, bronze was used primarily for coins and mirrors. By the Western Han period, the days of the Bronze Age in China were numbered.

With the decline of the Bronze Age in China came the end of the bronze vessel as an art form. The routine shapes and unadorned surfaces of most of the bronze vessels from Mancheng reveal only too clearly that the intense involvement with shapes and surface designs—the essence of the art of the bronze vessel from Shang to Eastern Zhou—had quite evaporated by Western Han. Whether cast in bronze (no. 94), painted in lacquer, or modeled in clay (nos. 98-105), representational themes far outnumber purely ornamental ones. Indeed, the bronze lamp in the shape of a kneeling girl (no. 94) ranks among the finest of early Chinese sculpture; its gilded surface represents the most popular bronze decorative technique of Western Han, attesting to the extravagant and worldly tastes of the time.

Encounters with foreign cultures, in part responsible for the growing interest in realistic representation and already evident in earlier periods, expanded with the territory of the Han empire. At the same time, the opening of the Silk Route permitted more Chu lacquers and silks to reach the hands of Hun chieftains in Central Asia, and silks alone traveled as far as the Roman Empire. The legendary "blood-sweating" horses of

Fergana and Sogdiana were first imported at this time, and a powerful representation of this high-spirited breed is seen in the famous "flying horse." Buddhist teachings probably first entered China at this time, too, although the earliest Buddhist representations in China date only from the Eastern Han period.

Another aspect of Han territorial expansion is illustrated by the bronze composition of bulls and tiger (no. 97) from the recently excavated site of the Dian tribe in Yunnan Province. The Dian were an independent tribe engaged in agriculture and stock rearing in the high mountain region of southwest China. Unlike other cultures, Dian neither gained much from its encounter with China nor contributed much to Chinese culture. Excavations at Dian sites show a clear division between the tribe's period of autonomy and its subsequent incorporation into the Han empire in 109 B.C.: tombs belonging to the earlier phase reveal a highly localized culture of complex origins and significant artistic character (see no. 97), while those from after the Han conquest yielded little more than routine Han remains.

Tombs from the early phase probably date back at least to the late Warring States period. The artifacts reveal an essentially bronze-using culture with distinct local characteristics. With its geographical isolation high among the hills of the southwest, the only discernible Chinese influence on Dian came from Chu and its southwestern neighbors. The combination of serpents with various animals, a typical Chu motif, is also frequently encountered in Dian art, and the bronze drum played an important part in both Chu and Dian cultures.

The greater part of Dian culture, however, was drawn from steppe cultures of Central Asia to its northwest, and from peninsular Southeast Asian and Indian cultures to its west and south. Steppe influences would have filtered down the narrow mountain passes of Sichuan, perhaps even through Chu territory, for Chu silks and decorative motifs had penetrated nomadic circles in the Altai Mountains as early as the fourth century B.C. Dian culture probably also came into contact with early cultures in mainland Southeast Asia, even as far as India, judging from the prominence of the bull as a Dian decorative motif (no. 97). Finally, the unusual shape of bronze ritual objects like no. 97, which finds no counterpart in either Chinese

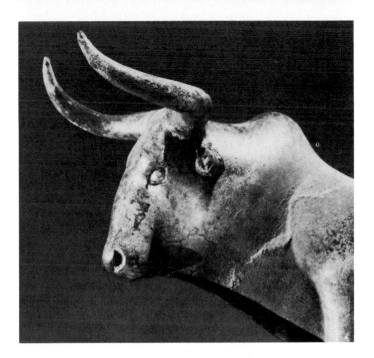

Made by a tribe that lived on the fringes of Chinese civilization (no. 97), this bull's fluid modeling and undisguised realism contrast with the Chinese emphasis on decorative appeal

or other cultures, reflects the native Dian culture at its most individualistic.

Dian bronze culture before the Han conquest also seems to have been familiar with a metal-working tradition distinct from China's. While lost-wax casting may have been known in China by the early Warring States period (see no. 67) and certainly by Western Han times (nos. 94, 95), the method was not widely adopted until much later. Most of the bronzes from Dian sites, in contrast, show fluid modeling of intricate animal and human forms, often in freestanding relief (no. 97), which points to lost-wax casting as their common manufacturing technique. The complex form of no. 97 was constructed in a piecemeal manner that is also distinctly un-Chinese: the various animals were first cast separately, then assembled with a liberal use of soldering and additional pours of metal. All this suggests that there must have been a thriving local metal industry in the Dian culture which had learned its craft from other than Chinese sources.

The characteristic features of Dian culture disappeared soon after the Han conquest of 109 B.C. Dian tombs that date after the second century B.C. are poor in typical Dian artifacts. Iron implements and weapons began to replace bronze ones, and bronze vessels of the time are usually routine Han types imported from metropolitan China, or rough ceramic ones of equal inconsequence.

10 The Terracotta Army of the First Emperor of Qin (221-206 B.C.)

A chance discovery made in 1974 is the most important revelation in recent Chinese archaeology: an army of some 7,000 life-size soldiers and horses sculpted in clay, painted in brilliant colors, and equipped with real chariots and bronze weapons was found buried near the tomb of China's unifier, the First Emperor of Qin, to serve as an imperial bodyguard in his afterlife.

China's unification by the ruler of Qin in 221 B.C. had the greatest impact of any event in Chinese political history. Just as he connected

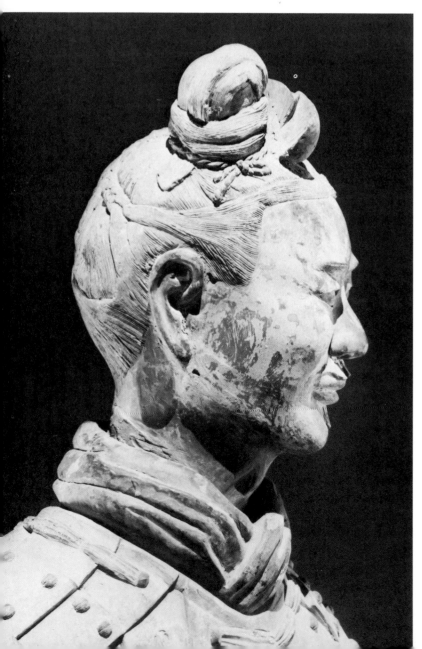

the many separate ramparts previously erected against nomad incursions to form the 1,500-mile-long Great Wall, the First Emperor welded the competing states into a single empire. By promulgating a uniform code of law, by standardizing currency, weights and measures, and even the written language, he unified the country under his rule, ending centuries of discord and warfare. Although the dynasty itself would end in 206 B.C., less than four years after the First Emperor's death, this unification laid the foundation for China's imperial order of the next 2,000 years.

The grandiose governmental powers assumed by the First Emperor were expressed in the cultural sphere by an imperial art imposed upon the disparate traditions of the earlier Warring States period of the preceding Zhou dynasty. Twelve colossal statues cast in bronze are our first evidence in historical accounts of this imperial art in China: "All weapons of the empire were collected and brought to the capital Xianyang, where they were melted down to make bells, as well as twelve metal figures that each weighed 1,000 *dan* [roughly 3½ tons], which were erected in the palace." The last of the twelve colossi were melted down in A.D. 190, but the large-scale terracotta warriors discovered near the First Emperor's tomb can offer a clue as to their appearance. In addition, being an outgrowth of the sculptural traditions of the late Zhou, the pottery figures provide new evidence that by the third century B.C. Qin culture, traditionally regarded as semibarbaric, stood unequivocally within the mainstream of Chinese culture.

Qin's avid acquisition of Zhou culture is best illustrated by the eastward movement of its own capital and its concomitant adoption of Zhou principles of city planning, architectural construction techniques, and styles of art. The most elaborate cultural remains yet discovered in Qin territory are those of Xianyang. Located on the north bank of the Wei River, just west of modern Xi'an, it served as the last Qin capital from 350 to 206 B.C. During its brief imperial era as the first

This archer's coiffure was depicted with the same precision as his uniform (no. 99)

capital of a unified China, Xianyang enjoyed extraordinary prosperity.

With the unification of the country in 221 B.C., work was begun on a vast building program: "As each feudal domain was abolished," the history runs, "replicas of the feudal lords' palaces were constructed in the hills north of the capital overlooking the Wei River. . . . Connected by elevated avenues and encircling corridors, they were filled with the beautiful women and musical instruments captured from the different states."

In 212 B.C. the First Emperor ordered the construction of another imperial residence, the legendary E Pang palace, south of the Wei River in the imperial parklands of his capital, Xianyang. So immense was the projected size of the palace that several hundred thousand laborers were conscripted to work there, yet it was still incomplete at the time of the emperor's death in 210 B.C. The vast scale of this and other colossal undertakings, including the construction of the Great Wall and the First Emperor's mausoleum, strained the population to the breaking point. His heir, the Second Emperor, by refusing to halt construction on the palace even as the empire faced open rebellion, obstinately led his dynasty to utter collapse.

Razed by rebel armies in the same year the Qin dynasty fell, only the elevated foundations of the E Pang palace survives, but its name still lives as the epithet for unbridled luxury. Similarly, the layout of the First Emperor's mausoleum epitomizes his vision of an everlasting world order. As described by a later historian, the First Emperor's tomb chamber reproduced in minute detail the universe over which he expected to rule:

More than 700,000 conscripts from all parts of the country labored there. The laborers dug through three subterranean streams which they sealed off with bronze in order to make the burial chamber. This they filled with [models of (?)] palaces, towers, and the hundred officials, as well as precious utensils and marvelous rarities. Artisans were ordered to install mechanically triggered crossbows set to shoot any intruder. With quicksilver the various waterways of the empire, the Yangtze [Yangzi] and Yellow Rivers, and even the great ocean itself were created and made to flow and circulate mechanically. The heavenly constellations were depicted above and the geography of the earth was laid out below. Lamps were fueled with whale oil so that they might burn forever without being extinguished. . . . Finally, trees and grass were planted [on the tumulus] to make it appear like a mountain.

While this description has not yet been confirmed by modern excavation, it is strongly supported by the tomb site's outward configuration, which functioned as a replica of a palace city and as a diagram of the cosmos.

Evidence that the area around the First Emperor's tumulus might conceal a population of pottery figures appeared sporadically between 1932 and 1970. During this time five kneeling figures—probably servants—were discovered inside or near the outer wall of the complex. Slightly over two feet in height, each is individually modeled, with head and hands fashioned separately.

The kneeling figures discovered thus far have all been found close to the present soil surface and in no discernible pattern, although it has been suggested that they may be attendants accompanying sacrifices to the First Emperor. The army of warriors and horses found in 1974, however, had been carefully arranged within several elaborately constructed subterranean chambers. The first of these to have been discovered—beyond the outer wall of the mausoleum, 4,000 feet to the east—is estimated to contain some 6,000 pottery figures of warriors and horses outfitted with real weapons, chariots, and chariot gear. The Chinese excavators' designation for this underground complex is "Pit No. 1," though it is actually a series of eleven parallel trenches or corridors, each about 9¾ feet wide and over 656 feet long; overall it stretches 689 feet from east to west and 197 feet from north to south. When completed, the interior of each corridor was about 10½ feet high. From the amount of soil that filled in these trenches when the wooden ceilings collapsed, the excavators have estimated that the mound on top of the pit probably stood about 6½ feet higher than the surrounding soil surface in Qin times. This prominence would have made it an obvious landmark; it is hardly surprising, therefore, that the pit was looted of weapons and burned not long after it was built. Most likely, the subterranean complex did not outlast the fall of the Qin dynasty in 206 B.C., when a rebel general is said to have razed the palaces of the Qin capital

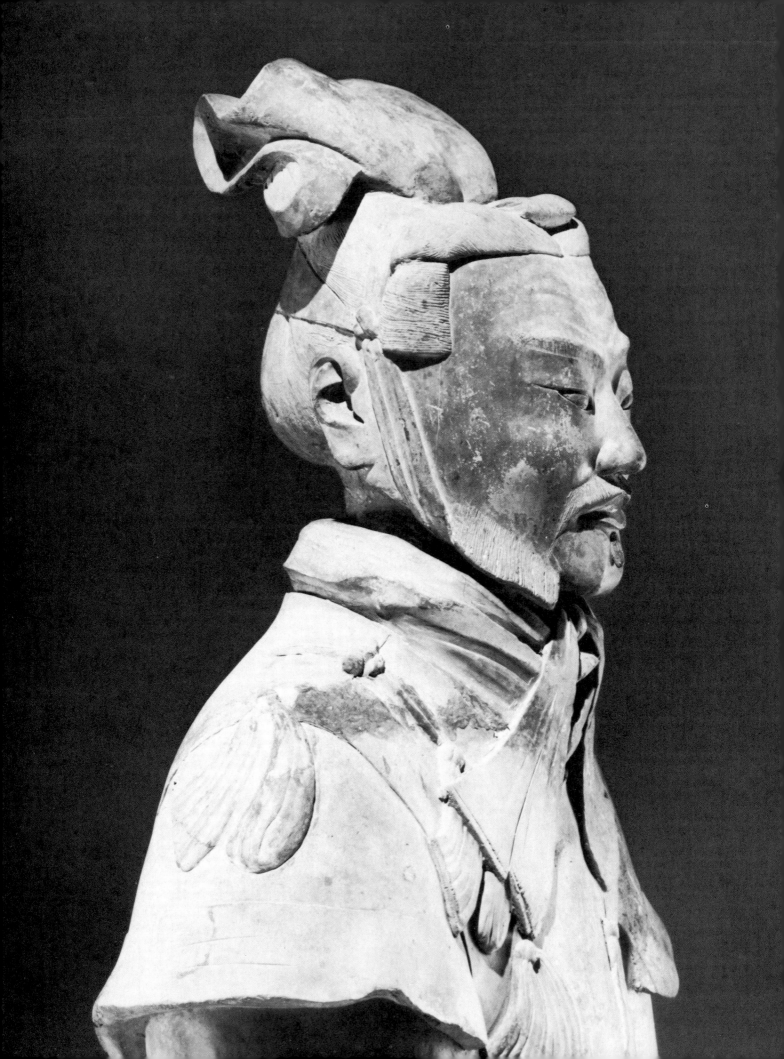

and desecrated the First Emperor's tomb. Whatever the cause, the pit was filled in and forgotten, preserving intact the entire army of terracotta figures.

From the position of the various figure types and few remaining weapons it is evident that the subterranean complex was designed to accommodate a specific military formation. A wide gallery at the eastern end of the pit contains a vanguard unit of unarmored bowmen and crossbowmen, whose long-range weapons would have been the first to be employed in any military engagement. Behind the vanguard, the formation is subdivided within the eleven long corridors. The narrow outer corridor on either side contains two files of archers; the outer file faces outward, prepared to repel a surprise attack from the flank, and the inner file faces forward to assist in an assault. Inside these units stands the heart of the army—thirty-six files of infantrymen divided evenly among the nine remaining corridors. All wear armor and carry spears or other close-combat weaponry (e.g., no. 105). Between this body of infantrymen and the vanguard of bowmen is a specialized unit of six chariots and three unarmored infantry squads. Each chariot, pulled by a team of four life-size pottery horses, is manned by both a charioteer and a warrior. An advance squad of twelve foot soldiers stands at the front of each chariot. In the three corridors not occupied by a chariot team a squad of thirty-two unarmored spearmen precedes the main body of troops. The rear of the formation is protected by three ranks of armored infantrymen; the last of these faces west as a rearguard. This configuration of warriors follows military prescriptions in contemporary texts on military strategy: "Long-range crossbows in front, halberds behind," "bows are the outer layer, halberds and shields the inner," and "skilled soldiers and strong bows on the flanks."

In May 1976 a second subterranean complex with warriors (Pit No. 2) was discovered 65½ feet north of the eastern end of Pit No. 1. Whereas Pit No. 1 contains primarily infantrymen, Pit No. 2 holds a smaller complementary force composed largely of chariots and cavalrymen, estimated to number slightly more than 1,400 warriors and horses. Four basic units may be distinguished. A vanguard of archers is subdivided into an encircling array of unarmored striding infantrymen (no. 98) and a core of kneeling armored archers (no. 99). The figure of an officer (no. 100), probably the unit commander, once stood at the left rear of the vanguard. Directly behind this advance force are two units composed largely of chariots and cavalrymen. One of these, in which cavalrymen predominate, occupies three northern corridors. The other occupies three considerably longer corridors and is made up primarily of chariot squads, some accompanied by as many as thirty-two infantrymen. The center and right corridors in this unit have four cavalrymen as a rearguard. The left corridor has a large concentration of foot soldiers protecting the rearmost chariot, which is a mobile command post for another officer. The fourth unit, occupying a nearly square area at the southern end of the pit, is divided into eight corridors, each with eight chariots—a total of sixty-four in all.

A smaller, third pit (Pit No. 3) located just to the north of the west end of Pit No. 1 contains only sixty-eight figures. From its position toward the rear of the formation and the large number of "officer" figures found there, it would appear to represent an elite command unit.

A fourth pit, reportedly between Pits 2 and 3, has also been uncovered. Quite empty, it suggests that work on the terracotta army was abandoned before the formation had been completed.

Despite the staggering number of figures required to fill the ranks of this pottery army, warriors and horses were not stamped from molds, but individually modeled. Each body was built up from coils of coarse gray clay with the hollow torso fully supported by solid columnar legs. Once the desired shape was achieved, the surface was finished with a slip of finer clay. Smaller details—such as elements of armor—were individually modeled and applied to the surface while the clay was still pliant. Next, the entire assemblage was fired at high temperature, then mounted on a prefired base. The hands and heads of the warriors and the tails and forelocks of horses were fashioned and fired separately, and attached with clay strips. Finally, each figure was painted in bright colors and fitted with actual weapons or chariot gear.

Ordinary foot soldiers range in height from 5 ft. 8 in. to 6 ft. 1 in. Charioteers—such as no. 103, at 6 ft. 2½ in.—are even taller; the towering commander of the vanguard, no. 100,

This officer's face reflects the dignity and confidence of an experienced military commander (no. 100)

stands 6 ft. 5 in. For charioteers and officers, height may be a function of rank or importance rather than verisimilitude. This is certainly true of Han two-dimensional figural representations, where important personages are always shown in larger scale than subsidiary characters.

An astounding specificity in uniforms further distinguishes the role of each figure. Excavators have described seven basic types of armor and a wide range of specialized accouterments: caps, belt hooks, leggings, and shoe styles. The varied colors applied to the uniforms may also indicate the several units into which the army was divided. Faces and hands were painted in flesh tones, eyes were white with black irises; eyebrows, whiskers, and hair were black. The horses were also painted, usually with brown or black for coats, white for hooves and teeth, and red for the insides of ears, nostrils, and mouth.

However gaudy and splendid this spectacle must have been, the individual human quality of the warriors' faces is touchingly personal. Anatomical details are surprisingly lifelike, and so overpowering are the facial expressions, they suggested to the excavators that the First Emperor's entire bodyguard sat for their portraits in lieu of being buried alive. Even if such exacting realism had been intended, most faces do conform to an idealized type with high, smooth forehead, crisply molded, angular eyebrows above deep-set eyes, prominent cheekbones, and full nose. By varying hairstyles or applying elegant, trimmed mustaches or chin whiskers, this basic facial type was almost endlessly individualized. Other variations include clean-shaven and full-cheeked visages that appear youthful, and sharp-nosed, bearded countenances that suggest Central Asian ancestry. The degree to which such details are used to evoke specific character traits is apparent in the face of the infantry officer (no. 100). Given added prominence by his great height and distinctive uniform, he wears an elaborate coiffure and whiskers that bespeak the dignity of his rank; a furrowed brow testifies to the responsibilities and cares of leadership.

For all their realistic detail the Qin terracotta figures are types rather than portraits. Closer observation reveals that their bodies are not anatomically correct. Heads are attached to the torso by an elongated cylindrical neck. In the same fashion, forearms were frequently telescoped inside the rolled-up sleeves, making the arms appear unnaturally short (e.g., no. 105). Even allowing for the stiff greaves worn by many soldiers, legs are rigid tubes supporting symmetrically arrayed torsos.

Despite such representational inaccuracies, these terracotta figures mark a new level of achievement in naturalistic depiction. Their life-size scale enabled artisans to reproduce garments, hairstyles, and facial features in a comprehensive manner not possible in smaller works. Interestingly, the profusely detailed appearance of the terracotta army reveals the same ardor for minutiae that pervades Qin's precisely defined legal statutes.

The Qin terracotta figures, as the earliest known large-scale sculptures in China, provide new material for the study of Chinese sculptural arts. In addition, they offer graphic illustrations of contemporary treatises on military organization and tactics, giving precise information about battle formations, dress, and armor. Joining an earlier trend in representational accuracy with a new monumentality of scale, these figures reflect developments in the secular arts, arts made expressly for the enjoyment of the living. Their size, variety, and detail may have been further stimulated by the belief that mortuary arts should replicate the world of the living for the dead. By their grandiose conception and thoroughgoing depiction, as well as by the sheer magnitude of their numbers, the pottery army exemplifies the First Emperor's imperial vision, a standard that all later dynasties would strive to emulate.

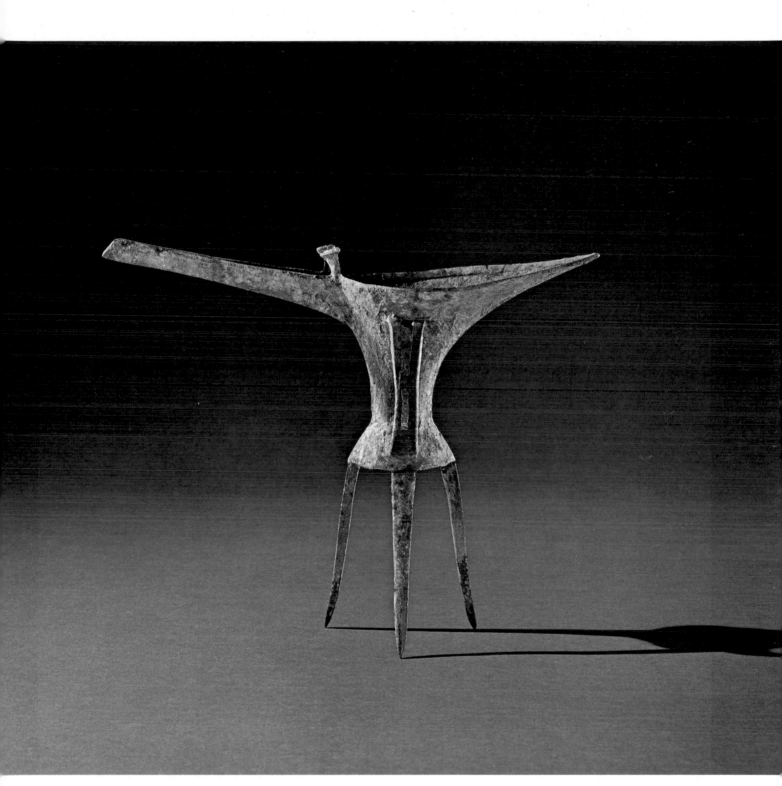

1 This fastidiously shaped wine cup, with its graceful, attenuated proportions, was made around the seventeenth century B.C. and is one of the earliest Chinese bronze vessels so far known.

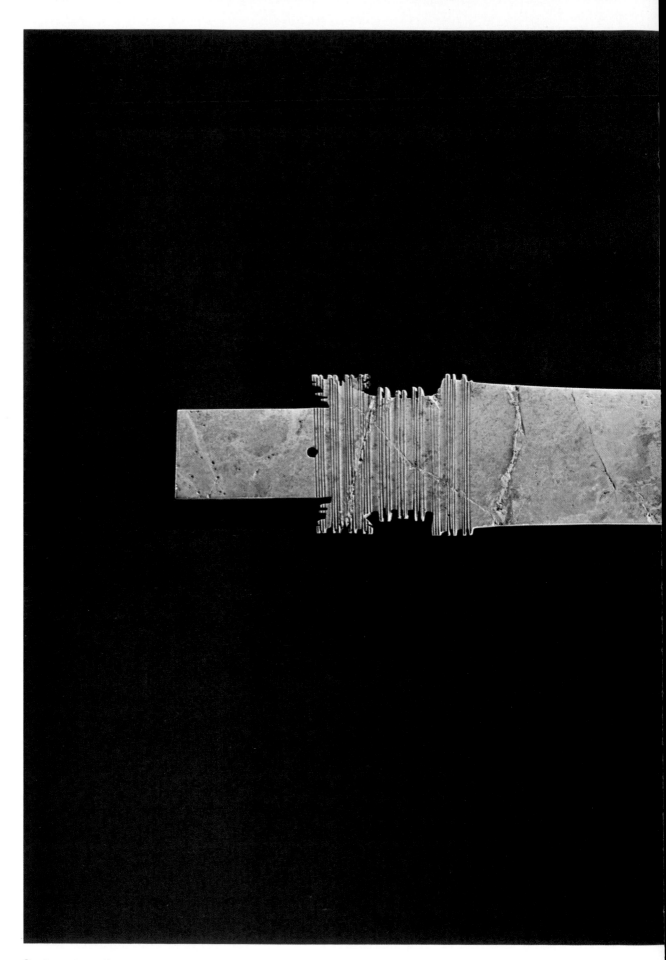

2 An outstanding example of a rare shape, the impressive blade illustrated
here is nineteen inches long. Painstakingly worked from a slab of jade
and ground very sharp on the right edge, it may copy an elongated bronze ax.

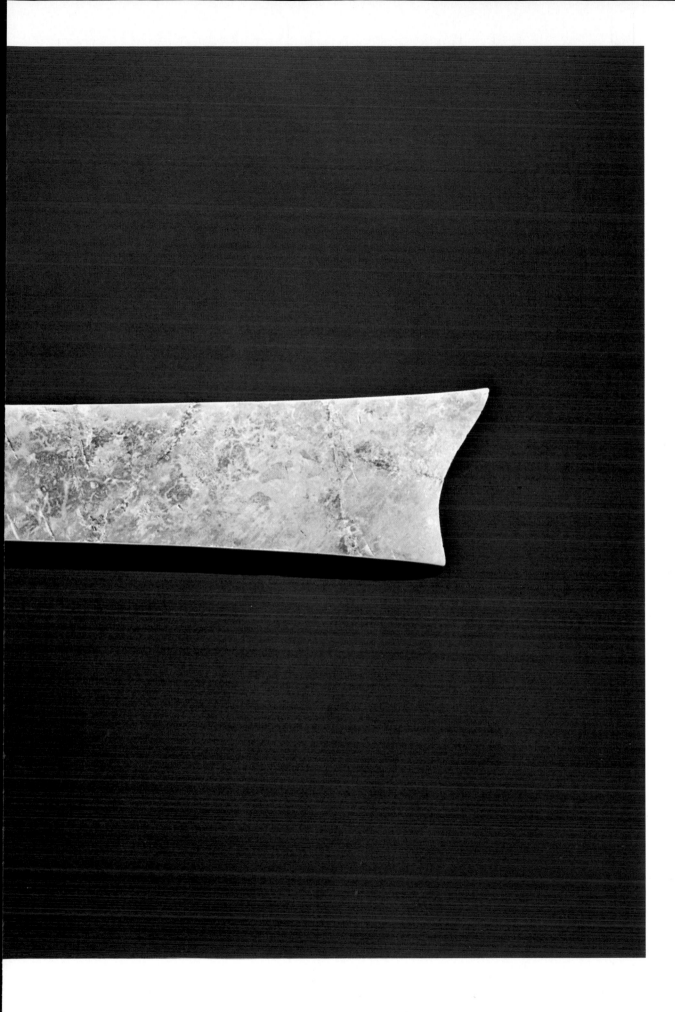

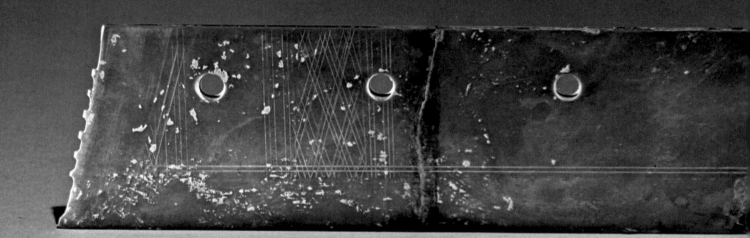

3　The prototype for this jade object is a Neolithic harvesting
knife and—like the jade craft itself—reaches back beyond the
Bronze Age into very ancient times. In a functional knife, a grip
would be attached to the perforations along the back.

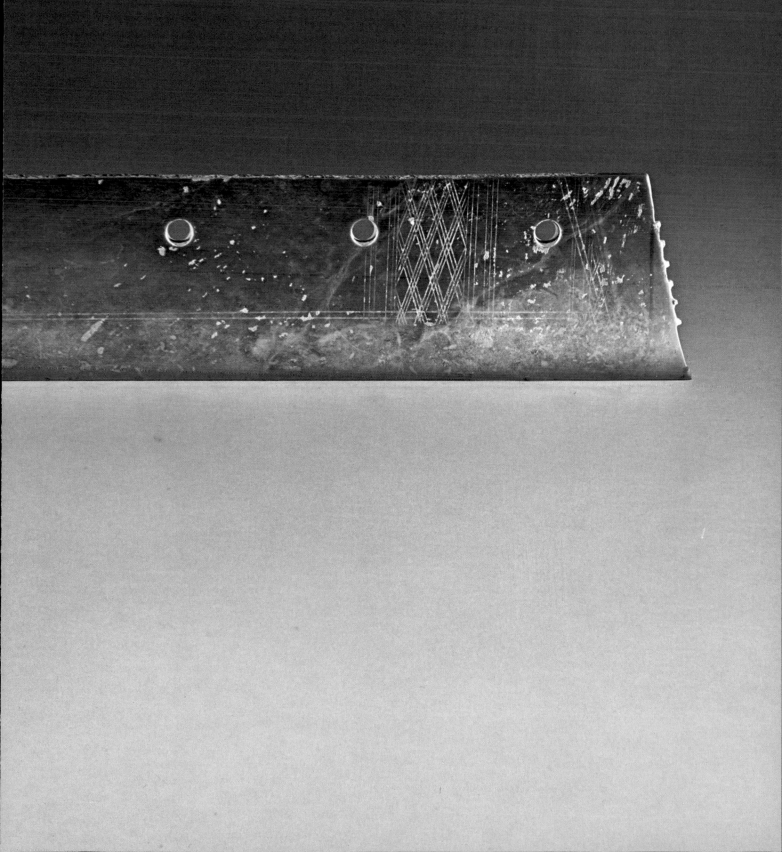

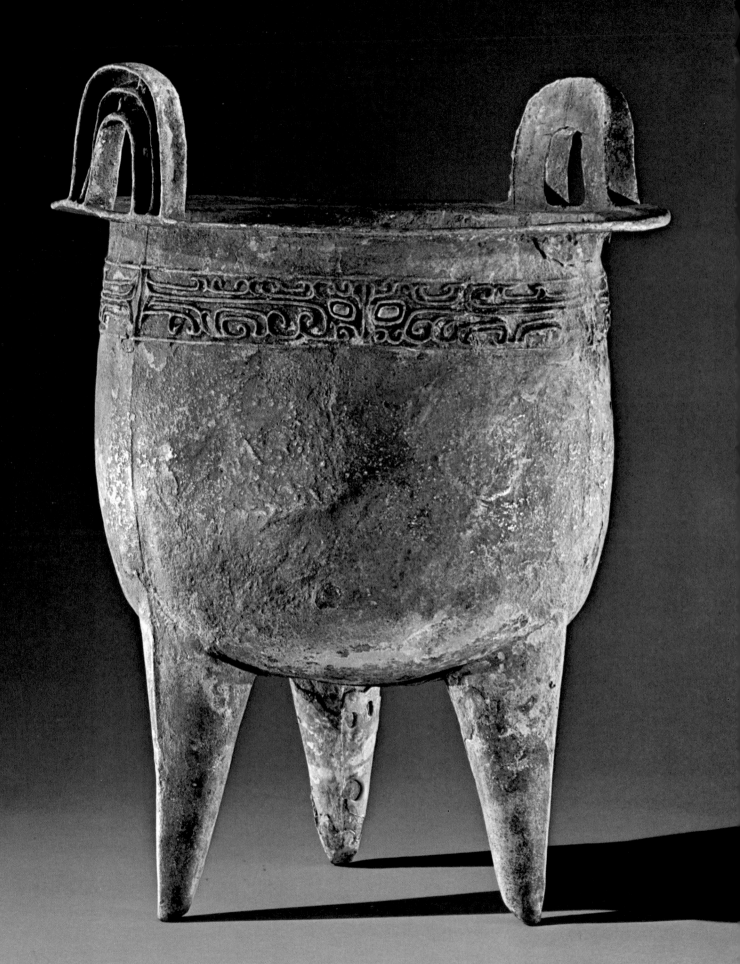

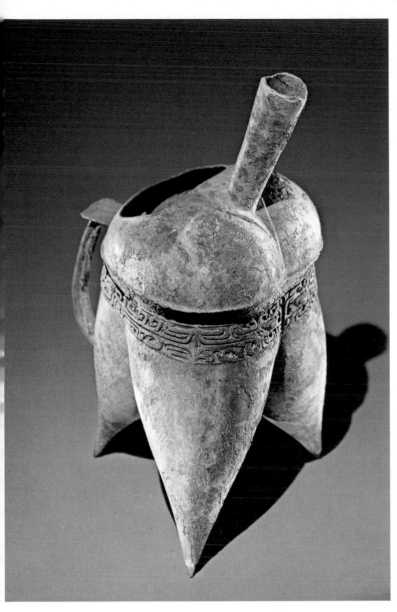

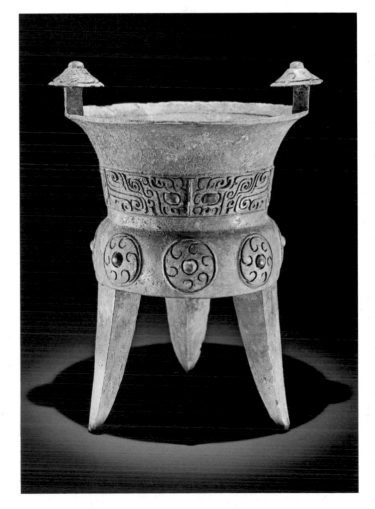

6 The shape of this wine container is derived from Neolithic precedents; the crisply executed and richly varied lines of the ornament, however, are hallmarks of Shang decorative treatment.

5 Although made entirely by casting, this pouring vessel draws on ceramic and wrought-metal prototypes: the lobed lower part imitates a Neolithic pottery shape, while the lid, spout, and handle seem to imitate a construction in sheet metal.

4 The florid band of decoration on the large cauldron at the left marks the first appearance in this exhibition of the animal mask, the principal motif of Shang art.

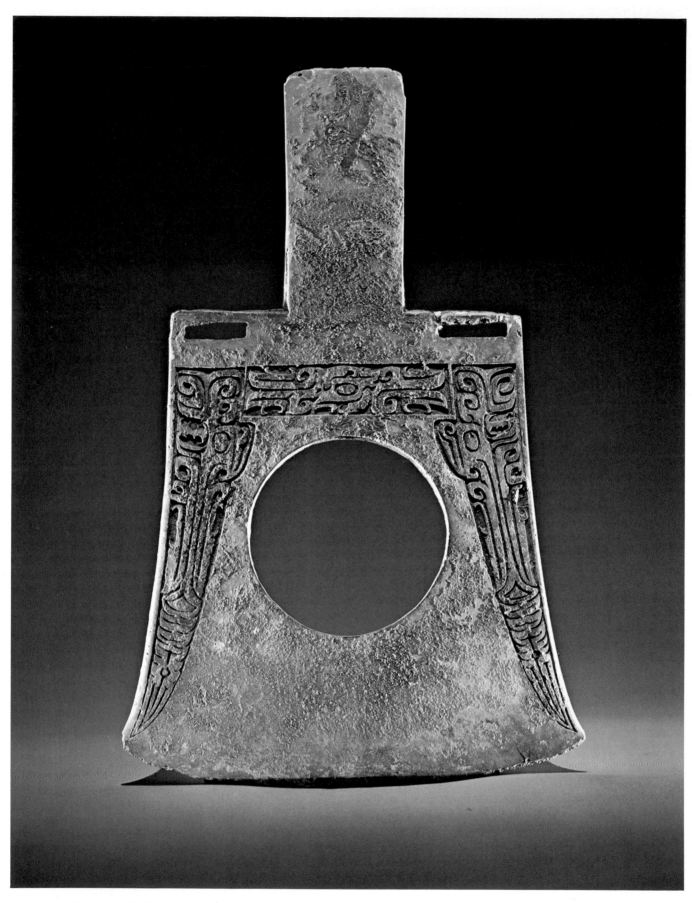

7 The aesthetic sensitivity of this bronze ax is unmatched: silhouette and decoration alike masterfully bridge the transition from the rectilinear hafting end to the flaring curve of the deadly cutting edge.

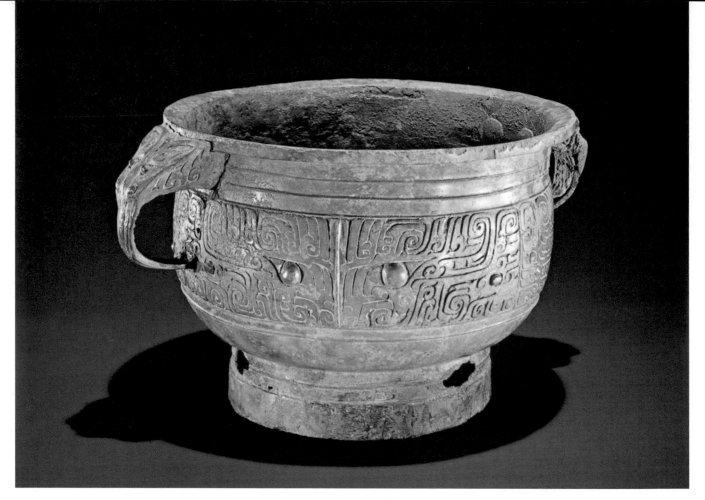

8 The food storage vessel shown above is the earliest
known example of a type common in later times. The animal-
mask motif has become more organic, with easily recogniz-
able eyes, snout, and jaw.

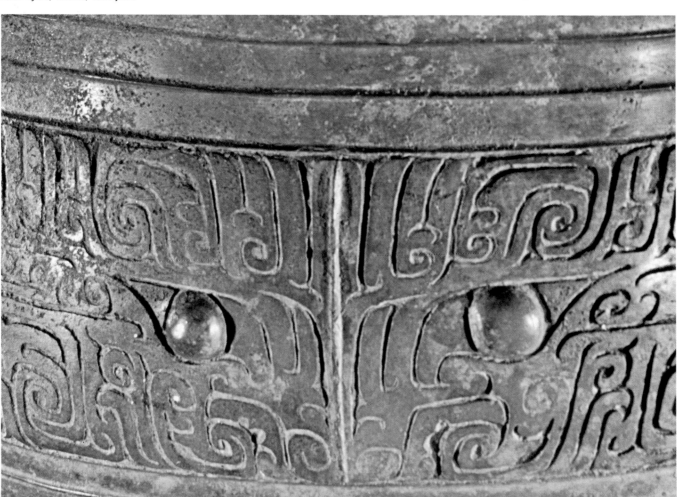

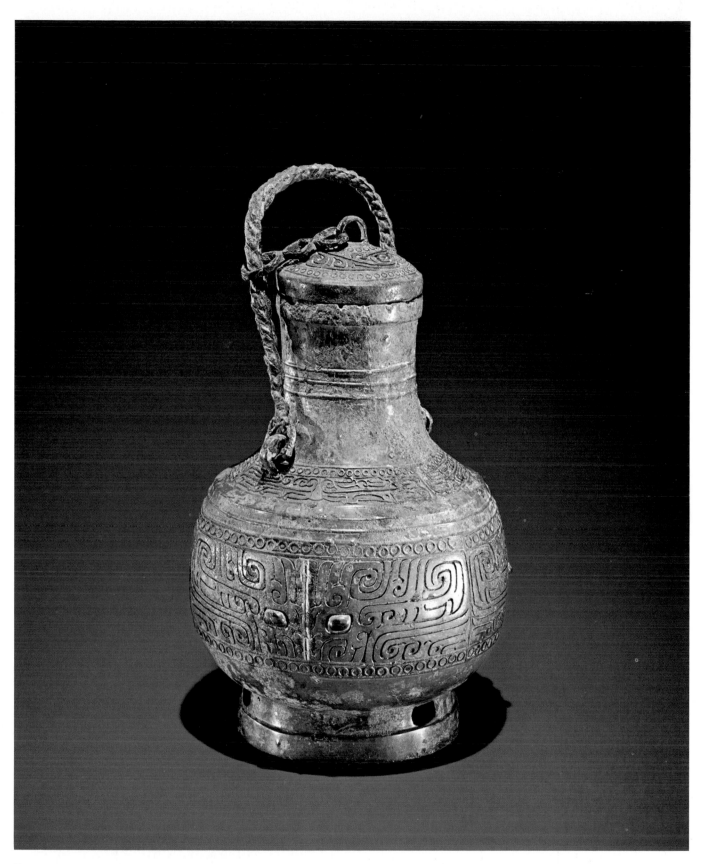

9 Like no. 8, this wine vessel is the first known of its type.
Linking the handle to both the lid and the body would have
involved four separate bronze-casting operations.

10 This extraordinary blade—over three feet long—was
worked with the utmost precision from a single piece of jade.
Based on a bronze halberd that was the characteristic weap-
on of the Chinese Bronze Age, a jade blade such as this must
have been made for ceremonial or mortuary purposes: it was
too large, too fragile, and too expensive for practical use.

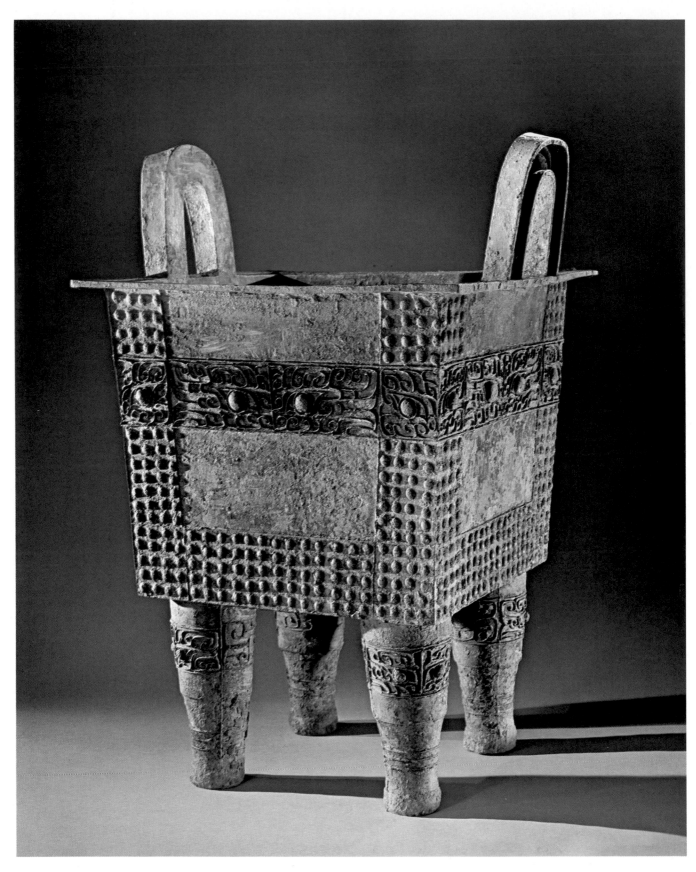

11 One of the earliest examples known, this monumental cauldron of
the fifteenth century B.C. is almost forty inches tall. Animal masks
decorate the body and legs: only the eyes are rendered unambiguously,
though the creature's horns, nose, jaw, and two bodies can be found by a
sufficiently imaginative observer. The elegantly drawn eye is one of the
most pervasive and characteristic of Shang design elements.

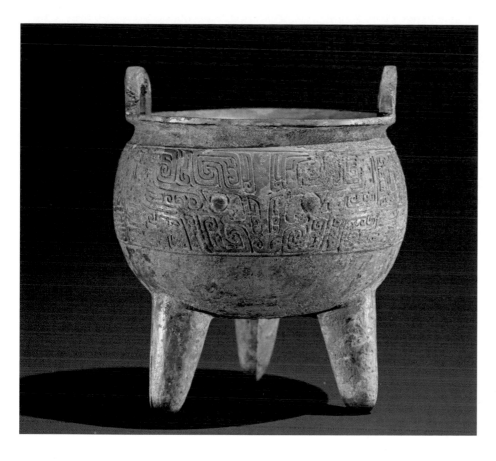

12 This small and engaging vessel was found in an early Shang tomb in the far north of China, testifying to the wide distribution of Shang civilization.

13 The unusual, puffy high relief of the main elements of the decorative mask on the wine bowl below represents a short-lived artistic episode (detail overleaf).

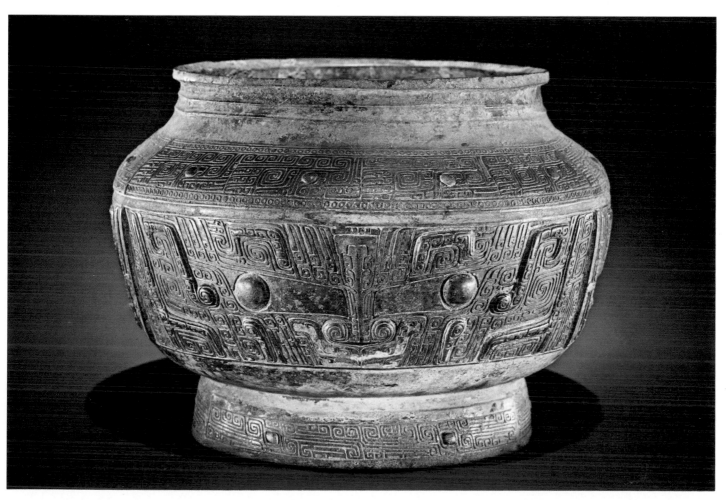

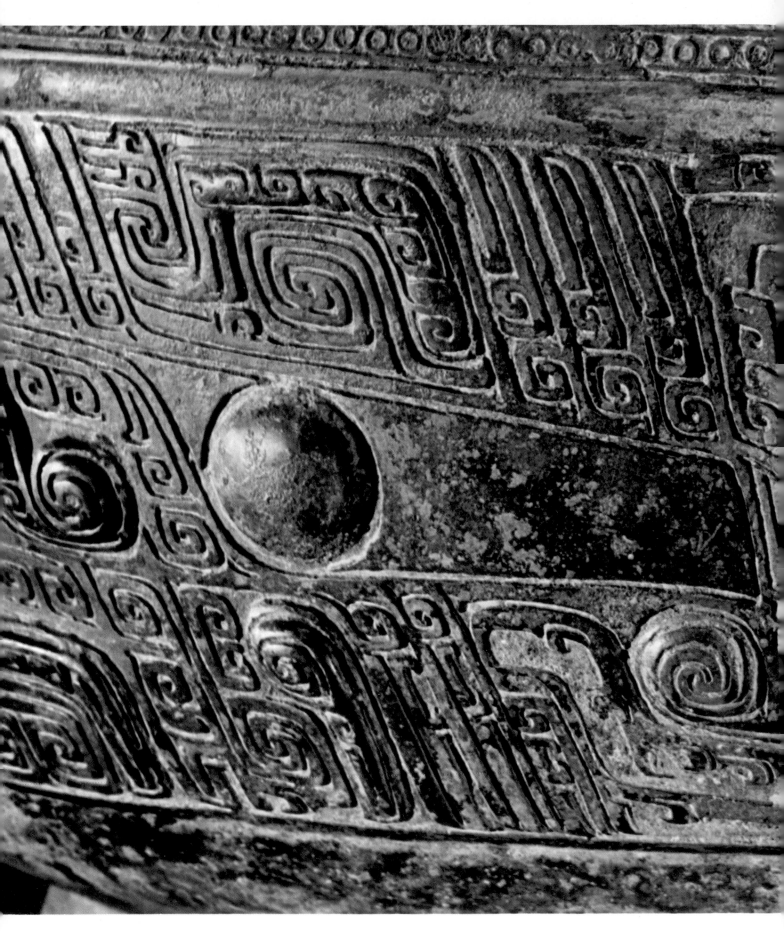

Detail of no. 13.

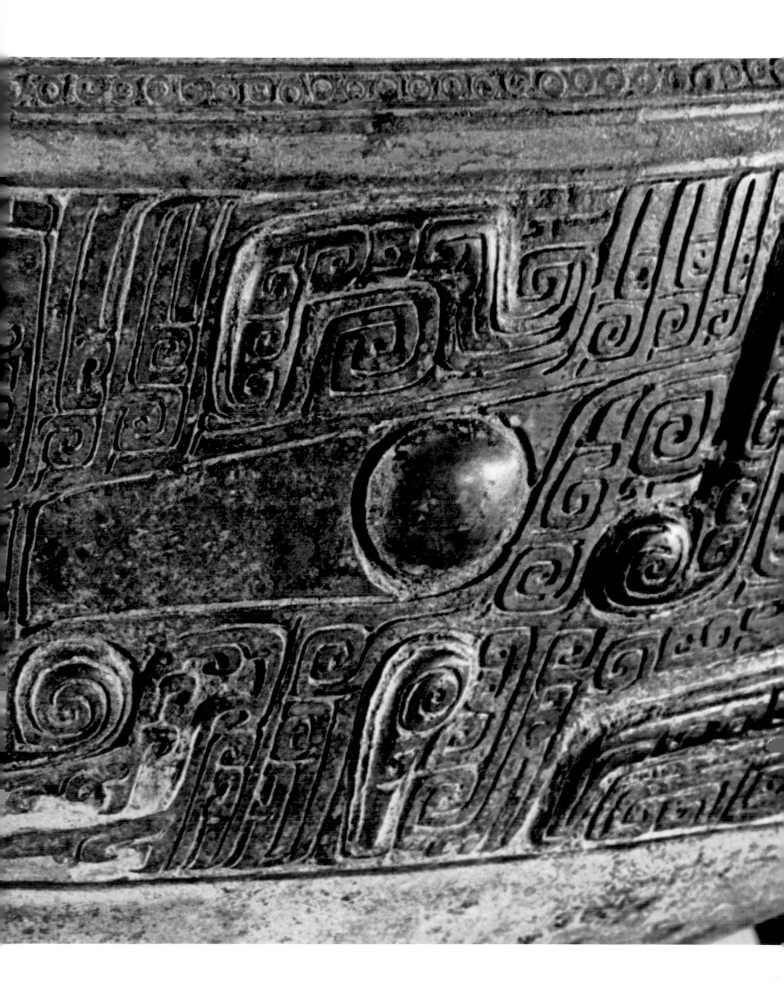

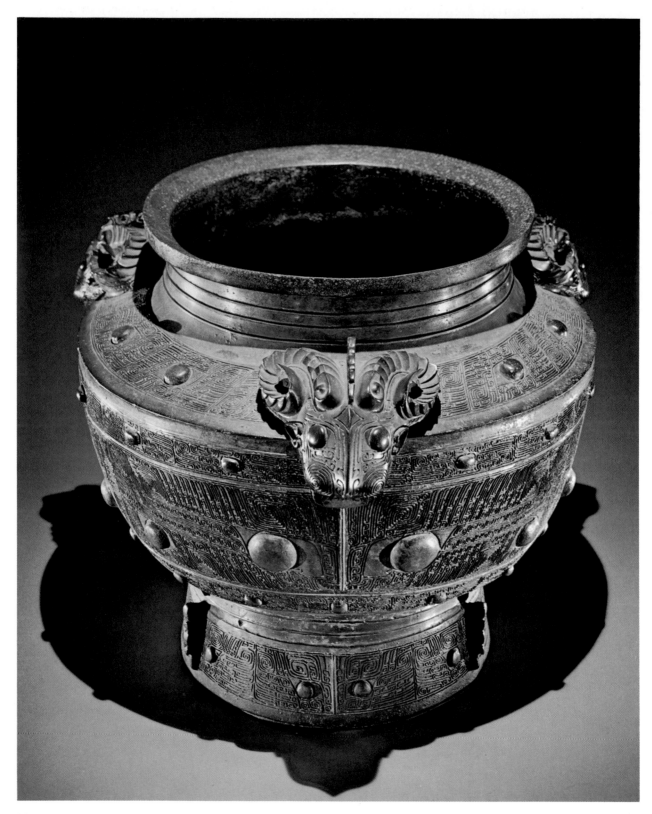

14 The large and boldly sculpted rams' heads were cast onto this
magnificent vessel after the body was made, and contrast with the
densely patterned surface designs. All sense of animal masks in the
surface decoration has been obscured by the infinite elaboration of linear
details, except for the prominent, protruding eyes. It is the syncopated
arrangement of these eyes, varying in size and placement in the different
friezes, that leads to the somewhat uncanny expression of the vessel.

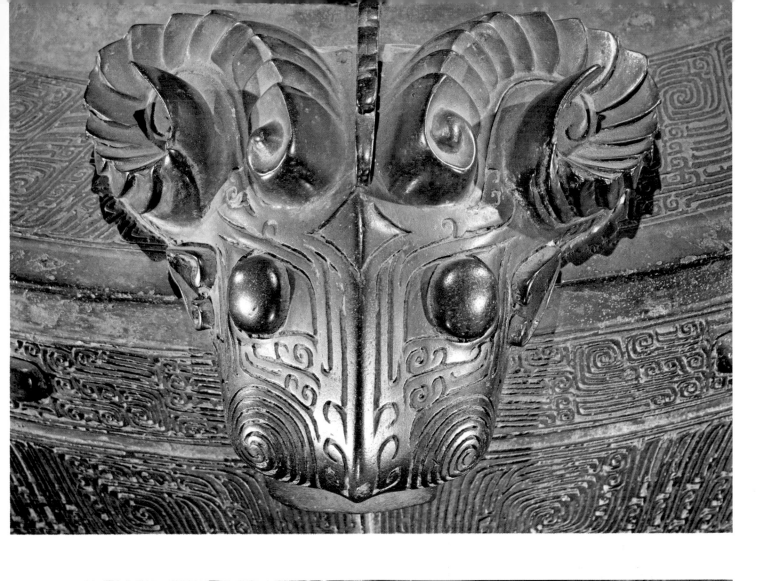

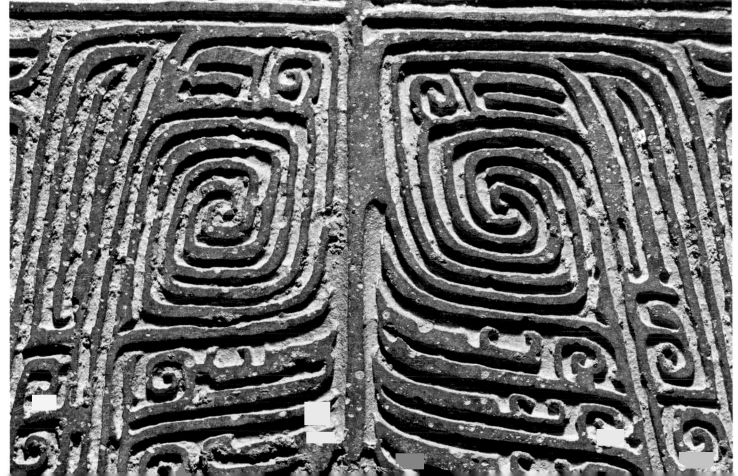

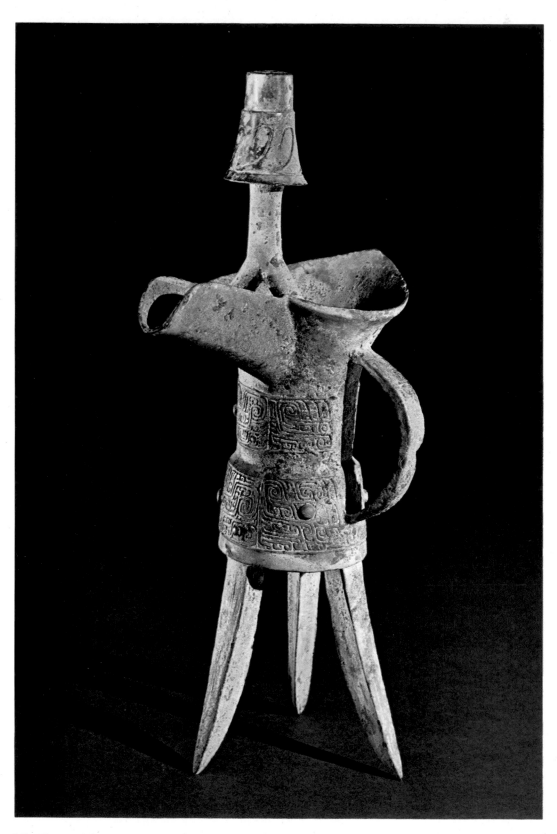

15 The decisive proportions and massive features of this wine cup demonstrate the foundryman's complete mastery of his art during the time that separates this piece from the earlier example shown as no. 1. The almost monumental capped post over the spout may have been used to lift the vessel from the fire.

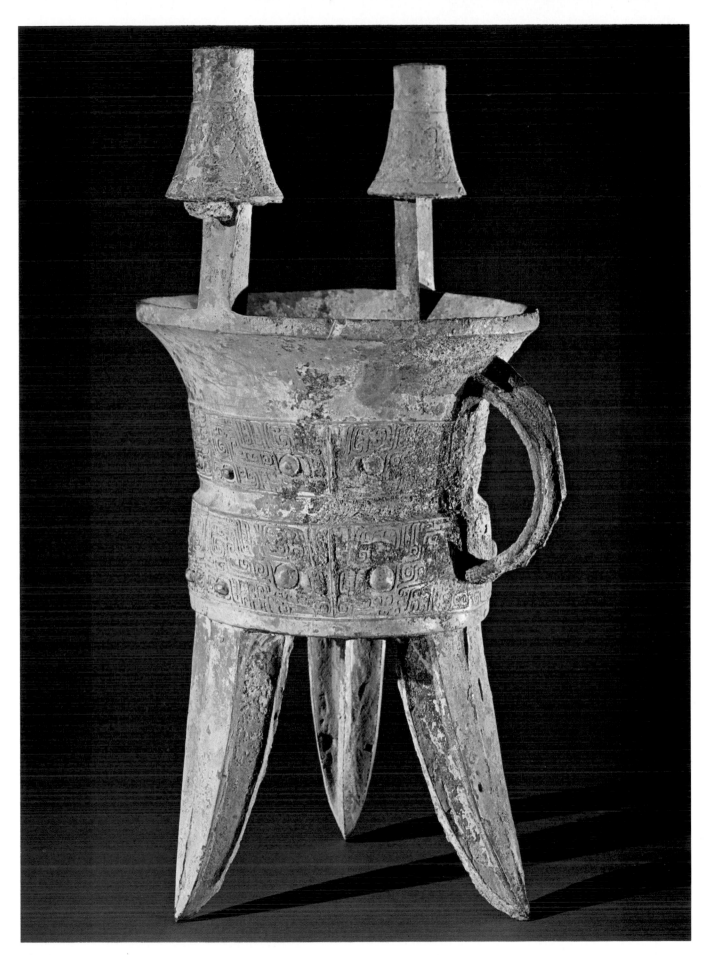

16 This bronze and no. 15 were part of a matched
set. The pairing of these two types of vessels,
both used for offerings of wine, was common in the Shang
period; in burial, no. 15 was placed inside this vessel.

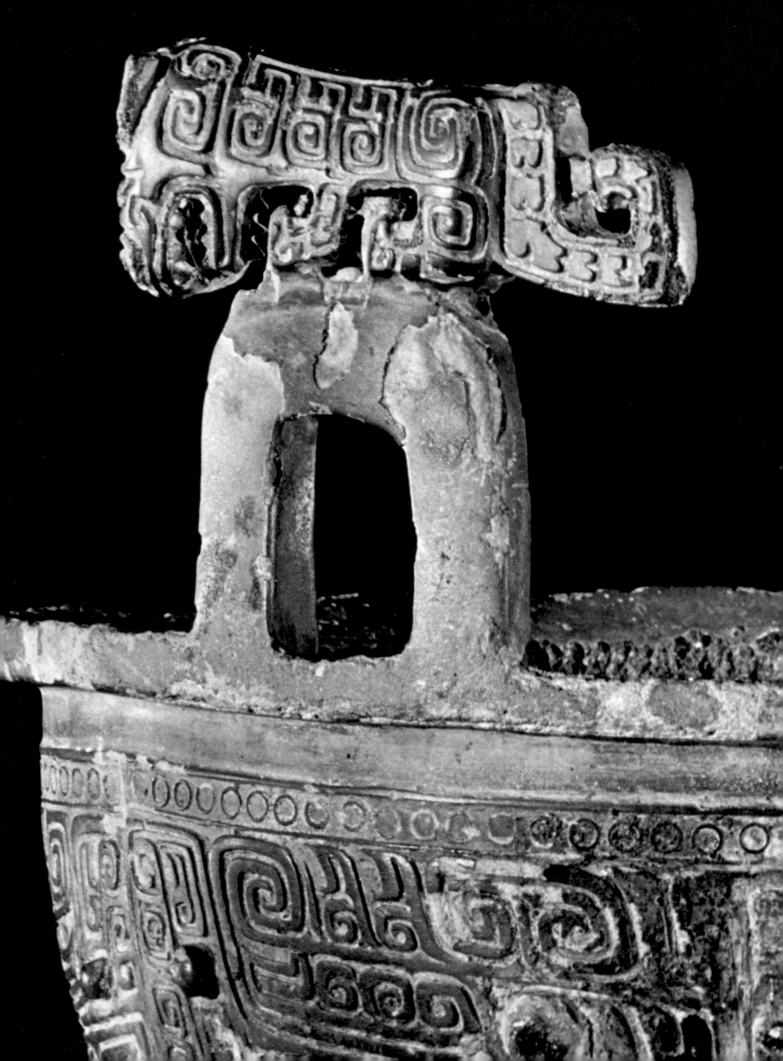

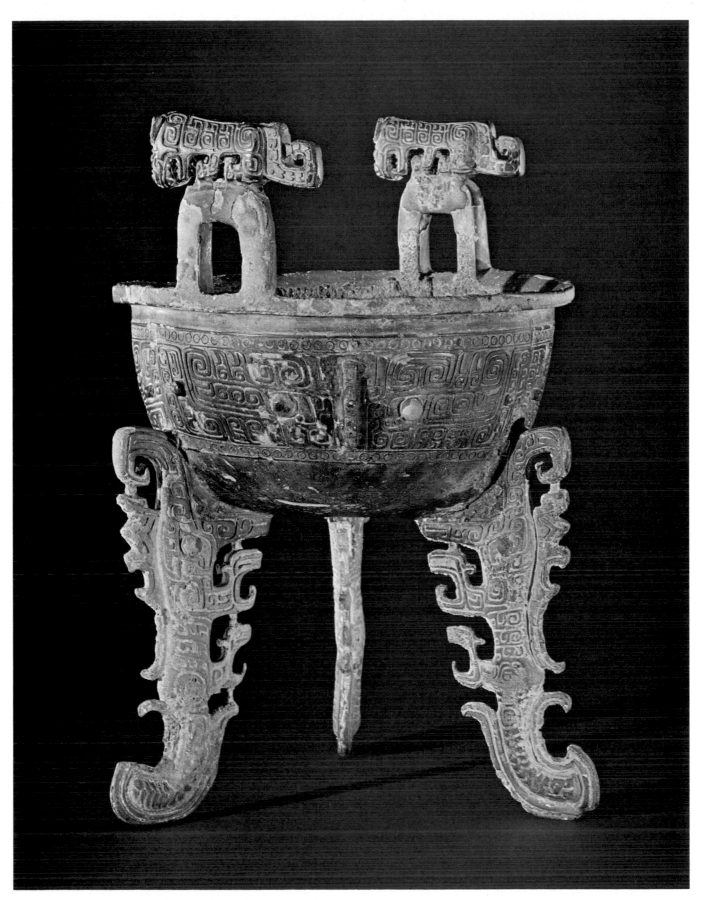

17 This is a distinctly provincial version of a fairly standard
type. The flat legs were precast, while the tigers at the top of
the handles were cast on.

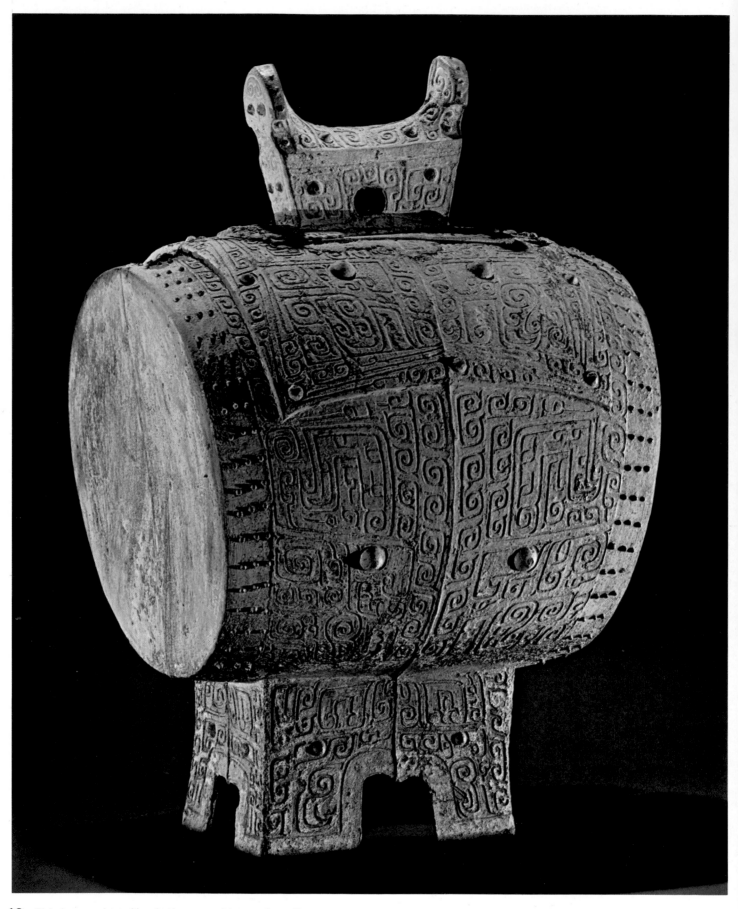

18 This bronze drum is only the second known from the
Shang dynasty. Like the bell at the right, it is embellished with
a key feature of bronzes from the south: a sparse network of
uniformly spaced sunken lines—all that is left of the Shang
animal mask.

19 Thirty-five inches tall and weighing
more than 338 pounds, this clapperless
bell was struck rather than rung. Its deco-
ration is dominated by an extraordinary
rendering of the animal-mask motif, one
known only from bells of southern type.

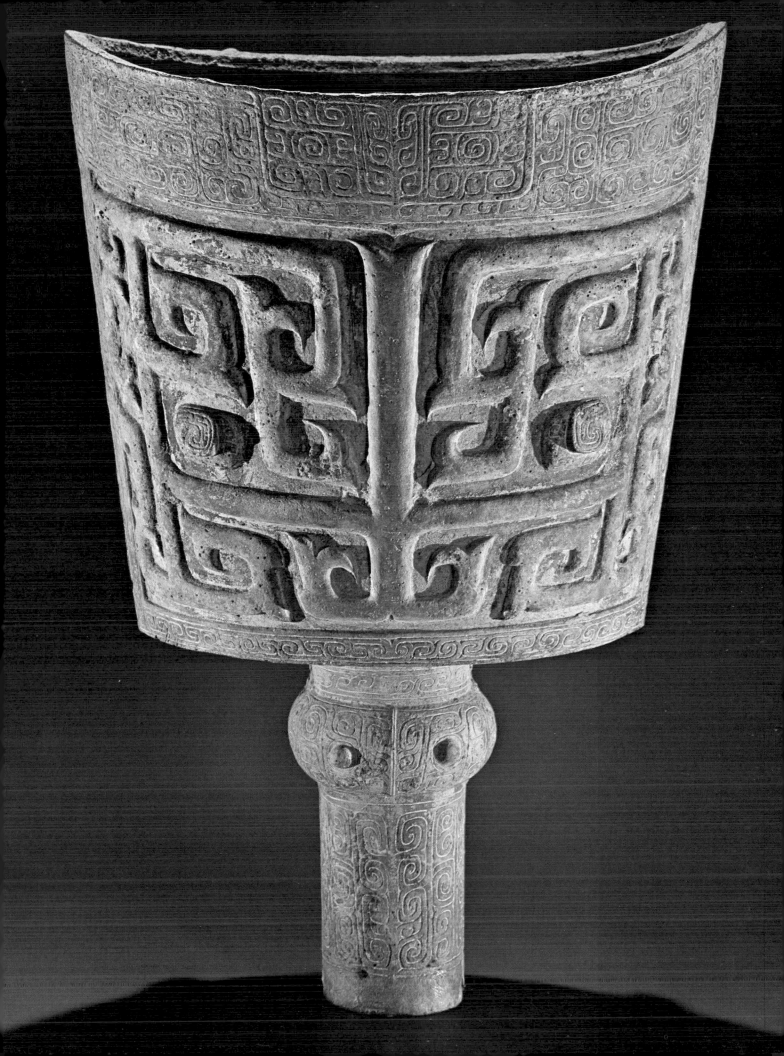

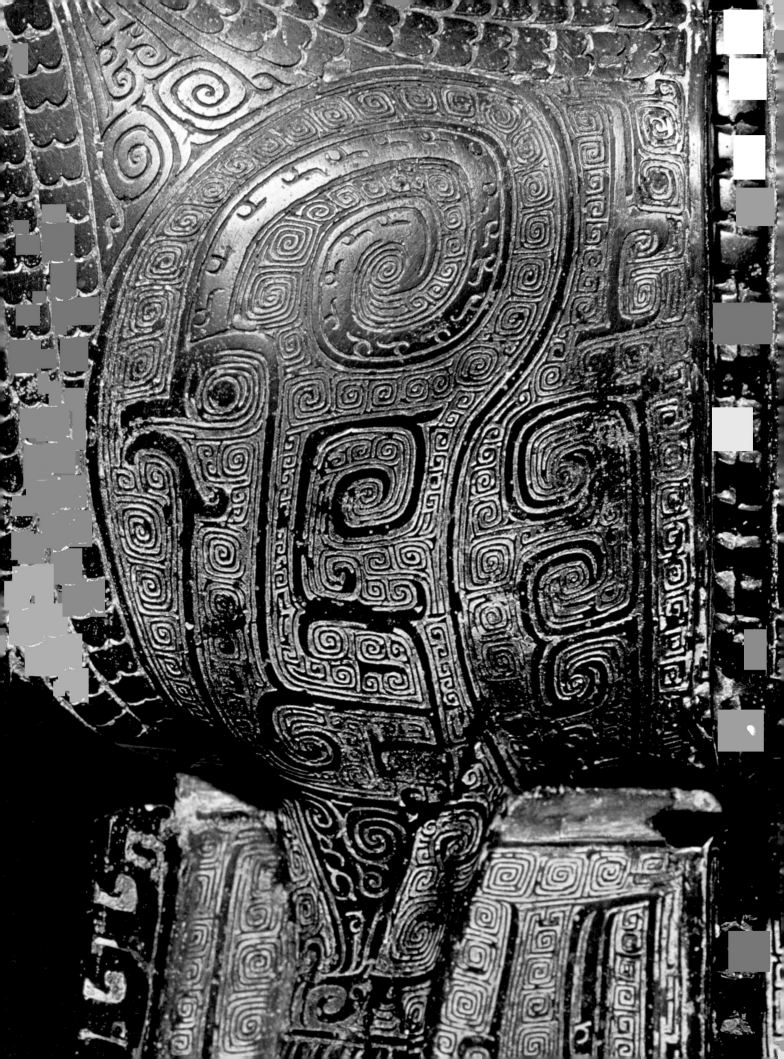

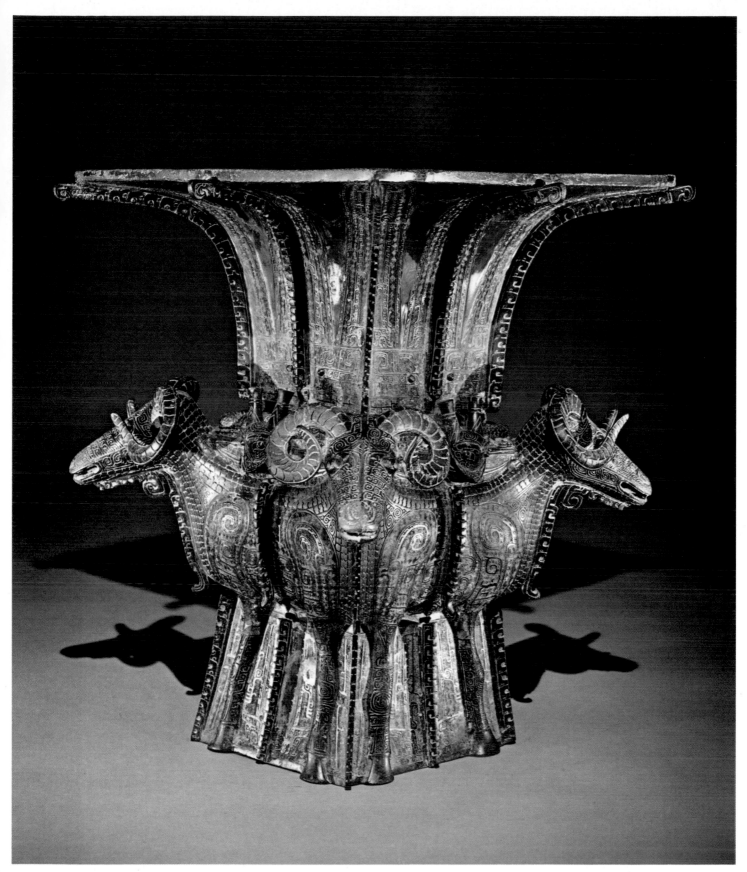

20 Whether considered as a feat of the bronze worker's artistic imagination or as a tour de force of casting, this unique vessel is equally astonishing. Meticulously observed realistic details are combined with imaginary ones: four horned dragons lie coiled around the shoulder of the vessel above the smoothly modeled rams (detail overleaf), whose bodies are decorated with a new and attractive motif of tall crested birds (detail opposite).

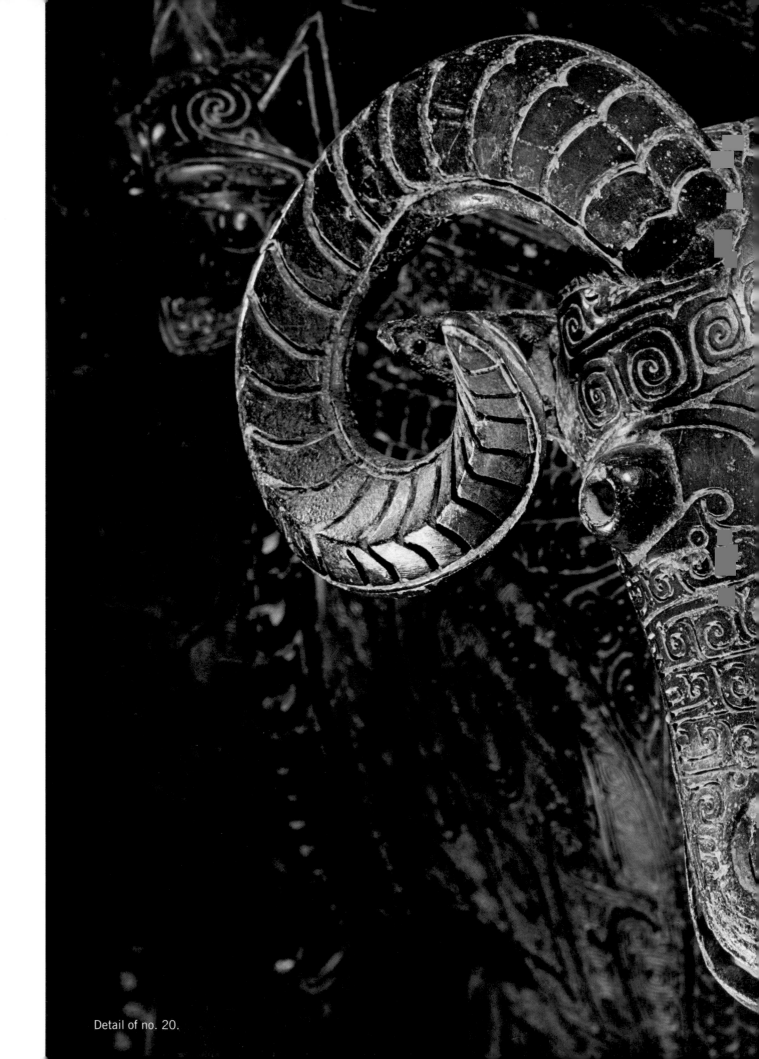

Detail of no. 20.

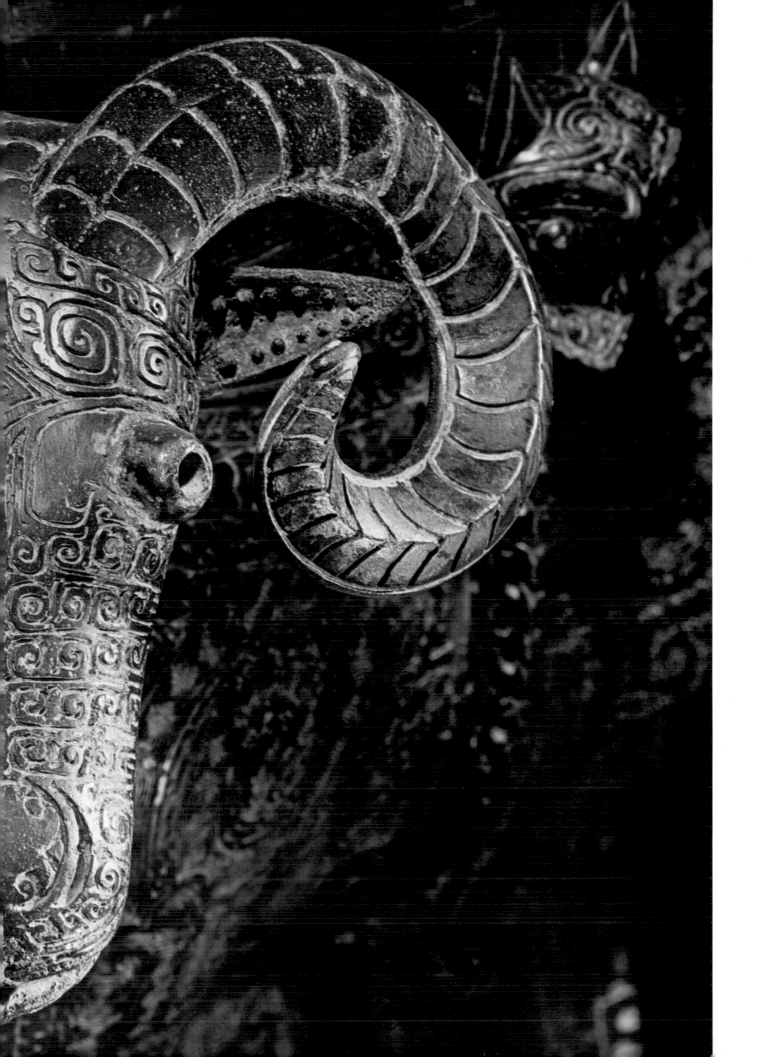

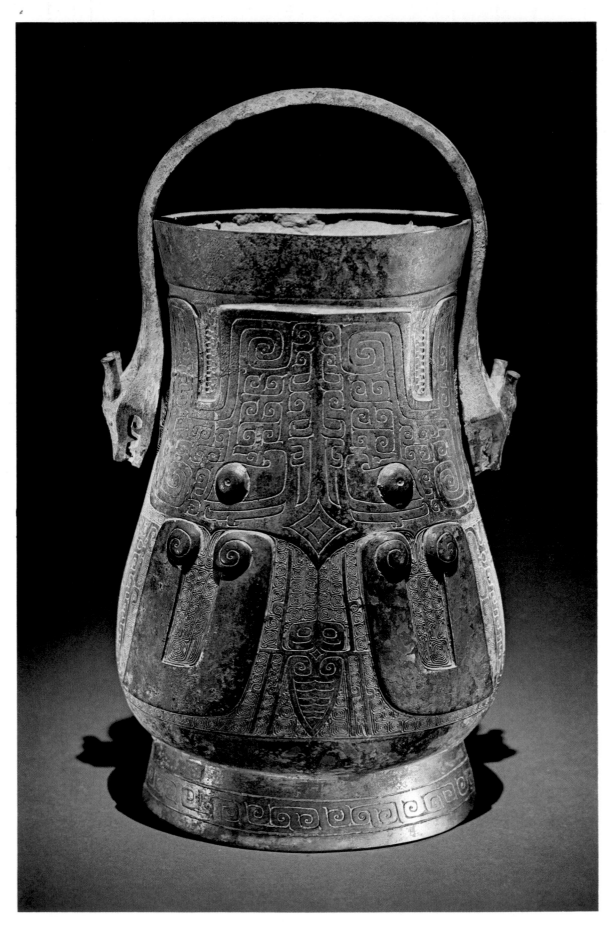

21 From a district in the northwest that has yielded a variety of unusual bronzes, the wine jar above is eccentric in decoration: each side is covered not with horizontal friezes but by a single animal mask turned upside down, as if its mouth were the mouth of the vessel itself. A cicada lurks below, between the horns of the mask.

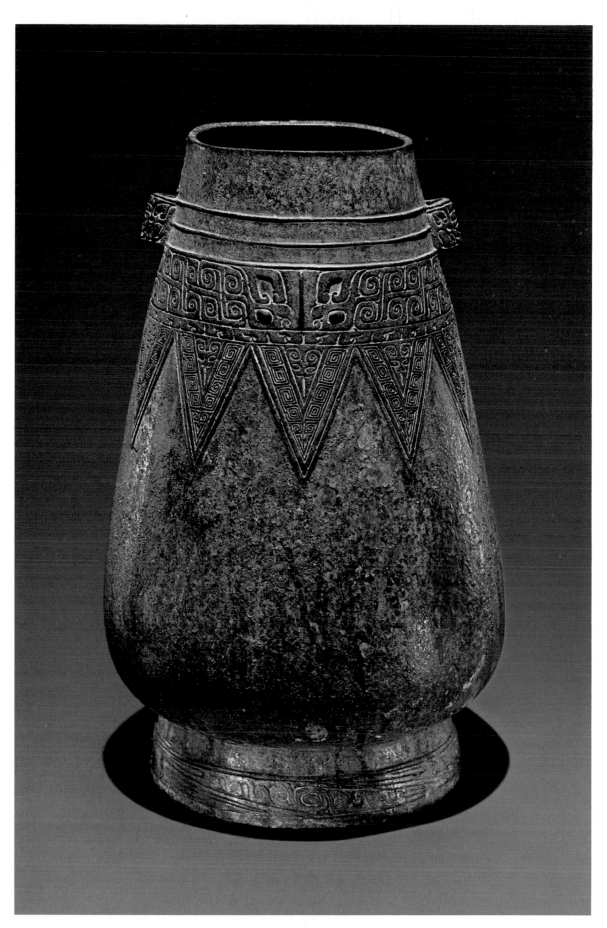

22 Also from the northwest, vases of this tapered shape are
rare, quite distinct from the more usual type like the one shown
at left, with S-curved profile and oval cross section.

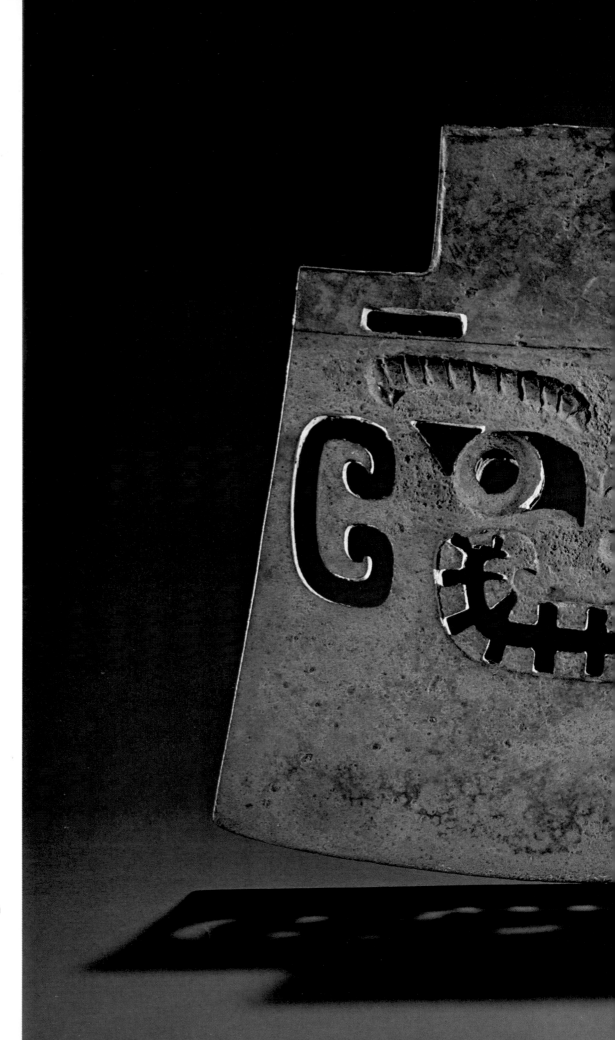

23 This ax was
made near the end
of the Shang period.
Of an almost barbaric
vigor, it was found
in a tomb together with
forty-eight decapitated
sacrificial victims.

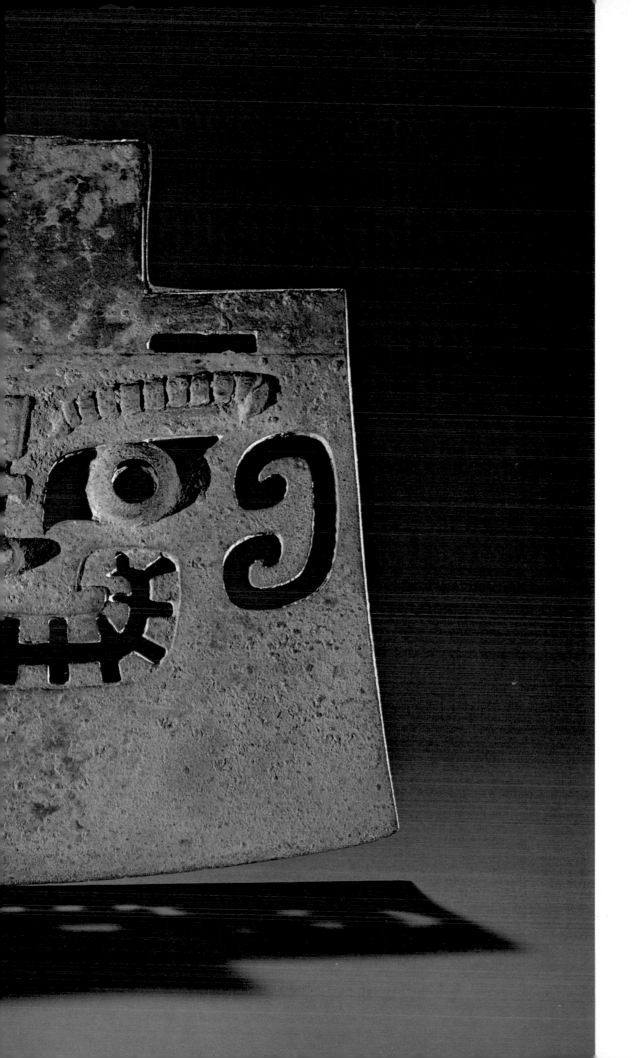

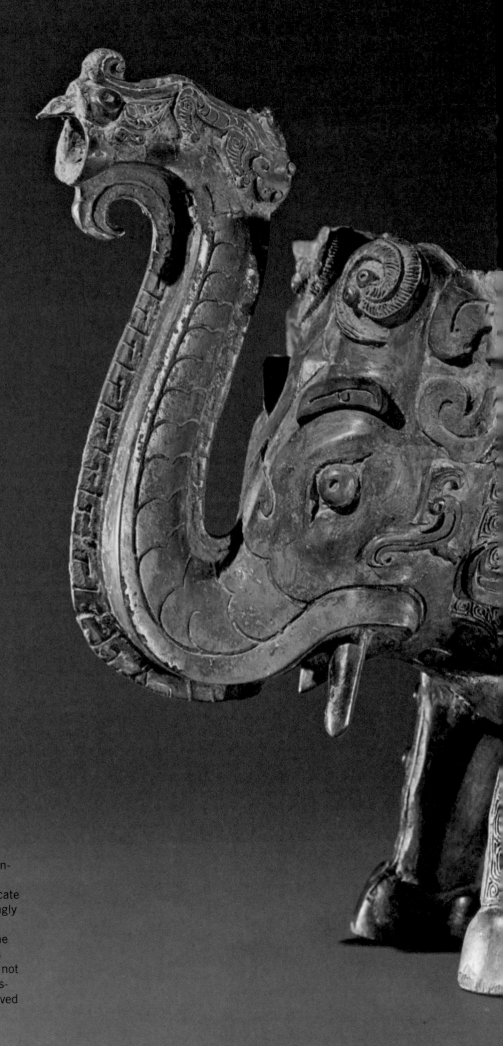

24 The surfaces of this small elephant-shaped container are crowded with ornament, sharp and delicate in execution and exceedingly forceful in design. It is a tribute to the artistry of the Shang craftsman that this wealth of decoration does not disguise the engaging presence of this vividly conceived creature.

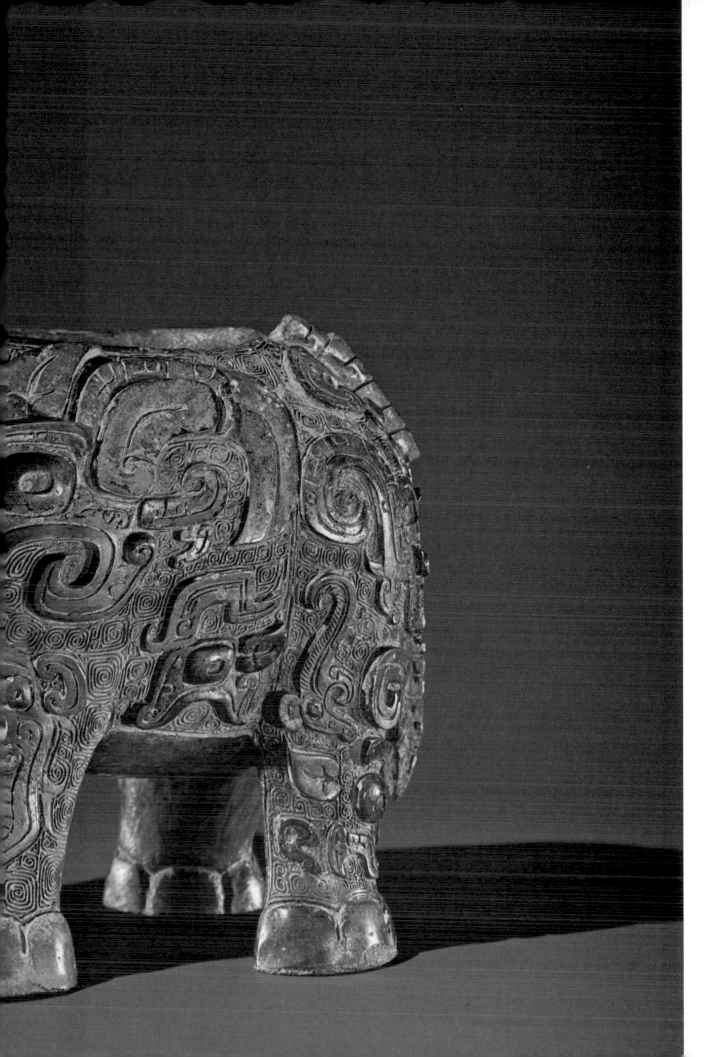

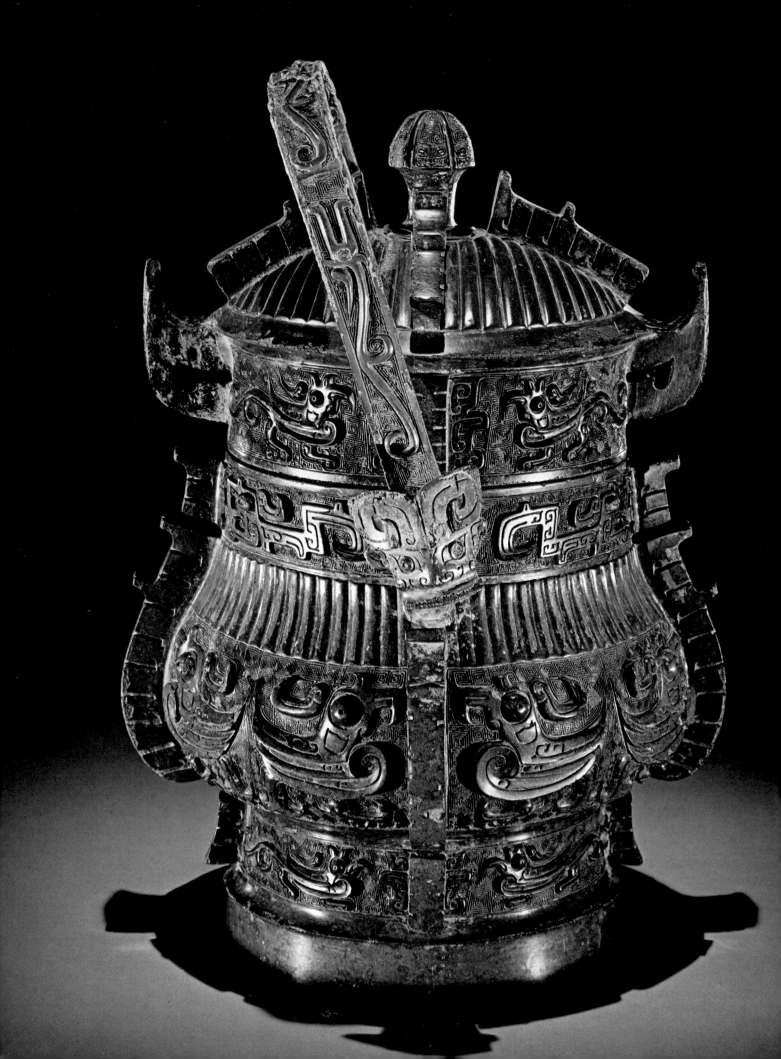

25 The arresting silhouette and bold ornament emphasize the important ritual function of this imposing wine bucket. The surface has a rich luster sometimes described as water patina, which depends on a high proportion of tin in the alloy; the much brighter green of the handle suggests it was cast from another batch of metal.

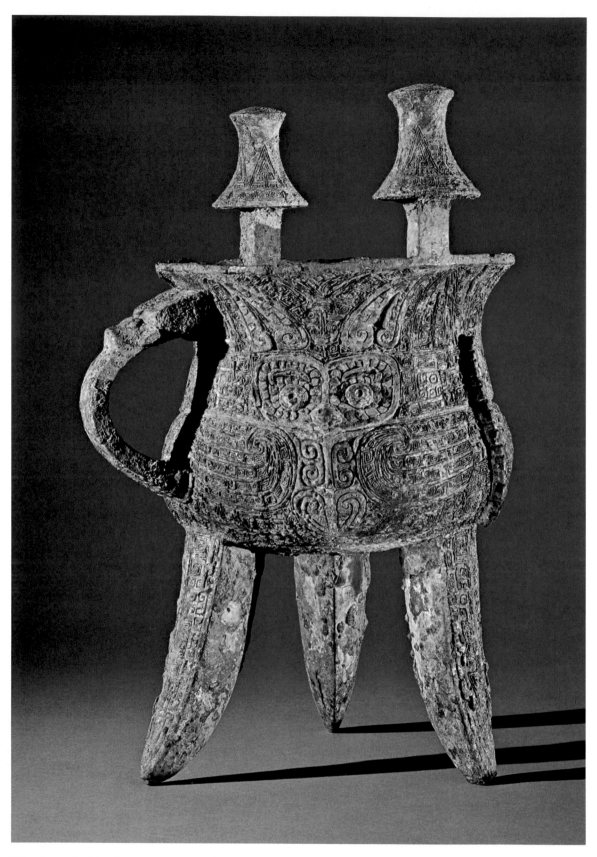

26 On each side of the three-legged vessel above, owls replace the more usual animal-mask motif and spread over the full height of the body.

27 The magnificent vessel at the right, to- ▷ gether with no. 25, belongs to a classic moment in the history of the bronze art and represents a level of achievement never surpassed. Elegantly modeled motifs are disposed against the sharply cast spiral background, and the intricate detailing is controlled by the careful spacing, proportion, and arrangement of each element.

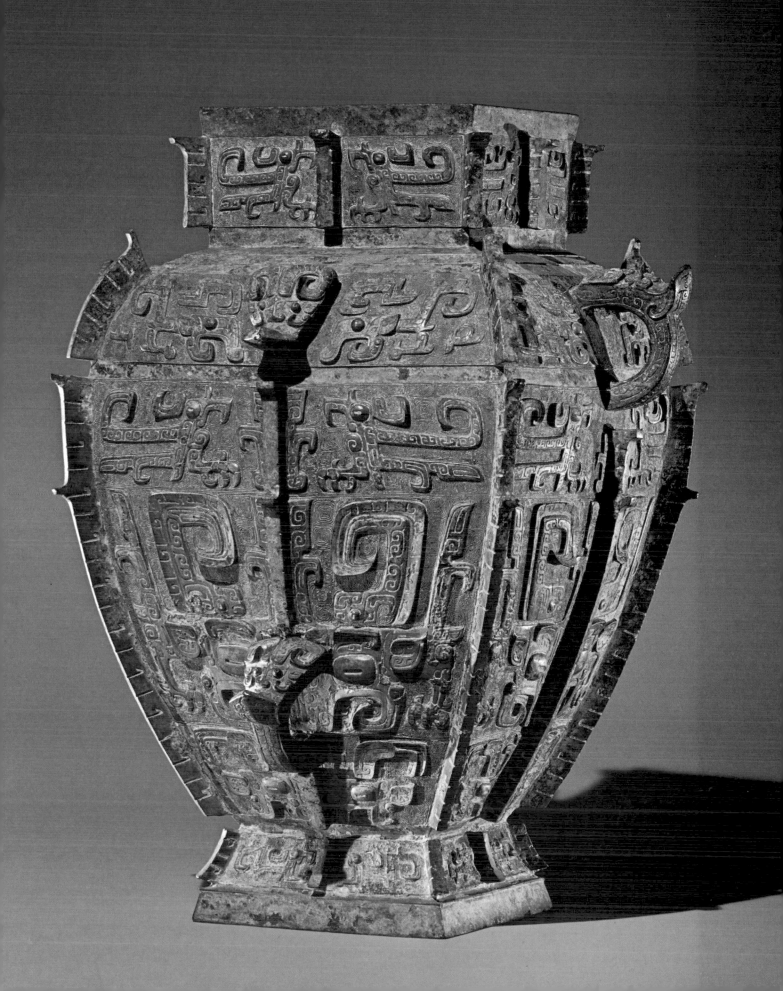

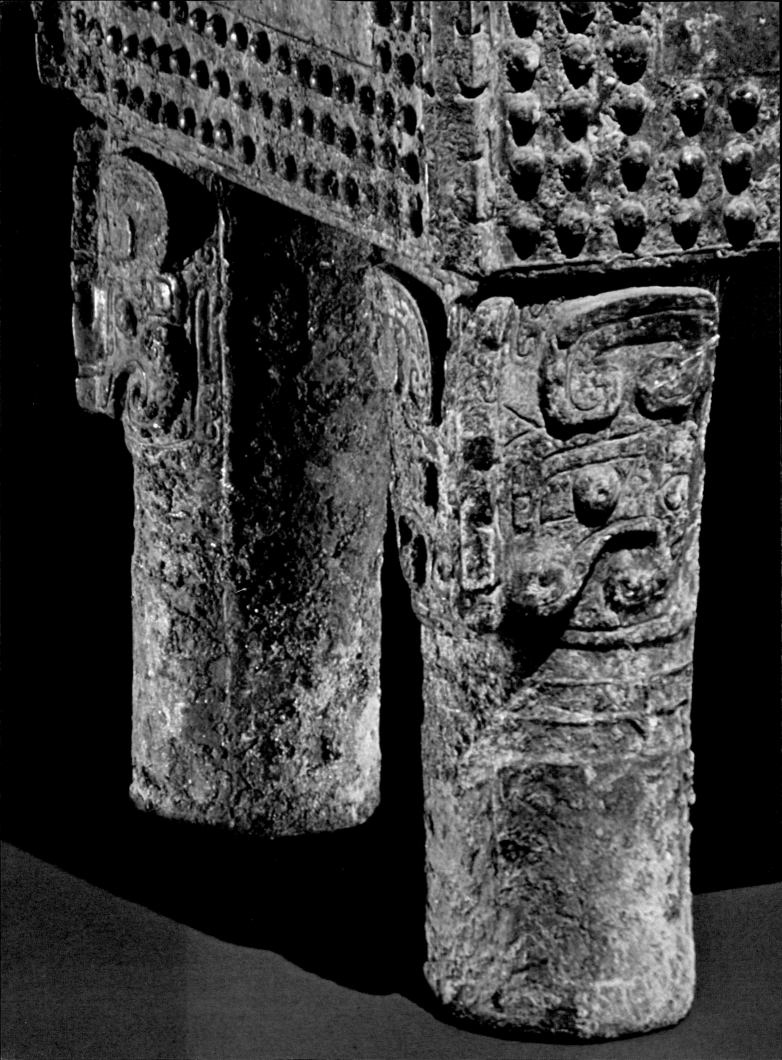

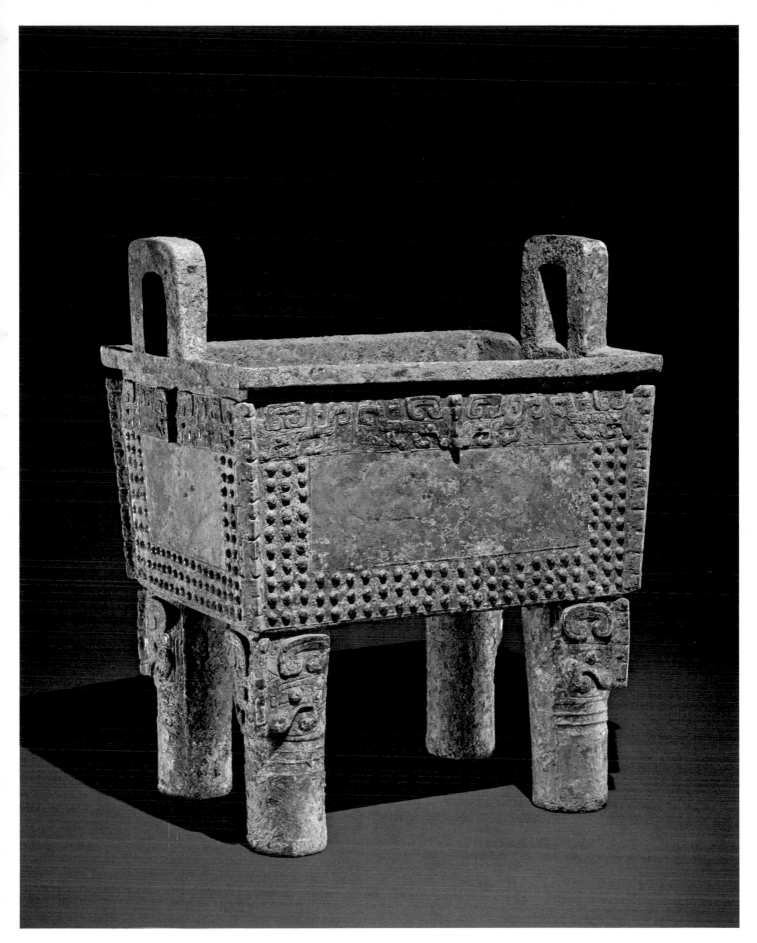

28 Clear and unambiguous relief gives the ornamentation of
this massive cauldron a new plasticity. Like the following twelve
pieces (nos. 29-40), it comes from the recently discovered tomb
of Fu Hao, a royal consort and lady-commander.

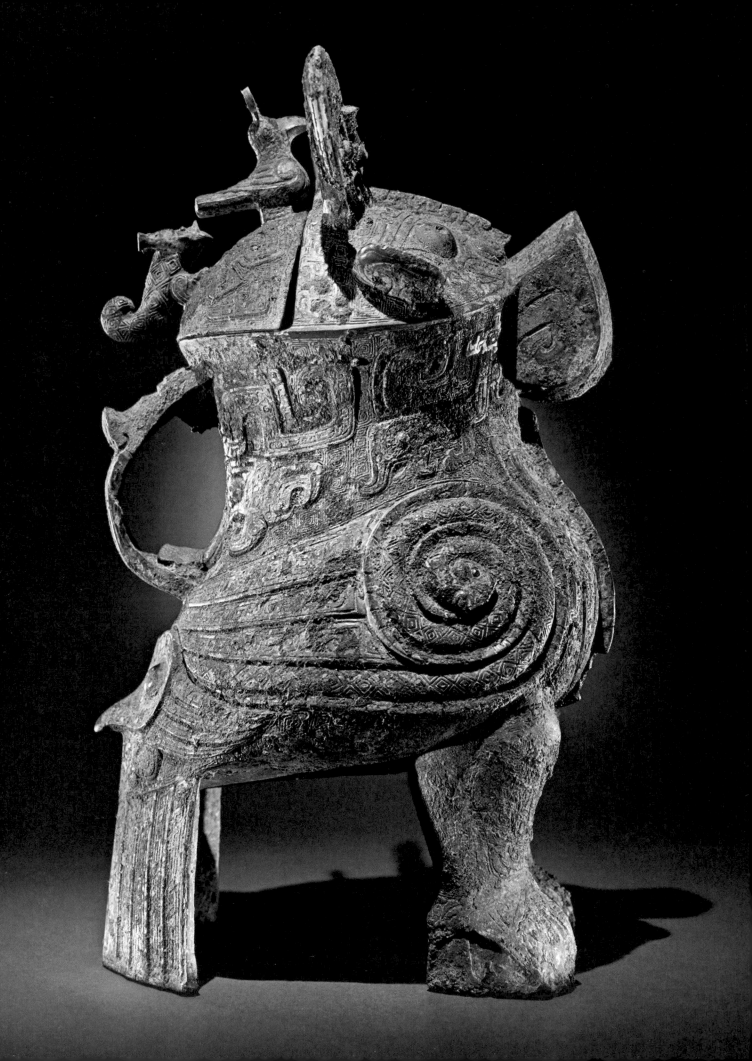

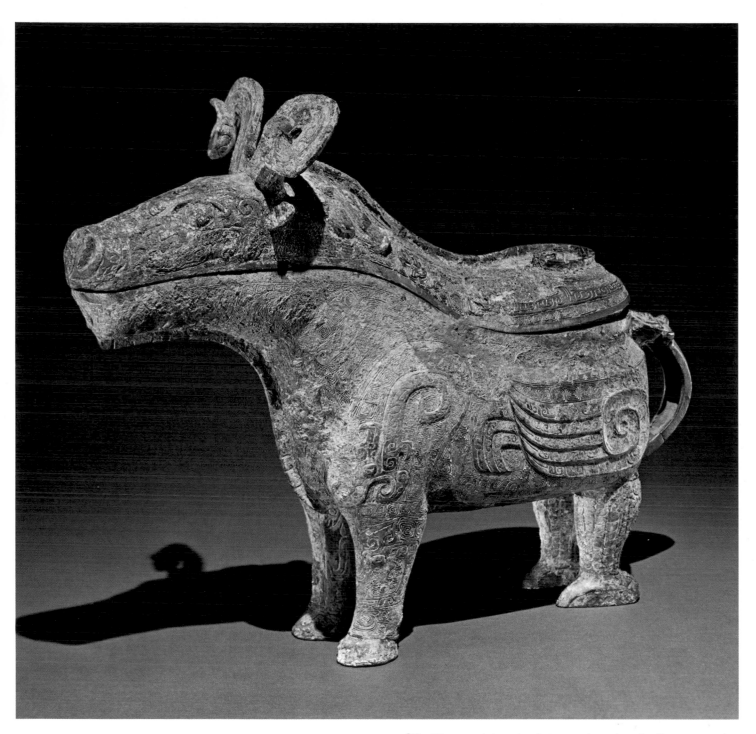

30 The ungainly animal shown above is actually a composite. The front half is shaped like a ram, while the feathered hind legs face backward and belong to an owl.

29 Its bristling silhouette enhances the baroque energy of the bird-shaped wine vessel at the left, while its decoration is an extravagant compound of abstract patterning and animal motifs.

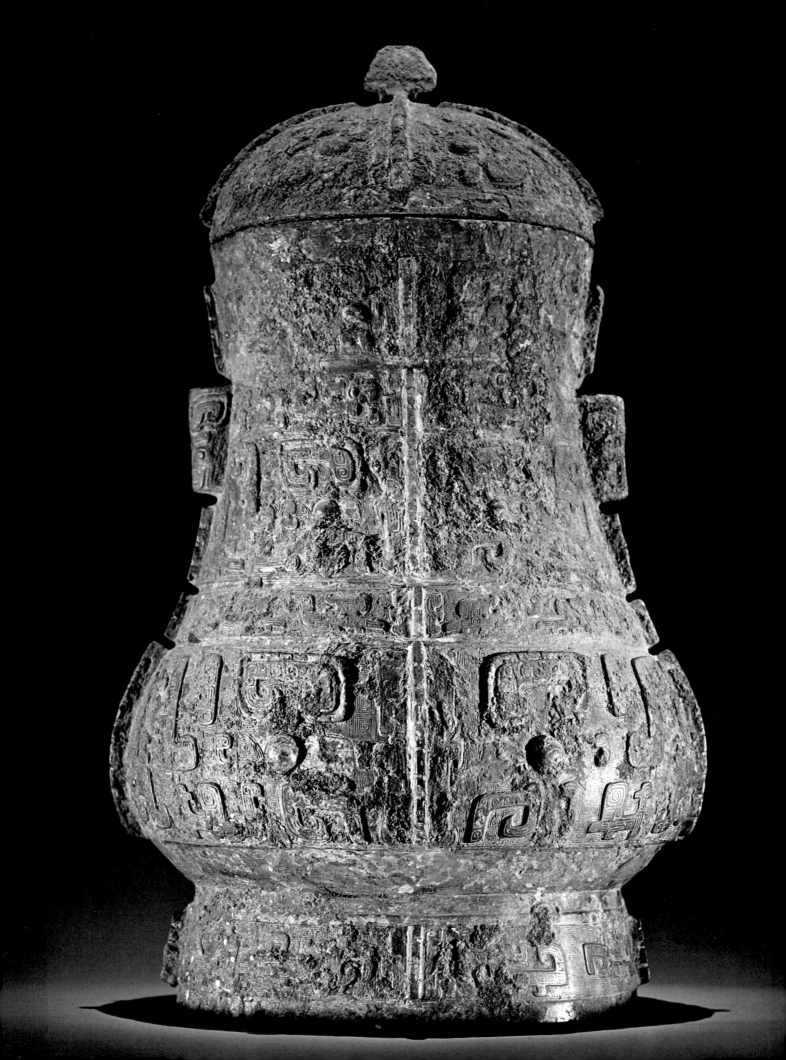

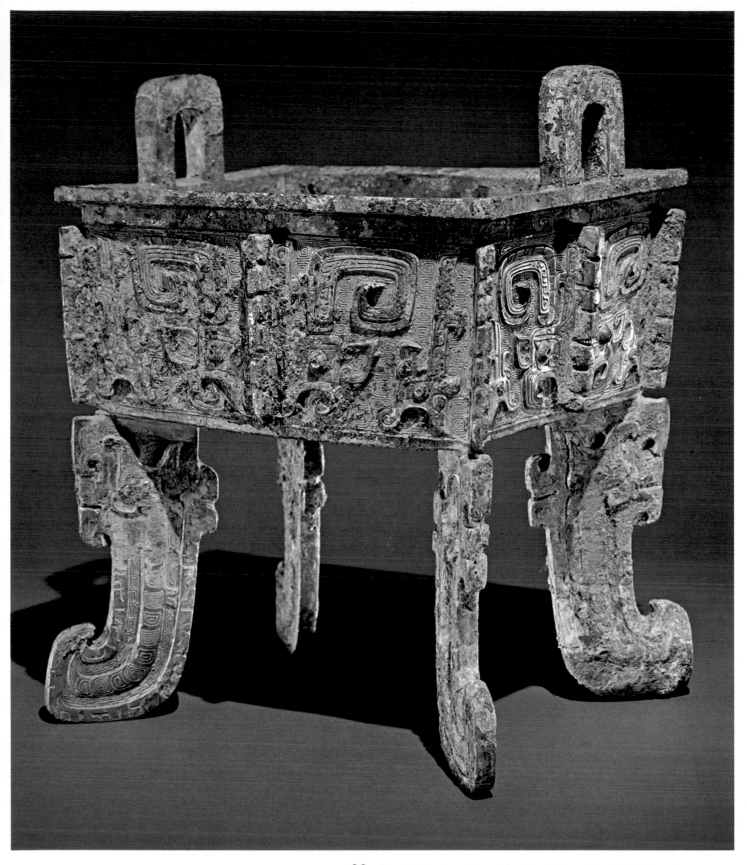

32 The finely proportioned food container illustrated above is an
impressive balance of opposing forces. The rectilinear body is supported
by dragon-shaped legs, which confront similar downward-facing dragons
that in turn flank large frontal masks (detail overleaf).

31 The flattened body of the large vase
at the left emphasizes a single frontal
vantage point for its decoration, unfor-
tunately much obscured by soft gray and
green corrosion.

Overleaf: Detail of no. 32. ▷

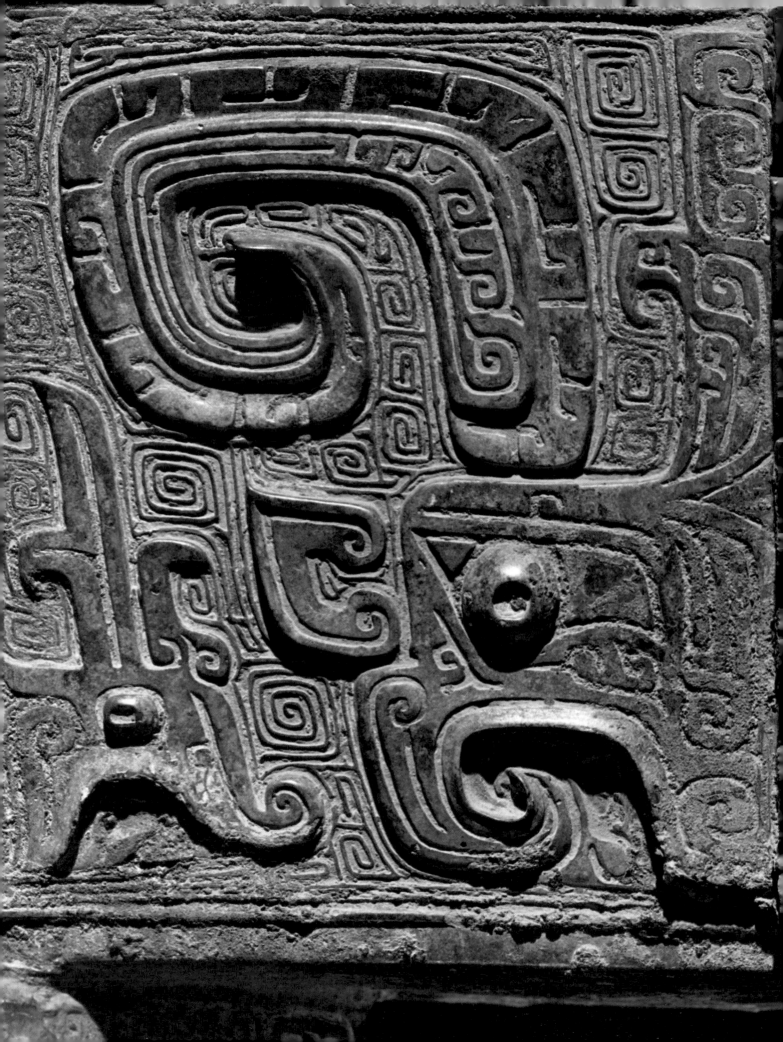

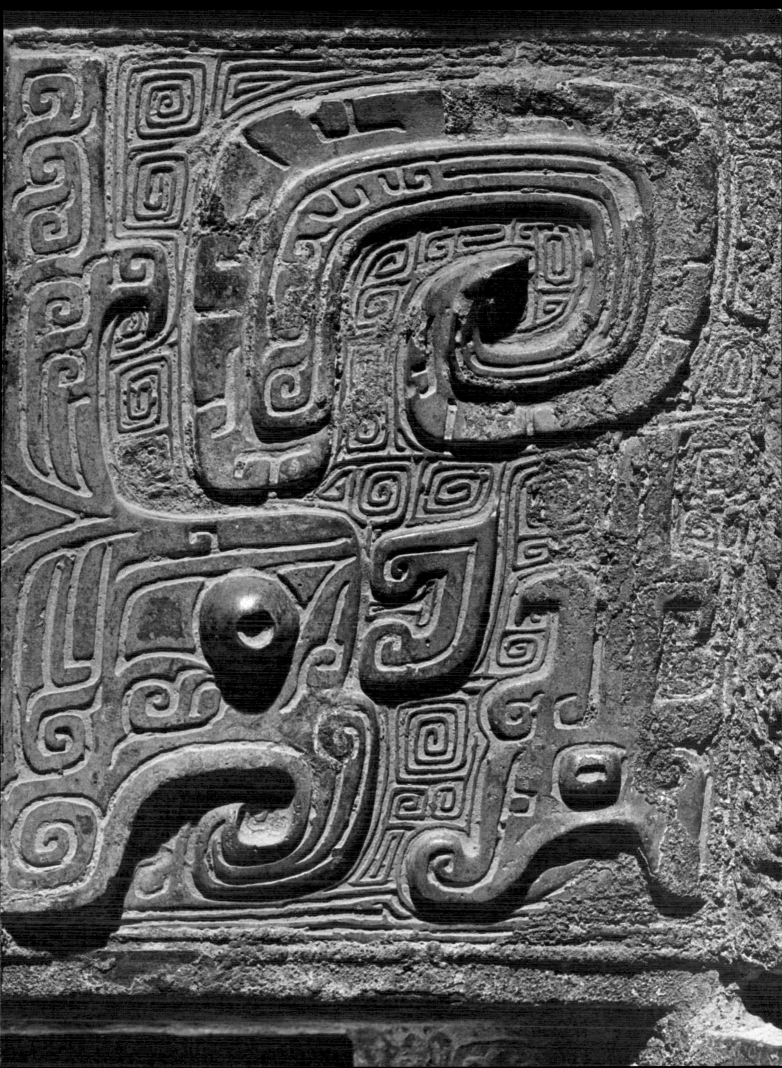

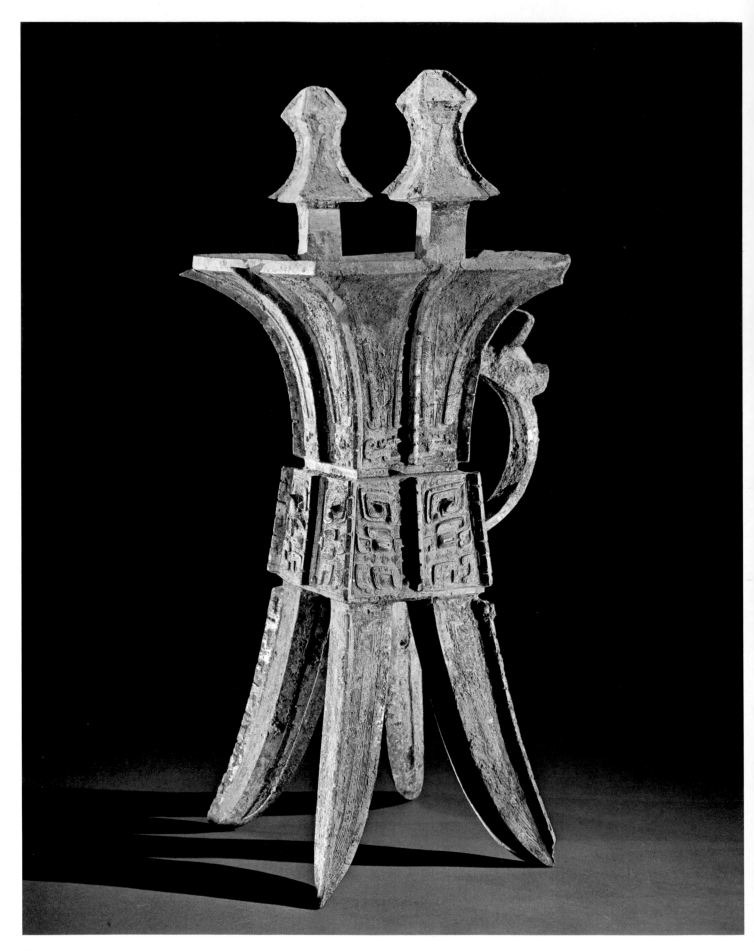

33 Over two feet tall, this dynamic wine vessel draws
on a vocabulary of forms proper to architecture
to achieve a convincing monumentality.

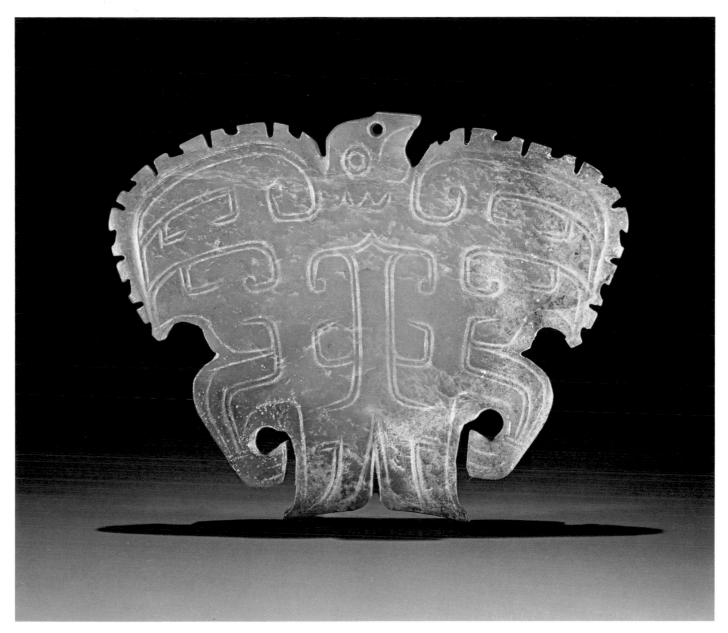

34 The jade pendant above, in the form of a hawk with out-
stretched wings, is less than three inches high. The uniformity
of the surface patterns suggests that pure ornament had a
firmer hold on the Shang artist's imagination than the problems
of imitating nature.

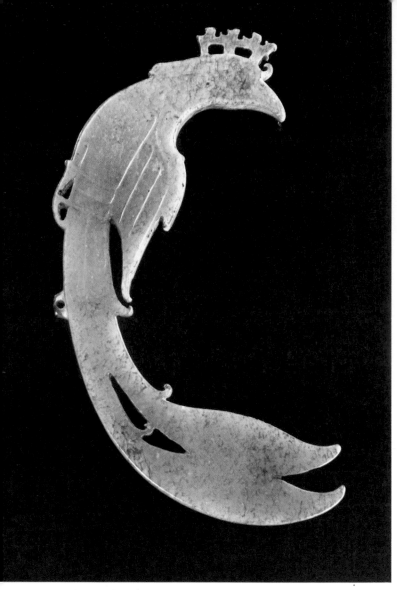

35 Possibly made in South China, this crested bird is unique in its bold, asymmetrically curved outline, openwork comb, and vividly portrayed plumage. The weight of the tail allows the pendant to be vertically suspended while keeping the head erect.

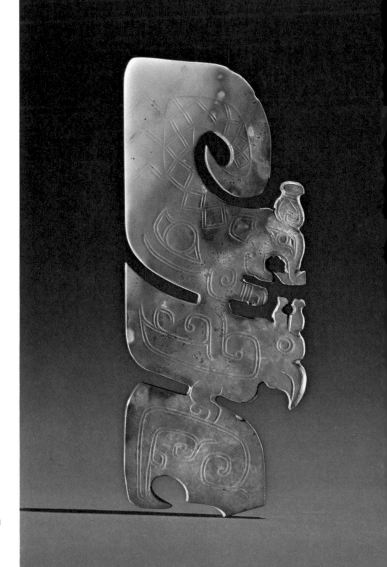

36 The outline of the curious plaque at the right suggests that it was recut from a fragment. Jade was too costly for the smallest piece to be wasted, and the recutting of broken pieces was a regular practice.

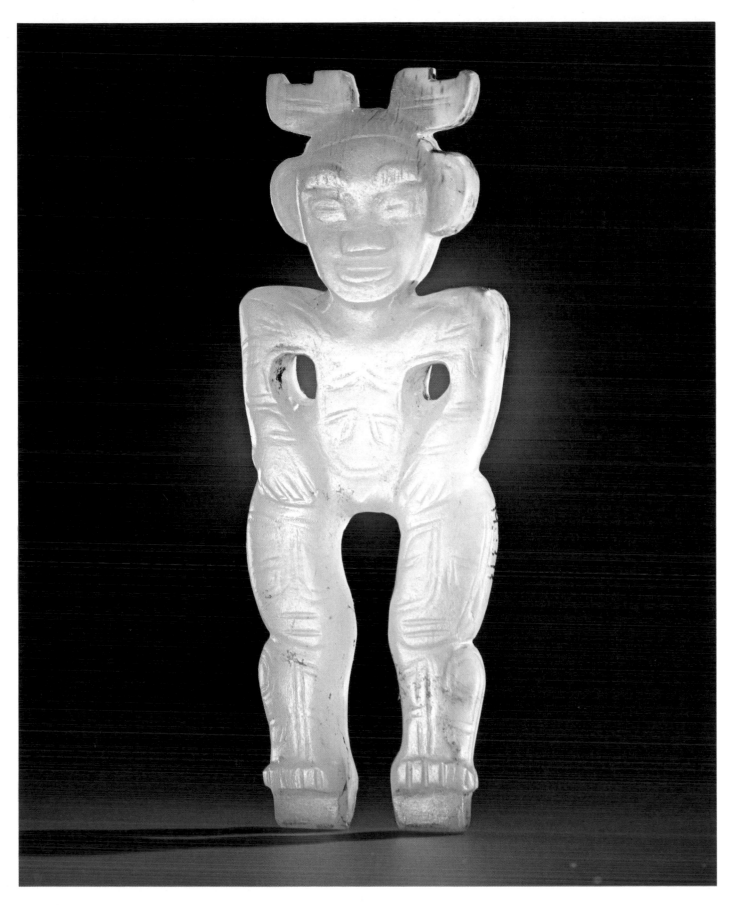

37 This Janus-like jade sculpture shows a crudely modeled human
figure on both sides. One side is female, and it is possible that
the side shown here is meant to be male.

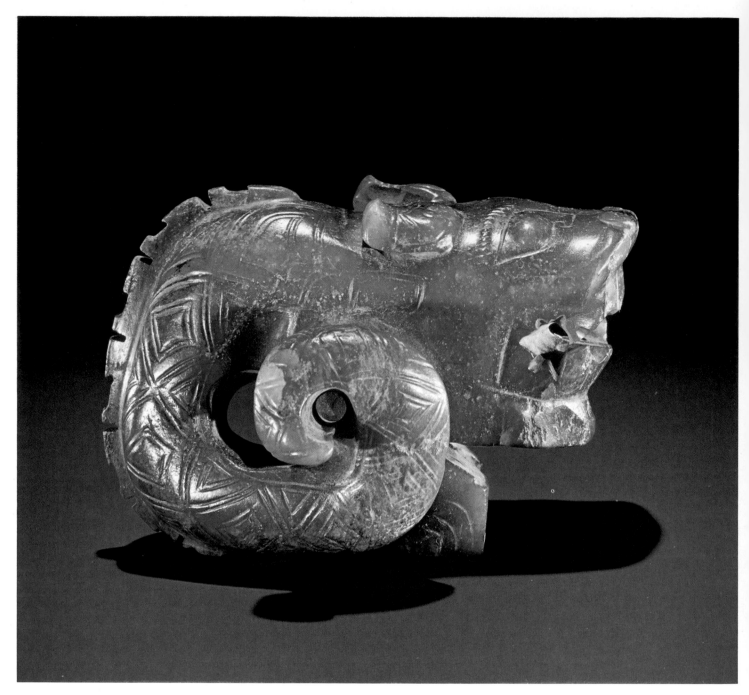

38 The compact figurine illustrated above represents a horned
dragon with massive head and small body, resting its weight on
its forepaws and curled tail.

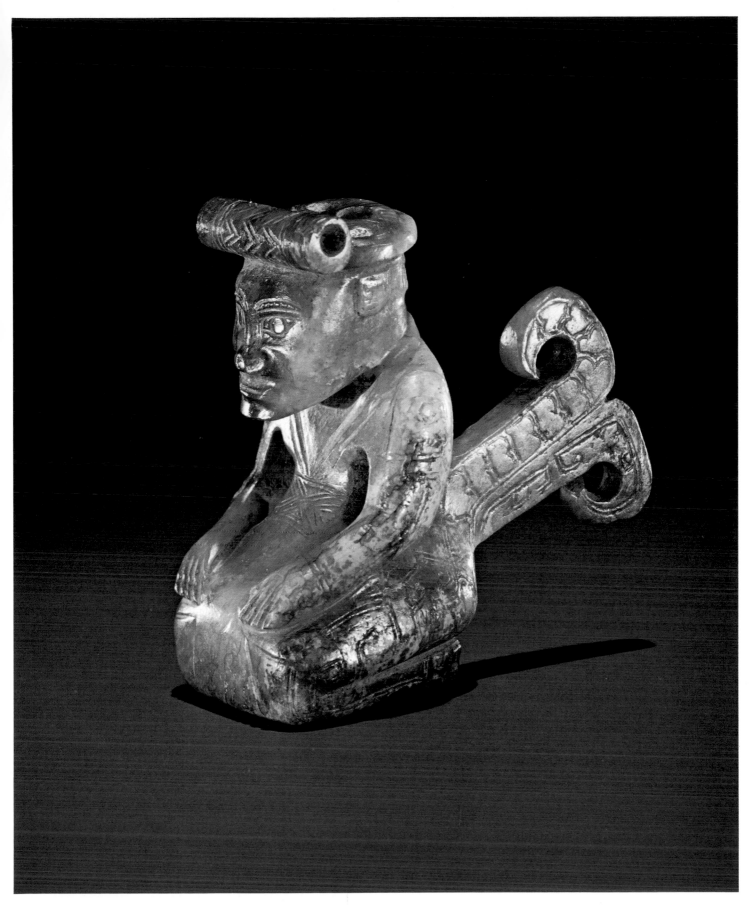

39 This small jade figure kneels in the formal seated posture current in China before the introduction of the chair, and transmitted from China to Korea and Japan. The hooked projection may be a decorative elaboration of the sash.

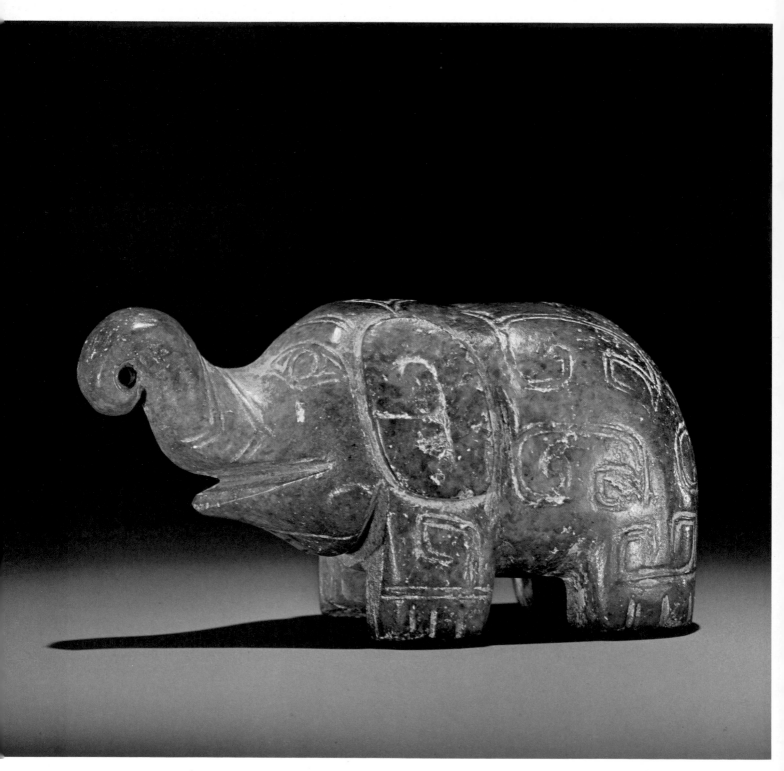

40 This charming elephant, only one and a quarter inches high, is ornamented in purely conventional patterns. The final curl of its trunk is formed by a perforation by which the figurine might have been suspended.

41 This vessel is an extraordinary historical document. Its unique importance lies in its inscription, which records that was commissioned on the eighth day after the conquest of t Shang dynasty by the Zhou.

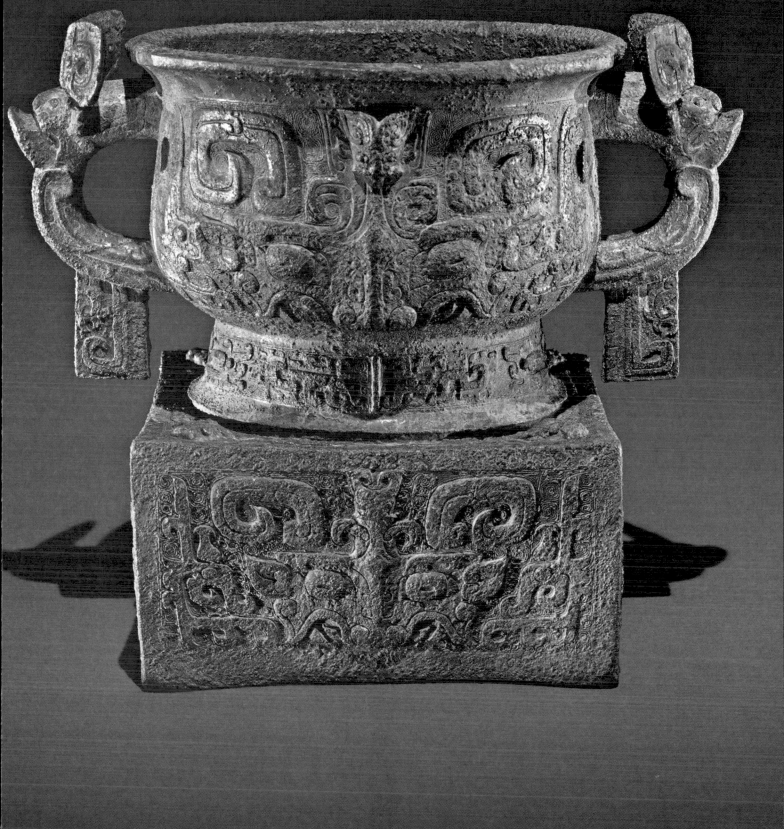

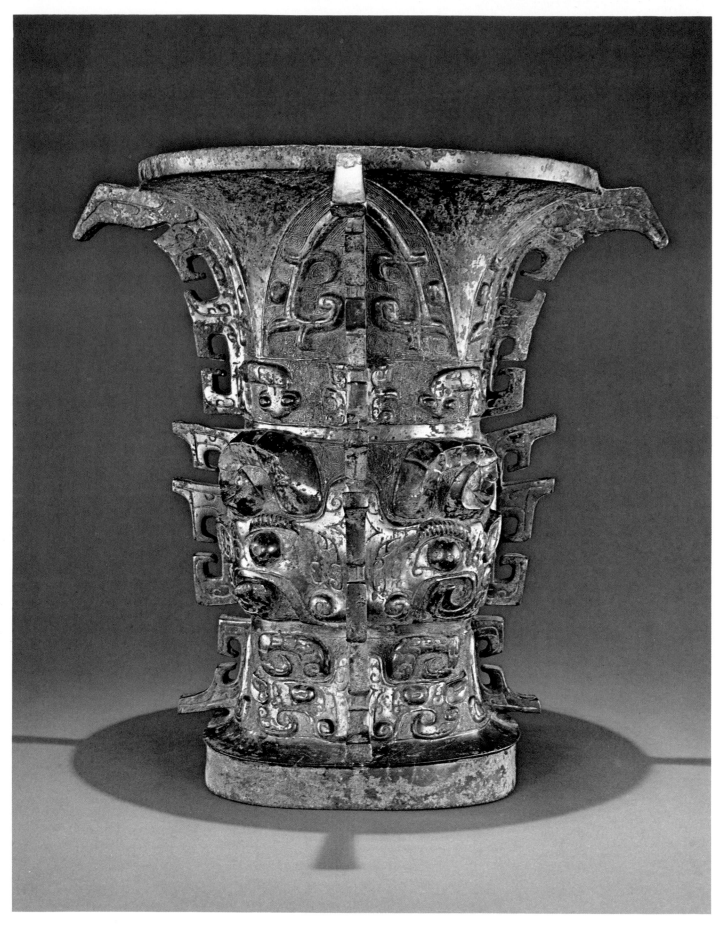

42 With its large and flamboyant flanges, this wine vase gives
an effect of overpowering mass and barbaric energy. Its remark-
able inscription gives an exact date for the Zhou founding of a
new eastern capital.

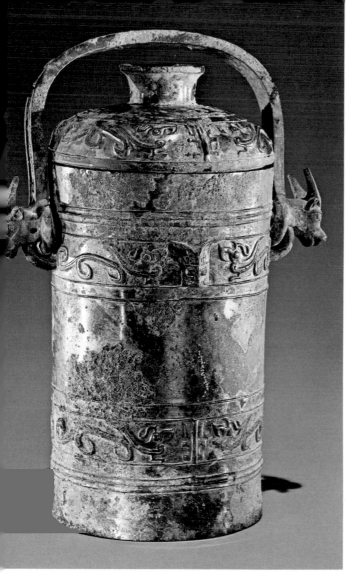

44 Several features of the three-legged pouring vessel shown
below recall much older types, reflecting either a deliberate
revival or a continuation of simpler antecedents that had existed
alongside more dramatic and architectonic styles.

43 The simple vessel illustrated above was found
with no. 44. They represent a taste different from the
extravagance of nos. 42 and 45 but equally prevalent
in early Zhou bronzes: the decoration is sparse, the
shapes are smooth and curvilinear.

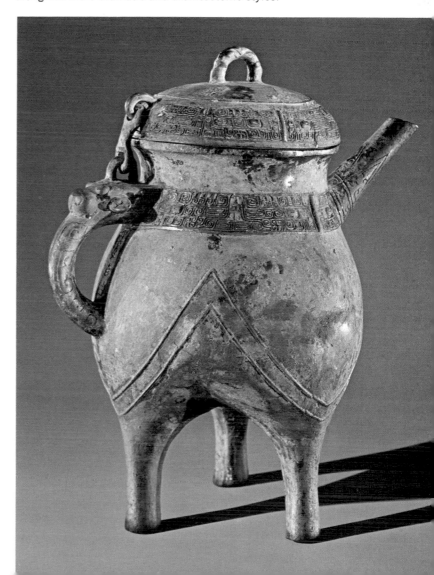

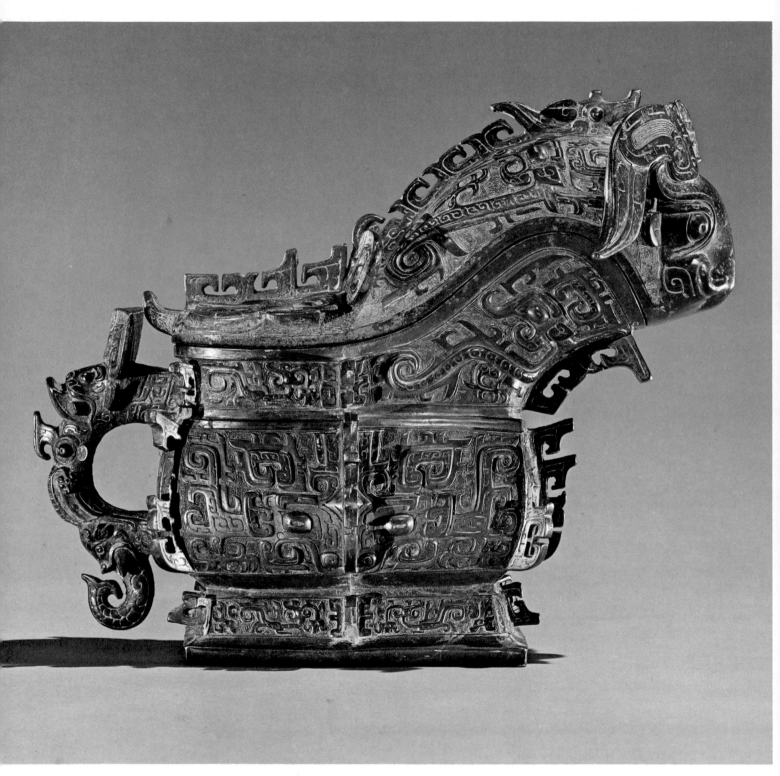

45 A knobby animal head with winglike horns animates the front of this odd wine container. The vessel's florid, richly patterned shape and decoration embody the beginnings of a patternizing tendency that increasingly dominates Western Zhou bronzes.

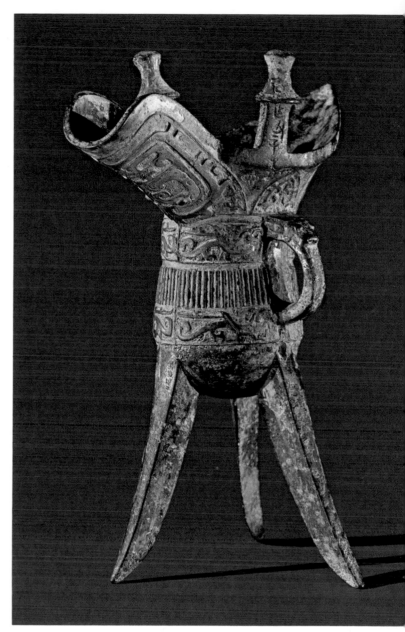

47 This typically Shang wine cup dropped out of the Zhou repertory of vessel types not long after this piece was cast. It was found in the same large hoard as nos. 45 and 46, which may represent the accumulated belongings of several generations of the same family. The political upheavals of the Zhou period led to the burial of treasured possessions for safekeeping, and Zhou objects are often found in hoards rather than tombs.

46 A rare example of an ancient bronze that has survived uncorroded, this wine goblet is also exceptional for its attenuated waist, which seems barely to support the widely flaring mouth.

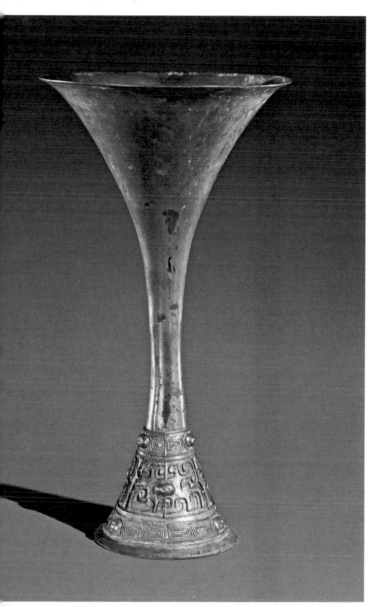

48 Over four feet wide, this altar table was cast in one piece. Ritual
vessels could be set (and perhaps heated) on the holes in the top.

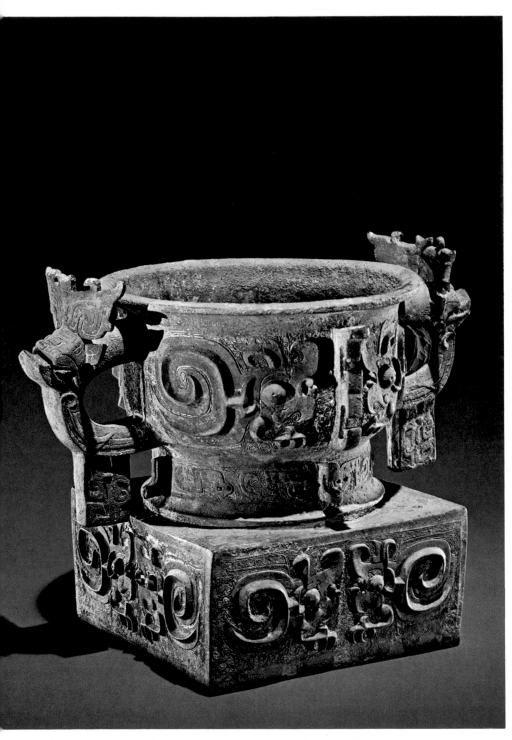

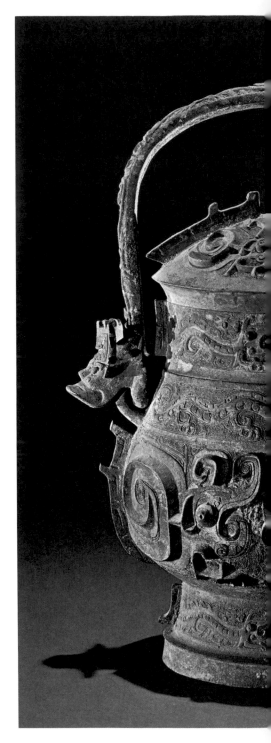

49-51 All three wine vessels shown here were found in the same tomb and share a similar decoration of confronted pairs of coiled monsters whose gaping jaws are supplied with pairs of conical teeth; they probably functioned as a matched set.

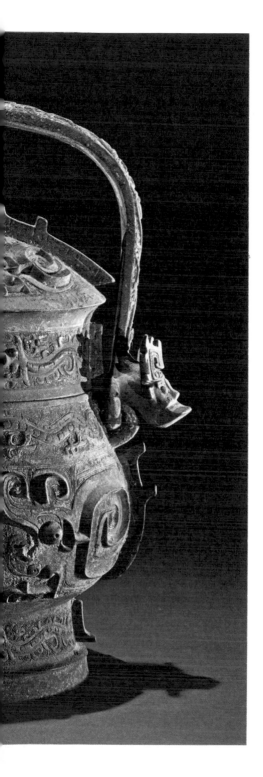

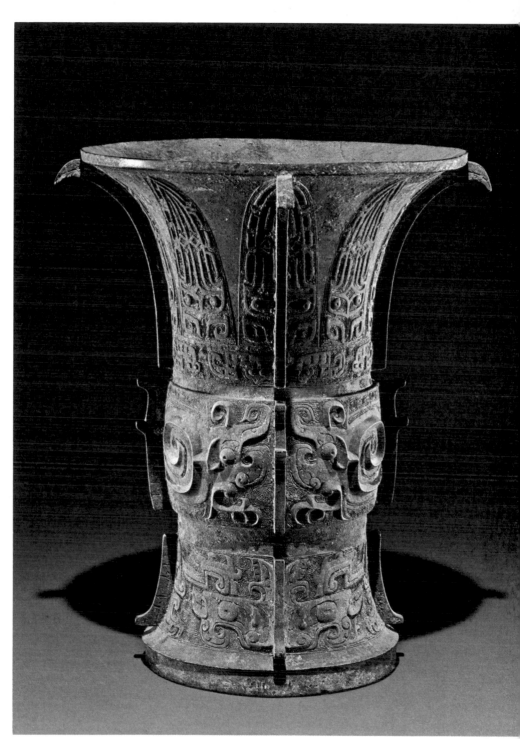

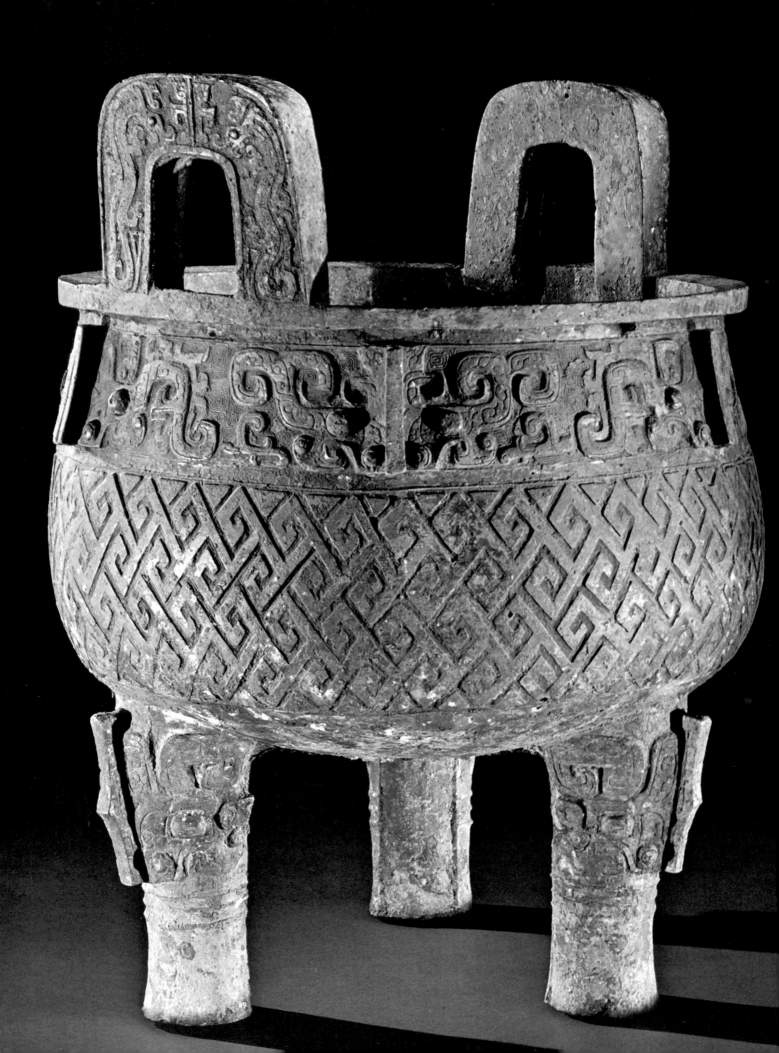

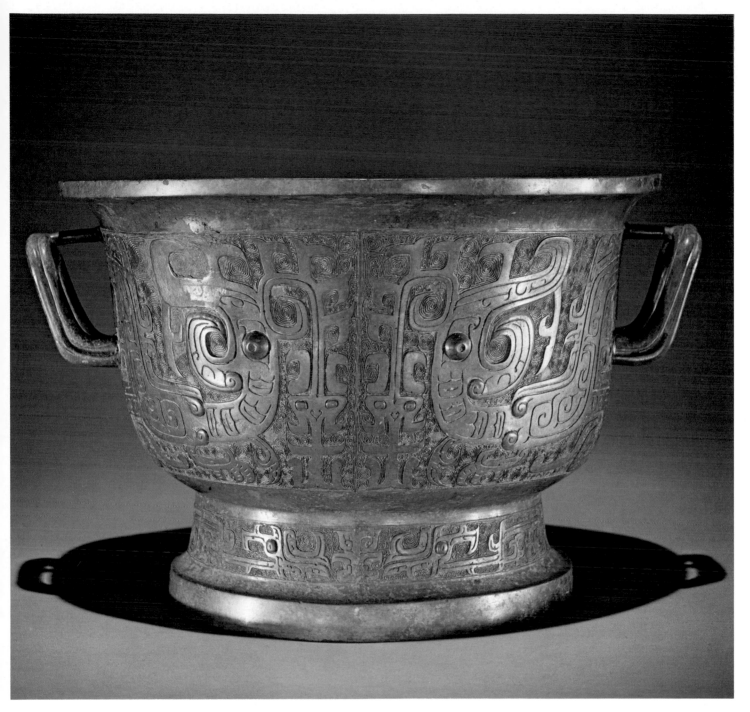

53 One of the most attractive of all Western Zhou bronzes, the food vessel shown here is decorated with a particularly elegant motif of a dragon with a bird's body. The dragons' crests terminate in serpent heads with bulging eyes, yet the Zhou preference for ornamental elaboration has led to the transformation of the tongues into decorative flourishes.

2 Over thirty inches in height and eighing more than 187 pounds, this triking cauldron was found buried in a mall pit, inverted over another bronze.

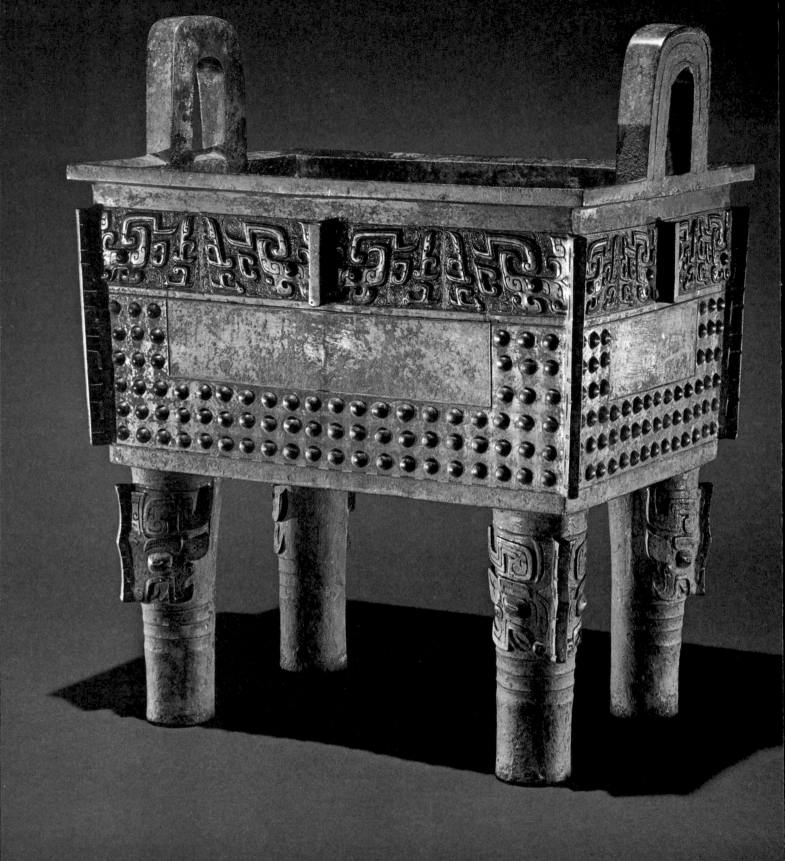

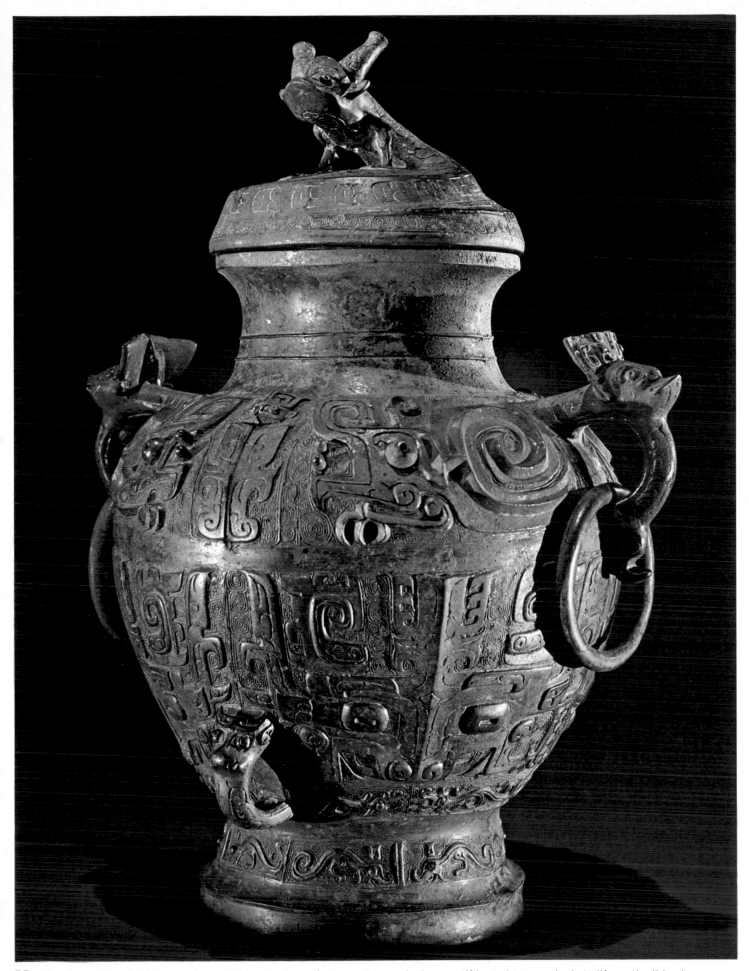

55 The decoration of this piece demonstrates the inventiveness with which Zhou artisans adapted Shang motifs. Recognizably Shang animal masks are topped by a Zhou creation: dragons with an abstract coil for a body, a motif brought menacingly to life on the lid, where the same serpentine animal rises up on its forelegs.

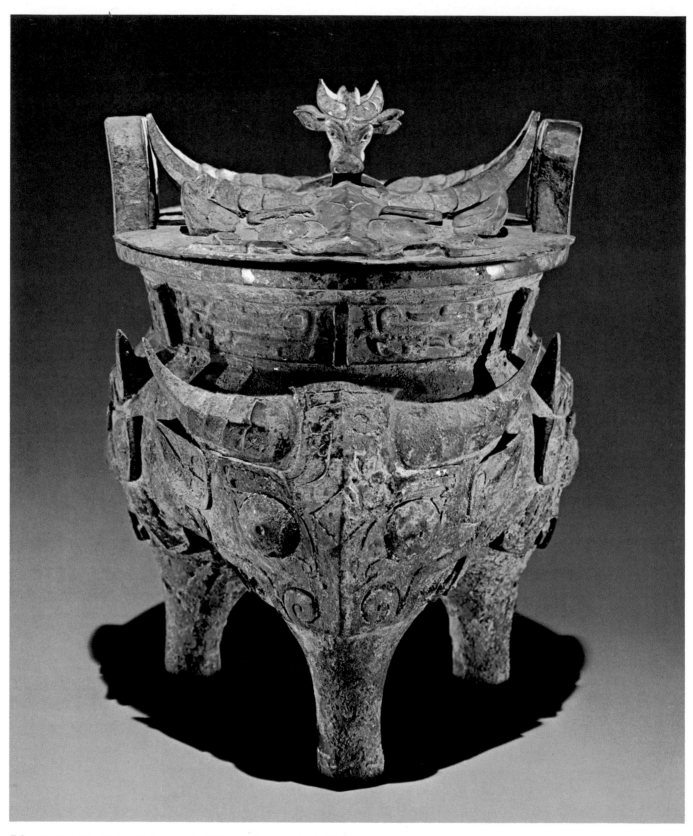

56 Modeled in high relief, water buffalo heads are adapted to the lobed body of this vessel so as to heighten the sense of their ponderous mass—a feeling entirely appropriate to the bulky shape of the vessel itself.

57 Judging by the trunk, the principal motif decorating this food container is an elephant, but the anatomically gauche creature seems to have been pieced together from a variety of other motifs. The extension of the handles to form legs is a Western Zhou design.

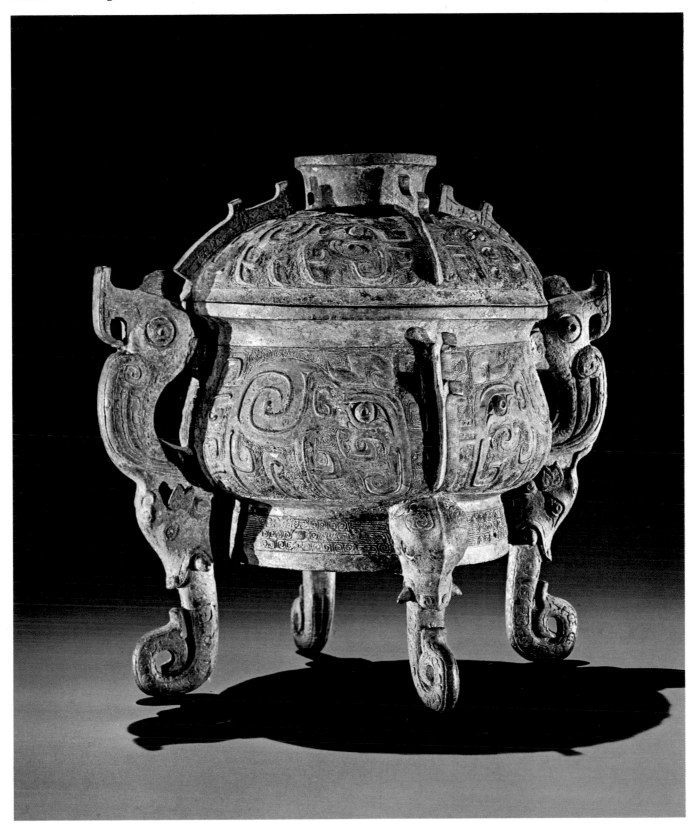

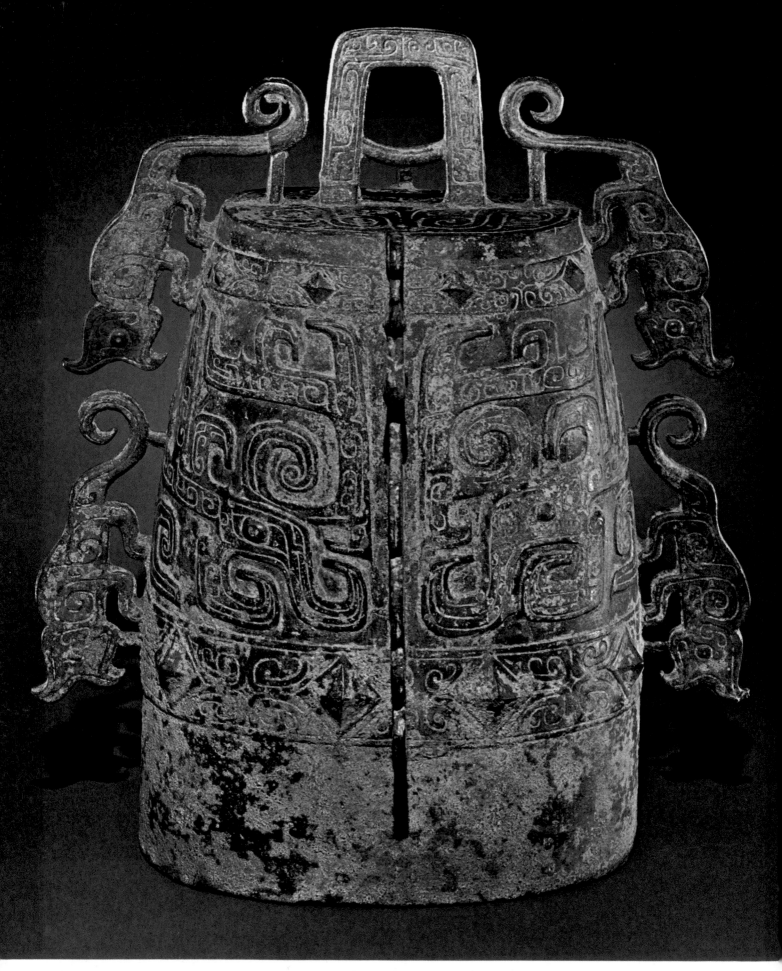

58　The clear-cut flat tigers that form the lateral flanges on this bell (detail opposite) contrast with the imprecise forms of confronting dragons that decorate its sides. Each dragon's elongated crest has become more conspicuous than its inarticulate body: the entire motif verges on dissolution into meaningless meanders, hooks, and linear flourishes.

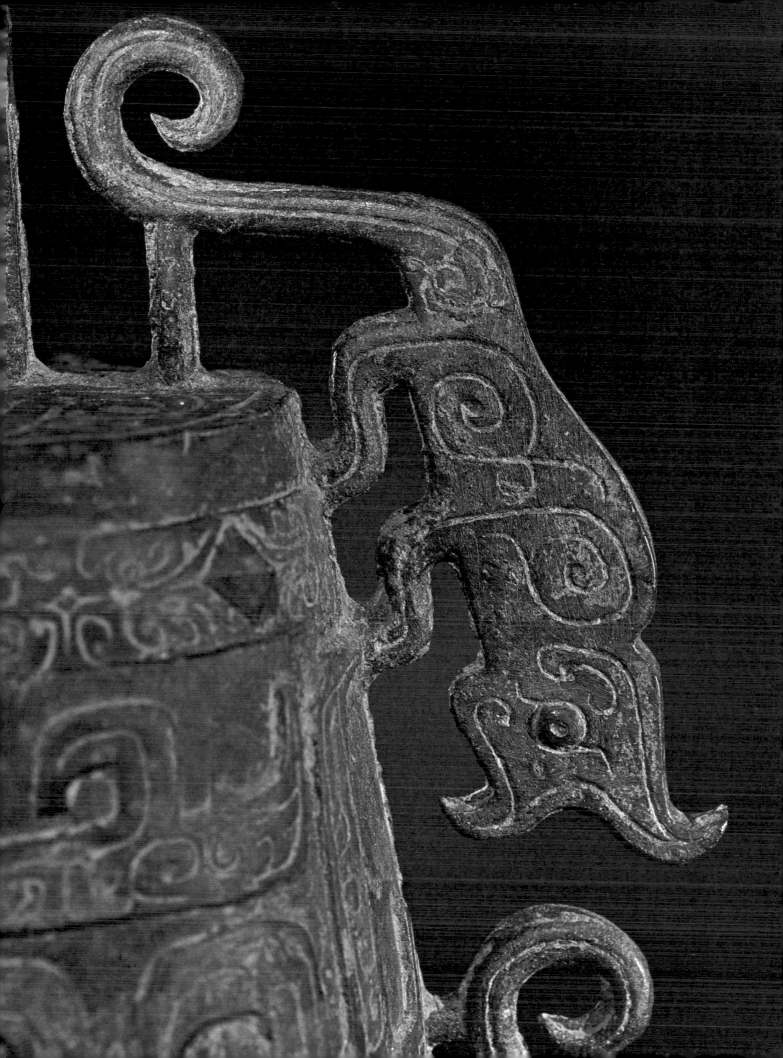

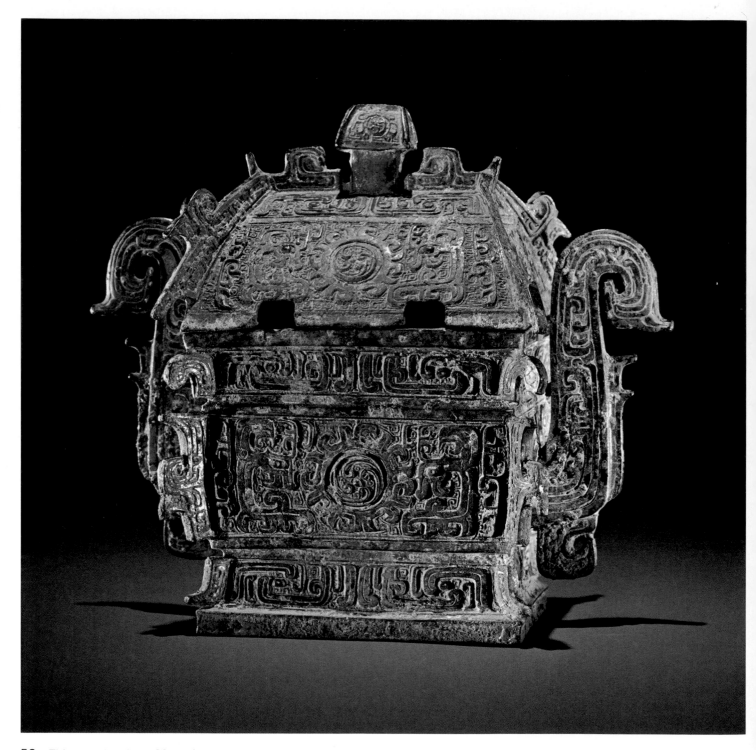

59 This vessel and no. 60 are from a set of four. Every
available space is covered with curvilinear patterns derived
chiefly from dragons. The interior of the piece above is divided
into two compartments by a partition; on one side of the lid,
two apertures would accommodate ladles.

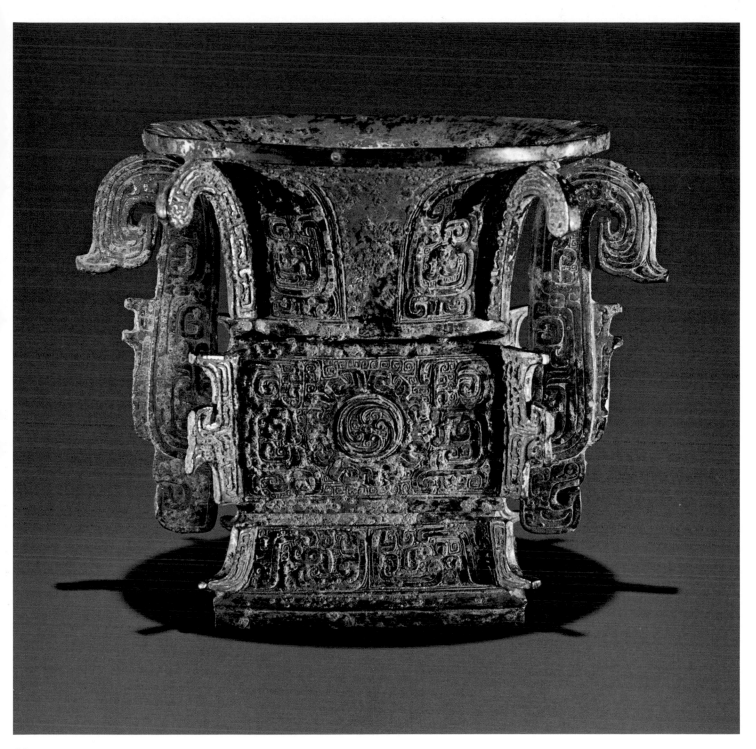

60 Like no. 59, this wine vessel bears a long inscription
concerning a court ceremony in which their owner was invested
with several important posts by the king. It is difficult to over-
look the discrepancy between the evident magnitude of the
posts and the small and poorly cast bronzes made in honor of
the occasion.

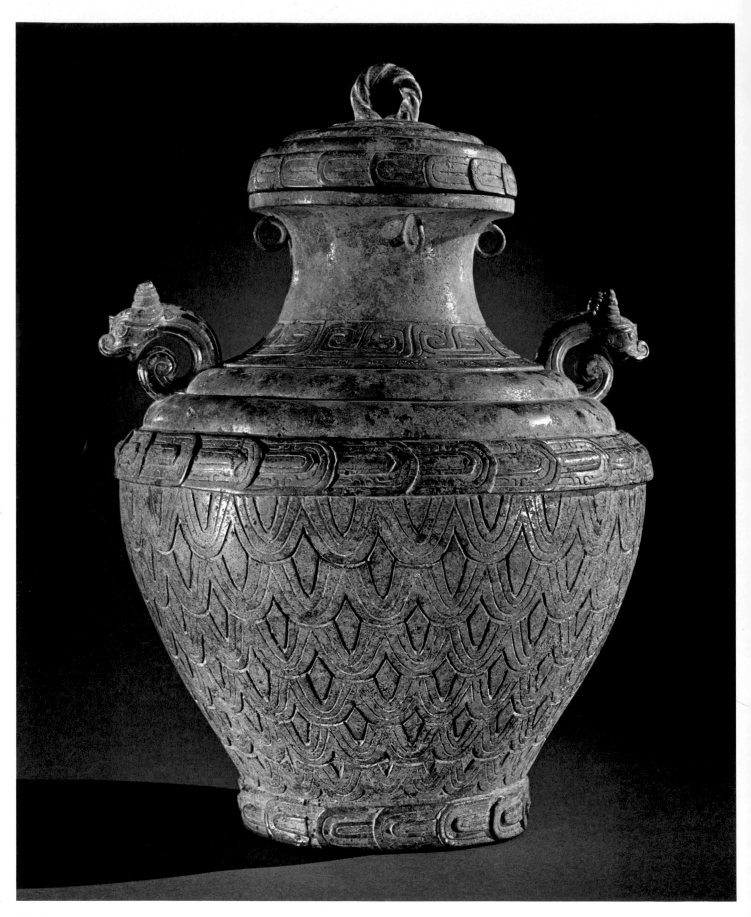

61 Most of the surface of this wine vessel is given over to an abstract scalelike pattern, a simplification of decoration appropriate to the new clarity of silhouette.

62 By the eighth century B.C., the bilateral symmetry of ▷ earlier designs was renounced in favor of patterns that sweep unbroken around the vessel, imparting a hint of motion. In the stately wine container at the right, the surface is dominated by undulating wave patterns that are echoed in openwork in the freestanding crown.

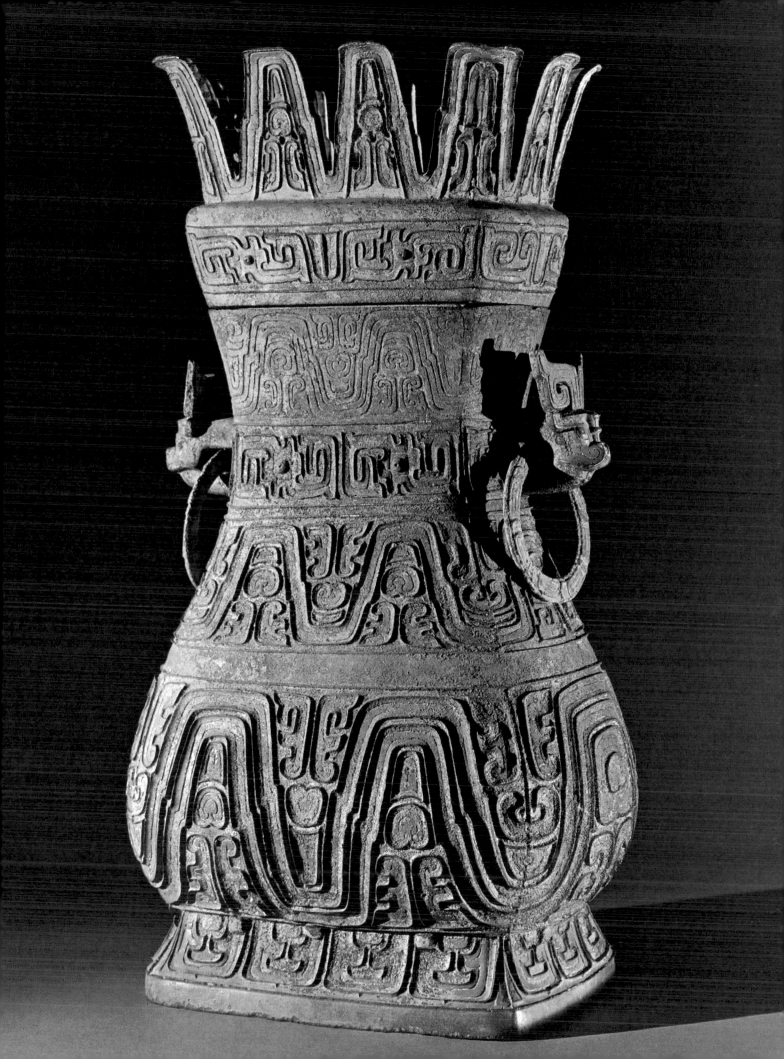

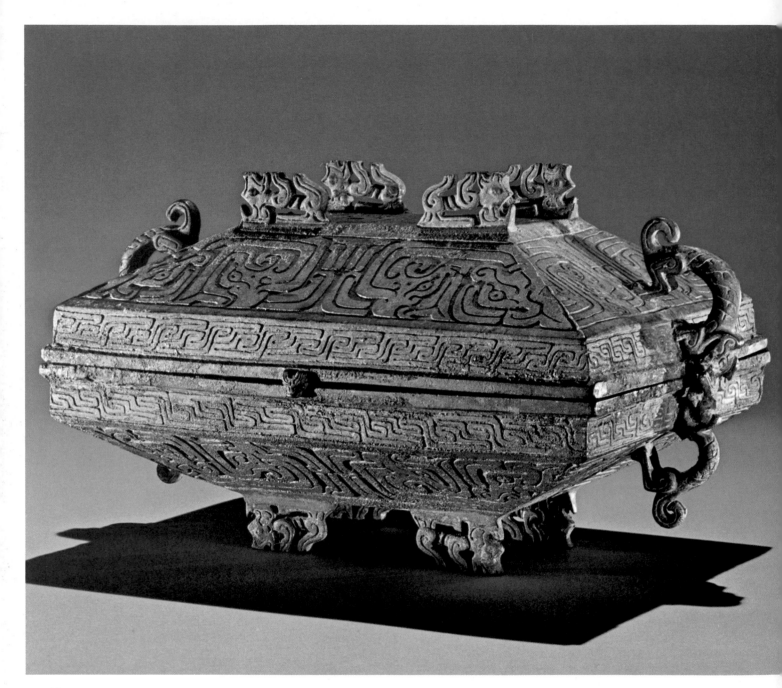

63 The two halves of this vessel are nearly identical, so that
the lid can be inverted to serve as a separate container standing
on legs of its own. Its swirling decoration based on coiled
dragons foretells later ornamental tendencies.

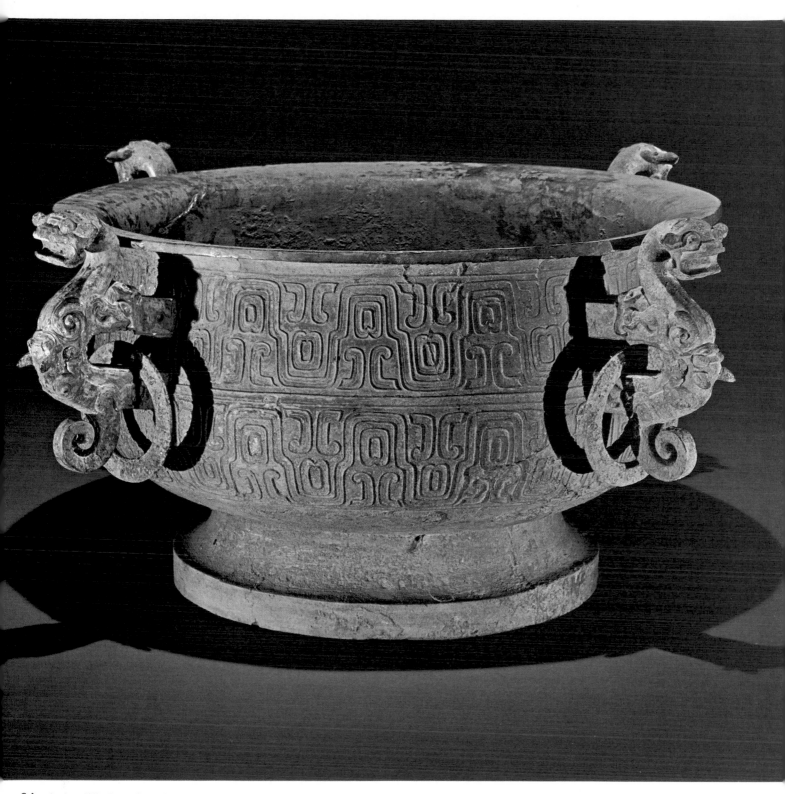

64 A simplified version of the wave pattern decorates this massive food container, which was made as a wedding present. Its inscription reads: "The duke of Qi of the Jiang family made this precious *yu* vessel for his second daughter in marriage. May it give her long life for ten thousand years, physical well-being always, and may generations preserve and use it forever."

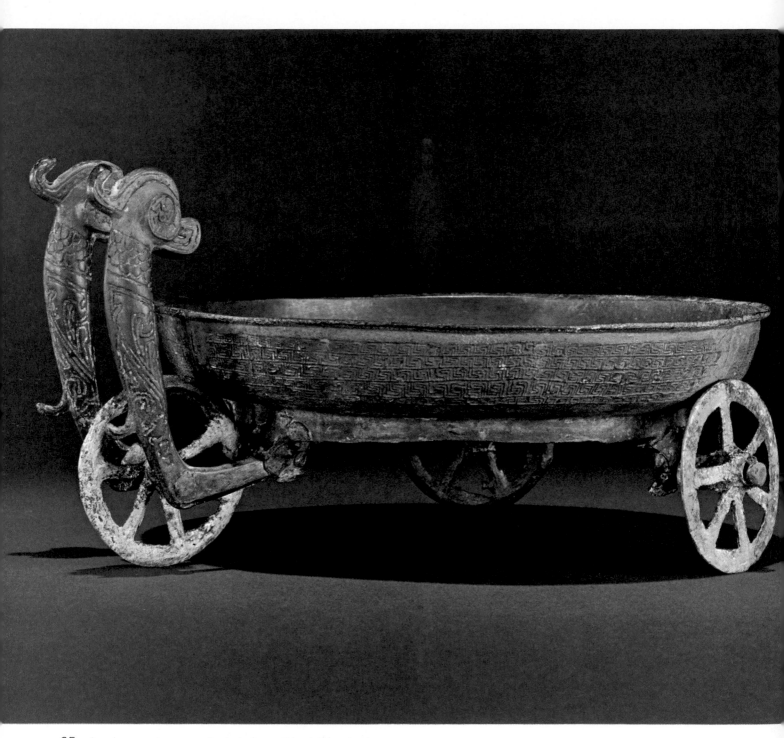

65 A unique and unprecedented piece, this striking basin
suggests a simple cart. Such bold inventions were possible only
in regional workshops where local peculiarities could still
express themselves unhampered by an established tradition.

66 The lively motif on the middle of this small vase has
been interpreted as silkworms feeding on mulberry
leaves, an unusual design that would reflect local
preoccupation with the cultivation of silk during this period.

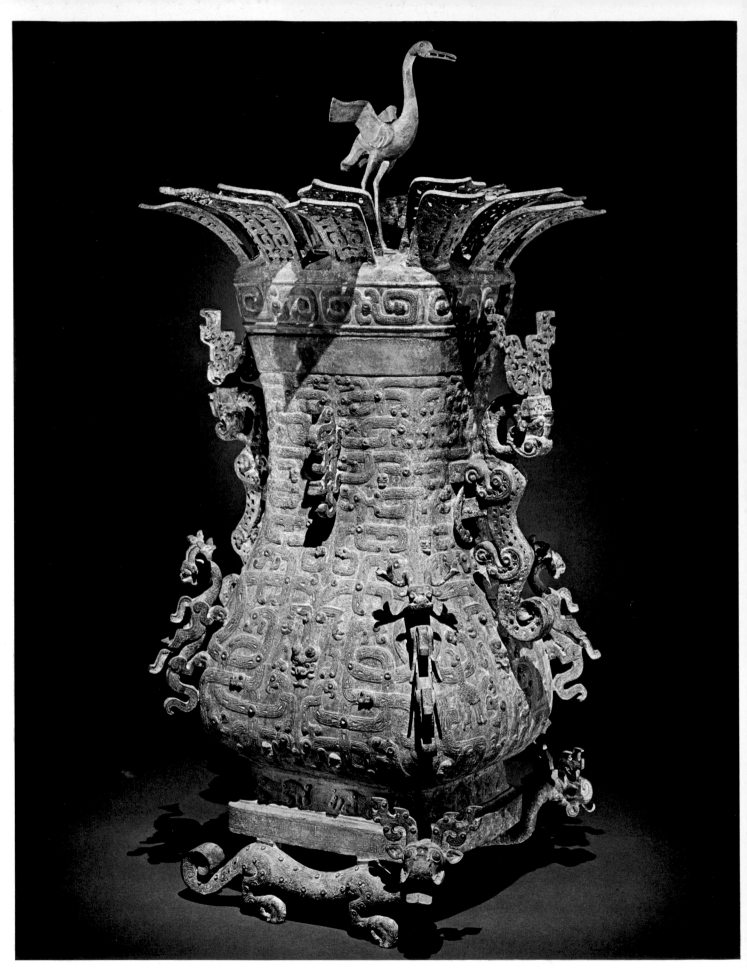

67 Few vessels can compare in size and exuberance with this astonishing bronze. Its traditional silhouette is almost completely overwhelmed by a flurry of animal forms, from the realistic crane poised on the lid to the fantastic creatures on the sides (detail opposite) and the slinking horned felines at the base.

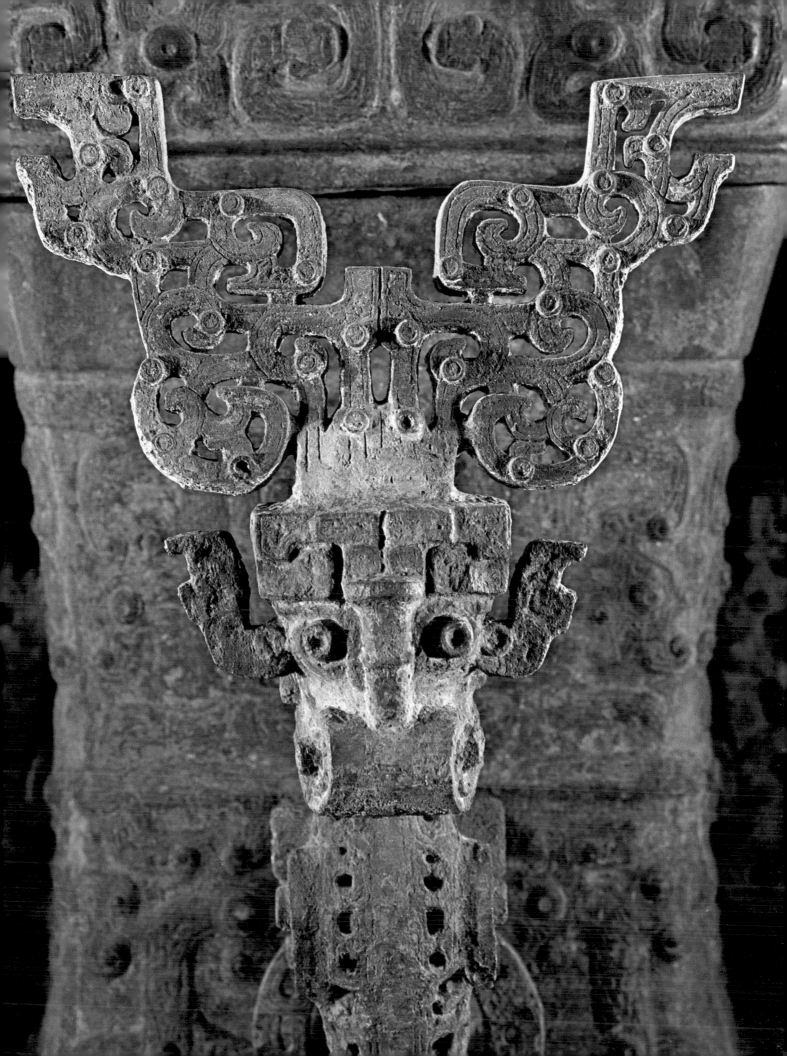

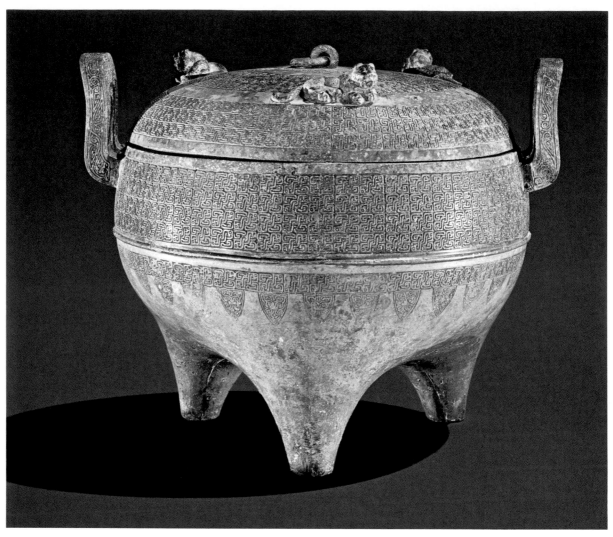

68 The intricacy and uniformity of the neat, interlocking units decorating this small bronze are typical of the sixth century B.C.

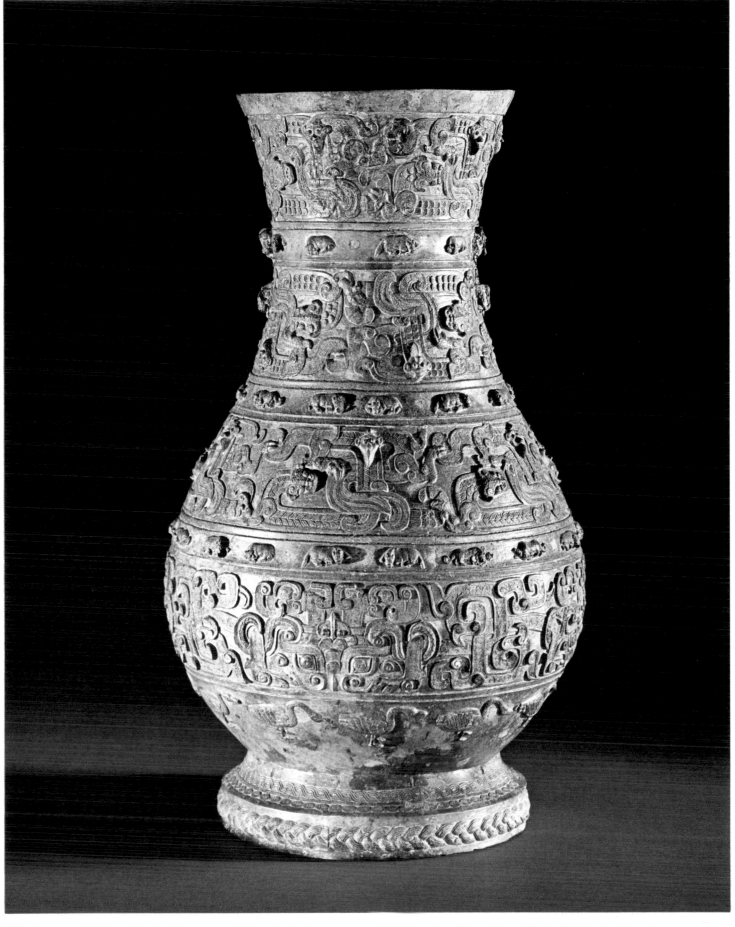

69 A renewed interest in plastic ornamentation during the sixth and fifth centuries B.C. is exemplified by the decoration of this wine container. Friezelike bands of animals sculpted in high relief alternate with registers filled with intertwining sinewy creatures that are themselves patterned with endlessly varied spirals, hatchmarks, feathers, and scales (detail overleaf).

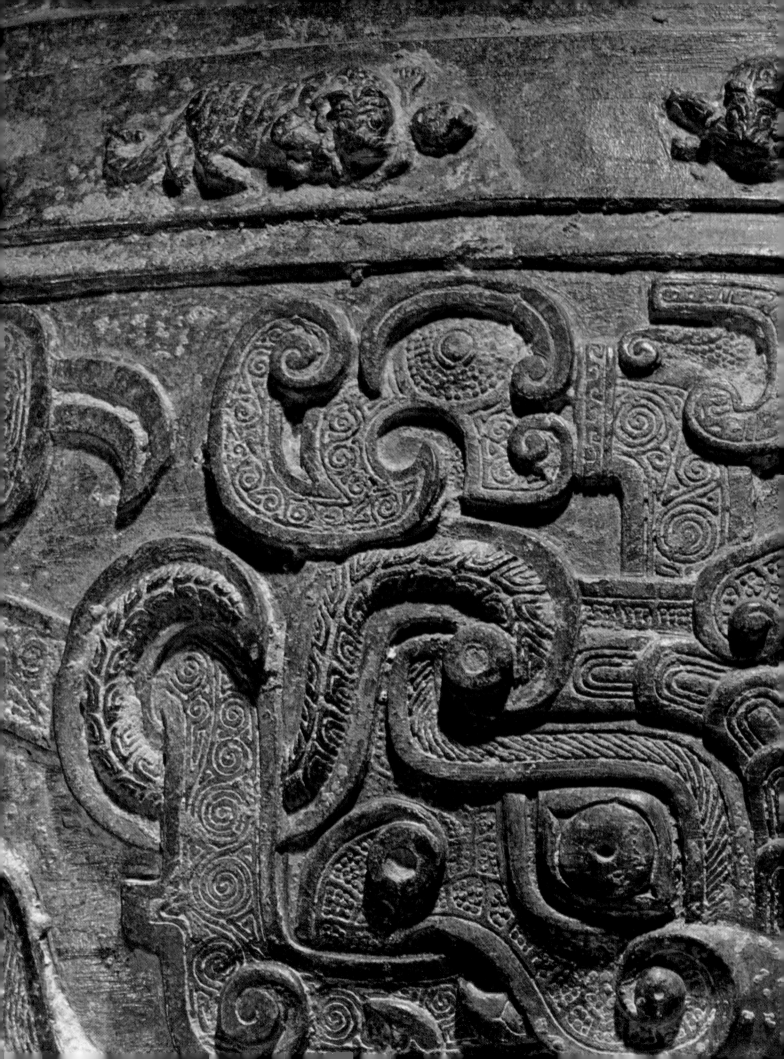

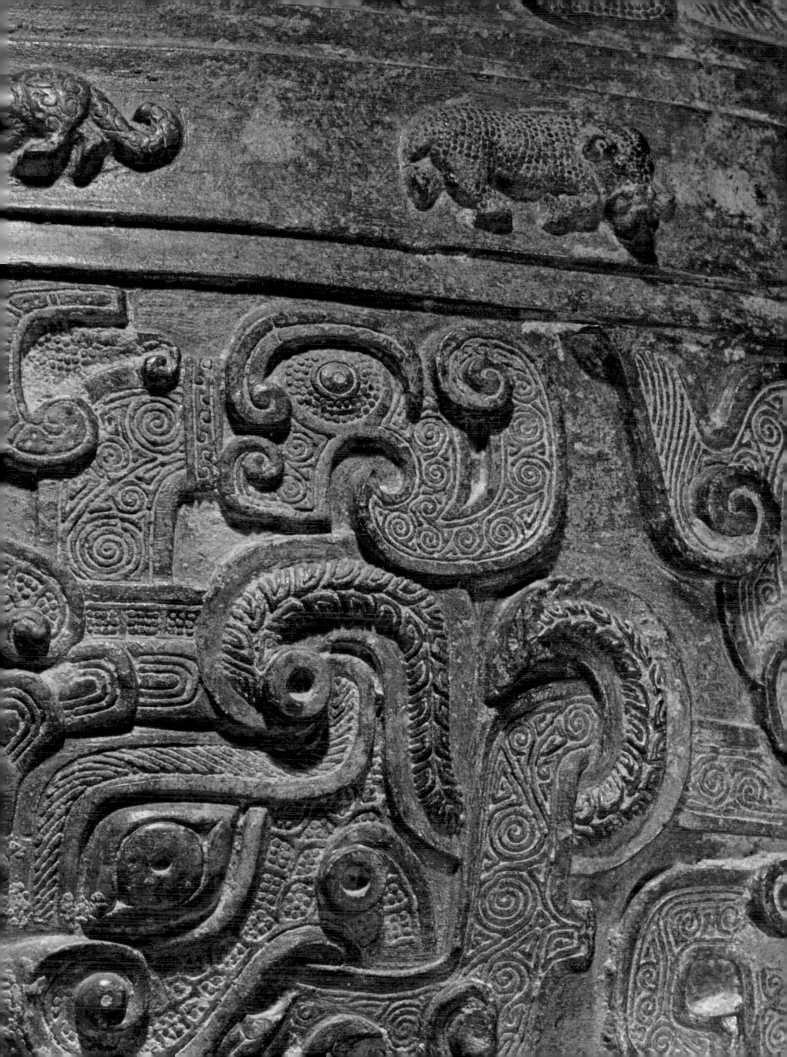

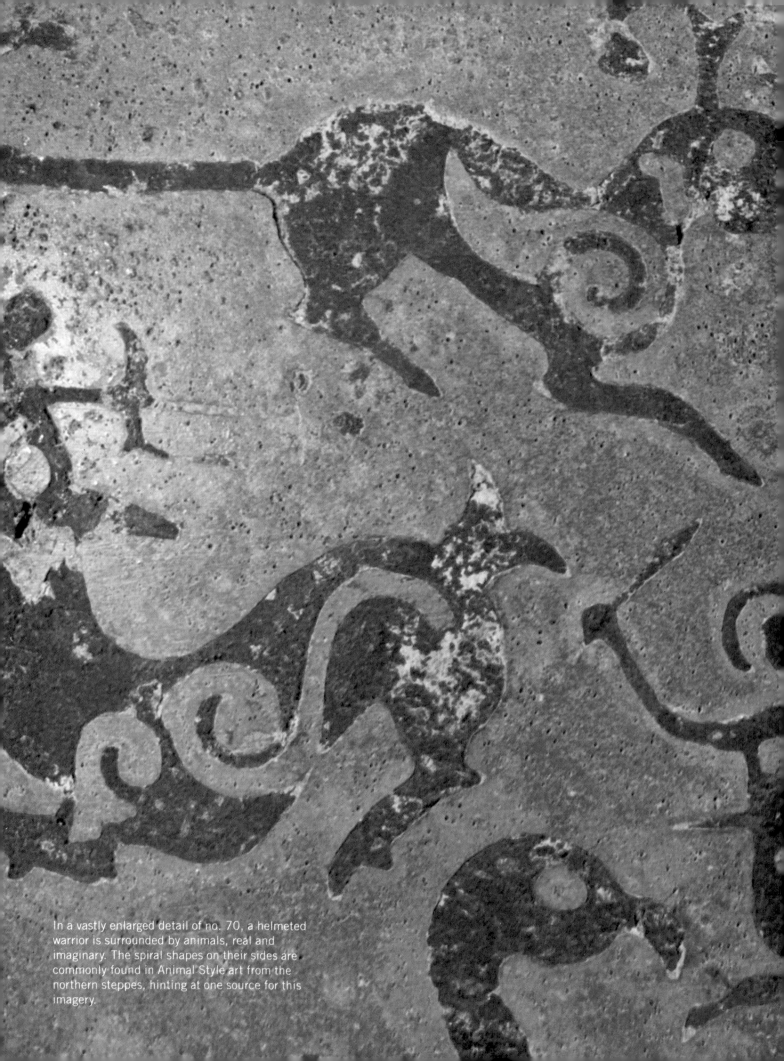

In a vastly enlarged detail of no. 70, a helmeted warrior is surrounded by animals, real and imaginary. The spiral shapes on their sides are commonly found in Animal Style art from the northern steppes, hinting at one source for this imagery.

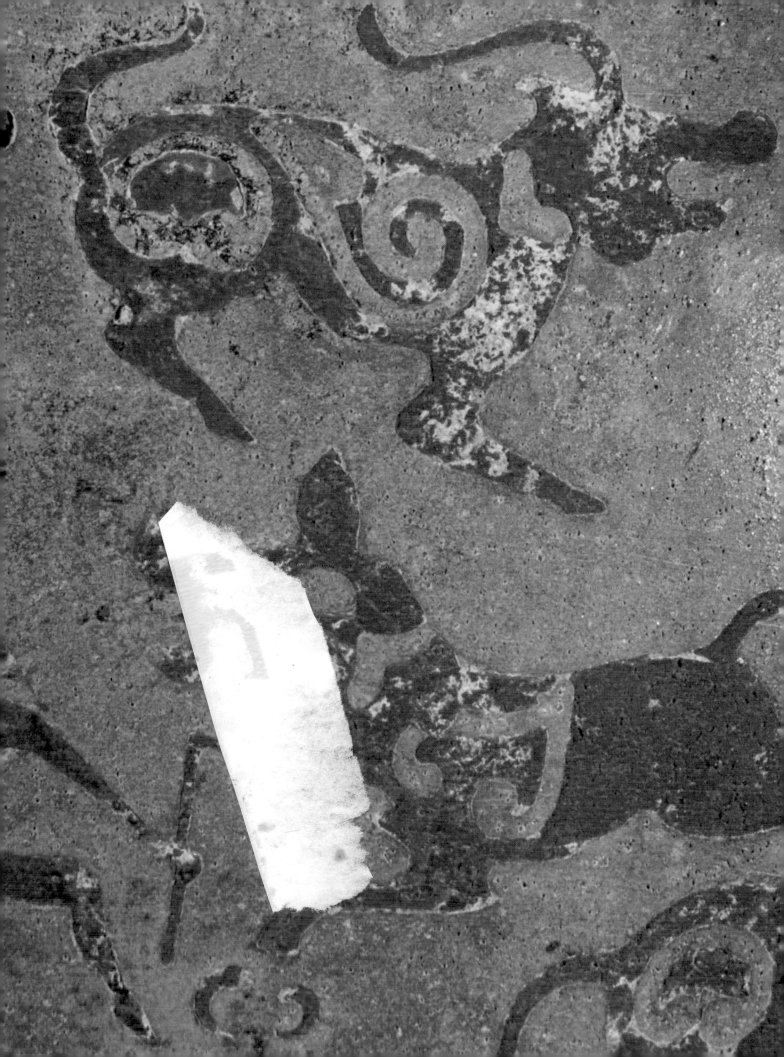

70 This covered bowl is the first piece in the exhibition to be
ornamented with inlay, a decorative technique that was later to
become dominant. Here the red of the copper inlay stands out
clearly against the even green patina of the plain bronze
surface.

71 The clean lines of this massive vessel—over twenty-eight inches wide—remain unchallenged by the incongruously fine ornament that covers the upper portion of the body. Only the handles and two strongly arched tigers that climb up the sides to peer over the brim interrupt the silhouette to inject a touch of humor into this austere form.

72 Only eight inches long, this elegant pendant is enlarged here to show the exquisite quality of its workmanship. Painstakingly carved and polished, the curls that rise with such ease and naturalness from the surface belie the patient grinding technique required to leave them in relief.

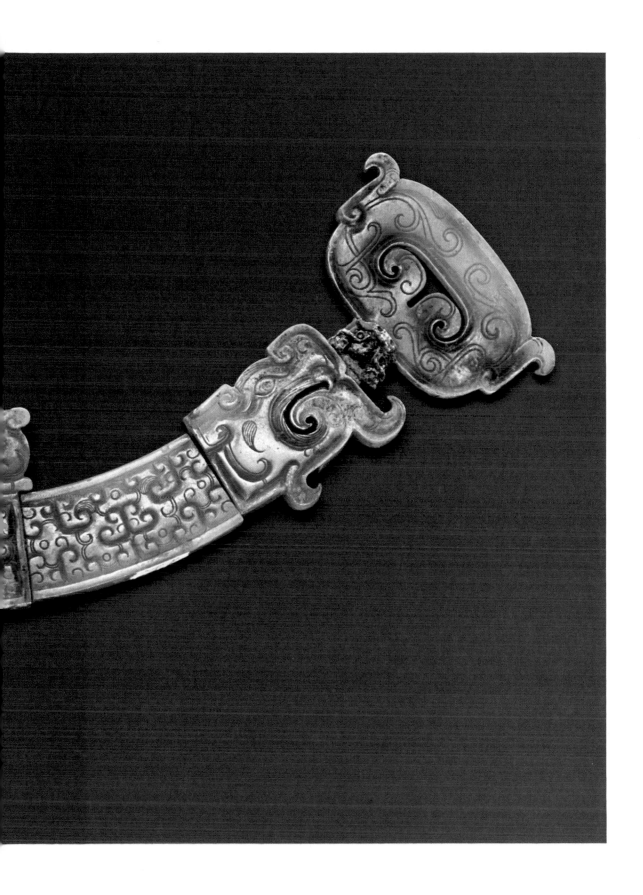

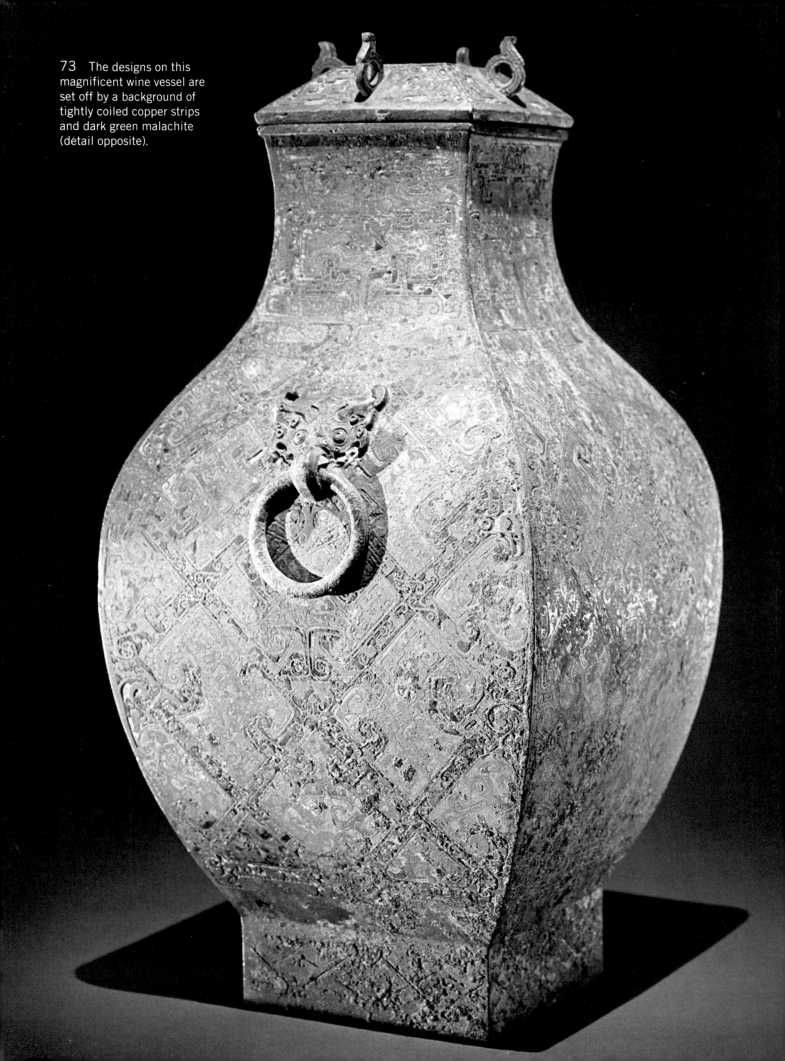

73 The designs on this magnificent wine vessel are set off by a background of tightly coiled copper strips and dark green malachite (detail opposite).

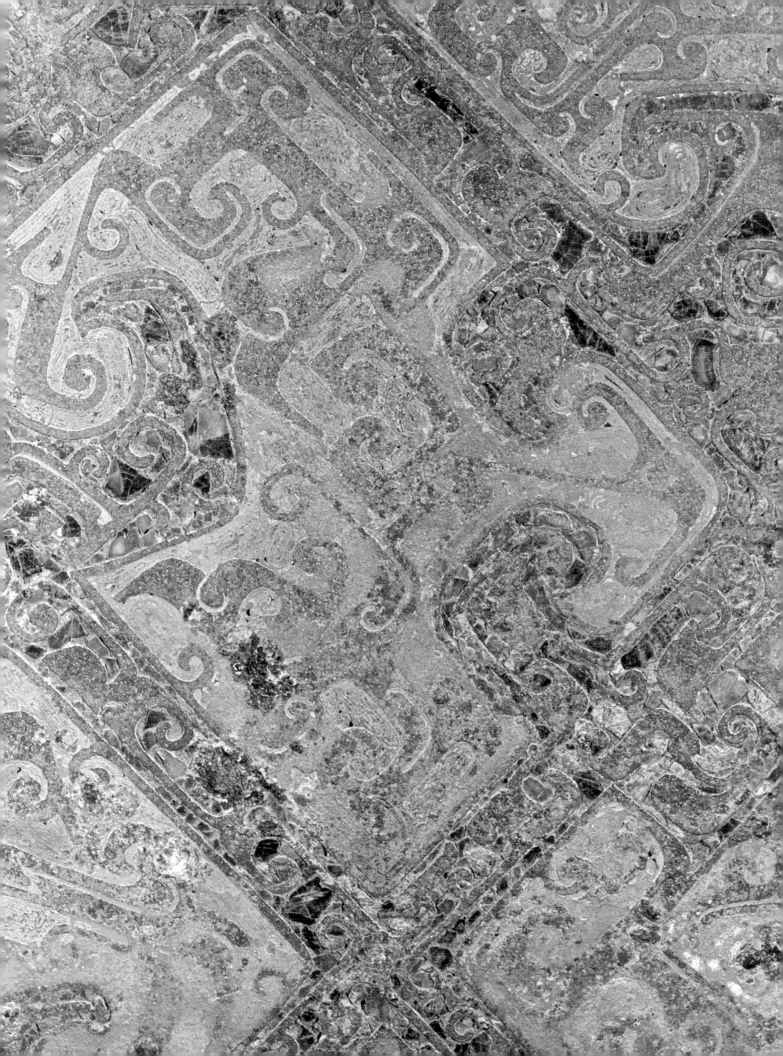

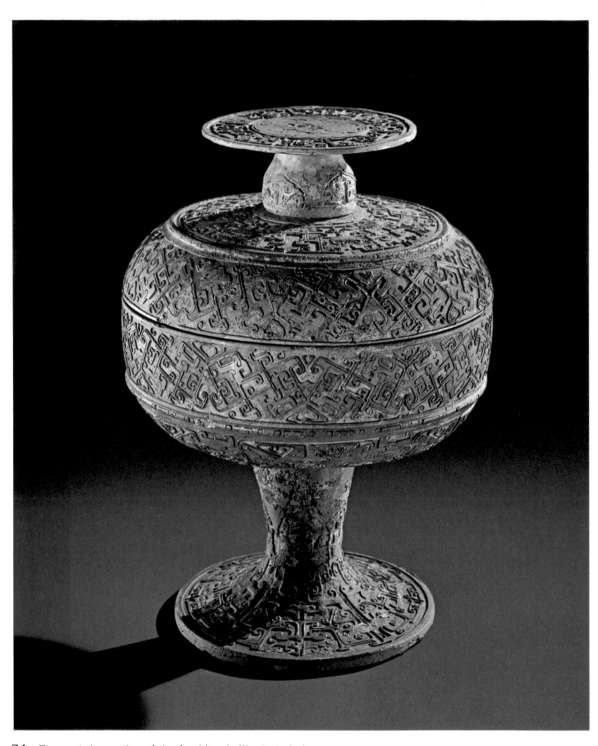

74 The cast decoration of the food bowls illustrated above combines animal designs with dynamic, tilting geometric patterns, originally enhanced by metal and malachite inlays.

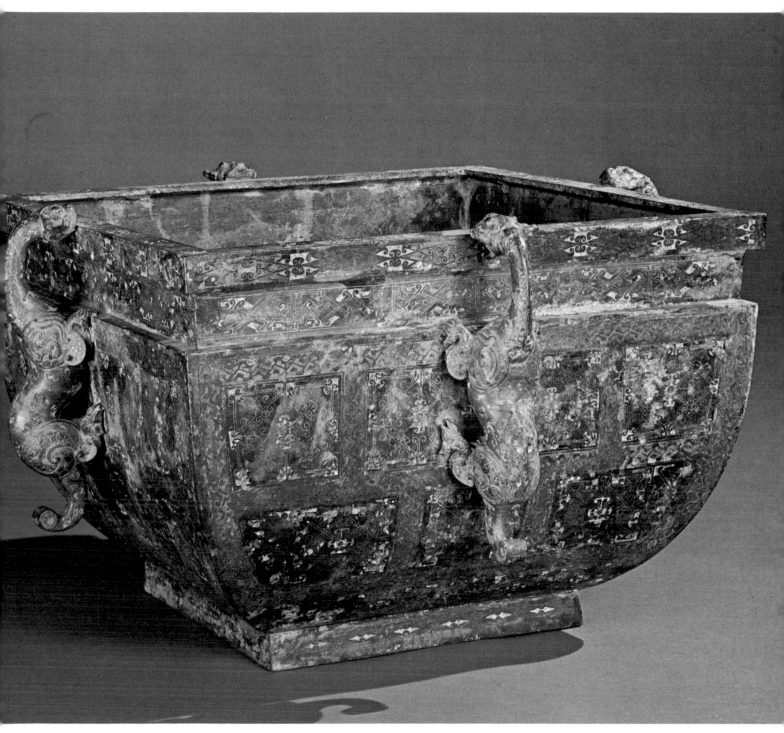

75 The minute tracery patterns of the gold and silver inlay, set within
a network of bordered rectangles, create an embroidery on this
vessel's surface that contradicts the massiveness of its proportions.

76 On this magnificent cast-iron belt hook, the interplay
between the gold and silver design and the dark background is
so complex that it is virtually impossible to distinguish pattern
from ground.

77-90 One of a set of fourteen (over-
leaf), the bell at the right is adorned with
cast decoration as well as a delicate gold
inlay. When struck, each bell can resonate
in two tones, allowing the performance of
fairly complex musical compositions.

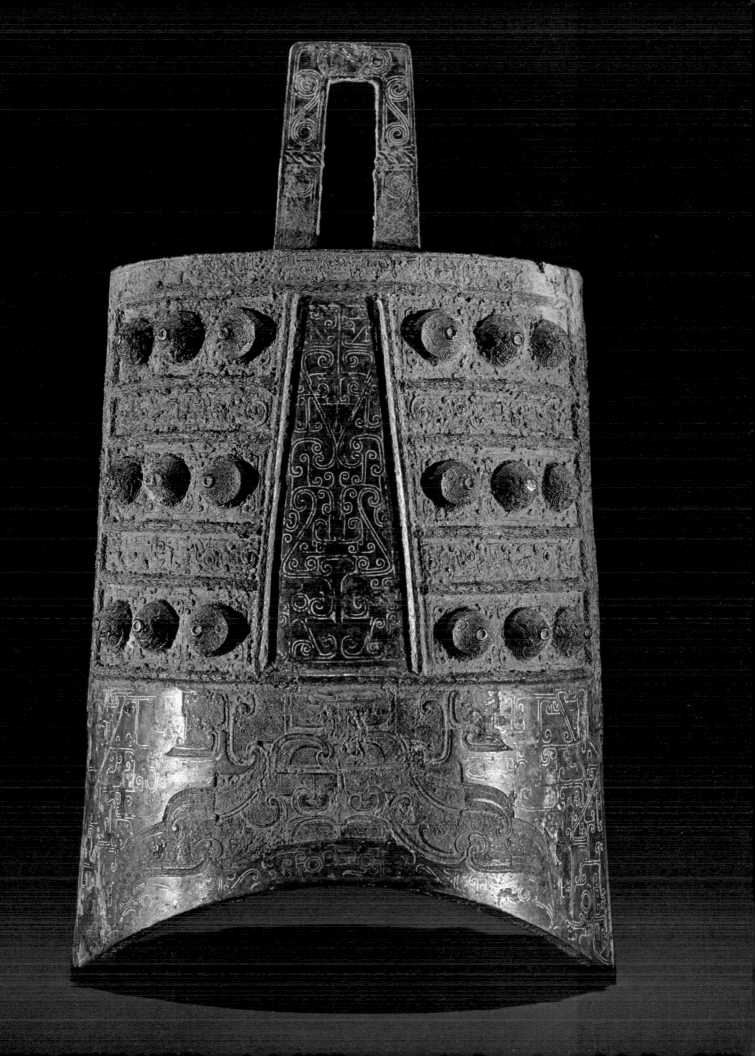

77-90 Eight of the fourteen bells in this set are inlaid with gold.
The wooden frame shown here is a reconstruction, but the two
pairs of tiger-head finials are original. The silver-inlaid designs
on these finials are more flowing and graceful than those on
the bells, and the tigers' eyes are inlaid with black glass.

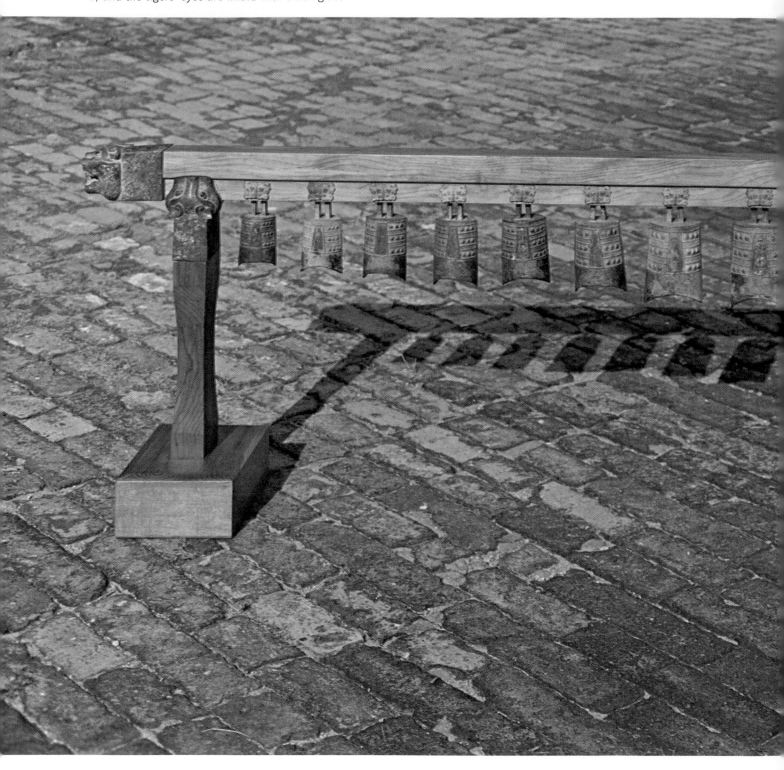

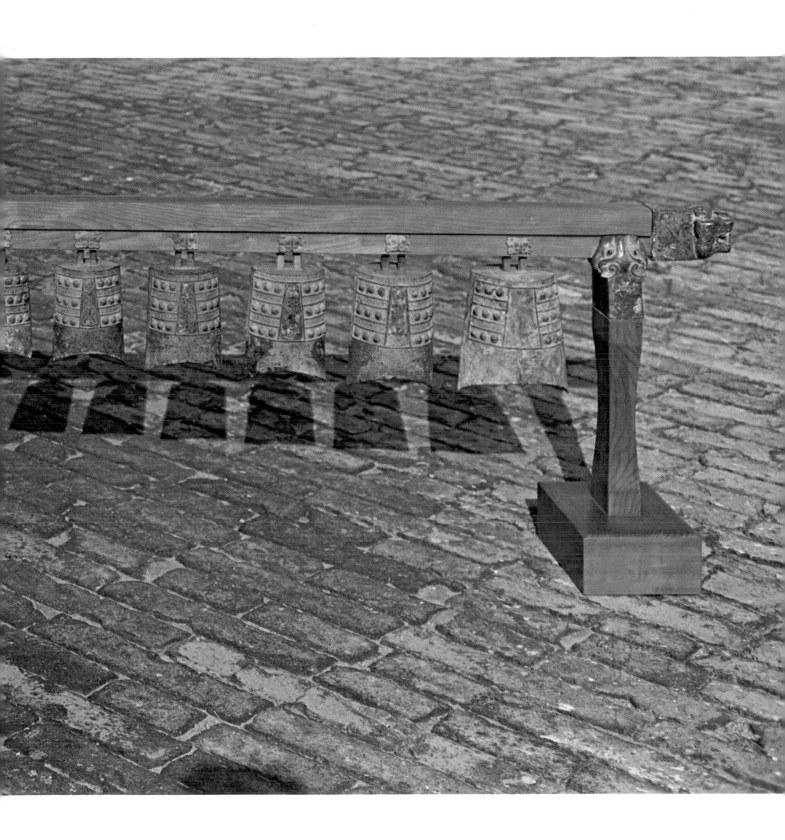

Overleaf: In this detail of the lively pictorial scenes ▷ that ornament no. 91, musicians are shown within a house playing bells (like the set illustrated above) and chimes suspended from the ceiling. On the second floor a banquet is in progress, while outside dancers (upper right) are accompanied by a figure beating a drum (lower right).

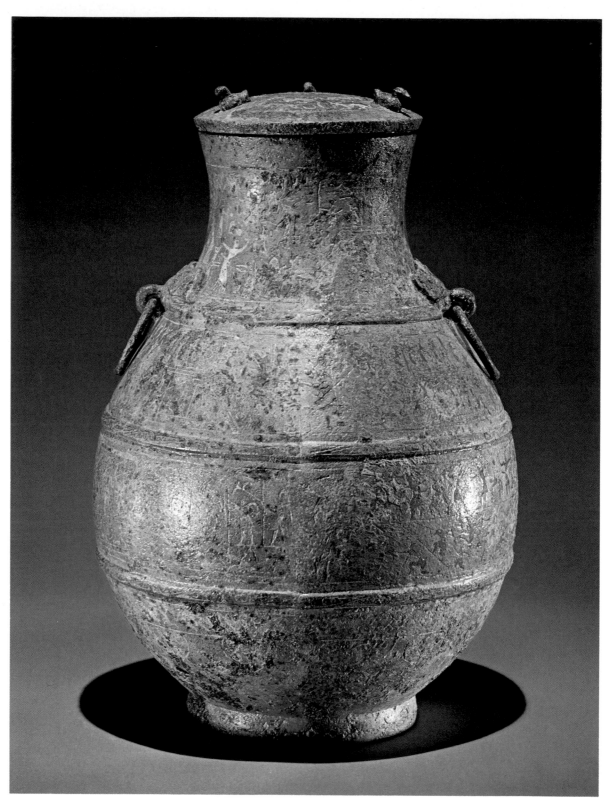

91 The naive scenes inlaid in this wine vessel, of the early fifth century B.C., represent one of the earliest known Chinese attempts at pictorial art. Set next to each other with no regard for spatial relationships, the scenes resemble line diagrams more than convincing evocations of an event.

92 Almost five feet tall, the powerful bronze ▷ trident at the right is of a type never before seen in China. It was probably a standard top to be set on a wooden pole outside a chieftain's tent, reflecting some nomad tradition of military encampment. It is a pictograph for the Chinese character "mountain."

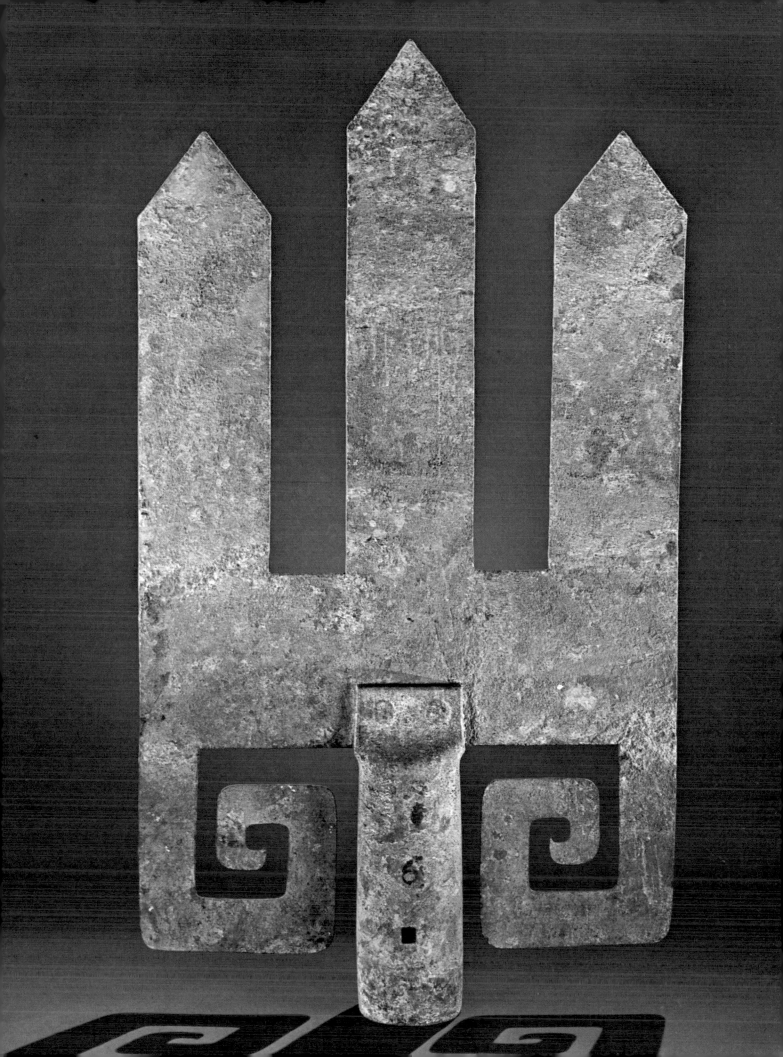

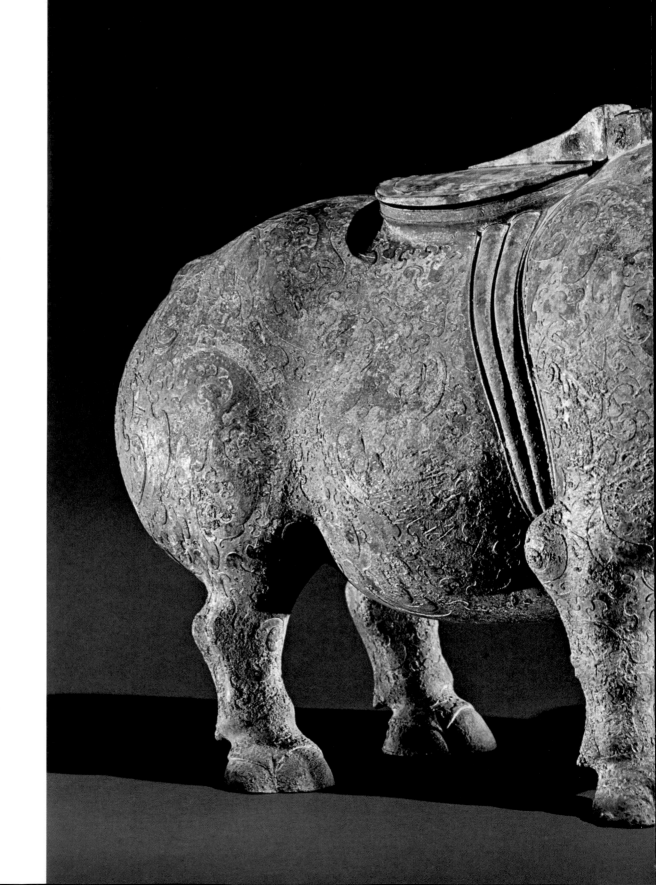

93 Discovered by a farmer plowing his fields, this rhinoceros is adorned with intricate patterns of inlay whose elegance contrasts with the rugged reality of the animal. It is an apt illustration of the paradoxical combination in early Chinese sculpture of descriptive detail and abstract ornamentation.

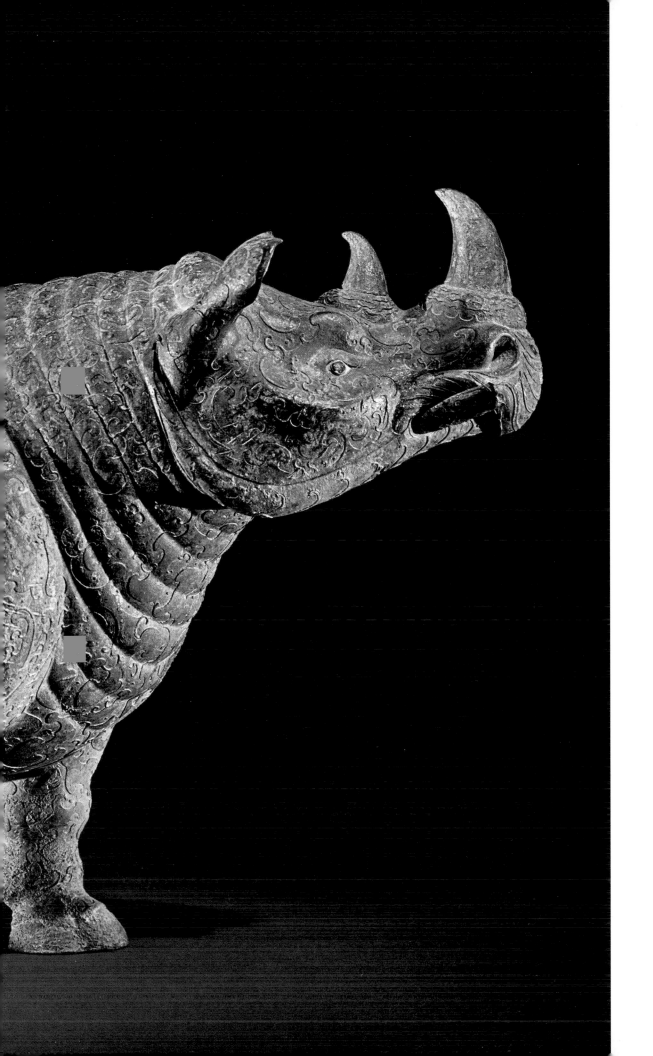

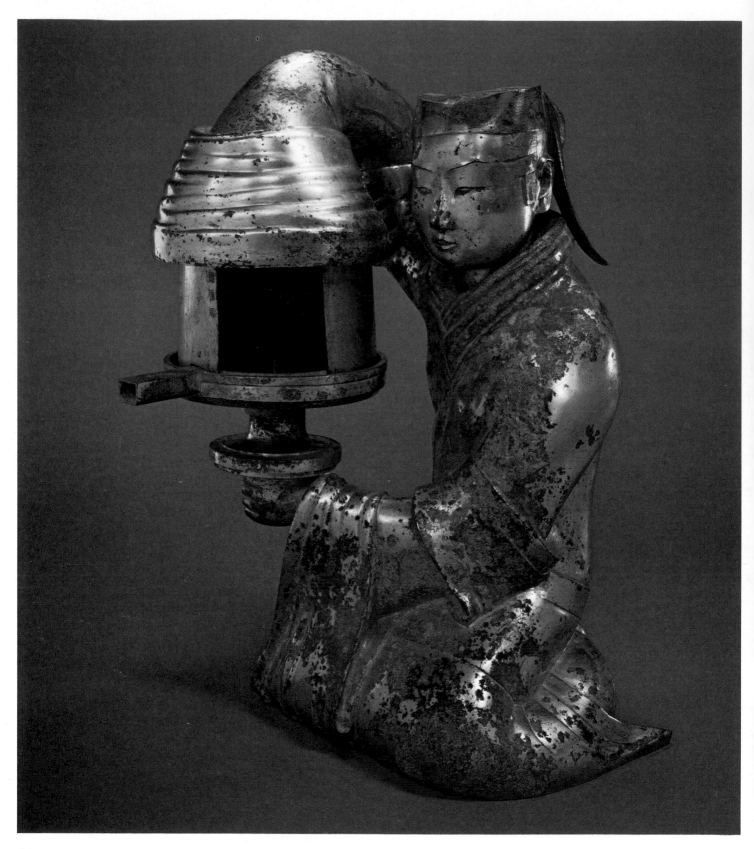

94 Ranking among the finest of early Chinese sculptures, this gilt-bronze figure is shown holding an actual oil lamp, whose smoke would rise inside her hollow sleeve to keep the room free from soot. Extraordinary in its psychological realism, the girl's face is sensitively modeled (detail opposite). Photographs: Wang Yugui, Cultural Relics Bureau, Beijing.

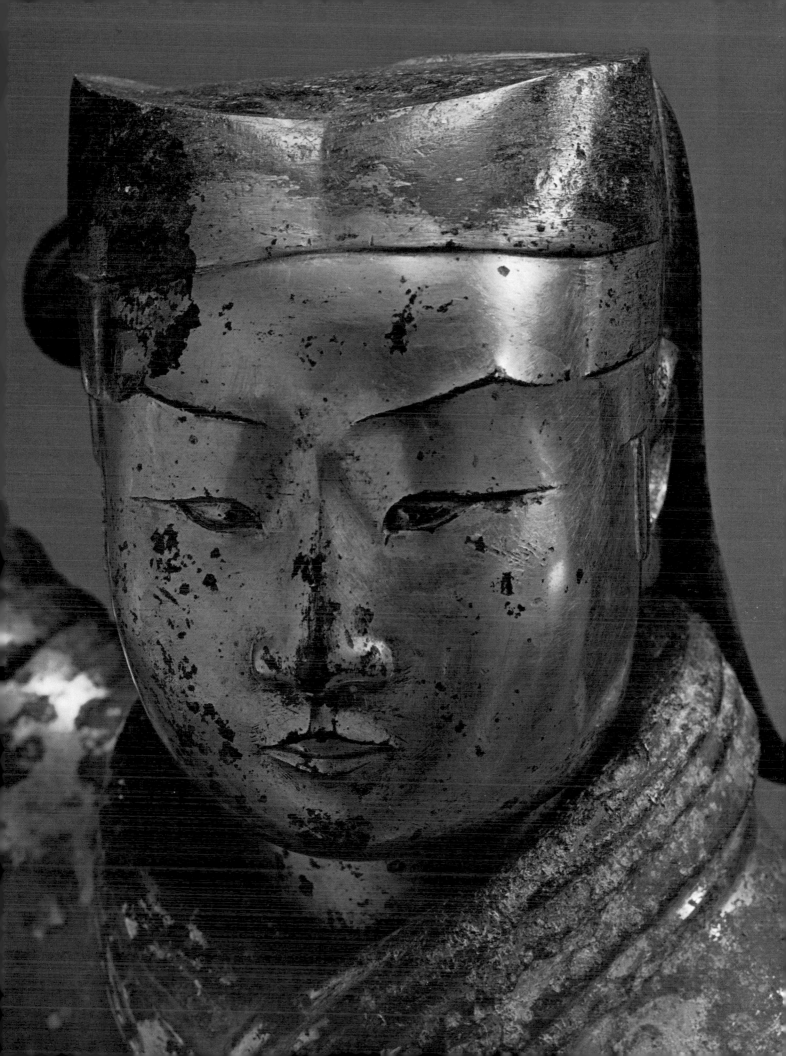

95 Exceptional in design and workmanship, the beautiful
incense burner illustrated above represents the mountainous
Isle of the Immortals of Taoist myth. The incense rising from the
perforations would have suggested clouds emanating from
mountain grottoes.

96 On this piece, fine gold and silver inlays form highly ornamental "bird-script" inscriptions, which conclude: "Let delicacies fill the gates and increase our girth, and give us long life without illness for ten thousand years and more."

97 This striking basin—a combination of two bulls and a tiger—comes from the remote
southwestern corner of China where a regional culture developed quite independently
of established Zhou traditions. The undisguised ferocity with which the tiger attacks
the bull dramatically points to an aesthetic foreign to that of the refined Zhou court.

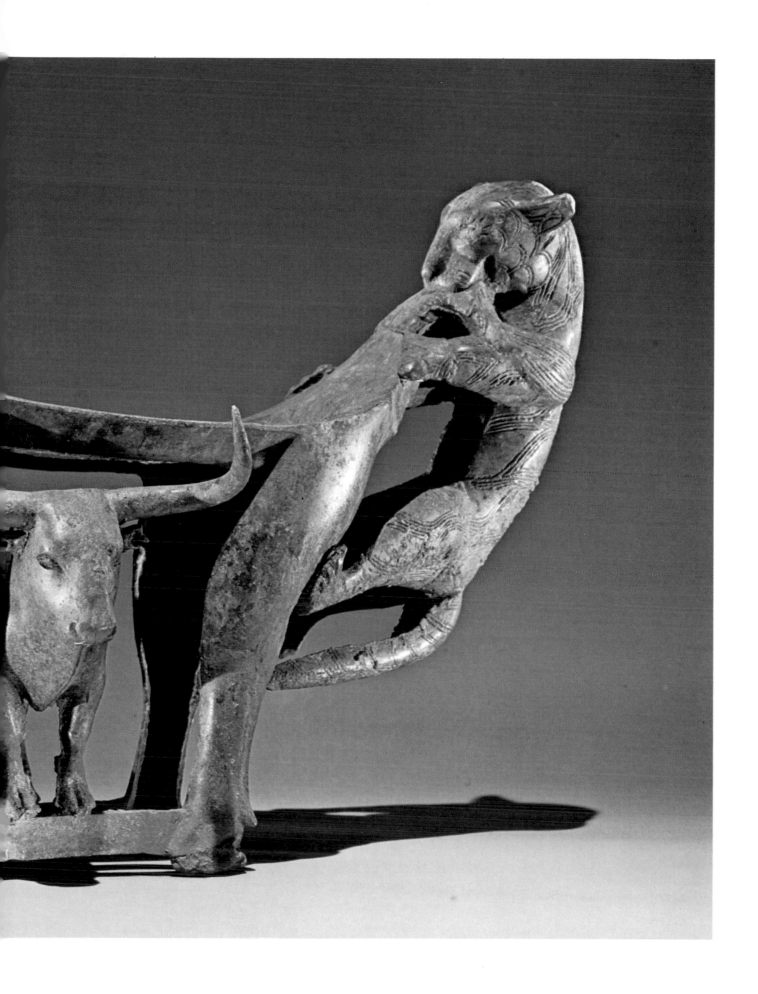

THE TERRACOTTA ARMY
OF THE FIRST EMPEROR OF QIN

The most important revelation in recent Chinese archaeology was the discovery in 1974 of a buried pottery army set in subterranean vaults near the tomb of the First Emperor of Qin, who unified China in 221 B.C. Created as an imperial bodyguard to serve the emperor in his afterlife, an army of over 7,000 life-size soldiers and horses sculpted in clay has begun to be uncovered (opposite), a spectacle awesome beyond imagination. Six of the figures and two horses have been included in this exhibition (nos. 98-105). Photograph: Wang Yugui, Cultural Relics Bureau, Beijing.

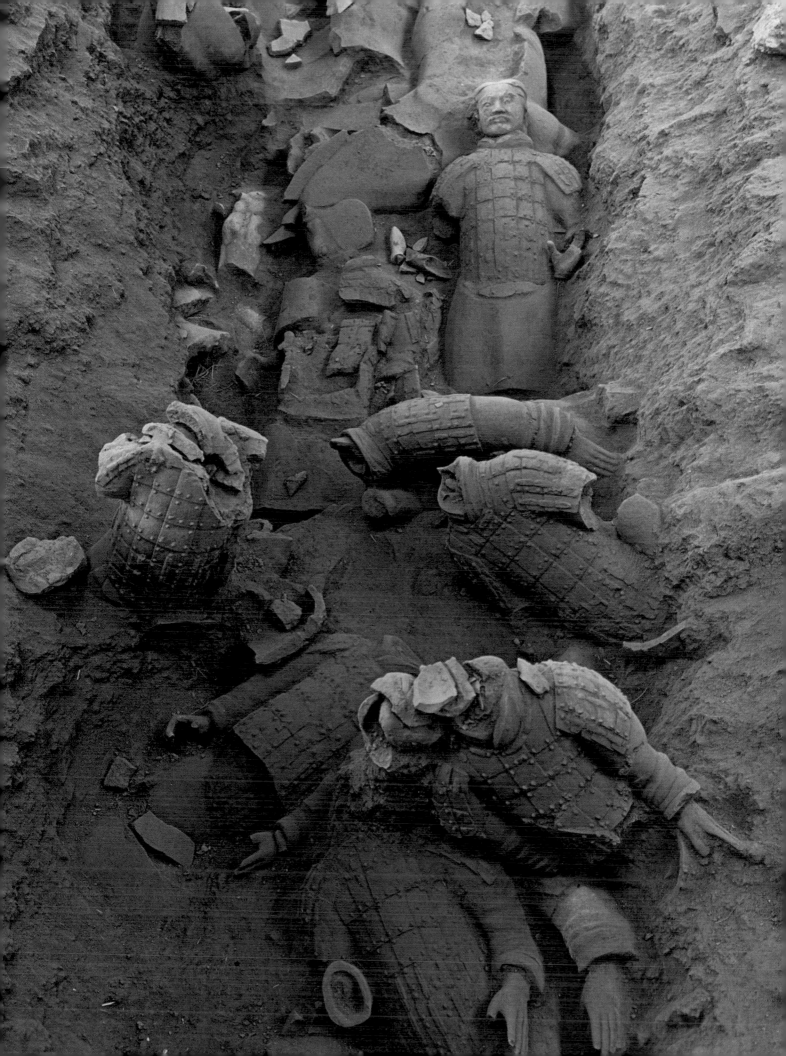

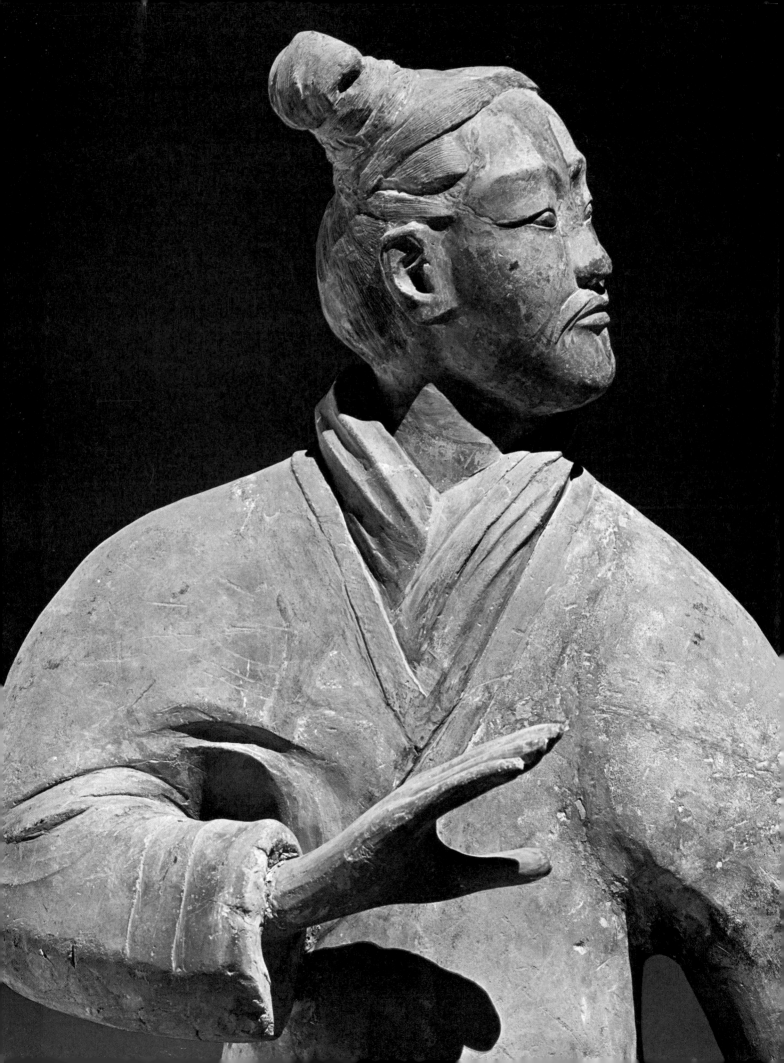

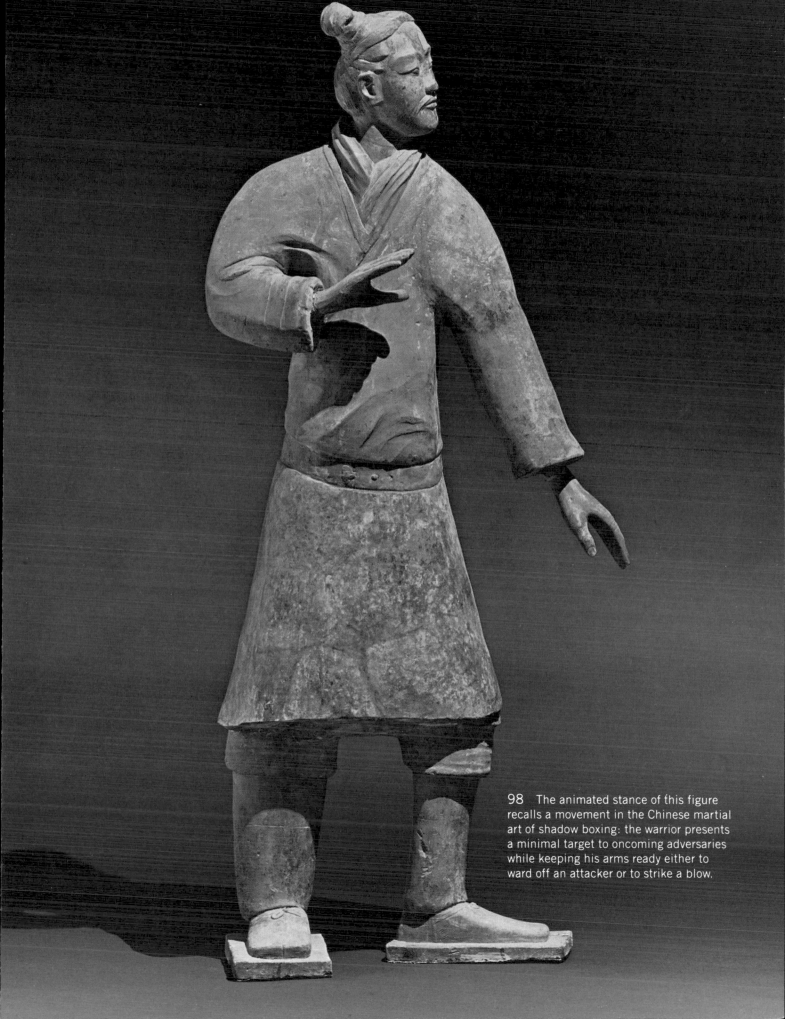

98 The animated stance of this figure recalls a movement in the Chinese martial art of shadow boxing: the warrior presents a minimal target to oncoming adversaries while keeping his arms ready either to ward off an attacker or to strike a blow.

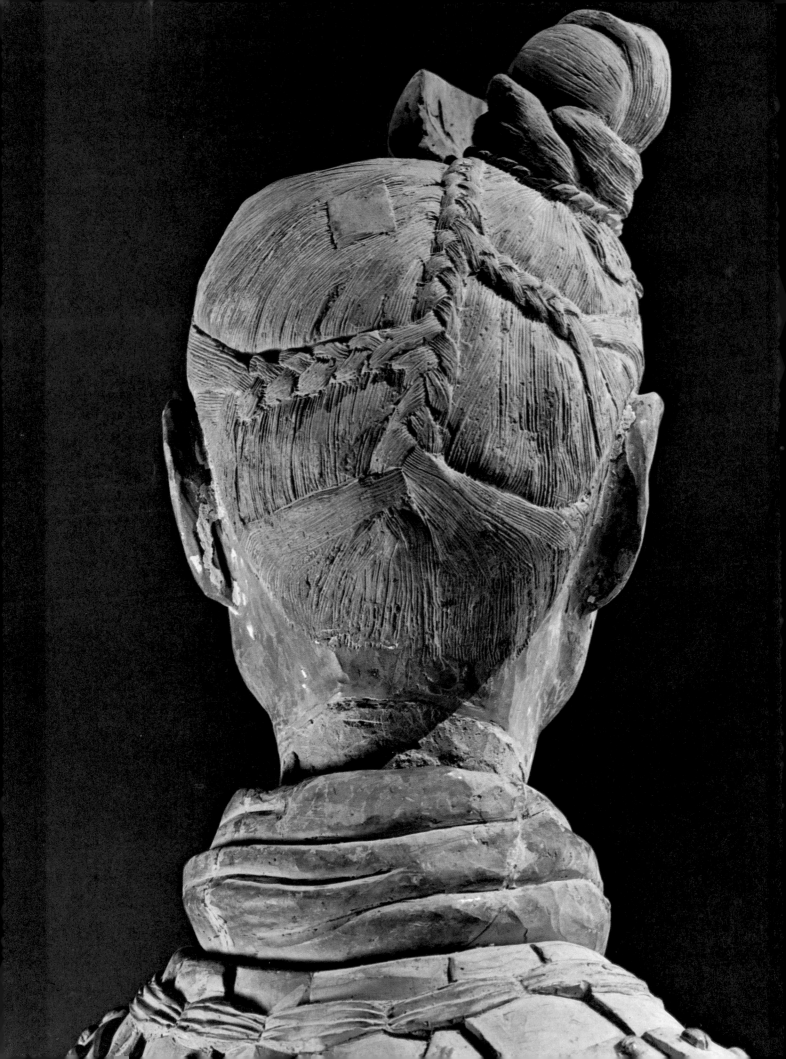

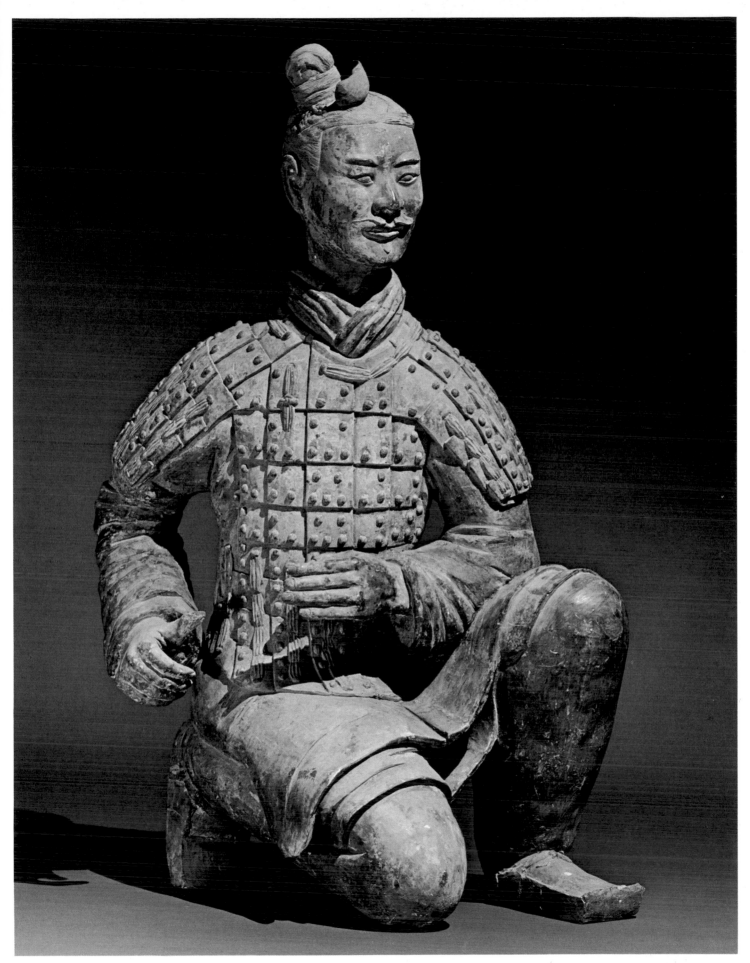

99 The arms of the kneeling archer above are flexed as if cradling a bow; actual arrowheads, traces of wooden bows, and fragments of swords and scabbards were found alongside such figures. The exacting portrayal extends to the minutely rendered details of the archer's elaborate coiffure (detail opposite).

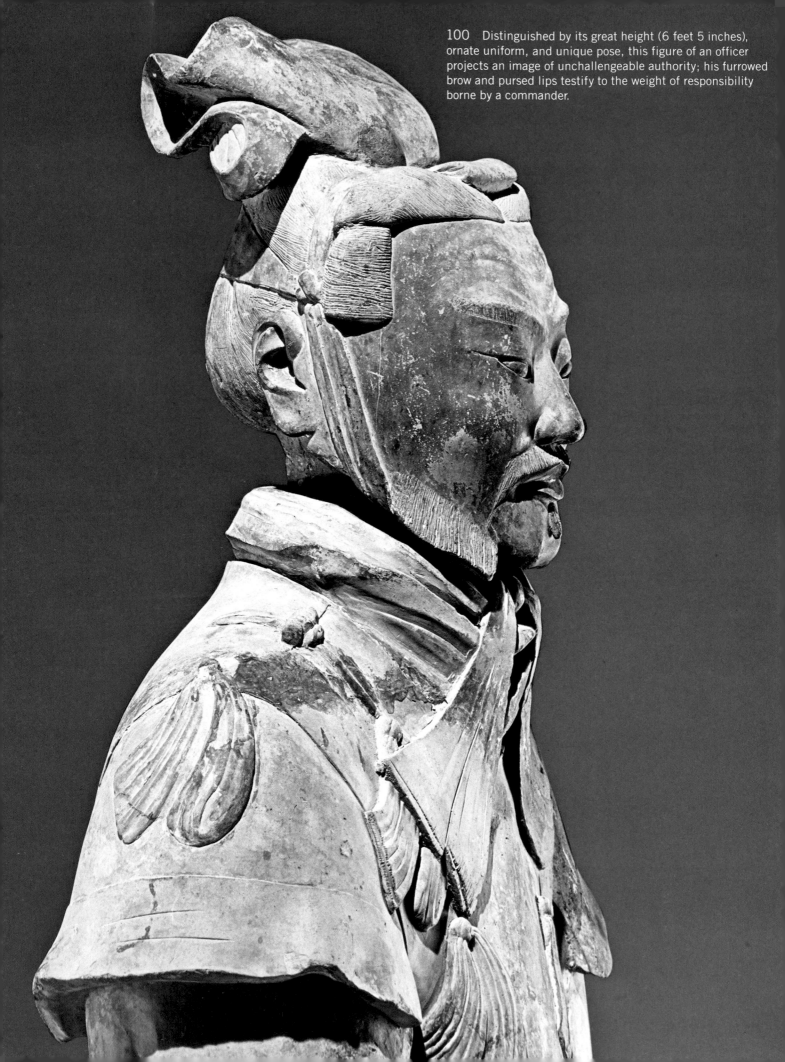

100 Distinguished by its great height (6 feet 5 inches), ornate uniform, and unique pose, this figure of an officer projects an image of unchallengeable authority; his furrowed brow and pursed lips testify to the weight of responsibility borne by a commander.

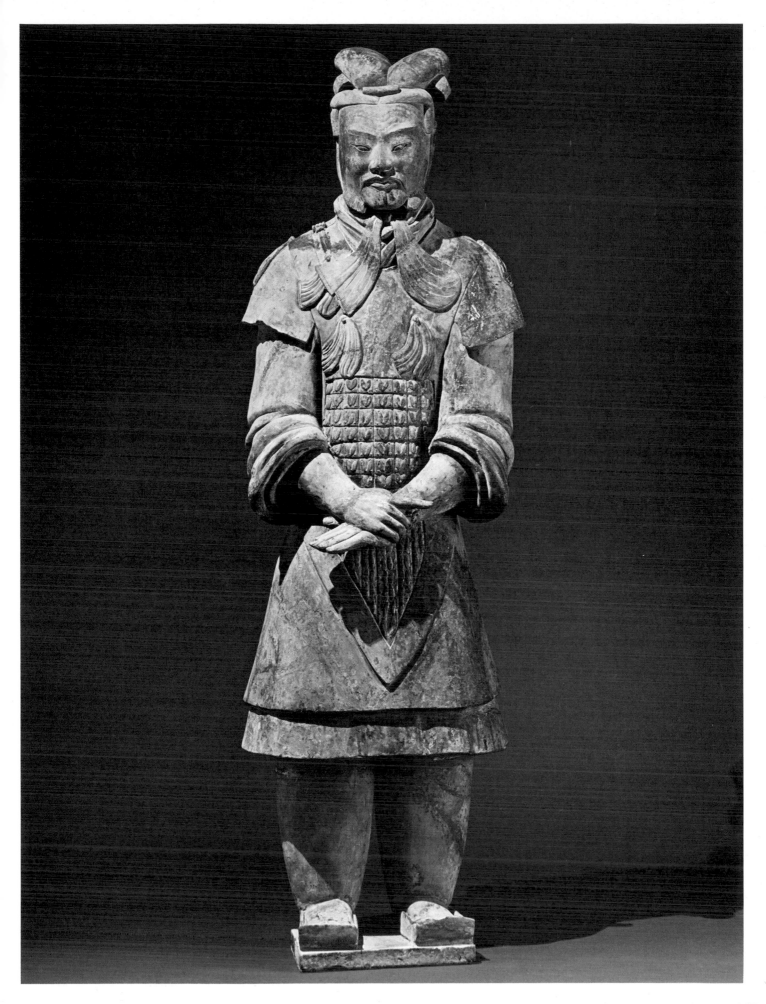

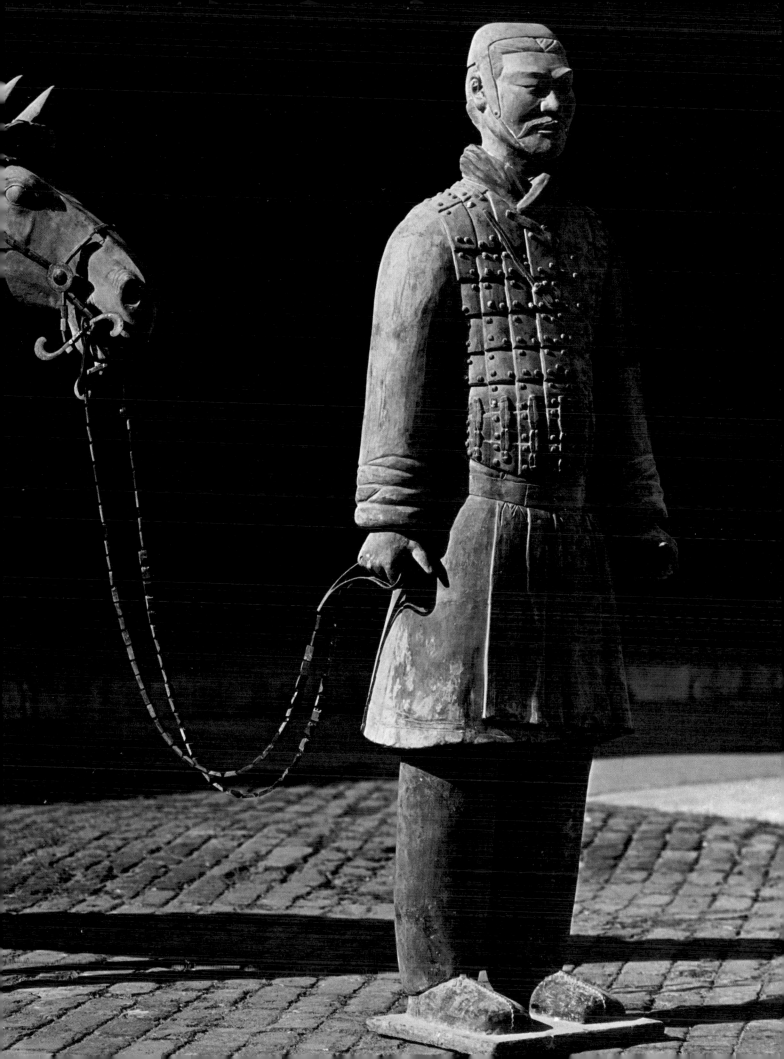

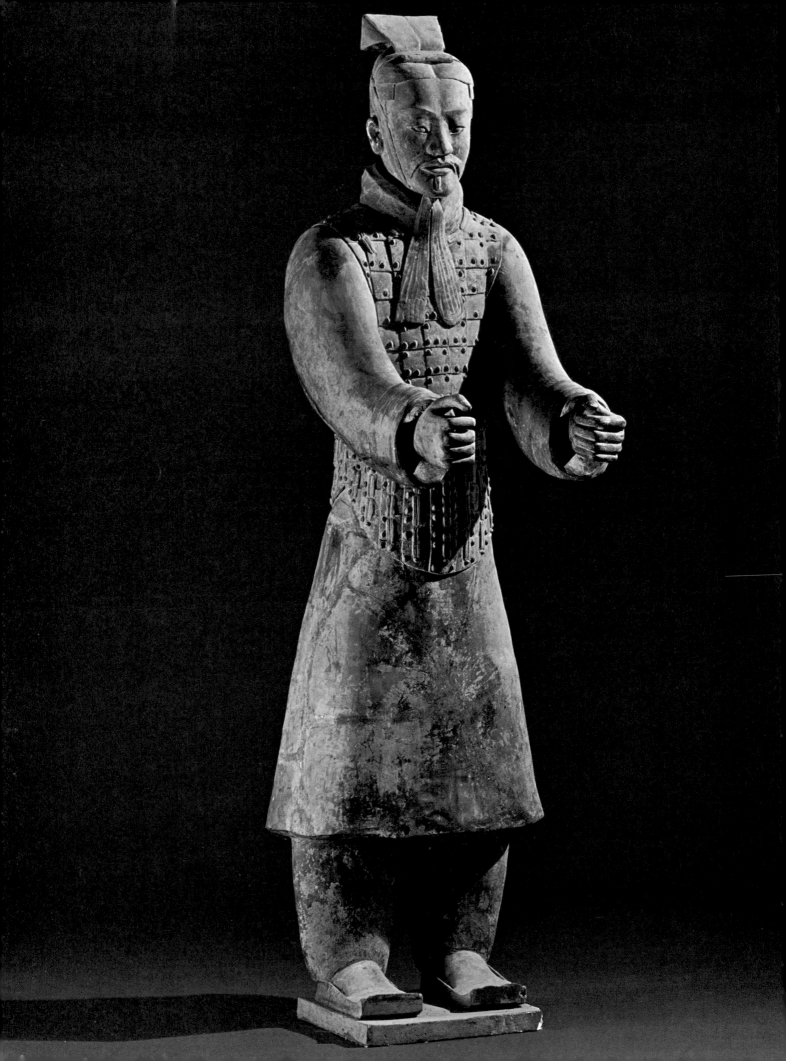

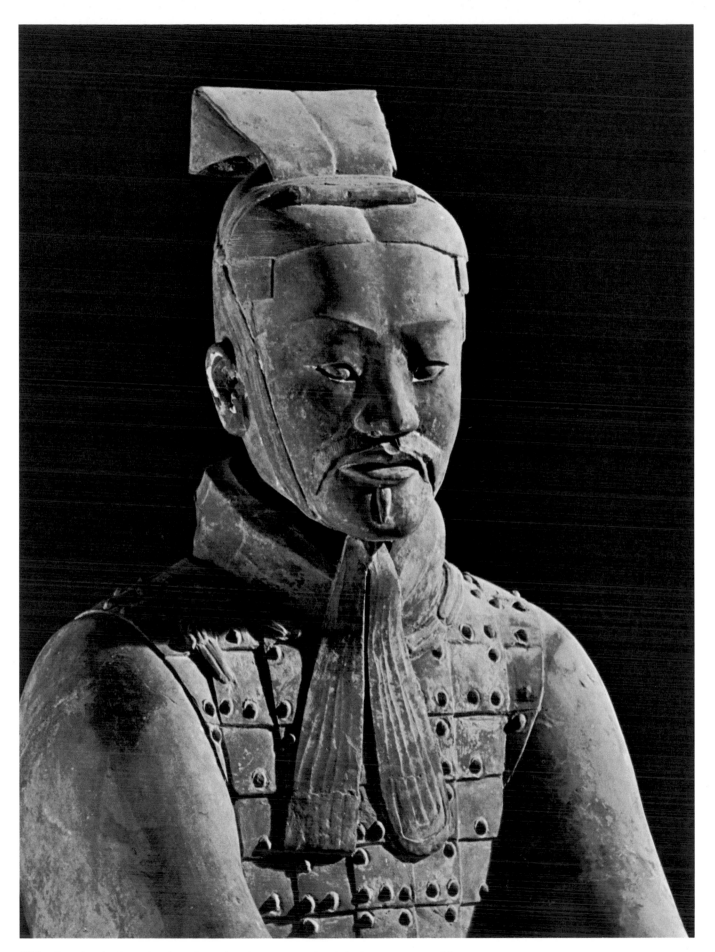

103 Despite the introduction of cavalry, the army retained the less maneuverable
chariot as a symbol of authority and for use as a command car. The imposing
height of this charioteer suggests that the status of chariot-mounted warriors
continued to be higher than that of foot soldiers.

171

104 Of the same stocky breed as the erect saddle horse
(no. 102), this chariot horse reveals his different character and
function: his tail is bound up to keep it clear of the harness
traces, and he strains forward against the reins in an expression
of bridled power.

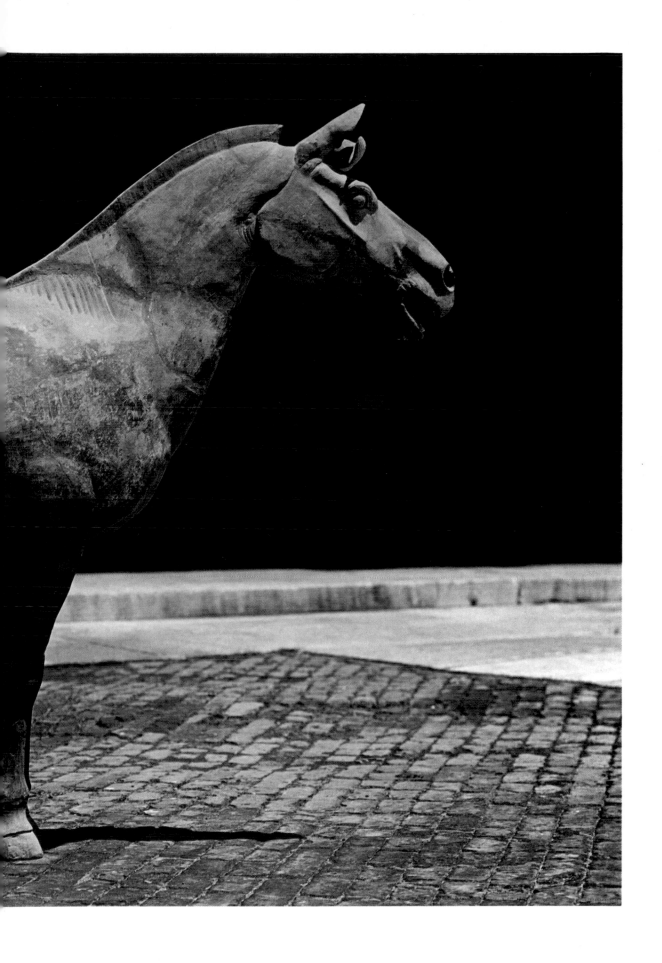

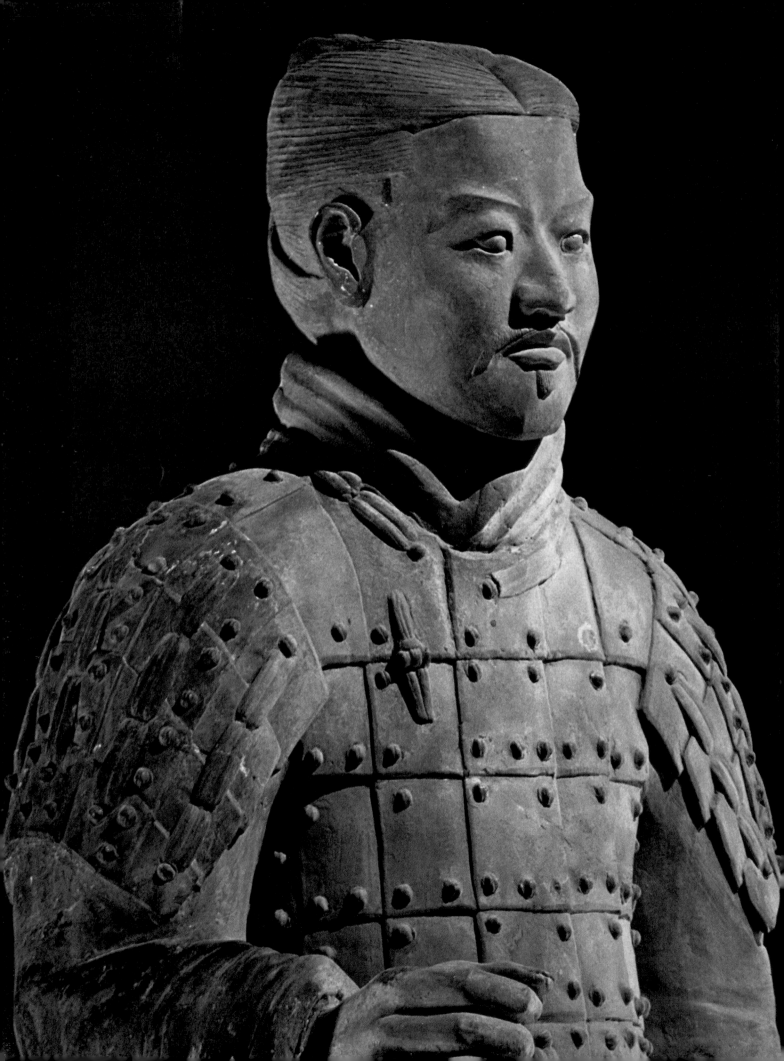

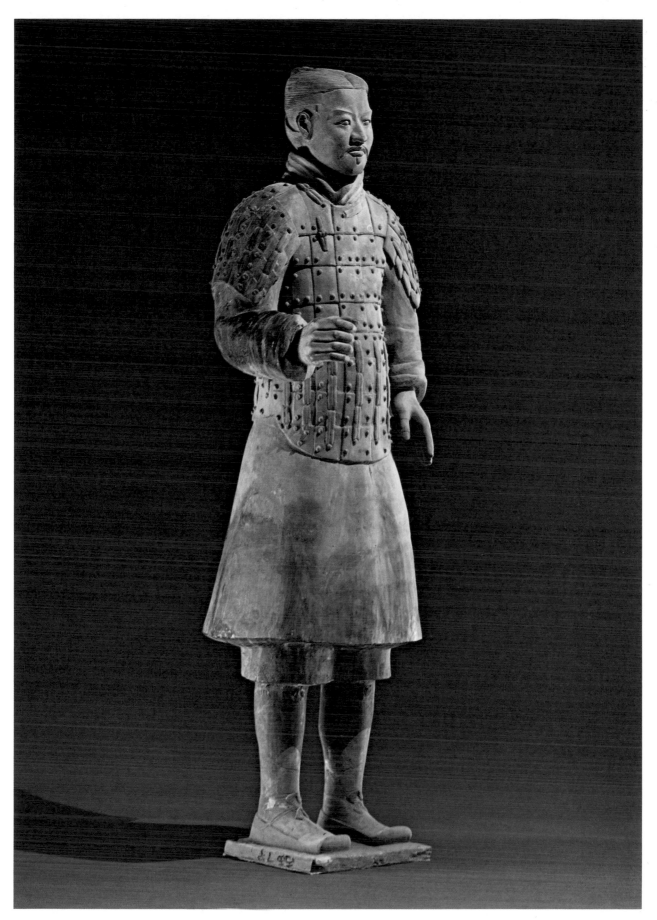

105 The vast majority of soldiers in the terracotta army are armored infantrymen, such as this foot soldier. The contemporary canon of beauty is epitomized by his face, sculpted with great sensitivity.

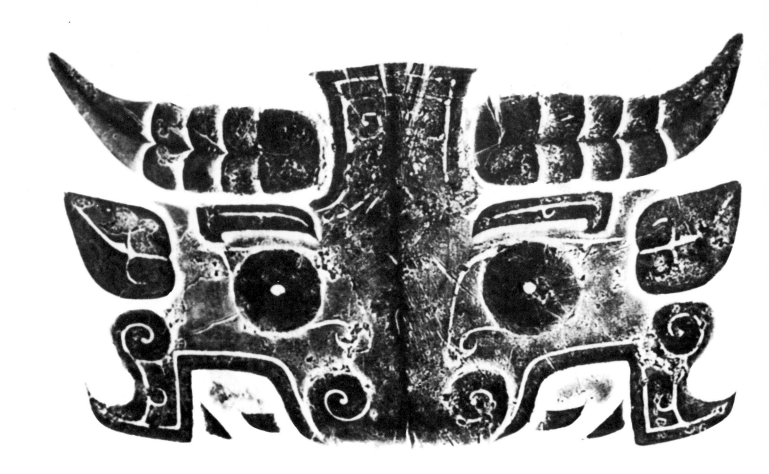

CATALOGUE

1 The Beginnings of the Bronze Age

The Erlitou Culture Period
First Half of the Second Millennium B.C.

1 The graceful, mannered proportions of this fastidiously shaped wine cup bear witness to the Erlitou craftsman's conscious concern for formal, aesthetic matters. His concern extended to a careful finishing of the object, and all the casting seams—where the sections of the mold met—have been polished away. Although the entire piece was made in one casting, its rim seems deliberately to imitate the inward-folding edge that might be expected in a vessel made from sheet metal. This feature may indicate that the Erlitou bronzes draw on a still more archaic stage of metalworking, when objects were formed from sheet metal or hammered into shape rather than cast.

The piece is the earliest decorated Chinese bronze so far known. The primitive design—five large dots bordered by a pair of lines in relief—occurs at the waist on the side away from the handle.

Three-legged wine vessel (*jue*). First half 2nd millennium B.C. (Erlitou culture period). Height 10⅛ in., weight 1 lb. 3 oz. Found 1975, Erlitou, Yanshi Xian, Henan Province. Cultural Office of Henan Yanshi Xian

2 An outstanding example of a rare shape, this impressive jade blade is nineteen inches long. It may have been derived from a metal ancestor, some sort of elongated ax; the haft was probably attached at right angles to the blade.

The task of extracting a finished object from a block of refractory jade was managed by a series of difficult and time-consuming operations. It was designed by drawing its outline on a flat slab sawn from the block, taking into consideration the stone's veins and flaws. The outline was then cut from the slab. One side of the blade remains perfectly flat, but the other was worked so its thickness decreases slightly toward the short end, and the edge itself is ground very sharp. The decoration involved the most limited technical means used with telling effect: the lapidary has applied saw cuts in two different ways, first enriching the flat surface with parallel lines and grooves, then

sawing the edges to produce a jagged silhouette that is striking and unforgettable.

Jade blade. First half 2nd millennium B.C. (Erlitou culture period). Length 19 in. Found 1975, Erlitou, Yanshi Xian, Henan Province. Cultural Office of Henan Yanshi Xian

3 The prototype for this jade knife is a very ancient one and—like the jade craft itself—reaches back beyond the Bronze Age into Neolithic times. The blade is an enlarged copy of a Neolithic harvesting knife: too large for use, of course, and of too precious a material. The perforations along the unsharpened edge would serve to attach a backing or a grip for the hand in a functional knife. The polish of the blade is nearly perfect, and the ends of the knife are superbly shaped and finished.

Jade knife. First half 2nd millennium B.C. (Erlitou culture period). Length 25⅝ in. Found 1975, Erlitou, Yanshi Xian, Henan Province. Cultural Office of Henan Yanshi Xian

2 Vigorous Development

The Zhengzhou Phase (The Erligang Period)
Mid-Second Millennium B.C.

4 To judge from the simple shape and threadlike relief decoration, this large cauldron is one of the earliest bronzes from the Panlongcheng site. The proportions of the deep bowl and clumsy legs are not subtle, but the designs of the ornamental band are vigorously drawn and floridly attractive. The decoration marks the first appearance in this exhibition of the animal-mask motif, which becomes the principal motif of Shang bronze art.

The vessel was cast in a mold with three vertical divisions; traces of seams run down the sides of the bowl and onto each leg. The hollow legs are open to the interior of the vessel, so that the cores for the legs could conveniently be made as conical extensions from the main casting core. One of the legs is recast, the new part fitting like a loose shell over the stump of the old.

Cauldron (*ding*). Mid-2nd millennium B.C. (Zhengzhou phase). Height 21¼ in., weight 21 lb. 2 oz. Excavated 1974 from Lijiazui M2, Panlongcheng, Huangpi Xian, Hubei Province. Hubei Provincial Museum

5 This lobed, spouted pouring vessel represents a shape fairly common at sites of the Zhengzhou phase, but rare thereafter. The finely shaped lower part, which imitates Neolithic ceramics with three hollow legs, is covered by a domed lid that, seen from above, becomes a face, with simple circular eyes in relief, a spout suggesting a nose, and the aperture below it a gaping mouth.

Although it was made entirely by casting, this vessel offers tantalizing clues to an earlier stage of metal technology that relied less exclusively on the casting process. The domed cover—which makes removal of the core after casting inconvenient—imitates a wrought-metal object so accurately that it can be used to illustrate the process of manufacture of its prototype. The domed shape is a typical product of the smith's hammering technique, and the tubular spout rolled from sheet metal is equally familiar in wrought-metal traditions. The cover would have been joined to the vessel by flaring the edges of both pieces and folding one over the other, a technique known as crimping; the crimped join is meticulously reproduced here.

Wine vessel (*he*). Mid-2nd millennium B.C. (Zhengzhou phase). Height 13⅝ in., weight 4 lb. 1 oz. Excavated 1974 from Lijiazui M2, Panlongcheng, Huangpi Xian, Hubei Province. Hubei Provincial Museum

6 This piece represents one of the most characteristic of Shang vessel types. The patterns around the flared upper part are relaxed, fluent, and richly varied, while the casting is exceedingly fine, the sharp-edged relief areas rising cleanly above the vessel's wall.

Wine vessel (*jia*). Mid-2nd millennium B.C. (Zhengzhou phase). Height 11⅞ in., weight 5 lb. Excavated 1974 from Lijiazui M1, Panlongcheng, Huangpi Xian, Hubei Province. Hubei Provincial Museum

7 This bronze ax stands alone: no other example remotely approaches it in quality. The designs along three sides of the blade, drawn with easy brilliance and sharply cast, are fresh inventions, unknown from other bronzes; elements recognizable as eyes and perhaps rows of teeth are playfully combined without any attempt at zoological plausibility.

The expressive power of the blade resides

chiefly, however, in its splendid silhouette. The perfect regularity of the large circular perforation serves to set off the less predictable curves of the cutting edge and sides, investing with the most intense significance an outer perimeter that might otherwise go unremarked.

Found in the same tomb as vessels nos. 4 and 5, this ax possibly played a role in the ceremony of burial, serving to behead the three sacrificial victims that were found in the tomb.

Ax (*yue*). Mid-2nd millennium B.C. (Zhengzhou phase). Length 16⅛ in., weight 8 lb. 8 oz. Excavated 1974 from Lijiazui M2, Panlongcheng, Huangpi Xian, Hubei Province. Hubei Provincial Museum

8 This food storage vessel is the earliest known example of a type common in later times. It was cast in a mold with three vertical divisions, with one animal mask ornamenting each division. No provision was made in this tripartite decorative scheme for the two handles, which have almost the look of an afterthought: they were in fact cast on in a second operation, locked in place through holes left in the side of the vessel. Since one handle was located on the seam that separates two animal-mask units, the handle diametrically opposite had to be set in the middle of a mask, a disconcertingly asymmetrical placement.

The handles are not the simple straps hitherto seen, but hollow shells with more substantial proportions. The upper end of each handle is shaped into a flattish animal head, the first appearance of a feature standard in later times on many vessel types.

Food container (*gui*). Mid-2nd millennium B.C. (Zhengzhou phase). Height 6⅞ in., weight 6 lb. 3 oz. Excavated 1974 from Lijiazui M1, Panlongcheng, Huangpi Xian, Hubei Province. Hubei Provincial Museum

9 Like no. 8, which came from the same tomb, this wine vessel is the earliest known example of its type. A detail not seen on the preceding objects is the generous use of small circles in rows bordering the various decorative friezes. The application of the handle to the vessel and lid is a tour de force of bronze casting. The handle was made first and then inserted into the mold for the vessel proper, which was thus cast onto the loops at the ends. Two further operations were required to cast the link to the lid and the handle to the link. The order of these operations might be shuffled.

Wine vessel (*you*). Mid-2nd millennium B.C. (Zhengzhou phase). Height 12¼ in.,

weight 3 lb. 12 oz. Excavated 1974 from Lijiazui M1, Panlongcheng, Huangpi Xian, Hubei Province. Hubei Provincial Museum

10 This extraordinary blade—over three feet long—is worked from a single piece of jade. The thickness of the blade nowhere exceeds ¹⁄₁₆ inch, and the edges are ground very sharp, so that the stone becomes translucent. The extreme restraint and understatement of all its details, executed with the utmost precision on an object of such remarkable size, give an air of great austerity and subtlety of expression.

It is based on a bronze halberd that was the characteristic weapon of the Chinese Bronze Age. The blade of the bronze weapon, sharpened on both edges, typically has the same asymmetrical outline as the present blade, with a slight downward curvature: the haft of the weapon was perpendicular to the length of the blade. In jade, however, such blades were made for ceremonial or mortuary purposes: a blade like the present one was too large, too fragile, and too expensive for practical use, and was almost certainly never hafted. In Shang tombs jade halberd blades are frequently found in a small pit sunk beneath the coffin; the pit ordinarily contains either a dog or, in richer tombs, a man, both apparently serving as guardians. Like other jade halberd blades from guardian pits in Panlongcheng tombs, the present example was found broken in several pieces. The breakage may have been deliberate, serving to "kill" the blade before interment.

Halberd (*ge*) blade. Mid-2nd millennium B.C. (Zhengzhou phase). Length 36⅝ in. Excavated 1974 from Lijiazui M3, Panlongcheng, Huangpi Xian, Hubei Province. Hubei Provincial Museum

11 Almost forty inches tall, this monumental rectangular cauldron is the most imposing bronze yet attributable to the Zhengzhou phase of the Shang period. It is also one of the earliest examples of its type known.

The decoration on the body is laid out in a scheme devised especially for the flat walls: a rectangular panel, left blank, is bordered on bottom and sides by rows of small round bosses, and above by a frieze of animal masks. In all the animal masks (which also appear on the legs), only the eyes are rendered unambiguously, though other parts of the creature—horns, nose, jaw, and two bodies (one on either side of the face)—can be found by a sufficiently imaginative observer. The elegantly drawn eyes, of which this vessel offers the earliest example in the

exhibition, are one of the most pervasive and characteristic of Shang design elements.

Rectangular cauldron (*fang ding*). Mid-2nd millennium B.C. (Zhengzhou phase). Height 39⅜ in., weight 181 lb. 4 oz. Found 1974, Zhengzhou, Henan Province. Henan Provincial Museum

3 The Spread of Shang Culture

The Appearance and Growth of Regional Bronze-Using Cultures 15th–11th Centuries B.C.

12 The ornamental patterns on this small and engaging vessel are reasonably close to those on pieces found at Panlongcheng (nos. 8, 9) and it cannot have been made much later than the end of the Zhengzhou phase. It was recovered from a damaged tomb in Beijing that contained sixteen bronze vessels, some comparable in date and others a little more advanced. Jades and ornaments of gold—a metal very rare in Shang finds—and one ax blade of iron (presumably meteoritic) were also found in the tomb. The discovery of an early Shang tomb as far north as Beijing testifies to a wide distribution of Shang civilization in pre-Anyang times.

Cauldron (*ding*). 15th-14th century B.C.? (Zhengzhou-Anyang transition). Height 7⅛ in., weight 2 lb. 12 oz. Found 1977, Lijiacun, Pinggu Xian, Beijing Metropolitan District. Beijing Cultural Relics Bureau

13 The unusual and somewhat bizarre puffy high relief in the main register of this piece represents a short-lived artistic episode in which high relief is introduced to give emphasis to the principal elements of motifs (here the horns, nose, bodies, and vestigial jaws of the animal mask), in order to rescue them from submergence in an overwhelming mass of fine details. Later, motifs will be made to stand out against subordinate filler patterns more dramatically, by the establishment of a distinction between image and ground: the animal mask and other motifs will be set against a very fine spiral background pattern.

The decoration is sharply and deeply executed. Each third of the circumference, corresponding to one section of the mold, contains four nearly identical pattern units on the shoulder and two on the foot. Although it might be supposed that such identical design units were mass-produced—for instance by stamping from a master pattern—in fact they all differ in details and

were executed individually; this seems invariably true of repeated designs on Shang bronzes, stamped patterns appearing only in the latter part of the Zhou period.

Wine vessel (*pou*). 15th–14th century B.C.? (Zhengzhou-Anyang transition). Height 10⅝ in., weight 16 lb. 8 oz. Found 1972, Taixicun, Gaocheng, Hebei Province. Hebei Provincial Museum

14 The organic features of all the motifs on this magnificent bronze recede from view in its highly elaborate linear ornament, the regular array of fine quills and swirling lines interrupted only by the boldly prominent eyes. It is chiefly the syncopated arrangement of these eyes, varying in size and recurring at different intervals in different friezes, that is responsible for the somewhat uncanny expression of the vessel.

It was cast in a three-part mold, with the large and handsome rams' heads overhanging the shoulder cast on afterward.

It is not known where this vessel was found, but examples with similar ornament have been discovered in many areas of Shang territory. The wide distribution of these closely related designs would seem to indicate that they belong to the "metropolitan style" of their time.

Wine vessel (*lei*). 15th–14th century B.C.? (Zhengzhou-Anyang transition). Height 20½ in.; weight 112 lb. 10 oz. Palace Museum, Beijing

15 The progress of the bronze art during the Zhengzhou phase is well illustrated by comparing this vessel with the fragile and awkward example from Erlitou (no. 1). In every essential, the Erlitou cup is the prototype; but the decisive proportions and solid, massive casting of the later vessel demonstrate the foundryman's complete mastery of his art in the time that separates the two. The unusual height of the body is accentuated by a gradual and restrained flare toward the rim. The inherent asymmetry of the vessel type is stressed by the massive spout, which the modest tail opposite does nothing to balance; and this effect of willful, irrational proportions is enhanced by the almost monumental capped post that forks over the base of the spout. Few if any later examples of this most common vessel type can rival the concentrated force and monumentality of this piece.

Three-legged wine vessel (*jue*). 15th–14th century B.C.? (Zhengzhou-Anyang transition). Height 15⅛ in., weight 3 lb. 12 oz. Found 1965, Feixi Xian, Anhui Province. Anhui Provincial Museum

16 This wine container was found with a second, matching vessel and the wine cup no. 15 and its mate; the pairing of these types, both used for offerings of wine, was common in the Shang period. The vessels bear similar decoration, their large post caps were all cast in the same way, and it may be assumed that they were made as a set.

Wine vessel (*jia*). 15th–14th century B.C.? (Zhengzhou-Anyang transition). Height 21¼ in., weight 17 lb. 4 oz. Found 1965, Feixi Xian, Anhui Province. Anhui Provincial Museum

17 This cauldron is a distinctly provincial version of a fairly standard type, the shallow bowl with flat legs in the shape of birds or dragons. The earliest examples of the type, including one unearthed at Panlongcheng, have the deep bowl of the traditional three-legged cauldron, but the shallow bowl is invariable after the Zhengzhou phase.

The flat legs, ordinarily cast with the rest of the vessel, in the present case were precast. The tigers on the handles, on the other hand, were cast on, each having been formed in a mold of two sections.

The precast legs and cast-on tigers are technical oddities seldom if ever encountered on comparable vessels from northern foundries, and they point also to the chief stylistic quirks of the piece. The tiger motif, though it does occur in the north, is associated particularly with the south by virtue of its frequent appearance on bells of a southern type (cf. no. 19). Paired tigers—but more often dragons—sometimes appear as surface decoration on the outer faces of handles (nos. 32, 52), but three-dimensional animal figures perched on such handles seem to be unknown in metropolitan Shang factories.

Cauldron (*ding*). 15th–14th century B.C.? (Zhengzhou-Anyang transition). Height 12⅛ in., weight 7 lb. 6 oz. Found 1975, Qingjiang Xian, Jiangxi Province. Jiangxi Provincial Museum

18 This is only the second bronze drum known from the Shang period; its sound is still quite nice. Like no. 17, this piece is one of the earliest bronzes of distinctly provincial character.

Although it evidently imitates a drum made in some other material, the construction of the prototype is not clear. The drumheads—perhaps animal skin—seem to have been attached by rows of tacks.

Drum (*gu*). 15th–14th century B.C.? (Zhengzhou-Anyang transition). Height 29¾ in., weight 93 lb. 8 oz. Found 1977, Chongyang Xian, Hubei Province. Hubei Provincial Museum

19 A pair of small striped tigers climb up each wall inside this bell. It apparently belongs to a group of five discovered in 1959, neatly arranged in a small pit. The sides of all five bells are decorated with the same principal motif, a nearly unrecognizable version of the animal mask executed in a relief formed of massive ropelike strands. The margins surrounding the mask are covered with a uniform mesh of scrollwork patterns, a key feature of these provincial bronzes from the south.

One of the bells from the cache has been analyzed and is reported to be ninety-eight percent copper. So high a figure suggests that the impurities are only accidental. Perhaps tin was temporarily unavailable; whatever the reason, its lack only increases the difficulty of melting and casting, since copper alloyed with tin has a lower melting point and better casting properties. The finished objects show little sign of technical difficulties, however. The size of the present bell—it is almost three feet tall—alone testifies to an awesome technical capacity in southern foundries.

Bell (*nao*). Anyang period (ca. 1300–ca. 1030 B.C.). Height 35 in., weight 338 lb. 12 oz. Found 1959, Laoliangcang, Ningxian Xian, Hunan Province. Hunan Provincial Museum

20 Whether considered as a feat of artistic imagination or as a tour de force of casting, this unique vessel seems equally astonishing. It is doubly surprising that so high a level of achievement should be attributed to a provincial foundry rather than to the Anyang capital.

The starting point for the design is a standard Anyang vessel type, but the southern artist's evident willingness to sacrifice the architectural qualities of his Anyang models permitted the essentials of the type to be turned to very different effect. He substituted rams' heads for the birds that perched on the shoulders of Anyang examples, and then reshaped the entire lower part of the vessel to depict the legs and forequarters of the rams in a smoothly modeled relief. The resulting violent distortion of the Anyang shape is amply justified by the brilliance with which so bizarre an idea is carried out, and by the deft ingenuity with which meticulously observed realistic details are expressed within a conventional

vocabulary of pure ornament. Nowhere, in fact, do the surface patterns representing details of the rams' heads or bodies stray outside the ornamental repertory of the Anyang artist: the flanges that run along the edges of the vessel are neatly adapted to serve as tufted beards. The caster has even remembered to include a cleft in the front of each hoof.

On the shoulder are eight horned dragons with coiled, snakelike bodies. By comparison with the extravagantly inventive lower part, the remainder of the vessel is quite conventional. The only real departure from the Anyang idiom lies in the flanges, whose designs are drawn with unusual elegance and regularity. They moreover include one amusing detail found only on the upper part, at the very bottom of the flange in the middle of each side: by the simple addition of a tiny eye and bill, the lower end of the flange is transformed into the silhouette of a small duck facing downward. This conversion of a flange into a bird is a recurrent theme in the southern bronze industry.

Square wine vessel (fang zun). Anyang period (ca. 1300-ca. 1030 B.C.). Height 23 in., weight 75 lb. 14 oz. Found 1938, Ningxiang Xian, Hunan Province. Historical Museum, Beijing

21 Each side of this oddly decorated wine vessel is filled entirely by a single animal mask turned mouth upward. The lower jaw is, as usual, seen in profile and doubled so that the mouth edged with teeth is repeated on either side of the broad snout. The animal's tall U-shaped horns are seen against a dense pattern of spirals; between the two horns appears a cicada with long tendrillike appendages. The handle terminates in triangular, horned dragon heads.

This piece comes from a richly furnished grave discovered in 1959. Many of the fourteen bronze vessels found in the tomb are eccentric in decoration or unfamiliar as types. Also numbered among the tomb furnishings were objects of bone and jade, and the occupant wore gold ornaments. From oracle inscriptions we learn the names of a host of statelets that were situated in the area of this find: deducing the precise locations of these tribes is exceedingly difficult, but the state of Guifang, a formidable enemy of the Shang king, may have lain somewhere in the vicinity of the tomb.

Wine vessel (hu). Anyang period (ca. 1300-ca. 1030 B.C.). Height 16½ in., weight 10 lb. 2 oz. Found 1959, Shilou Xian, Shanxi Province. Shanxi Provincial Museum

22 Wine vessels of this slender, round-bodied shape are rare, quite distinct from the more usual ones with S-curved profile and oval cross section (nos. 21, 31). The animal mask in the center of the main frieze has been much simplified, the patterns right and left of the face being organized into a neat array of regular spirals and thereby deprived of any zoomorphic content. This treatment seems to belong early in the Anyang period, a dating supported by the other twenty-one bronzes of the hoard from which this piece came.

An inscription on a similar example includes a clan sign that has been identified with a tribe or statelet called Qiangfang. Qiangfang is thought to have been situated near the southern end of the Shanxi-Shaanxi border, and thus a little to the south of Suide, where this vessel was found. It is noteworthy that Shang finds made there, at Shilou just across the river (cf. no. 21), and further north in Shanxi have included objects with affinities to the so-called "Ordos style," implying contact with nomadic populations in the northwest border region. Tribes like Qiangfang and Guifang are presumed to stand somewhere between the fully civilized Shang on the one hand and the barbarian nomads of inner Asia on the other. The numerous bronze vessels found at Suide and in central and northern Shanxi Province suggest that the populations of this region were rather more civilized than has generally been allowed.

Wine vessel (hu). Anyang period (ca. 1300-ca. 1030 B.C.). Height 12⅜ in., weight 6 lb. Found 1965, Suide Xian, Shaanxi Province. Shaanxi Provincial Museum

23 The blade of this large ax is perforated so as to depict a face in openwork—probably a human face, although all the features except the mouth are forms borrowed from animal-mask designs. The eyebrows and nose are plastic elements rising from the surface of the blade, while the other features are punched out. The face thus constructed is distinctly uncouth, with an almost barbaric force and vigor. The only other bronze depictions of human faces from the Shang period are modeled as plastic units.

The ax was found on the entrance ramp of a large tomb, unfortunately looted before excavation, at Sufutun, Yidu, Shandong Province. There were forty-eight sacrificial victims in the tomb. A second ax accompanying the first carries an inscription conventionally called the Ya Chou pictogram. Many bronzes with this inscription are

known, all of late Shang or early Western Zhou style, and a number of them are thought to have come from robbed tombs in the vicinity of Yidu. Possibly the pictogram and the Yidu tombs are associated with a Shang vassal state that survived into the early Western Zhou period: certain peculiar features of bronzes bearing the Ya Chou pictogram enjoy a brief currency in early Zhou bronze designs.

Ax (yue). Anyang period (ca. 1300-ca. 1030 B.C.). Height 12½ in., weight 10 lb. 5 oz. Excavated 1966 from Tomb No. 1, Sufutun, Yidu, Shandong Province. Shandong Provincial Museum

24 The surfaces of this small elephant-shaped container are crowded with ornament. The profusely varied motifs are rendered in high relief, sharp and delicate in execution and exceedingly forceful in design.

A small tiger with a tiny bird under its tail crawls down from the top of the elegantly curved trunk; the two bony lobes of the elephant's forehead are embellished with coiled snakes; not even the backs of the ears are left empty, this small space being occupied by birds whose long tail plumes extend in a curve onto the dome of the head. Dragons are disposed in every conceivable posture on the elephant's shoulder, body, front legs, and hindquarters. All the high relief ornaments are strongly silhouetted against a background of vigorous spirals, and ingeniously adapted to the contours of the body. It is a tribute to the sure tact of the Shang artist that the wealth of surface ornament does nothing to detract from the plumpness of this youthful and engaging creature.

The piece was found by a farmer in 1975, but no other artifacts were discovered in a later search of the spot. It has been suggested that this and other bronzes unearthed in Hunan and not associated with tombs, including nos. 19, 20, and 25, were buried as offerings to mountains or rivers. Although the elephant is decorated in what might be regarded as impeccable Anyang style, the only known Shang examples of this exceedingly rare vessel form seem to be associated with the south.

Elephant-shaped wine vessel (zun). Anyang period (ca. 1300-ca. 1030 B.C.). Height 9 in., weight 6 lb. 2 oz. Found 1975, Liling Xian, Hunan Province. Hunan Provincial Museum

25 The somewhat flattened body of this imposing, almost architectural bronze

serves to establish a preferred frontal viewpoint, and both the structure and the ornament are conceived with this viewpoint kept strictly in mind. The richly curved profile is everywhere emphasized by the formidable flanges, with their barbed projections and deep scorings. In contrast to the arresting silhouette, the ornament is subdued, consisting only of vertical ribbing and several varieties of birds, elegantly shaped and set against a background of fine angular spirals. The regular and precise disposition of these motifs reasserts the static symmetry of the shape, and avoids superfluous details that might compete for attention. The careless profusion of ornament on an object like no. 29, representing an earlier, preclassic stage, makes a sharp contrast with the noble grandeur of this bronze, the finest vessel of its type known.

The dark gray-green surface has the rich luster sometimes described as water patina, which depends on a high proportion of tin in the alloy. The much brighter green of the handle suggests that it was poured from a different batch of metal.

The piece was a chance find unearthed in 1970. There were no signs of a burial or of any other associated artifacts except for more than 320 jades found inside the vessel.

Wine vessel (*you*, inscribed with the character *ge*). Anyang period (ca. 1300-ca. 1030 B.C.). Height 15⅜ in., weight 23 lb. 10 oz. Found 1970, Ningxiang Xian, Hunan Province. Hunan Provincial Museum

26 This small three-legged vessel is distinguished from such predecessors as nos. 6 and 16 by its S-curved body and by its unusual decoration, in which the familiar animal-mask patterns are replaced by owls, which spread over the full height of the body. The principal motifs lie flush with the finely cast spiral background; sunken parts of the spirals retain traces of a black pigment, often applied to vessels decorated in this style in order to heighten the contrast between the motifs and the background. Above the owl's head, the decoration includes a configuration that may be a stylized character of the written language; on a very few Shang bronzes, inscriptions are in this way worked into the surface ornament.

An inscription of one character appears inside the vessel, in the center of the bottom, and can be transcribed by the modern graph *xi*. The vessel was found in what may have been a grave, with twenty-two other bronze artifacts, including four wine vessels also inscribed *xi*, possibly the name of the tomb's owner. None of the bronzes is stylistically outside the range of Anyang bronze casting, and the find might even be taken to typify the contents of a modest Anyang burial. The vogue of the owl as a motif of surface decoration seems largely confined to the earlier half of the Anyang period (cf. no. 29), and the contents of this tomb can probably all be dated to that time.

Three-legged wine vessel (*jia*, inscribed with the character *xi*). Anyang period (ca. 1300-ca. 1030 B.C.). Height 14¾ in., weight 9 lb. 7 oz. Found 1968, Wen Xian, Henan Province. Henan Provincial Museum

27 This magnificent vessel is discussed in Chapter 4. Although its provenance is unknown, it can be taken as typical of the finest bronzes cast in the latter half of the Anyang period, and its style is thoroughly metropolitan.

Worthy of special comment is the refined handling of the motifs at this late stage. As on no. 25, the elements set in high relief are disposed with extreme clarity against the sharply cast spiral background, and by comparison with earlier relief designs (such as nos. 29, 30), the ornament is simple and uncluttered. Nevertheless, the individual motifs are not mere silhouettes raised to a uniform height above the spiral ground. On the contrary, their shapes are elegantly modeled in three dimensions. Horns, tails, and jaws twist suddenly and throw sharp, curved, bladelike edges up into higher relief, and all the raised surfaces are enlivened with boldly incised spirals and volutes. The confusion that might be expected to result from such intricate detailing is forestalled by the careful spacing and proportioning of the motifs, and by their arrangement in a tightly knit, rigidly symmetrical ornamental scheme.

Square wine vessel (*fang lei*). Anyang period (ca. 1300-ca. 1030 B.C.). Height 20⅞ in., weight 65 lb. 2 oz. Shanghai Museum

4 A Classic Period in the Bronze Art

The High Yinxu Phase (Anyang Period), About 1300–About 1030 B.C.

28 Like the following twelve objects, this massive cauldron comes from Fu Hao's tomb. It is one of a pair; in their decoration, royal size, and even in the fact of being cast as a pair, they inevitably recall the much earlier cauldron no. 11. The ornament, now executed in high relief, has a new plasticity. The animal mask at the top is a typical Anyang version of the motif: to each side of the face is attached a horizontal body with a clawed foot and a curving, upturned tail. The peculiar anatomy of this double-bodied creature, which at an earlier stage was only vague and implicit (cf. no. 11), is now inescapable in the clear and unambiguous high-relief rendering.

Inscriptions on Shang bronzes are executed in a fancy script quite distinct from the ordinary writing of the time, more pictorial and more freely composed and varied. The inscription on this piece refers to Fu Hao not by her personal name, used in life, but by a posthumous name used in sacrifices by her descendants; and the character "mother" implies that in this case she is addressed by a son (or nephew, in Shang practice). Hence the vessel was cast for her funeral by her son or sons. She would not have been addressed in this way by the king, her husband, who presumably supplied many of the other bronzes in the tomb.

Rectangular cauldron (*fang ding*, inscribed Si Mu Xin, Fu Hao's posthumous title). Anyang period (ca. 1300-ca. 1030 B.C.). Height 31⅜ in., weight 258 lb. 8 oz. Excavated 1976 from Tomb No. 5, Anyang, Henan Province. Institute of Archaeology, Beijing

29 In the shape of a parrotlike bird, this vessel conveys a stolid energy much enhanced by the bristling silhouette and vigorously plastic surface ornament. Another bird and a tiny horned dragon with a curled tail perch atop the back half of the head, which is a removable lid. One of the most playful and unexpected features of this bronze appears below the handle—a small owl, reduced to a wide-eyed facial mask joined directly to stumpy wings with clawed legs.

An uninhibited delight in reinterpreting one shape as another—thoroughly characteristic of the Shang artist's flexible imagination—occurs several times on this piece, as in the case of the strange motif on the neck of the vessel, to either side of the beak: this motif is a bird in front, but toward the rear, the bird's body turns into a downward-facing dragon with gaping jaws.

Bird-shaped wine vessel (*zun*, inscribed with the name Fu Hao). Anyang period (ca. 1300-ca. 1030 B.C.). Height 18⅛ in., weight 36 lb. 12 oz. Excavated 1976 from Tomb No. 5, Anyang, Henan Province. Institute of Archaeology, Beijing

30 This ungainly animal is actually a composite: the front suggests a ram, while the hind legs, encased in feathers, face backward and belong to an owl whose wings are depicted on the body of the vessel. The owl's head, however, is missing altogether. The full length of the lid is occupied by the coiled body of a dragon whose horned head rises in high relief just behind the upraised horns at the front end. The handle of the vessel is surmounted by a small head with a plump nose and inward-spiraling horns, rather resembling a human face with a headdress.

Such vessels on four legs are very rare; ordinarily they rest on an oval foot rim (cf. no. 45).

Wine vessel (*guang*, inscribed Si Mu Xin, Fu Hao's posthumous title). Anyang period (ca. 1300-ca. 1030 B.C.). Height 14⅛ in., weight 18 lb. 11 oz. Excavated 1976 from Tomb No. 5, Anyang, Henan Province. Institute of Archaeology, Beijing

31 The flattened body of this large wine vessel serves to make the entire width of each of the six decorative friezes—unfortunately much obscured by green and gray corrosion—visible from a single frontal vantage point. The animal masks arrayed in these friezes are not plastic units, but instead are composed of separate parts individually raised in high relief. The horizontal divisions are stressed by breaks in the flanges, a refinement missing from many of the Fu Hao bronzes.

Wine vessel (*hu*, inscribed with the name Fu Hao). Anyang period (ca. 1300-ca. 1030 B.C.). Height 20¼ in., weight 37 lb. Excavated 1976 from Tomb No. 5, Anyang, Henan Province. Institute of Archaeology, Beijing

32 This graceful and finely proportioned vessel is supported by flattish legs in the form of dragons. It is the first example known of a rectangular analogue to the familiar round-bodied cauldron with three flat legs (such as no. 17), and one of the most satisfying designs among the bronzes from Fu Hao's tomb. The sides of the vessel are decorated with large animal masks flanked by downward-facing dragons, boldly executed in high relief against a background of loosely drawn spirals. The flanges are heavy and deeply notched, with the cornicelike overhanging rim contributing an effect of architectural mass and stability.

Rectangular cauldron (*fang ding*, inscribed with the name Fu Hao). Anyang period (ca. 1300-ca. 1030 B.C.). Height 16¾ in., weight 37 lb. 6 oz. Excavated 1976 from Tomb No. 5, Anyang, Henan Province. Institute of Archaeology, Beijing

33 This square version of a standard shape draws on a vocabulary of forms proper to architecture to achieve a convincing monumentality. The boxlike bottom of the vessel, decorated with animal masks, is nearly dwarfed by the extraordinarily massive legs and the overhanging flare of the upper section. The architectural air of the whole is accentuated by the massive flanges, applied like moldings to stress vertical lines, and by the firmly molded rim. A three-dimensional animal head at the upper end of the handle has large freestanding horns; the head appears to be devouring a bird, of which only the beak is visible. More explicit renderings of this theme are common at a later stage, on the handles of both Shang and Western Zhou bronzes (cf. nos. 41, 45, 49).

Square wine vessel (*fang jia*, inscribed with the name Fu Hao). Anyang period (ca. 1300-ca. 1030 B.C.). Height 26¼ in., weight 41 lb. 15 oz. Excavated 1976 from Tomb No. 5, Anyang, Henan Province. Institute of Archaeology, Beijing

34 This jade pendant is in the form of a hawk with outspread wings. The surface is covered with scrollwork patterns executed by incising lines side by side in pairs; each line of a pair is painstakingly beveled on the edge away from the other line, so that the thin strip of material between the two seems to stand in relief above the surface. On the reverse side the pendant is carved with similar patterns more carelessly incised in single lines.

Jade pendant. Anyang period (ca. 1300-ca. 1030 B.C.). Height 2⅜ in. Excavated 1976 from Tomb No. 5, Anyang, Henan Province. Institute of Archaeology, Beijing

35 The curved outline of this bird, with its dripping edges and swollen plumage, is quite extraordinary. The weight of the tail allows the pendant to be suspended symmetrically from the small nub set midway down the outer edge. The surface is polished smooth on both edges and faces, and left almost unembellished: besides a series of hooked lines defining the wing, there are only a few faint indications of the bird's eye and the lower edge and hinge of its jaw. In all cases these are raised lines, formed by grinding away the surrounding stone.

The openwork crest on the bird's head, which is only about half the thickness of the jade elsewhere, calls to mind a few bronzes likely to be from the South that are decorated with crested birds. It seems quite possible that this piece, which in style has nothing in common with other jades from Fu Hao's tomb, was made in South China.

Jade pendant. Anyang period (ca. 1300-ca. 1030 B.C.). Length 5⅜ in. Excavated 1976 from Tomb No. 5, Anyang, Henan Province. Institute of Archaeology, Beijing

36 The outline of this curious plaque suggests that it was recut from a fragment of a halberd blade, and in fact the stone is thinnest near the edges and thickest at the remnant of a median crest near the center.

The upper half of the piece takes the form of a dragon with a paw extended below its gaping mouth and a large tail arched above it. Lower down is a small bird with two appendages on its head, evidently representing horns seen from the front. The bird's clawed foot clutches the lowermost section of the jade, an irregular piece that perhaps owes its shape to a break in the stone.

The dragon's body is illogically supplied with a large eye set upside down behind the paw; this favorite Shang design element recurs on the arms of the human figure no. 39.

Jade plaque. Anyang period (ca. 1300-ca. 1030 B.C.). Length 4½ in. Excavated 1976 from Tomb No. 5, Anyang, Henan Province. Institute of Archaeology, Beijing

37 This fairly thick plaque depicts a human figure on both sides, with two winglike crests on the head and small tabs projecting below the feet as though for insertion into a support of some kind. The surface is not highly polished. Incised lines mark the fingers and toes, and incised double lines decorate the body elsewhere. The features of the face are not incised, however, but crudely modeled—a wide mouth, flat nose, eyes, and bushy eyebrows. The faces on the two sides differ slightly, and the position of the hands is also not the same; one side is female, and it is possible that the other is meant to be male.

Jade plaque. Anyang period (ca. 1300-ca. 1030 B.C.). Height 4⅞ in. Excavated 1976 from Tomb No. 5, Anyang, Henan Province. Institute of Archaeology, Beijing

38 This compact figurine represents a dragon with a massive, blocky head and a small body curled up asymmetrically on the right side; it rests on two forepaws and its tail. On the right side the jade shows dark green; the left side is discolored brown. The last coil of the tail is formed by a drill hole, a suspension hole is drilled in the chin, and the teeth that line the gaping jaws were formed by repeated drillings.

Jade figurine. Anyang period (ca. 1300-ca. 1030 B.C.). Length 3¼ in., weight 8 oz. Excavated 1976 from Tomb No. 5, Anyang, Henan Province. Institute of Archaeology, Beijing

39 The carver's resolute effort to model the features of this small figure's face was only partly successful: the attempt has left the face with a series of small facets rather than a smoothly modeled surface. The elaborate coiffure consists of a long curl marked with zigzags above the forehead, and a fringe on the sides and rear descending from a band tied round the head. A few other jade figures from Fu Hao's tomb, which appear by comparison more boyish, have simple, perfectly combed pudding-basin haircuts.

The figure kneels in the formal seated posture current in China before the introduction of the chair, and transmitted from China to Korea and Japan. The person depicted here wears a robe bound at the waist by a sash; the surface patterns yield no clue as to the meaning of the hooked projection in back—perhaps it is a decorative elaboration of the end of the sash.

Jade figurine. Anyang period (ca. 1300-ca. 1030 B.C.). Height 2¾ in. Excavated 1976 from Tomb No. 5, Anyang, Henan Province. Institute of Archaeology, Beijing

40 This small and charming elephant, of jade altered to a dark brown, is one of a pair from Fu Hao's tomb. The final curl of the elephant's trunk is formed by a perforation by which the figurine must have been suspended.

The decorative patterns are purely conventional, and do not differ in any essential from those seen, for instance, on the hawk pendant no. 34. The ears are set in relief, as is the short fat tail. A small four-pointed star is incised on top of the head.

Jade figurine. Anyang period (ca. 1300-ca. 1030 B.C.). Length 2½ in., weight 2¾ oz. Excavated 1976 from Tomb No. 5, Anyang, Henan Province. Institute of Archaeology, Beijing

5 Unrestrained Invention

The Rise of the Western Zhou Dynasty, Late 11th–Early 10th Century B.C.

41 The unique importance of this vessel resides in its inscription, which alludes to the Zhou conquest of Shang, and is dated on the eighth day thereafter. It had been buried in a pit with four other vessels, a set of thirteen bells, and bronze tools, weapons, and chariot fittings to a total of sixty items. Apart from this piece, all the major items of the hoard date to the very end of Western Zhou; thus this bronze was older by

nearly three centuries than the objects interred with it.

As a type this vessel derives from the much earlier handled vessel no. 8, to which it adds a hollow rectangular base cast with the bowl, a feature popular in early Western Zhou. Large animal masks in high relief fill the sides of the bowl and base. Each handle is surmounted by a head with large horns, apparently engaged in devouring the head of a bird; the cicada filling the space beneath the handle is seen again in the same position on nos. 45 and 57.

Food container (gui, inscribed for its owner Li). Late 11th century B.C. (first year of Wu Wang's reign). Height 11 in., weight 17 lb. 8 oz. Found 1976, Lintong Xian, Shaanxi Province. Cultural Office of Lintong Xian

42 Large and impressive, this vessel gives an effect of overpowering mass and barbaric energy. Although the mouth is circular, the body lower down is square: this flattening of the sides allows the animal masks to be displayed almost entirely in the frontal plane, concentrating the forward gaze of the staring eyes. More forceful than the mask on the foot, the mask in the middle zone has imposing rams' horns that spiral into relief, and hooked lower jaws that twist outward from the surface in the same way.

The vessel's remarkable inscription, obscured by corrosion and not discovered until twelve years after the piece was found, provides an exact date for the founding of the new Zhou capital at Luoyang.

Wine vessel (zun, inscribed for its owner He). Late 11th century B.C. (fifth year of Cheng Wang's reign). Height 15¼ in., weight 32 lb. 8 oz. Found 1963, Baoji Xian, Shaanxi Province. Shaanxi Provincial Museum

43 This and the next vessel were excavated from a cemetery in Gansu Province evidently connected with Zhou holdings in the area. The two vessels come from the tomb of an earl of Luan and have the same inscription: "The earl of Luan made this precious ritual vessel." Judging by the style of the bronzes in his tomb, the earl must have lived about the time of the second or third Zhou king.

The simple, perfectly cylindrical tall wine vessel is a shape that had appeared before the end of the Shang dynasty. The present one is the smaller vessel of a matched pair, differing only in size; in early Western Zhou and perhaps also in late Shang, such vessels seem often to have been cast in pairs identical except in size.

Wine vessel (you, inscribed for its owner Luan Bo). Late 11th-early 10th century B.C. Height 11⅜ in., weight 4 lb. 15 oz. Excavated 1972 from Tomb No. 2, Baicaopo, Lingtai, Gansu Province. Gansu Provincial Museum

44 As a type this three-legged pouring vessel derives from much older types, represented by the Panlongcheng example no. 5, and recalls early bronzes in several specific features. The most conspicuous of these is the large zigzag pattern of parallel thread-relief lines decorating the lobes; the same pattern is common on pre-Anyang lobed vessels. The decoration in two narrow bands on neck and lid, shared by many early Zhou bronzes, carries definite allusions to patterns of three or four hundred years before, with their rows of parallel quills (cf. no. 17), though the Zhou versions have lost altogether the expressive draftsmanship of the early designs. While at first glance it might seem that these features represent deliberate revivals of designs long out of fashion, it is possible that they will prove instead to descend in unbroken sequence from the earlier versions, constituting a simple and unostentatious alternative that coexisted alongside more dramatic and more architectonic Anyang styles.

Wine vessel (he, inscribed for its owner Luan Bo). Late 11th-early 10th century B.C. Height 11¼ in., weight 5 lb. 8 oz. Excavated 1972 from Tomb No. 2, Baicaopo, Lingtai, Gansu Province. Gansu Provincial Museum

45 The front end of this odd container takes the shape of a knobby animal head with winglike horns. The body belonging to this head is nowhere depicted, yet the formidable arched neck of the animal and the intense gaze of its bulging eyes come close to animating the entire object.

No part of the vessel is left unenlivened. In the rectangular side panel a florid animal mask is elaborated to fill every corner of the available space; spiraling bodies on either side set up an effect of swirling movement insistently repeated in the barbed contours of the C-horns and the ubiquitous flickering borders.

The handle is a zoological riot: the top takes the form of a large tusked head with horns; below is a bird whose beak is shaped like one hook taken from a flange. The wing of this bird—on which coils a snake—occupies the arc of the handle, with a small tusked head appearing just below it; from inside the mouth of this head an elephant's trunk emerges.

Set next to a bronze so unequivocally

Zhou as the wine vessel no. 42, this piece seems rather closer to Shang taste, an impression enhanced by its familiar motifs, conventional relief technique, and fine spirals.

It is one of a matched set of three vessels found in a storage pit, all sharing the same inscription of thirty-nine characters and a clan sign. A number of other vessels from the hoard (e.g., no. 47), including some far later, bear this clan sign, suggesting that the bronzes in the pit represent the accumulated possessions of several generations of the same family.

Wine vessel (*guang*, inscribed for its owner Qi). Late 11th-early 10th century B.C. Height 11¼ in., weight 16 lb. 10 oz. Excavated 1976 from Storage Pit No. 1, Zhuangbo, Fufeng Xian, Shaanxi Province. Zhouyuan Archaeological Team, Shaanxi Province

46 This cup is one of the rare examples of an ancient bronze that has survived uncorroded, perhaps due to the phenomenon known as cathodic protection (which in this case probably implies a high copper content). Its slender, simply curved silhouette is no less exceptional, while its decoration is completely unfamiliar. The amorphous thread-relief designs look distinctly like cloisons meant to receive some sort of inlay material, of which there is no trace.

Wine vessel (*gu*, inscribed Lü Fu Yi). Late 11th-early 10th century B.C. Height 9⅞ in., weight 1 lb. 3 oz. Excavated 1976 from Storage Pit No. 1, Zhuangbo, Fufeng Xian, Shaanxi Province. Zhouyuan Archaeological Team, Shaanxi Province

47 From the same large hoard as nos. 45 and 46, this vessel is one of the few examples of its type from the Zhou period. The decoration of birds and vertical ribbing has precedents in late Shang times, notably on no. 25. Especially typical of Zhou designs, however, is the treatment of the birds under the spout, their shapes reduced to flowing patterns dominated by long trailing crests.

Three-legged wine cup (*jue*, inscribed for its owner Fu Xin). Late 11th-early 10th century B.C. Height 8¾ in., weight 2 lb. 5 oz. Excavated 1976 from Storage Pit No. 1, Zhuangbo, Fufeng Xian, Shaanxi Province. Zhouyuan Archaeological Team, Shaanxi Province

48 This large bronze altar table, decorated with dragons set against a spiral ground, was cast in one piece. There are three oval holes in the top over which ritual

vessels could be set and perhaps heated. Only two bronze tables from Shang or Zhou times are known, and both were reportedly found in Shaanxi Province, in Baoji Xian.

Altar table (*jin*). Late 11th-early 10th century B.C. Width 49½ in., weight 103 lb. 10 oz. Said to have been found 1925 or 1926, Baoji Xian, Shaanxi Province. Tianjin Cultural Relics Administration

49 The decoration of both vessel and pedestal is dominated by confronted pairs of coiled monsters whose gaping jaws are supplied with pairs of conical teeth projecting sideways from the surface. The powerful hooked flanges that separate the two monsters on the bowl are typical of early Western Zhou (cf. no. 42). The vessel is one of a pair from the same tomb in which nos. 50 and 51 were found.

Food containers (*gui*). Late 11th-early 10th century B.C. Height 10⅜ in., weight 13 lb. 14 oz. Found 1971, Gaojiabao, Jingyang Xian, Shaanxi Province. Shaanxi Provincial Museum

50 Together with nos. 49 and 51, this piece came from a small tomb that contained thirteen bronze vessels, a bronze halberd blade, and five objects of jade. The bronzes were set near the head and the jades on the breast.

Like no. 49, this vessel's principal frieze is decorated with coiled monsters, but these creatures are more firmly shaped than the somewhat puffy versions on no. 49. Sinuous dragons are confronted on foot and lid, while in the uppermost zone of the body two more dragons come together to share a single three-dimensional head.

The flanges on this example and no. 51 are solid with blunt projections—stiff and rather lifeless descendants of the Shang form seen on no. 25—rather than openwork and hooked like those of no. 49. Their coexistence with the hooked variety is a reminder of the wide range of forms inherited and freely employed by the Zhou artist.

Wine vessel (*you*). Late 11th-early 10th century B.C. Height 14⅛ in., weight 14 lb. Found 1971, Gaojiabao, Jingyang Xian, Shaanxi Province. Shaanxi Provincial Museum

51 The inscription of this wine vessel is shared with no. 50 from the same tomb, and they were no doubt made as a pair. The motif of the coiled animal appears here only in the middle register; the foot is occupied by animal-mask designs, while the upper part is dominated by eight triangular blades rising

to the rim. The blades are filled with staring faces—two jaws in profile and two eyes—attached to "bodies" devoid of any organic feature.

Wine vessel (*zun*). Late 11th-early 10th century B.C. Height 12⅜ in., weight 9 lb. 7 oz. Found 1971, Gaojiabao, Jingyang Xian, Shaanxi Province. Shaanxi Provincial Museum

52 This cauldron is very large: over thirty inches tall and weighing more than 187 pounds. It was found buried in a small pit, where it had been inverted over another bronze, a large wine vessel. There are no signs of a tomb or of any other artifacts. The cauldron belongs to the early Western Zhou period, while the wine vessel, decorated with a wave pattern, dates to the end of Western Zhou; for disparity of contents, this was the quintessential Western Zhou bronze hoard.

A large part of this piece is covered with a geometric pattern of interlocked T-hooks, which occurs on pre-Anyang bronzes. Below the rim are six animal masks, their bodies alternately turning upward and downward, while rampant dragons decorate the handles.

Cauldron (*ding*). Late 11th-early 10th century B.C. Height 30¾ in., weight 187 lb. 7 oz. Found 1973, Chang'an Xian, Shaanxi Province. Shaanxi Provincial Museum

53 The motif of the crested dragon with a bird's body in the particularly elegant form seen on this bronze is quite rare. The vessel formed part of an oddly assorted hoard of sixteen bronzes, apparently not connected with a tomb, that included both familiar early Zhou types and such curiosities as a large bronze duck. This piece is by far the finest vessel of the group, and the only one mentioning a marquis of Yan in its inscription. The state of Yan lay in the far northeast of the Zhou realm, and is mentioned in numerous inscriptions on bronzes dating from the early Zhou period.

Food container (*yu*, inscribed for its owner Yan Hou). Early 10th century B.C. Height 9½ in., weight 14 lb. 3 oz. Found 1955, Machanggou, Kezuo Xian, Liaoning Province. Historical Museum, Beijing

54 This rectangular cauldron was found in a storage pit together with no. 55 and four other vessels. It represents a late and somewhat lackluster variation on the classic decorative scheme of the much earlier examples nos. 11 and 28.

The vessel is inscribed in several places,

but the text is peculiarly worded and contains several indecipherable proper names. It mentions, however, a "marquis of Ji," a title occurring in at least one oracle text, suggesting that the marquis of Ji was a vassal of the Shang court. It is possible that this vessel was cast in Shang times and somehow found its way into a hoard of early Zhou bronzes.

Rectangular cauldron (*fang ding*). 11th century B.C. Height 20⅜ in., weight 68 lb. 3 oz. Excavated 1973 from Pit No. 2, Beidongcun, Kezuo Xian, Liaoning Province. Liaoning Provincial Museum

55 Pride of place in the decoration of this bronze is taken by the coiled monsters on the shoulder (already familiar from nos. 49–51), while the expression of the vessel as a whole is given by the lid, which takes the form of a coiled, bottle-horned dragon rising menacingly on its forelegs. The animal-mask motif has been relegated to a distinctly subordinate position: it occurs at the lower corners, an off-axis positioning that deprives the motif of its usual dominating frontality and weakens its effect.

Wine vessel (*lei*). Late 11th-early 10th century B.C. Height 17¾ in., weight 18 lb. Excavated 1973 from Pit No. 2, Beidongcun, Kezuo Xian, Liaoning Province. Liaoning Provincial Museum

56 The compact shape of this vessel and the sensitive adaptation to it of extravagantly plastic decoration give an effect of concentrated energy and force without obscuring the delicate proportions; the achievement is almost unique in Western Zhou.

Very realistic water buffalo heads modeled in the round surmount the handles, and similar horned heads—not easy to cast—decorate the body and lid.

Food container with three hollow legs (*li*, inscribed for its owner Bo Ju). Late 11th-early 10th century B.C. Height 13 in., weight 18 lb. 2 oz. Excavated 1975 from M251, Huangtupocun, Liulihe Xian, Fangshan, Beijing Metropolitan District. Beijing Cultural Relics Bureau

57 The principal motif decorating the body of this vessel is—judging by its trunk—an elephant; but the anatomically gauche creature seen here owes nothing to earlier and more successful depictions of elephants, being instead pieced together from a variety of other motifs. The horn or crest of the traditional animal mask serves as an ear, and the jaw and eye are type forms equally old. The chief impetus behind the assembly

of the various parts must come from the coiled monster seen on nos. 49-51: the confronted pairs of elephants, the relief technique, and the raised spiraling lines that mark the elephants' bodies allude to the monster motif. We might thus be tempted to view the elephant's sudden appearance in fully developed form as an attempt to rationalize the motif of the coiled monster by converting it to the semblance of a real animal. The new motif occurs with little variation on a series of early Zhou vessels.

This kind of vessel on legs seems to have been a fashion largely confined to early Western Zhou, and none could be said to attain any great structural eloquence. Here the legs take the form of elephant trunks, the trunks issuing illogically from the mouths of elephantlike tusked heads.

Food container (*gui*, inscribed for its owner Yi Gong). Late 11th-early 10th century B.C. Height 10⅝ in., weight 11 lb. Excavated 1974 from M209, Huangtupocun, Liulihe Xian, Fangshan, Beijing Metropolitan District. Beijing Cultural Relics Bureau

6 Patterns and Interlace

Transformation of the Bronze Art in Later Western Zhou Late 10th Century—771 B.C.

58 Four odd sets of flanges divide this bell into quarters. The lateral flanges have been transformed into a procession of flat tigers, while those on front and back take the form of hooks and loops surmounted by a crested bird. Each quarter of the bell's surface is decorated with a large downward-facing dragon head; the dragon's body has dwindled to an inarticulate appendage less conspicuous than the hooked crest lying against its forehead. Unlike the earlier bell no. 19, which was mounted stem downward, this bell is equipped with a loop for suspension; both varieties existed in Shang times.

In the absence of excavated examples, it is uncertain whether such Zhou bells are southern provincialisms like similar Shang examples, or whether the Shang provincial type had by Zhou times been absorbed into the mainstream of metropolitan bronze casting, since ornamental motifs on the verge of dissolution into uniform ribbons seem to reflect the ruling decorative trends of metropolitan Zhou foundries.

Bell (*bo*). Late 10th-early 9th century B.C. Height 16½ in., weight 25 lb. 6 oz. Shanghai Museum

59 Every available space on this tiny vessel is covered with curvilinear patterns. The ornaments, derived chiefly from dragons, are reduced to hooked ribbons, each with a median groove. In the main zones the patterns are still recognizable as dragon pairs flanking large medallions, but in the subsidiary friezes the only remaining organic elements are barely discoverable eyes. The fluent curves of the surface ornament are reiterated in the patterns on the clumsy flanges, and on the ostentatiously unfunctional trunklike arms. More convincing on a few earlier and finer castings, the arms seem sadly out of place on these small and poorly cast vessels; their flamboyance has become an empty gesture.

The interior of the vessel is divided into two compartments by a partition; two apertures are cut into the lid to accommodate ladles.

Rectangular wine vessel (*fang yi*, inscribed for its owner Li). Late 10th-early 9th century B.C. Height 7⅛ in., weight 4 lb. 8 oz. Found 1956, Licun, Mei Xian, Shaanxi Province. Shaanxi Provincial Museum

60 In ornament, patination, and inscription this wine vessel agrees with no. 59. The two belong to a set of four connected by long inscriptions concerning their owner, a man named Li. The text, 106 characters long, describes a court ceremony in which Li is given certain duties and posts, including charge of the army of the West and the army of the eastern capital. Judging by the large number of similar inscriptions known from the latter part of Western Zhou, the event was a routine one, the protocol highly formalized, the king's symbolic gifts customary, and the phrases largely stereotyped. It is difficult, however, to overlook the discrepancy between the evident magnitude of the responsibilities conferred on Li, and the paltry bronzes cast in honor of his investiture.

Square wine vessel (*fang yun*, inscribed for its owner Li). Late 10th-early 9th century B.C. Height 6⅞ in., weight 6 lb. Found 1956, Licun, Mei Xian, Shaanxi Province. Shaanxi Provincial Museum

61 This vessel, one of an identical pair, reportedly belonged to a hoard of more than 120 bronzes unearthed in 1890 in Shaanxi Province. The scale pattern, ubiquitous in late Western Zhou, is imaginatively used. The scales are plastically rendered and overlapping on narrow bands on foot, lid, and widest part; a flatter version of the pattern covers most of the remaining surface. Two

small animal heads with spiraling horns are set on the shoulder. Apart from these heads, the only remnant of the rich zoomorphic imagery of earlier times appears in a narrow band of decoration on the neck, and another encircling the loop on the lid; and in both cases the animal patterns have been reduced to mere ciphers.

An inscription of sixteen characters is cast in a circle around the shoulder; it reads, "Zhong Yi Fu made this *ling* for use on travels; let sons and grandsons treasure and use it forever." The concluding formula, which becomes increasingly common in bronze inscriptions during the course of Western Zhou, accords well with the frequent discovery of hoards of Zhou bronzes spanning a wide range of dates (see nos. 41, 45, 52). Apparently the vessels were indeed long used by sons and grandsons before eventually finding their way into the ground.

Wine vessel (*ling*, inscribed for its owner Zhong Yi Fu). Late 10th or 9th century B.C. Height 17⅜ in., weight 31 lb. 12 oz. Said to have been found 1890, Qishan Xian, Shaanxi Province. Shanghai Museum

62 The ornament of this stately vessel is dominated by the slow uninterrupted horizontal movement of large undulating ribbons, filling three registers on the body and repeated in the freestanding crown on the lid. The surface acquires a rich plasticity from the concave profile given both the ribbons and the filler motifs. The handles, surmounted by crested animal heads, carry pendent rings whose decoration of overlapping scales calls to mind the preceding vessel, no. 61. The lid is perhaps misnamed, since it does not close the vessel; behind the fringe of the crown it is open to the interior.

This is one of a pair of identically inscribed vessels from a hoard of ninety-seven bronzes found in Hubei Province. The style of the vessels is consistent with a date around the eighth century, but it is not certain whether they belong just before the end of Western Zhou or just after.

Wine vessel (*hu*, inscribed for its owner You Fu). 8th century B.C. Height 26 in., weight 70 lb. 1 oz. Found 1966, Jingshan Xian, Hubei Province. Hubei Provincial Museum

63 The two parts of this vessel are nearly identical halves, so that the lid can be inverted to serve as a second container standing on legs of its own. The legs are small, wispy dragon silhouettes, their snouts to the ground; the handles take the form of three-dimensional tigers with arching striped bodies.

The patterns everywhere are equally flat, with an abstract recumbent S-shaped motif on top and sides. Those on the sloping sections are not abstract: they represent dragons, composed of broad grooved ribbons that curve to fill the entire surface uniformly. The even, swirling texture thus obtained was the artist's chief end, while individual motifs served him as nothing more than raw material. The designs stand in a direct line of descent from the patterned versions of zoomorphic motifs that evolved in the course of Western Zhou, but this bronze was probably made after the end of that period. At any rate its textured decoration based on dragon units offers a foretaste of the dominant modes of ornament of early Eastern Zhou.

Rectangular food container (*fu*). 8th century B.C. Height 6⅞ in., weight 9 lb. 6 oz. Found 1963, Feicheng, Shandong Province. Shandong Provincial Museum

7 Variety and Freshness

New Departures in Eastern Zhou Bronze Designs
The Spring and Autumn Period (770–476 B.C.)

64 This large food container is an isolated find, discovered buried less than two miles north of the Eastern Zhou capital, Luoyang. An inscription cast inside the basin was not noticed until 1974, when cleaning uncovered twenty-six characters executed in an elegantly slender script:

The duke of Qi of the Jiang family made this precious *yu* vessel for his second daughter in marriage. May it give her long life for ten thousand years, physical well-being always, and may generations preserve and use it forever.

The vessel's inscription and provenance suggest a marriage contract between Qi and the royal Zhou clan. At least two such marriages were recorded in history, in 603 B.C. and in 558 B.C. Both the overall thread-relief wave pattern and the secondary features of handle and movable ring favor a date from the seventh to early sixth century, but since vessels associated with Qi are noted for their conservative designs, it has been suggested that the piece may date from the mid-sixth century.

Food container (*yu*, inscribed by Qi Hou). Eastern Zhou (6th century B.C.). Height 18 in., weight 165 lb. Found 1957, Luoyang, Henan Province. Luoyang Municipal Museum

65 This striking object suggests a simple cart. No other bronze vessel known alludes in shape to a vehicle, and this is a unique and unprecedented example of its kind. Such bold inventions were possible only in regional workshops where local peculiarities could express themselves unhampered by an established tradition.

The provincialism of the vessel manifests itself not only in its shape, but also in surface decoration and manufacture. The design on the birdlike projections flanking one of the wheels suggests a loose interpretation of conventional bronze motifs, while the impressed meanders on the bowl and the small dots lining the birds' crests are decorative motifs common on pottery from the region. The casting is crude and no attempt was made to polish away seams or to disguise the additional pours of metal that secured the projecting parts to the basin. Even the surface decoration on the bowl is carelessly and irregularly stamped.

Considered in isolation, such a vessel would be extremely difficult to date. Its excavation supplies a secure provenance and related data, but can only hint at its date. The twelve other bronzes found with it are similarly provincial; among these, a set of three wine vessels is slightly more familiar, representing a regional Eastern Zhou perpetuation of a Western Zhou vessel type, a trend that seems to have disappeared by the Warring States period. The find also yielded an iron knife and sickle, which suggest a burial date no earlier than the sixth century B.C.

When unearthed, this piece was found inverted over two spouted water containers. Its almost uncorroded surface retains much of the golden luster of the original bronze (see no. 46 for another exceptionally preserved vessel).

Shallow basin (*pan*) on three wheels. Eastern Zhou (6th-5th century B.C.). Height 6¼ in., weight 3 lb. 10 oz. Excavated 1957, Yancheng, Wujin, Jiangsu Province. Historical Museum, Beijing

66 Like no. 65, this wine vessel represents yet another regional variation of Eastern Zhou bronzes, with its old-fashioned shape and unique decoration. Its lively main motif has been interpreted as silkworms on mulberry leaves, an unusual design that would reflect local preoccupation with the cultivation of silk during the Spring and Autumn period. Indeed, if the richly embroidered silks and woven damasks recently recovered from an early second-century B.C. tomb at Mawangdui in Changsha (about

sixty-two miles north of Hengshan) are any indication, the silk industry in this region must have been of great scale and sophistication for centuries. Whatever its meaning, the originality and local character of this design remains undisputed.

The provincialism of this piece lies not only in its shape and decoration, but also in its execution. Unlike no. 65, its casting is bold and crisp, yet the edges of the decorative motifs have a roughness not found on vessels from metropolitan workshops.

Wine vessel (*zun*). Eastern Zhou (6th century B.C.). Height 8 in., weight 4 lb. 10 oz. Found 1963, Hengshan, Hunan Province. Hunan Provincial Museum

67 Among the significant features of this monumental vessel, its hybrid character is the most fascinating. The diverse artistic and cultural forces behind its conception are further revealed in the realism of the crane, poised with half-spread wings above an overwhelming flurry of fantastic animal forms, and the surprisingly foreign note of the eight felines crouching around the foot, peculiarly reminiscent of creatures in seventh-century Scythian art. The rest of the surface decoration, such as the interlacing bird-dragons on the body, remains traditionally Chinese.

The technical achievement of the workshop that produced this piece is clear in its successful casting of a vessel so large that few bronzes can compare with it in size and quality. A small detail—the spiraling trumpet-shaped horns of the four winged creatures at the belly of the vessel—suggests either very sophisticated section-mold assembly techniques or a different casting procedure altogether, such as the lost-wax method that allows for irregular, gyrating shapes.

Square wine vessel (*fang hu*). Eastern Zhou (late 7th-6th century B.C.). Height 46½ in., weight 141 lb. 7 oz. Found 1923, Xinzheng, Henan Province. Palace Museum, Beijing

68 The crisp and neatly interlocking units decorating this small three-legged vessel are among the finest of their kind. The sharp contrast between motif and ground was accentuated by a black substance filling the background, some of which remains along the bottommost register. In most cases, these units were impressed into the clay mold with stamps, leaving clear demarcations of the stamp unit on the finished piece. On this example, however, no stamp marks are visible, suggesting that the design was carved by hand

into the mold. The interlocking units are identical except for those filling the concentric zones nearest the center of the lid, where each unit becomes more complex, interlocking three instead of two zoomorphs with eyes, in order to accommodate the decreasing circumference of the zones at the top. The attention lavished upon such fine details reflects a level of workmanship far higher than commonly encountered on bronzes of this style.

The uniform, virtually abstract design forms a sharp contrast with the three small reclining tigers on the lid. Their poses are relaxed, with front paws folded over each other, hind legs swung toward the front, and long tails drawn out in an elegant curve.

Food container with three hollow legs (*li ding*). Eastern Zhou (6th century B.C.). Height 7⅜ in., weight 4 lb. 8 oz. Found 1923, Liyu, Hunyuan, Shanxi Province. Shanghai Museum

69 This wine vessel is one of the best of its kind, its exceptional design and workmanship evident everywhere, from the lyrical interlace to each finely executed detail, and from the three-dimensional animal forms to the subtle layered effect created by controlled variations in relief.

It is one of a pair reported to be from Liyu (see Chapter 7). Broken stumps on each side of the neck mark the position of handles, presumably feline-shaped.

The vessel is decorated in four registers divided by bands. The first three registers carry identical motifs of a backward C-shaped dragon. Intertwined with the dragon is an S-shaped, birdlike creature whose head, seen alternately full face and upside down, possesses a strangely human quality, and whose body, with granulated scales, is dominated by a long, feathered wing. The birdlike creature is a rare Liyu motif that is known on only one other piece.

The fourth register carries a more typical Liyu composition, a large mask with magnificent coiled horns and a pair of back-to-back birds, their heads visible above the mask on either side. This interlacing unit of mask and birds is repeated four times around the vessel in an unbroken rhythm with the grace and discipline of classical choreography.

In low relief on the lowest register is a series of gooselike birds whose long, graceful necks are alternately raised and twisted. Below the birds are three bands, one a twisted rope, another a cowrie design, while a plaited rope in high relief circles the foot ring.

Small reclining animals in high relief are placed regularly around the vessel, a feature

not uncommon among Liyu bronzes. It is unusual that, in addition to rather harmless animals, are such creatures as a tiger with a man in his jaws, a leopard attacking a boar, and a bearlike creature holding another in its mouth. Here, the animal-combat theme of the northern steppes has been robbed of its sinister overtones and exploited largely for variety as quaint, miniaturized ornaments.

Wine vessel (*hu*). Eastern Zhou (early 5th century B.C.). Height 17⅜ in., weight 12 lb. 11 oz. Found 1923, Liyu, Hunyuan, Shanxi Province. Shanghai Museum

70 The red copper-inlaid animal and human figures decorating this small vessel stand out clearly in contrast to the even, light green patina of the plain bronze surface. The figures are randomly and liberally distributed across the surface, with no indication of setting or spatial relationships. The animals portrayed are not all recognizable species, many represented as vague types or adorned with imaginary appendages. All of them, however, are marked by large spiral shapes at their haunches, a motif commonly found on animal representations in Animal Style art from the northern steppes.

The Animal Style connections of this decoration are supported by two vessels with similar copper-inlaid designs. One carries an inscription saying that the vessel was acquired from the Xianyu barbarians, who became rulers of the state of Zhongshan during the Warring States period. The other was unearthed at a border site on the edge of the steppes.

An unusual inlay process was apparently used for the copper decoration of these vessels. X-ray studies of a large copper-inlaid wine vessel with animal decorations in The Metropolitan Museum of Art have suggested to Pieter Meyers of the Museum's research laboratory that its copper motifs were cut from sheet copper and secured between the mold and the core by chaplets. In the subsequent pouring process, the molten bronze flowed around these chaplets, thus locking (or "casting") the copper motifs into place. The innumerable chaplet marks visible throughout this piece suggest that it too was inlaid during the casting process. This technique appears to be restricted to copper-inlaid animal and pictorial style decorations (cf. no. 91), and does not seem to have been used for inlays of gold, silver, or copper in geometric designs, which were hammered into existing depressions in the cold bronze surface (see nos. 73, 75, 76, 93, 94).

Food container (*dou*). Eastern Zhou (late 6th-5th century B.C.). Height 8⅛ in., weight 3 lb. 15 oz. Found 1923, Liyu, Hunyuan, Shanxi Province. Shanghai Museum

71 Three identical large basins were reported to have been found with the present one. One of them bears an inscription that associates the vessel with Fuchai, the last king of the Wu state who reigned from 495 to 473 B.C. Both the inscription and the decorative style of these basins support a date no later than the early fifth century B.C. for the group.

Although the surface is heavily encrusted with patches of blue, green, and brownish red patina, the size of this vessel makes it powerful and impressive. The uniform surface decoration, a raised comma pattern that covers much of the basin, is offset by the strongly arched silhouette of the tigers climbing up the sides to peer over the brim.

Basin (*jian*). Eastern Zhou (early 5th century B.C.). Height 17¾ in., weight 118 lb. 13 oz. Reportedly found 1941, Hui Xian, Henan Province. Cultural Relics Bureau, Beijing

72 While most pendants of this type are carved from a single piece of jade, this elegant example is composed of seven. They are held together by a narrow bronze strip, wrapped in wood and inserted through rectangular perforations in the five middle sections, emerging at each end as gilt-bronze dragon heads that hold the last two sections in their mouths. The composite structure reflects the preciousness of the material: even the smallest fragments of jade were not wasted, but painstakingly worked and ingeniously assembled.

Jade pendant (*huang*). Eastern Zhou (late 6th-5th century B.C.). Length 8 in. Excavated 1950 from Tomb 1, Guweicun, Hui Xian, Henan Province. Historical Museum, Beijing

8 Splendor and Sophistication

The Inlaid Bronzes of the Warring States Period (475–221 B.C.)

73 The dominant ornamental designs on this square wine vessel—a rectangular framework on the neck and a diagonal grid on the body—are emphasized by the dark green of inlaid malachite chips. The large

intervening spaces are broken by a myriad of hooked motifs in bronze set against a background of inlaid coiled copper strips; the copper, originally reddish brown, has corroded green.

The mate of this magnificent vessel is in the Freer Gallery of Art, Washington, D. C. The vessels differ only in the allocation of the inlays: on the Washington piece, copper coils are inlaid into the diagonal and rectangular grids, and malachite chips fill the grounds of the interstices.

Square wine vessel (*fang hu*). Late Eastern Zhou (4th century B.C.). Height 20⅞ in., weight 22 lb. 14 oz. Excavated 1957, Shan Xian, Henan Province. Historical Museum, Beijing

74 This type of vessel is a food container whose cover often serves as a second container when inverted. On this example a cast design is set against an empty ground that was once filled with inlays of coiled metal strips (probably copper) and malachite. The metal inlay is preserved only in isolated places and has corroded to a light green, and malachite chips have fallen off everywhere except in the inside rim of the bowl, where they have been protected by the lid. The central medallion on the flat top of the lid's stem is filled with a blue substance that resembles glass paste—a new departure, reflecting an expanded repertory of inlay materials that were to include crystal, jade, and glass in the third and second centuries B.C.

The decoration on this vessel is an unusual combination of the first and second stages of the Inlay Style (see Chapter 8): a zoomorphic motif of S-shaped dragons—an advanced first stage design—occurs on the stems, bases, and flat undersides, while the sides bear a second stage design: a dynamic, tilted, geometric pattern with constantly overlapping elements.

Food container (*dou*). Late Eastern Zhou (4th century B.C.). Height 9½ in., weight 5 lb. 1 oz. Excavated 1965, Xiangxiang, Hunan Province. Hunan Provincial Museum

75 The gold and turquoise on this exquisite vessel not only highlight the pattern cast in bronze—a rectangular grid—but also provide the pattern themselves in the inlaid panels defined by the grid. This distinction between ground and pattern, inlay and bronze, becomes less obvious in the decorated registers at the top of the vessel, where both the inlaid areas and the bronze forms assume equal weight as patterns. The inlays also form the pattern on the bodies of the

four long-necked felines that climb up the sides to peer over the edge. Most of the fine gold inlay has been preserved, but much of the turquoise has fallen from its place. This type of vessel is rare among Eastern Zhou bronzes.

Rectangular basin (*fang jian*). Late Eastern Zhou (3rd century B.C.). Height 8½ in., weight 26 lb. 3 oz. Excavated 1975, Sanmenxia, Shan Xian, Henan Province. Henan Provincial Museum

76 The only cast-iron object in the exhibition, this strongly arched belt hook is lavishly inlaid with gold and silver in a design composed of three dragons and eleven birds in a sea of curves and spirals. The interplay between the inlaid motifs and the cast metal ground is so complex that it is virtually impossible to distinguish pattern from background. The gold and silver strips are set into precast depressions, the widest areas filled with three or more parallel strips. The iron is heavily corroded and the silver tarnished, but the gold has remained brilliant.

The belt hook as an ornament on a fabric or leather belt was introduced in China by the steppe nomads toward the end of the Spring and Autumn period. The earliest belt hooks are modest in size, and appear to have been produced in quantity by the foundry at Houma. This magnificent example, the largest known of its kind, came from a rich Chu tomb. It is 18⅞ inches wide and both its size and weight suggest that it could not have been an ordinary garment accessory, if it was worn at all.

Iron belt hooks are much rarer than bronze ones, but the fact that they were made at all indicates fascination with the new metal and readiness to explore its potential, although its limitations were soon realized.

Iron belt hook. Late Eastern Zhou (4th century B.C.). Length 18⅞ in., weight 1 lb. 9 oz. Excavated 1965 from Tomb 1, Wangshan, Jiangling, Hubei Province. Hubei Provincial Museum

77–90 The fourteen bells in this set are identical in shape, and each is suspended by a U-shaped loop at the top. The first and largest bell, much repaired, is heavily corroded and not inlaid; eight of the others carry similar but not identical patterns of fine lines inlaid with gold on the body (the one illustrated here also has inlay in the running spiral pattern of the suspension loop), and the remaining five carry only cast decoration. These clapperless bells

were meant to be struck on the outside with wooden hammers.

Pictorial scenes on contemporary or earlier bronzes show that such bells were hung in graduated order from a wooden frame, usually ornamented. Only the two pairs of tiger-head finials are preserved from the frame of the present set. The silver-inlaid designs on these finials are more flowing and graceful than those on the bells, although all the designs are characterized by numerous tendrillike terminations.

Fourteen bells. Late Eastern Zhou (3rd century B.C.). Height of largest bell 10⅞ in., weight 6 lb. 11 oz. Excavated 1972, Fuling Xian, Sichuan Province. Sichuan Provincial Museum

91 The inlaid pictorial scenes that decorate this wine vessel encompass a wide range of subjects. The top register shows figures among trees and an archery contest. The second includes scenes of a ritual dance with long spears, musicians playing instruments—bells and chimes suspended from a frame, wind instruments, and a drum—and a banquet held inside a building while food is cooked outside. Next to these is another archery contest, followed by figures hunting wild birds with bows and arrows. The third register depicts battles on land with figures scaling a walled fortification, and on sea, fought from boats with oarsmen and with long banners trailing in the wind. The lowest register and the lid are both decorated with freely disposed animals.

A new meaning for the scene with figures among trees has recently been suggested. Instead of the widely accepted interpretation that the scene represents the picking of mulberry leaves, an activity related to the cultivation of silk, it is now thought that the scene depicts a ritual selection of mulberry branches for making bows. This agrees well with the accompanying archery scenes, and with all the activities in the first two registers—rituals and festivities related to the peacetime display of martial skills—in contrast with the actual confrontations in battle depicted in the third register.

On the second register, next to the scene of bird hunting and below the archery contest, six figures are grouped under an arched canopy supported in the middle by a vertical post, probably a tent in which the bird hunters rest. This is a graphic illustration of the outdoor life that accompanied such expeditions, and may reflect a practice learned from more experienced tent dwellers, the steppe nomads.

The scenes represented on this vessel are unusually lively by comparison with similar examples. There is little doubt that the vessel dates from the early Warring States period, but its place of manufacture is less certain. It might be a metropolitan product, as a scene of figures among trees appears on a mold fragment from the Houma factory.

The inlay is a substance predominantly brownish in color, but in some places light creamy white. This substance, described as "leadlike," is possibly silver, but more probably copper; laboratory tests should provide a more definite answer. Whatever the substance, the inlay, corroded and pitted like the rest of the bronze surface, is so well bonded to the sunken areas of bronze that it may represent the unusual inlay technique described in entry no. 70.

Wine vessel (*hu*). Eastern Zhou (late 6th-5th century B.C.). Height 15¾ in., weight 9 lb. 14 oz. Excavated 1965, Chengdu, Sichuan Province. Sichuan Provincial Museum

92 This enormous bronze trident—56¾ inches tall—was one of a set of six, buried with remains of a leather tent, bronze tent structures, and many vessels of pottery, bronze, and lacquer in a tomb believed to be that of a Zhongshan king. Another group of five slightly shorter trident-shaped bronzes was buried nearby. The immense size, bold form, and burial context of these sets suggest that they were standard tops, set high on wooden posts outside the chieftain's tent. Visible from long distances and awesome at close range, they are effective emblems of power and reflect dramatically the nomadic, tent-dwelling origins of the Di nomads who became rulers of Zhongshan in the Warring States period. There is no adequate Chinese parallel for these magnificent objects, but they and their original may be found somewhere in the vast Central Asian steppes.

Standard top. Late Eastern Zhou (4th century B.C.). Height 56¾ in., weight 110 lb. 1 oz. Excavated 1978 from Tomb 6, Pingshan Xian, Hebei Province. Hebei Provincial Museum

93 This rhinoceros was discovered accidentally by a farmer plowing his fields. It was found inside a large pottery urn packed with soil and buried only three feet deep. Its hollow body contained various bronze objects, including a belt hook and miscellaneous bronze tools, fittings, and weights. There was no sign of a tomb at the site. It appears that the urn held valuables temporarily buried for safety, but never recovered by their owner.

Like the Shang elephant no. 24, this object must have served as a container for wine or other liquids. A narrow tubular spout issues from one side of the rhinoceros' mouth, while the hinged lid on its back allows access to the interior of the vessel.

The beast is draped with a dense raised pattern of scalloped cloud scrolls that are found on both lacquers and embroidered silks of the late third to second centuries B.C. On this rhinoceros, however, these abstract ornamental patterns swing around the bronze surface with such energy and vigor that they suggest, in a strange way, the rugged liveliness of the animal, while being beautifully decorative at the same time.

These cloud scrolls were once inlaid, presumably with gold or silver which has not survived. The slightly raised areas between the cloud scrolls are inlaid with gold in short, furlike strokes, some of which are still visible. The eyes of the animal are inlays of black glass.

Rhinoceros container (*zun*). Late Eastern Zhou-Western Han (late 3rd century B.C.). Height 13⅜ in., weight 29 lb. 4 oz. Found 1963, Xingping Xian, Shaanxi Province. Historical Museum, Beijing

9 The Waning of the Bronze Age
The Western Han Period (206 B.C.—A.D. 8)

94 The shape of this brilliantly gilded bronze lamp is unique among Western Han examples. It also ranks among the finest of early Chinese sculpture, whether in bronze, terracotta, or wood. The girl's young face is sensitively modeled, her pose natural with feet neatly tucked behind, and her full, flowing robe draped with substance and decorum.

The lamp itself has a movable circular base with a small pin in the center for the candle. The vertical wall of the lamp consists of two freely sliding sheets that can be adjusted to control the direction of light and to regulate the brightness by changing the size of the opening. The hollow right arm and body of the girl act as a funnel and container for the smoke rising from the burning candle, trapping it inside her body to keep the room free from soot. This elegantly functional design fully reflects the remarkable creativity and mechanical re-

sourcefulness of the artists of the time.

As in nos. 95 and 97, lost-wax casting must have been employed in the production of this figure, a technique that seems to have been increasingly exploited during the Western Han period to meet the demand for highly irregular and complex shapes in bronze. Its gilded surface also represents the most popular bronze decorative technique in Eastern Han, and was almost always used on Buddhist and other bronzes in the subsequent Six Dynasties and Tang period. The technique of fire-gilding appeared during the Warring States period (see no. 72), and its overriding popularity in Western Han is a natural development from the taste for elaborately inlaid surfaces on Warring States bronzes. Compared to inlaying, however, gilding required less time and labor, but it was no less attractive to the extravagant and worldly tastes of the time. The fluidity of the mercury and gold-powder mixture used in gilding also enabled the bronze master to produce painterly designs on bronze with the same ease and dynamism as on painted lacquers, with which the bronze industry had to compete since the late Warring States period.

Gilt-bronze lamp. Western Han (first half 2nd century B.C.). Height 18⅞ in., weight 34 lb. 14 oz. Excavated 1968 from the tomb of Dou Wan, Mancheng, Hebei Province. Hebei Provincial Museum. Photographs: Wang Yugui, Cultural Relics Bureau, Beijing

95 Exceptional in design and workmanship, this beautiful incense burner is also extremely well preserved. The irregular shapes and deep undercuts that form the top suggest strongly that the lost-wax method was used in its casting, for no mold-assembly technique could have produced a form as complex and as sculptural. The same method might have been involved in the casting of the bowl, which is also cast integrally with its freestanding elements.

The iconographic separation between island and sea (top and bowl) is obscured by the presence of the same fingerlike peaks on each. Animals and vegetation are also found among both, making the distinction even more vague. Six figures are visible on the island: three are near the top; a man on a donkey is halfway up; further down, another carries an axlike object over his shoulders; and a sixth figure is found nearest the bottom. Tigers and bearlike creatures emerge from among the formations. There are even two schematized tree motifs at the rim of the bowl, while straight hairlike strokes at the tips of the peaks suggest distant foliage.

The swirling and overlapping pattern on the bowl and sleeve is precast in the bronze surface and inlaid with thin gold sheets cut to fit the size of the depressions. The fine threadlike lines, on the other hand, appear to have been cut into the cold bronze surface, since the curves they describe seem halting and jagged in places. These, too, are inlaid with thin threads of gold. The inside of the pierced top shows signs of browning by smoke, indicating that this censer must have been used and was not merely a mortuary item. It was found in the small side chamber next to the burial chamber, suggesting that in life, as in death, it would have served as a private, personal accessory.

As a type, the censer is well known in Western Han art, and is believed to be an imaginative rendering of one of the three Isles of the Immortals of Taoist myth. Plainer and more standard bronze versions are common, as well as cheaper substitutes in pottery; extravagantly inlaid censers such as this are rare.

Recent finds of lacquer objects with similar peaklike motifs and swirling currents can be dated to the first half of the second century B.C., suggesting that the ornamental forms on this censer, which must date from the second half of the century, were probably derived from preexisting painted lacquer designs. This further suggests that, by the early Western Han period, the art of painted lacquers not only rivaled, but perhaps had already surpassed, the art of the bronze vessel in creativity and elegance.

Censer. Western Han (second half 2nd century B.C.). Height 10¼ in., weight 7 lb. 8 oz. Excavated 1968 from tomb of Prince Liu Sheng, Mancheng, Hebei Province. Hebei Provincial Museum

96 Like the incense burner no. 95, this wine vessel was buried in the tomb of Prince Liu Sheng at Mancheng, Hebei Province. Its surface is covered with fine gold and silver inlays in complex scroll-like configurations forming a highly stylized script commonly known as "bird script." The inscription on the body reads:

With happy hearts [let us] gather in banquet.
The occasion is grand and the fare sumptuous.
Let delicacies fill the gates and increase our girth,
And give us long life without illness for ten thousand years and more.

Histories noted that Liu Sheng reveled in wine and festivities; the sentiments of this inscription express vividly what the historian could only report.

Highly ornamental bird-script characters originated with inscriptions on bronze weapons and swords from the southern state of Yue during the Warring States period. It is interesting that this peculiarly local trait persisted long after Yue's fall at the end of the fourth century, to the time of the workshops that produced the bronzes buried at Mancheng at the end of the second century B.C. Another southern connection lies in the design of the narrow dividing bands of this vessel, whose animals among angular scrolls are related to designs painted on lacquered vessels from Changsha, generally dated to the end of the Warring States period. Both connections illustrate the artistic borrowing between regions and mediums during the Western Han period.

The pronounced, curving silhouette, full and somewhat low-slung belly, and high foot ring are characteristic of Western Han types of this vessel.

Wine vessel (*hu*). Western Han (second half 2nd century B.C.). Height 17⅜ in., weight 14 lb. 7 oz. Excavated 1968 from tomb of Prince Liu Sheng, Mancheng, Hebei Province. Hebei Provincial Museum

97 This unusual object is a combination of a tiger, a young bull, and an older bull. The head and body of the larger bull form the major part of the object. Its head is smoothly modeled in the round, with a pair of proudly curved horns and small ears, but its body has been reduced to a saddlelike slab, its back scooped away to form a shallow depression, and its belly removed to allow the young bull, sculpted in its entirety, to be placed beneath. The bony features of both bulls are simply and realistically modeled and their sweeping horns magnificently conceived. The tiger clutches the hind end of the larger bull and holds its tail in its teeth; the tiger's body is marked with raised stripes.

The cultural and technological significance of this object has been discussed in Chapter 9. In the piecemeal construction of this object, organic consistency is sometimes sacrificed to production: for example, the bull's tail was cast as part of the tiger, and attached by soldering.

The function of this striking object is perhaps its most intriguing aspect. Chinese archaeologists have variously classified it as a low table and as a kind of ritual altar. No precedent in either Dian or Chinese contexts can aid us in this question. It was found in one corner of the burial pit among spearheads and next to bronze drums and fragments of armor. This burial association

suggests that the object, like the bronze drums, probably served in a ritual related to warfare. Without question, it represents a type unique to Dian culture.

The motif of a tiger attacking a bull from the rear evokes a famous Near Eastern parallel—the reliefs of a lion attacking a bull that flank the stairway at the sixth- to fifth-century Achaemenian site of Persepolis.

Ritual object. 3rd-2nd century B.C. Height 16⅞ in., weight 27 lb. 11 oz. Excavated 1972, Lijiashan, Jiangquan, Yunnan Province. Yunnan Provincial Museum

10 The Terracotta Army of the First Emperor of Qin (221–206 B.C.)

98 Unlike the vast majority of foot soldiers in the terracotta army that stand in strictly frontal poses, this figure's animated stance recalls a movement in the Chinese martial art of shadow boxing. Facing to the side, feet apart, the left arm extended and the right arm cocked, the warrior presents a minimal target to oncoming adversaries while keeping his arms ready either to ward off an attacker or to strike a blow. The slight tilt of the head and thrust of the chin heighten the impression of alert readiness implicit in the tensed gesture of the hands and arms. Bronze arrowheads found beside these pugilists suggest that they doubled as archers. Unencumbered by heavy suits of armor, such vanguards might be deployed ahead of the main army to observe, harass, or decoy enemy troops prior to any full-scale engagement.

Striding infantryman. Qin dynasty (221-206 B.C.). Height 5 ft. 10 in. Excavated 1976-77 from Trench 5, Pit No. 2, Lintong, Shaanxi Province. Shaanxi Provincial Museum

99 Although this kneeling figure's head and eyes are fixed frontally, the torso is slightly turned to the side, pulled by the arms, which are flexed as if cradling a bow. Arrowheads, traces of wooden bows, and fragments of swords and scabbards uncovered alongside these infantrymen confirm that they depict archers, some of whom, at least, were also armed with swords.

The trousers, short double-layered robe, and waist-length suit of armor worn by these warriors have been delineated with the utmost care. Note, for example, the armored

tunic and epaulettes. Rectangular armor plates—leather or metal in the original —are arrayed in overlapping rows seemingly fastened together with numerous clay studs that simulate either metal rivets or knotted cords. At the shoulders and curved skirt of the tunic, the plates are strung together by broad laces for added flexibility. A similar lace encircling the neck and secured at the chest by a toggle permitted the collar to be loosened so that it would pass easily over the head. The figure's coiffure is described with the same precision as the uniform. Traces of red pigment on the cord holding the elaborate chignon, as well as white underpaint on the face, remind us that the realism of such minutely portrayed details was originally further enhanced by the addition of color.

Kneeling archer. Qin dynasty (221-206 B.C.). Height 3 ft. 11 in. Excavated 1976-77 from Trench 10, Pit No. 2, Lintong, Shaanxi Province. Shaanxi Provincial Museum

100 Among the more than 200 terracotta warriors unearthed from Pit No. 2, two figures are distinguished by their great height, ornate uniforms, and unique poses as commanding officers. One is a chariot-mounted officer; the other, shown here, depicts an officer of the infantry vanguard. With its furrowed brow, pursed lips, and bony chin set off by side whiskers and goatee, this figure's face captures the dignity and confidence of an experienced military commander. The pyramidlike stance formed by the legs and coupled forearms, once braced by a sword, underscores this impression of authority. The wide-sleeved double robe and intricate plate-armor tunic are attributes of elevated rank, as is the elaborately folded bonnet secured under the chin by cap strings tied in a flamboyant bow. Smaller bows decorate the front, back, and shoulders of the tunic, which has a waist-length back but hangs down in front in a long, tapered apron.

Infantry officer. Qin dynasty (221-206 B.C.). Height 6 ft. 5 in. Excavated 1976-77 from Trench 4, Pit No. 2, Lintong, Shaanxi Province. Shaanxi Provincial Museum

101, 102 According to a historian of the second century B.C., cavalry was introduced into Zhou China by King Wu Ling of Zhao (reigned 325-299 B.C.); to combat the mounted tribesmen of the steppes threatening the Zhao state's northern frontier, the king ordered his people to practice the nomadic custom of horseback riding and mounted archery and to replace the cum-

bersome long Chinese robe with barbarian trousers.

The advent of cavalry revolutionized warfare. During the Shang and most of the Zhou dynasty, chariots were an army's main striking force. The Zhou four-horse chariot was an unwieldy vehicle, however, requiring wide expanses of dry, level ground for its maneuvers, as well as an auxiliary force of infantrymen to protect it from being captured in close-quarter engagements. The cavalry horse was far easier to handle and could be employed in terrain too rugged for wheeled vehicles. Thus, while the chariot remained a symbol of authority and continued to be utilized as a command car, by Han times its role as a tactical weapon had been superseded by the saddle horse. Judging from the almost equal numbers of chariots and cavalrymen in the First Emperor's buried bodyguard, during the Qin dynasty the transformation from chariot-mounted warfare to cavalry was not yet complete. Pit No. 2, for example, contains an estimated ninety-one chariot teams compared with 116 cavalry troops. Nevertheless, the Qin clearly appreciated the versatility of cavalry. Whereas the chariots in the terracotta army are massed close to the main body of infantrymen, the cavalry troops are deployed in the outside ranks of the formation, a position from which they could maneuver freely to the side or rapidly advance to reinforce the infantry vanguard.

The clay cavalrymen stand as if for an imperial review, each rider at attention in front of his mount in ranks of four abreast. The present figure, representative of his type, stands with his arms at his sides, the right hand grasping the reins, the left hand half-clenched with thumb out as if holding a weapon. Since two bronze crossbow trigger mechanisms and the remains of six quivers filled with eighty to one hundred arrows each were discovered in the same trench with this figure, it is likely that he was armed with a crossbow. The figure's uniform is appropriate to his role as horseman. He wears a short robe topped by a brief armor vest, long close-fitting trousers, shoes of stitched leather, and a cap secured by a chin strap.

The saddle horse is also at attention, its head erect and legs together, perfectly upright with muscles taut as if awaiting the command to charge into battle. The vitality and animation of the animal almost obscures the remarkable feat of its construction and firing. Weighing well over 500 pounds, the entire horse was built up of clay coils, the hollow head and torso supported by solid legs. The tail and forelock were added later, as were the large round plugs

located on each flank below the saddle, filling holes that served as vents during the firing of the piece to permit the escape of gas and vapor from the hollow interior. The saddle is fashioned from the same piece of clay as the horse's torso, but it reproduces in detail what must have been leather and metal in the original. Placed atop a saddle blanket and secured by means of a girth and crupper, the saddle is depicted with a seat studded with rivets or knotted cords, a padded pommel and cantle, and even leaf-shaped ornamental flaps and ribbons attached to the sides. There are no stirrups, since that piece of equipage did not become part of Chinese saddles until after the Han dynasty.

Each horse was originally equipped with a separate bridle, but only one example, from Trench 14, has been successfully reassembled. This unique bridle has been fitted to the saddle horse in this exhibition. The reins terminate in bronze hand rings that imitate leather, suggesting that the bridles worn by the terracotta horses were specially crafted from imperishable materials so that they might survive underground forever.

Cavalryman and saddle horse. Qin dynasty (221-206 B.C.). Height of man 5 ft. 10½ in., height of horse 5 ft. 7½ in. Excavated from Trench 12, Pit No. 2, Lintong, Shaanxi Province. Shaanxi Provincial Museum

103 Charioteering was one of the six arts practiced by the aristocratic class in Zhou China. Although Qin laws sought to replace hereditary distinctions with a hierarchy of ranks based on military merit, the imposing stature of this charioteer—6 ft. 2½ in.—suggests that the status of chariot-mounted warriors, as might be expected, continued to be higher than that of ordinary foot soldiers. The driver's distinctive bonnet and cap strings further imply elevated rank. The charioteer's uniform, which includes a long robe topped by an armored vest, with broad leggings or greaves and square-toed sandals, is considerably lighter than the suits of other charioteers; a driver found in Trench 1, for example, is protected by thigh-length armor fitted with a high collar, and armor plating that entirely covers his outstretched arms and fists.

Although Pit No. 2 has not been fully excavated, it is estimated that it contains ninety-one chariots, each drawn by four terracotta horses and manned by a driver, one or two armed riders, and in some cases accompanied by from eight to thirty-two infantrymen. The present charioteer belongs to one of the teams located immediately behind the infantry vanguard; he was accompanied by a chariot-mounted warrior. Unlike those of Pit No. 1, both the drivers and riders in Pit No. 2 were positioned behind rather than inside their wooden chariots.

Charioteer. Qin dynasty (221-206 B.C.). Height 6 ft. 2½ in. Excavated 1976-77 from Trench 13, Pit No. 2, Lintong, Shaanxi Province. Shaanxi Provincial Museum

104 This example of a Qin chariot horse belongs to the same stocky breed as the terracotta saddle horse no. 102. Of the same height, both horses are characterized by compact bodies, short legs, and broad necks. Despite their generic similarities, however, the distinct characters and functions of the two animals are immediately apparent from their profiles and details of grooming. While the cavalry horse stands erect, the chariot horse strains forward against the reins, giving an impression of bridled power heightened by the taut, angular muscles of his head, the bared teeth, the curled lips, and forward cant of the ears. The tail of the chariot horse, tied up to keep it clear of the harness traces, contrasts with the long, plaited tail of the saddle horse. The original full complement of harness trappings included a yoke, leather reins, and ornamental bridle.

Chariot horse. Qin dynasty (221-206 B.C.). Height 5 ft. 7 in. Excavated 1976-77 from Trench 1, Pit No. 2, Lintong, Shaanxi Province. Museum of Qin Figures, Lintong, Shaanxi Province

105 The vast majority of soldiers in the terracotta army are armored infantrymen, such as this foot soldier from Pit No. 1. Judging from the extended right forearm and its half-clenched fist, this type once held actual spears. A robe topped by an armored tunic, puttees, and square-toed sandals tied with a cord complete the uniform of the basic type. In spite of their uniformity in pose and dress, these pottery figures were not moldmade but individually sculpted, often with great sensitivity and particularity. For example, while most warriors from Pit No. 1 have their hair tied in a bun at the top of the head, this figure is depicted with the hair combed into six strands plaited in a flat braid at the back of the head, where it is secured with a criss-crossed cord and a square patch of ornament. The idealized canon of beauty epitomized by the face foretells the similarly perfected features of the gilt-bronze lamp in the form of a female servant (no. 94). The shared preference for smoothly tapering cheeks and chin, deep-set eyes, crisp, angular eyebrows, and stepped-back hairline reveals a remarkable continuity in aesthetic sensibilities between the artisans working at the mausoleum of the First Emperor of Qin and later sculptors of the Han imperial palace.

Armored infantryman. Qin dynasty (221-206 B.C.). Height 6 ft. Excavated 1974-78 from Pit No. 1, Lintong, Shaanxi Province. Museum of Qin Figures, Lintong, Shaanxi Province